Sacred

Sacred

Books of the Three Faiths: Judaism, Christianity, Islam

Edited by John Reeve

Essays by
Karen Armstrong, Everett Fox, F.E. Peters

Catalogue contributions by
Colin F. Baker, Kathleen Doyle, Scot McKendrick,
Vrej Nersessian, Ilana Tahan

BRITISH LIBRARY

First published in 2007 by
The British Library
96 Euston Road
London NW1 2DB

To accompany the exhibition 'Sacred' at the British Library 27 April – 23 September 2007

British Library Cataloguing-in-Publication Data
A catalogue record for this book is available from The British Library

ISBN
Paperback 978 0 7123 4955 0
Hardback 978 0 7123 4975 8

Designed and typeset by Andrew Shoolbred
Colour reproductions by Dot Gradations Ltd, UK
Printed in Italy by Printer Trento S.r.l.

Acknowledgements
Many British Library colleagues assisted with this catalogue, as well as the following whom we
would like to thank individually:

British Museum: Chris Entwistle, Venetia Porter, James Robinson
Chester Beatty Library: Charles Horton
The Jewish Museum: Jennifer Marin
Hill Museum and Manuscript Library, Saint John's University: Tim Ternes
Victoria & Albert Museum: Paul Williamson, Marian Campbell
Others: Gitl and Marton Braun, Mark Negin, Cathy Rostas

Lenders to the exhibition:
Ashmolean Museum, Oxford
Bibliothèque Nationale, Rabat
Trustees of the British Museum, London
Brotherton Library, University of Leeds
Trustees of the Chester Beatty Library, Dublin
Jewish Museum, London
John Rylands University Library, Manchester
Daniel Lehrer
The Montefiore Endowment at Ramsgate
Musée Bible et Terre Sainte, Paris
Nationalmuseum, Stockholm
Private lenders
The Royal Library, Marrakesh
Saint John's University, Collegeville, Minnesota, USA
Tashkent Islamic University, Uzbekistan
Victoria and Albert Museum, London

Contents

Loyalty to a strongly held religious faith has been a feature of human nature for a very long time. Unfortunately, that loyalty has only too frequently been matched by intolerance and hostility towards all other faiths. As a consequence many vicious and destructive wars have been fought on religious grounds. Today, people are able to move about the world with greater freedom than ever before. If they are to become constructive and happy members of their new communities, there is a really urgent need for people of different faiths to become more tolerant of each other's beliefs.

I would, therefore, like to commend the British Library for assembling this very important exhibition of sacred texts from the three Abrahamic faiths, Judaism, Christianity, and Islam. It reflects the achievements of some very enlightened and civilised communities, where the followers of these three faiths have lived and worked together in peace and harmony for many centuries. In this divided world, the need for understanding and collaboration is greater than ever.

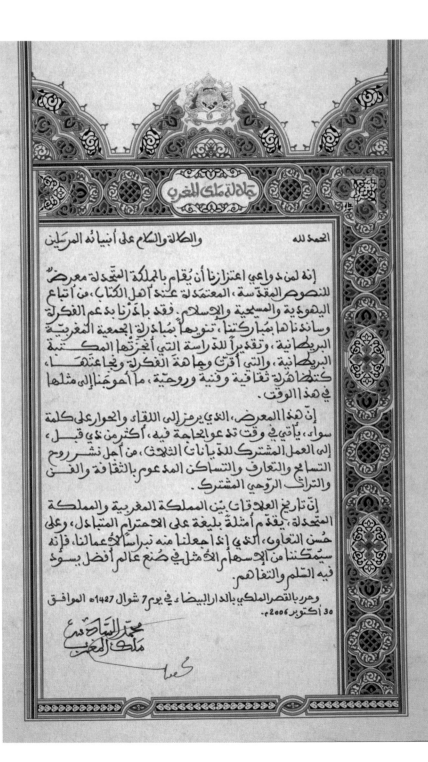

الحمد لله

والصلاة والسلام على أنبيائه المرسلين

إنه لمن دواعي اعتزازنا أن يُقام بالمملكة المتحدة معرضٌ للنصوص المقدّسة، المعتمدة عند أهل الكتاب، من أتباع اليهودية والمسيحية والإسلام. فقد بادرنا بدعم الفكرة وساندناها بمباركتنا، تنويهاً بمبادرة الجمعية المغربية البريطانية، وتقديراً للدراسة التي أنجزتها المكتبة البريطانية، والتي أقرّت وجاهة الفكرة ونجاعتها، كتظاهرة ثقافية وفنية وروحية، ما أحوجنا إلى مثلها في هذا الوقت.

إنّ هذا المعرض، الذي يرمز إلى اللقاء والحوار على كلمة سواء، يأتي في وقت تدعو الحاجة فيه، أكثر من ذي قبل، إلى العمل المشترك للديانات الثلاث، من أجل نشر روح التسامح والتعارف والتساكن المدعوم بالثقافة والفن والتراث الروحي المشترك.

إنّ تاريخ العلاقات بين المملكة المغربية والمملكة المتحدة، يقدّم أمثلةً بليغةً على الاحترام المتبادل، وعلى حسن التعاون، الذي إذا جعلناه منه نبراساً لأعمالنا، فإنه سيمكننا من الإسهام الأمثل في صنع عالم أفضل يسود فيه السلم والتفاهم.

وحرر بالقصر الملكي بالدار البيضاء في يوم ٧ شوال ١٤٢٧هـ الموافق ٣٠ أكتوبر ٢٠٠٦م.

محمد السادس
ملك المغرب

Praise be to God Peace and blessings be upon His
 Prophets and Messengers

I am delighted that the United Kingdom is hosting an exhibition of the Sacred Books of the followers of Judaism, Christianity and Islam. I readily supported the idea and gave it my blessing. In this respect, I should like to commend the Moroccan British Society's initiative and to express my appreciation to the British Library for endorsing the idea as both relevant and useful. Cultural, artistic, spiritual events, such as this one, are indeed very much needed today.

This exhibition is a clear example of what we can do to foster interaction and constructive dialogue. There has never been a greater need for the three revealed religions to join efforts and build on culture, art and the spiritual legacy we have in common to promote a spirit of tolerance, mutual understanding and coexistence.

Throughout their history, the Kingdom of Morocco and the United Kingdom have provided telling examples of mutual esteem and good cooperation. By drawing inspiration from that past, we will certainly contribute to shaping a better world, where peace and understanding prevail.

Mohammed VI
King of Morocco

The Royal Palace, Casablanca
30 October, 2006.

Sacred is made possible by the generosity of donors from all three faiths:

Coexist Foundation, The Moroccan British Society, Saint Catherine Foundation

The Clore Duffield Foundation, Sami Shamoon, The Dorset Foundation, William & Judith Bollinger, The Samuel Sebba Charitable Trust

The Horace W. Goldsmith Foundation, The Eranda Foundation, The Rubin Foundation, New Star Asset Management, Sir Harry Djanogly CBE

The Moroccan British Society is supported by:
Maroc Telecom, ONA (Omnium Nord Africain), CMH (Compagnie Marocaine des Hydrocarbures), AKWA Group, ONE (Office National d'Electricité), ONMT (Office National Marocain de Tourisme), Banque Centrale Populaire, Caisse de dépôt et de Gestion, OCP (Office Chérifien des Phosphates)

Introduction

A sacred, revealed text is fundamental to each of the faiths of Judaism, Christianity and Islam. To further and deepen understanding of these three traditions, *Sacred* explores the means by which these sacred texts were transmitted over time. It reveals afresh the shared, as well as the distinctive aspects of the three great religions, as seen in some of the world's most sublimely beautiful books.

The phrase 'People of the Book' derives from the Arabic *Ahl al-Kitab*, a term used in Islam to embrace both Jews and Christians as people who received Scriptures revealed to them by God before the revelation of the Qur'an. The present publication and the related exhibition emphasize the critical value of re-examining the books of Jews, Christians and Muslims, as well as some of their traditions and customs, for a fuller understanding of all three peoples.

An exhibition such as this, consisting mainly of texts, gives an impression of certainty, of finality in form and words – but that is very deceptive. This exhibition – and therefore this book – is a form of archaeology. It deals as much with intangible as with tangible heritage. It can obviously display only what survives, and then we make what sense we can from that sample. In the diverse situations reflected, we do not often have the luxury of other eras and kinds of histories where it is possible to feel like a fly on the wall. Most of the texts displayed are precious survivals. A lot of the evidence we would like to have – buildings, books, recorded memories and images – has gone. Pogroms, rampaging armies, furious reformers, communal violence and revolution, wilful neglect, fire and time have all played their part in destroying the sacred record. Precious documents have not even been safe in libraries and museums, as shown by objects such as the singed Cotton Genesis (see page 119).

These manuscripts and objects often prompt more questions than answers, not least about a process of transformation from revelation through oral tradition to text, and then via printing and translation to a mass audience. Many copies of these sacred texts are also beautifully decorated, for example, a sumptuously gilded and multi-volume Qur'an, such as that of Sultan Baybars (see page 130), made in Cairo in the early fourteenth century.

The range of this exhibition is astonishing, and the British Library is an extraordinarily appropriate place for it to take place: few other libraries could demonstrate so much over so many continents and centuries. By combining the British Library collections with generous loans, this exhibition is able not only to illustrate many of the key texts, people and places, but also to show evidence from all over the world. There are traces here of Jews in Ethiopia, China and India; the

distinctive art of Armenian, British, Bulgarian, Byzantine and Ethiopian Christians; Muslims in China, India, Malaysia and Saudi Arabia; the polyglot worlds of Sicily, Mecca, Jerusalem, Cairo and Isfahan. The earliest exhibits are from Egypt (see page 70), from the first half of the second century (the Egerton Gospel), and from *c.*250 (Chester Beatty Library, Dublin, page 64). From the third or fourth century comes a papyrus unearthed in the rubbish tips of the ancient city of Oxyrhynchus (south of Cairo), with one of the earliest copies of part of the book of Revelation (see page 69). The later exhibits include examples of contemporary Christian illumination and Jewish metalwork.

Structure of the catalogue

This catalogue is organized thematically, and within each section the faiths are generally presented in order of their chronological development, namely Judaism, Christianity, Islam. The first section presents splendid examples of the Torah, Bible and Qur'an from fifteenth-century Lisbon, tenth-century Constantinople and fourteenth-century Mosul respectively. The next explores the principal elements in the faiths, and travels around the Middle East and Mediterranean, then outwards to Ethiopia, Asia and London. Among the displays is a prayer book for a Liberal synagogue in London (1967), open at the United Nations Sabbath (page 48). The third section looks at the text and its transmission, right through to the modern era. In the section 'Illuminating the Word', many of the most sumptuous exhibits, such as The Golden Haggadah, Sultan Baybars' Qur'an and The Lindisfarne Gospels are included (pages 152, 130 and 110). This section also pairs and contrasts examples from different faiths on similar subjects. The last section explores aspects of religious life through objects that illustrate worship, ritual, pilgrimage and the celebration of festivals.

The main questions this exhibition asks all of us are: what do these three faiths have in common, and how have they in their very separate and diverse histories created or received their holy texts? How and where have they become standardized, and what do they signify for us – of whatever faith or none – in the twenty-first century? Such questions are the most likely entry point for many of us. There are many potential additional narratives, and some visitors and readers may see connections and conflicts that weren't envisaged in juxtaposing these traces of three faiths over such a spectrum of time, place and experience.

Notes to the reader

- The catalogue entries for the exhibits provide titles, sources and dates, plus a brief description of each item.

- Glossaries for each of the religions and a selection of further reading can be found at the end of the book. The British Library authors in particular have recently written at greater length on many of the topics and exhibits discussed here.

- Christian biblical quotations are from the New International version.

- Psalms appear with two numbers: the first is the modern numbering, the second from the Vulgate.

- Dating is AD/CE unless BC is stated.

- Ancient or medieval place names are used, although where possible the modern equivalent is also provided when a term is first employed.

Essays

The Idea of a Sacred Text

Karen Armstrong

By the middle of the twentieth century, many people believed that the Scriptures had been irrevocably discredited. They believed that modern scholarship had proved decisively that both the Bible and the Qur'an were human constructs deeply coloured by the conditions of their time. The myth of their divine origin seemed patently absurd. Science had clearly shown that God had not created the world in six days, as the Bible attested, and no educated person could take seriously the miracles that the Scriptures took for granted. The new historical criticism, which subjected these holy books to the same stringent scrutiny as any other ancient text, had established beyond dispute that Moses was not the author of the Pentateuch, and that David did not write the Psalms (and that God had not dictated the Qur'an to Muhammad). Moreover Scripture was – and still is – held responsible for abominable behaviour. The Bible had been used to endorse slavery, the suppression of indigenous peoples, and the oppression of women. Both the Bible and the Qur'an were accused of advocating holy warfare. It was said that Scripture preached divinely sanctioned intolerance and encouraged a credulity that was detrimental to progress. A massive edifice of theological dogma had been erected on the unstable foundation of these manifestly flawed texts, but education and scientific progress had rendered them obsolete. Holy writ may once have played a role in the development of civilization, but, mercifully, humanity had outgrown it.

Scripture has, however, made a comeback, and once again the Bible and the Qur'an are in the news. Terrorists quote the Qur'an to justify their atrocities, and pundits confidently lard their assessments of the international situation with Qur'anic verses. Jewish fundamentalists cite the Hebrew prophets to validate their settlements in the West Bank, and Jewish extremists have used Kabbalistic texts to authorize plots to blow up the Muslim shrines on the Temple Mount in Jerusalem. In the United States members of the Christian right scour the book of Revelation to sanction their government's policies in Israel and the Middle East; they are convinced that the first chapter of Genesis is a factual account of the origins of life, and campaign for the school curriculum to include the teaching of what they call Creation Science; they have also dispatched teams of archaeologists to Mount Ararat in Turkey to unearth Noah's ark.

This recent preoccupation with Scripture is the result of a widespread religious revival, but it also represents a literalistic approach to the sacred texts that would once have been regarded as exceedingly simple-minded. People trained in the rational ethos of modernity expect truth to be logical and accurate. If these sacred texts are not scientifically or historically sound, many assume that they cannot be true at all. But in the past the faithful immersed themselves in their holy books for an experience that went beyond mundane reality and could not be apprehended by ordinary, secular modes of thought. They described the transcendence they encountered in various ways – as God, Nirvana, Brahman or the Dao. There has always been something about the world that has eluded our understanding. We used to imagine that science would answer all our questions, but modern physics and cosmology have revealed yet further mysteries. It is a peculiar characteristic of the human mind that it habitually has experiences that exceed its conceptual grasp and – however we choose to define it – transcendence has been a fact of human life.

We seem to need the experience of ecstasy, those times when we feel fully alive, deeply touched within and lifted momentarily beyond ourselves. We make a point of seeking out these heightened moments, and if we no longer find them in a religious setting we turn to art, music, dance, sex or even

drugs instead. Religion has been a major means of accessing this transcendence, however, and it has nearly always done so by means of the arts: music, poetry, painting, dance, architecture and drama. Indeed, religion itself can be seen as an art form that helps us to cultivate what Keats called 'the holiness of the heart's affections'.[1] Not all faiths see holiness as supernatural; most regard it as an indispensable dimension of our humanity. Like art, religion should expand our horizons and help us to cultivate a sense of ourselves, our fellow humans and the natural world as 'sacred' – inviolable, awe-inspiring and uniquely precious. In this exhibition we see the alliance of art and religion very clearly. Painters, scribes and craftsmen have so embellished their sacred texts that these artefacts, made by human hands, have themselves become icons of contemplation, windows through which we glimpse a deeper dimension of existence.

We have never experienced the sacred directly, but always in earthly objects – in mountains, rivers, cities and temples. Human beings have regularly been revered as manifestations of the divine. These earthly symbols are, by their very nature, inadequate. The faithful have to learn to look through the unsatisfactory husk to the transcendent kernel within. Jews, Christians and Muslims have all, in slightly different ways, found the sacred in a holy book. They believe in a God who, somehow, speaks to them in their Scriptures. The symbolism of the Word is powerful. Our words are uniquely our own, but they are separate from the essence of our being, which remains mysterious and hidden; we choose our words with care, but there is always an ineffable something left unsaid. In the same way, the Scriptures tell us that the Word was with God from all eternity.[2] It was divine, but remains distinct from God's essence. This Word is present in Scripture, but concealed in the inescapably limited human text. We have to work hard to look beneath the surface before we can glimpse the divine presence.

Torah

Originally the people of Israel had transmitted their sacred stories orally. Historians probably began to record them in writing during the eighth century BC, and their work has been preserved in the oldest strata of the Torah, as the first five books of the Bible would eventually be called.[3] But these writings were not yet cast in stone. Later authors felt at liberty to qualify their insights and contribute their own versions of the Israelite epic. From the very beginning the Bible was an interpreted document:[4] the biblical authors felt no compunction about rewriting the older accounts, adding radically innovative legislation, and making up new stories in order to ensure the tradition spoke to the particular needs of each generation. Readers would continue to interpret these texts with the same freedom long after they had been canonized as sacred Scripture.

Modern historical criticism of the Bible has enabled us to see that it is not a monolithic Scripture with a single message. A number of competing voices, dating from different periods of history, are still embedded in the extant text. When we read carefully, we can discern the authors, as it were, engaged in an open-ended conversation – even arguing with each other. Thus we find two independent and mutually exclusive accounts of Creation, two versions of the Flood narrative, and at least four significantly diverse interpretations of the stories of the patriarchs (Abraham, Isaac and Jacob), the Exodus from Egypt, and the Sinai revelation which included the handing down of the Ten Commandments.

By the third century BC, some people had begun to approach these texts as holy objects: they fasted and prayed to prepare themselves for their perusal of the ancient writings, and were rewarded with visions of the heavenly world.[5] The study of Scripture was becoming what meditation and yoga were in other traditions. Those involved in its exegesis or explanation felt inspired: old oracles and laws took on startling new meanings that had never been intended by the original authors, but that shed light on the perplexities of the present.[6] In the eighth century BC the prophet Isaiah had had a vision of God in the Temple; now Daniel, a new kind of prophet, experienced a revelation while studying the sacred texts.[7] Philo of Alexandria (30 BC–AD 45), who wrote lengthy allegorical commentaries on Genesis and Exodus, explained that when he struggled with his books, he felt possessed by the divine – 'filled with Corybantic frenzy' – and seemed to inhabit his humanity more fully than usual: 'For I acquired expression, ideas, an enjoyment of life, sharp-sighted vision, exceedingly distinct clarity of objects, such as might occur through the eyes as a result of clearest display.'[8]

Most Jews, however, still approached their God in the Temple in Jerusalem, where he dwelt in the holy of holies. But this access to the divine was no longer possible after AD 70, when the Roman army had quashed a Jewish uprising in Palestine and burnt the Temple to the ground. Gradually, Scripture became a substitute for the lost Temple, the 'place'

where Jews encountered their God. 'When two or three study the Torah together,' the rabbis explained, 'the Shekhinah [divine presence] is in their midst.'⁹ Biblical interpretation was becoming a theophany, a manifestation of God. The Word of God was infinite; it could not be tied down to a single interpretation, but contained countless readings. Revelation had not happened once and for all on Mount Sinai, because the Word was eternal. The job of the exegete was not simply to uncover the original meaning of the text, but to make the divine voice heard in the present, uttering a new message that would speak to the current needs of the community.

Exegesis kept the Bible open; it was not a closed book; everything had not – indeed, could not – have been said already. Some of the biblical stories were terse and laconic: the rabbis filled the gaps. They clarified obscurities and ambiguities. Once the canonical text was settled (probably in the second century AD), all the books that had been included were felt to be profoundly interconnected. The rabbis liked to link sentences from texts that had no obvious connection in order to create meanings that were, in both senses of the word, 'original'. They were new, but they also revived hitherto hidden aspects of the primal revelation to Moses. One day somebody went to Rabbi Akiba (d. 132), one of the greatest of the early rabbis, to tell him that his colleague Ben Azzai was surrounded by leaping flames as he expounded the Scriptures. 'I was only linking up the words of the Torah with one another, and then with the words of the Prophets,' Ben Azzai explained. 'The words rejoiced, as when they were delivered from Sinai, and they were sweet as at their original utterance.'¹⁰ The exegete felt that he was standing at Sinai; revelation was renewed every time a Jew confronted the text, exposed his entire being to it, and applied it to his own situation. This dynamic interchange with the divine could set the world afire.

The rabbis did not believe that they were adding something extraneous to the text, but were convinced that they were disclosing something that had been there all along and could be appreciated only at this particular moment: 'Matters that had not been vouchsafed to Moses were vouchsafed to Rabbi Akiba and his generation.'¹¹ Even the Song of Songs, an erotic poem sung in taverns, with no apparent religious credentials, could be read as an allegory of God's love for Israel. *Midrash* (interpretation) was derived from the Hebrew verb *darash* (to go in search of). Exegesis was a spiritual quest, not an academic discipline. Interpreters did not expect to come up with the expected, orthodox answer. They were seeking guidance that was urgently needed here and now. Their exegesis was action-orientated. You could not fully understand the text you had interpreted until you put it into practice.

Gospel

At the same time as the rabbis were reaching their conclusions, Jews who were followers of Jesus of Nazareth, who had been crucified by the Romans in about AD 30, were reinterpreting Scripture in rather the same way. The Law and the Prophets, they claimed, could only be understood in the light of Jesus's life, death and resurrection. They were convinced that he had been the Messiah (*Christos* in Greek), the saviour of Israel and the entire world, and had thus inaugurated a new phase of salvation history. Their exegesis resulted in the twenty-seven books of the New Testament, written in *koine* Greek only, which is really a long commentary on the Hebrew Bible. When they read the first line of Psalm 22 – 'My God, why hast thou forsaken me?' – Christians believed that these words had been intended to foreshadow Jesus's desolation on the cross.¹² Isaiah had thought that he was simply predicting the birth of a royal baby when he had prophesied, 'A young girl (*almah*) shall conceive and bear a child', but, according to the evangelist known as Matthew, he had unwittingly foretold the miraculous birth of Jesus, who had been born of a virgin.¹³ Jesus himself, it was said, had read a passage from Isaiah in the synagogue and proclaimed, 'This text is being fulfilled today, even as you listen'.¹⁴ Christians were convinced that they were the first to understand what Scripture had really been saying all those centuries ago. In an extraordinary exegetical tour de force, the author of the Epistle to the Hebrews argued that the entire, complex, tortuous history of Israel had a simple message: from the beginning it had prefigured the coming of Jesus.¹⁵

This was not a cynical manipulation of the text to further their cause. Like the rabbis, Christians found that when two or three of them studied the Scriptures together, they entered the divine presence, which for them was enshrined in the person of Jesus. This is clear in the emblematic story of the two disciples who, shortly after Jesus's crucifixion, met a stranger while they were travelling from Jerusalem to nearby Emmaus. They were in despair, but the stranger consoled them by expounding 'the full message of the prophets'. Starting with Moses, and proceeding through all the Scriptures, he explained that it had long been ordained that the Messiah must

suffer before entering into his glory. That evening, when the stranger broke bread, the disciples realized that he was Jesus: their 'eyes had been held' from recognizing him. As he vanished from their sight, they recalled how their hearts had 'burned' within them when he had 'opened the Scriptures'.[16] The hidden significance of the Scriptures only became clear after you had wrestled with the text; then – and only then – you encountered the divine as a burning, vibrant presence within you.

Neither the rabbis nor the early Christians could confine themselves to the literal meaning of the text. There is, for example, no overt reference in the Hebrew Bible to the Messiah, which is a post-biblical concept. The Christians had to 'open' the Scriptures, in other words crack the code, before they received spiritual insight. Like the rabbis, they had to enter into a dynamic dialogue with the text before this ancient record of long ago battles and obsolete ceremonial laws became a revelation and experience of God. These Scriptures were revered as holy, not so much because of their divine origin, but because time and again they proved that they were capable of being transformed in this way, as well as enlightening those who interrogated them. We see a similar dialogue in this exhibition. The artists often bring their own familiar world to the ancient Scriptures, setting a biblical scene in their synagogue or monastery, and depicting prophets and patriarchs as contemporaries, thus compelling these old texts to speak to their own time. And they celebrate the holiness they have experienced with elaborate calligraphy and rich decoration, which sets the language of Scripture apart from ordinary speech. The Aramaic word *qaddosh* (holy) means 'separate' or 'other' in Hebrew.

Later Christian theologians developed their own *midrash*, going in search of a meaning that was concealed by the plain sense of the words. Origen (185–254), an Egyptian theologian from Alexandria, and one of the most original and influential theologians of the early Church, argued that much of the Hebrew Bible was frankly unedifying. It was full of scurrilous stories, bloodthirsty massacres and incomprehensible laws. The exegete had to define the *literal* sense of a passage as accurately as possible, but he could not end there. He must draw *moral* lessons from the text, and finally discover an *allegorical* interpretation that revealed its spiritual, timeless core. Allegory was a popular genre in Alexandria. Like Philo, a fellow Alexandrine, Origen was a Platonist, who experienced exegesis as an *ekstasis* (a 'stepping outside' of his secular self) achieved by casting aside the time-bound, earthly meaning

of Scripture and ascending to the pure world of the spirit. Later the monastic reformer John Cassian (360–445) added another 'sense' to Origen's threefold method: the *anagogical* sense, which uncovered the eschatological significance of a passage. Throughout the Middle Ages, the Christians of western Europe systematically applied these four 'senses' to every single verse of the Bible. As Pope Gregory the Great (590–604) explained, the true meaning of Scripture was 'hidden under the cover of the letter'. A Christian must learn to look through the overt sense of, for example, the Song of Songs, and allow himself to be 'taken out of the body'. In the Song, God had deigned to use 'the language of our shameful loves in order to set our hearts on fire with a holy love' – the love of the purified soul for God.[17]

But most Jews and Christians were quite unable to follow this learned exegesis as the vast majority could not even read. They had to listen to the sacred text read aloud in synagogues and churches, and had a relationship with the Bible that was entirely different from that of most people today. They nearly always heard the words of Scripture in a liturgical setting, where the music, ritual and prayerful atmosphere added an emotional resonance that inevitably affected their response. They certainly could not pick and choose their favourite passages, ignoring the more inconvenient verses that contradicted them. They had no option but to see Scripture in the round. Certain phrases and verses, heard year in and year out, would take root in the memory, become part of their interior landscape, and acquire an entirely independent life there. This was especially true of the early monks, who, during the fourth century, began to retire to the deserts of Egypt and Syria to live a solitary life of Prayer. They feared that if they depended on the written text, the living Word would become a dead letter. To this end they deliberately memorized long passages of the Bible, which lost much of their original meaning as the monks ruminated continuously upon them, using them to nourish their own insights.[18]

All this changed in the early modern period, as more and more people became literate, and as the technology of printing made it increasingly possible for everybody to have a copy of the Bible. Given the modern inclination for literalism it is natural for people today to confine their reading to the plain sense of Scripture, which has rarely been productive of spiritual experience. In our world of instant communication, we rarely ruminate on a text year in, year out, but expect it to be instantly comprehensible. Many are also highly selective in their reading. Christian fundamentalists prefer the vengeful

book of Revelation rather than the Sermon on the Mount, while Muslim extremists emphasize those passages of the Qur'an that preach *jihad*, and ignore the far more numerous exhortations to forgiveness, kindness, courtesy and tolerance.

The humanists and reformers of the sixteenth century pioneered this privatized relationship with Scripture. They encouraged the printing and mass distribution of the Bible, and translated it into the vernacular. The translation of the Bible was, of course, not a new venture. Jews had translated it into Greek for those who could no longer understand classical Hebrew. St Jerome (342–420) translated the Old and New Testament into Latin for the Christians of the West. Many of the texts displayed in this exhibition are translations. But in a deeper sense, translation symbolizes the entire scriptural enterprise. If these ancient texts are not to become antiques, they must somehow be 'translated' into a different cultural idiom. In the medieval period this was achieved by allegory, which is not congenial to the modern sensibility. If the Scriptures have become opaque to us, this is because we have not found a way of transposing them into our own world. Modern biblical criticism has done much valuable work on the surface meaning of Scripture, but it has not been able to transform this academic pursuit into a spiritual discipline.

The allegorical method of Philo and Origen 'translated' these ancient Hebrew tales in a way that made them accessible to Jews and Christians who were versed in Greek philosophical rationalism, entirely different from the Semitic thought of the Bible. We are suspicious of allegory today because it seems to violate the integrity of a text, but there was a generosity in this approach that is lacking in some modern responses to Scripture. Accustomed to the intellectual stimulus of Alexandria, Philo and Origen could easily have despised the Bible, as so many sophisticates do today. But they preferred to assume the best rather than the worst, and were able to build a bridge between Moses and Plato that satisfied many of their contemporaries. They achieved their *ekstasis* only because they had put so much of themselves into the text, found something of inestimable value beneath the unpromising exterior, and left the arrogance and self-importance of egotism behind.

Qur'an

There was a similar generosity in the Qur'an, which was revealed to the Prophet Muhammad in the Hijaz in northern Arabia in the early seventh century. The last great Scripture to emerge in the Middle East, it has been described as the most advanced expression of the genre.[19] The Biblical canon had taken centuries to evolve, but the Qur'an was revealed in its entirety in a mere twenty-three years, and the official text was produced in about 650, less than twenty years after the Prophet's death. Other communities produced sacred books, but in Islam the sacred book created the community. The Qur'an, which records the words that God had spoken through his Prophet, was soon revered as the definitively human expression of the uncreated, pre-existent Word of God, and became for Muslims what Jesus, the incarnate Word, was for Christians.

The first Muslims were not converted to Islam by the charisma of Muhammad, but by the extraordinary beauty of the Qur'an, which, they were convinced, proved its divine origin. It is difficult for non-Arabic speakers to appreciate the linguistic felicity of the Qur'an because this is not easily conveyed in translation. It can seem tediously repetitive, lacking in structure, and with no sustained argument or coherent narrative. But the Qur'an was not designed to be read in sequence. Its *suras* (chapters) have been arranged arbitrarily, with the longest at the beginning and the shortest at the end. Each *sura* contains essential teachings, so it is possible to dip into the text at any point and imbibe important lessons.

Above all, the Qur'an was an oral Scripture, designed to be recited and listened to, not read in private. Indeed, *qur'an* means 'recitation'. Sound was essential to the meaning of this Scripture. The Qur'an is indeed repetitive, designedly so. Themes, words, phrases and sound patterns recur again and again, like variations in a piece of music, which subtly amplify the original melody, adding layer upon layer of complexity. Ideas, images and stories are bound together by these internal echoes, linking originally separate passages together in the mind of the audience. All reinforce the central teaching: Muslims must contemplate the benevolence of God in the natural world, and reproduce this generosity in their dealings with one another. They must create a just and decent society, where poor and vulnerable people are treated with respect. They must integrate their lives, making God their first priority, and in the unified self they will glimpse intimations of the divine unity.

Figural art was denied the same role in Islam that it had in Christianity. The images of the old, superseded deities were gradually replaced by the Word alone. Calligraphy, which glorified and embodied the uncreated Word in human script,

became the major art form in the Islamic world, expressing the egalitarian and unitive ethos of the Qur'an. There are no capital letters in Arabic; all are on the same level and many characters are linked together, forming words in a smooth, unified flow. This calligraphic art, originally devised to inscribe the Qur'an, spilt out into everyday life. It was evident everywhere: on doors, walls, chests, carpets and the frontispieces of books. The divine Word thus permeated secular life, drawing everything into the ambit of the sacred. These compositions of sacred letters became an esoteric expression of eternity, presenting infinite complexity within a total harmony. The eye is nourished with an intricate infinity of beauty, and no single item dominates the whole.

There is a similar complexity in the Qur'anic text. God did not boom clear commands from on high. He was not imparting factual information that could be grasped instantly. Like great poetry, the language of the Qur'an is often dense, elliptical and richly ambiguous. Muslims are instructed by the divine voice to absorb its teachings slowly. They must listen intently to each utterance as it emerges, and be careful not to impose a meaning prematurely, before its full significance has been revealed. Each verse, it is said, can be understood only in the context of the whole Scripture.[20]

Muhammad's first converts had long admired the faith of the Jews and the Christians, the *ahl al-kitab* (People of the Book), and yearned for a Scripture in their own language. They knew the Torah acknowledged that the Arabs were the descendents of Ishmael, Abraham's eldest son, and were thus part of the Abrahamic family.[21] Allah (whose name means simply 'God') was, they believed, identical with the God of the Torah and the Gospel. The Qur'an, therefore, was not replacing these earlier scriptures, nor was it inaugurating a new religion. In one remarkable passage Allah made it clear that Muslims must believe indiscriminately in all his previous prophets:

> Say: We believe in God, and in that which has been bestowed from on high upon us, and that which has been bestowed upon Abraham and Ishmael and Isaac and Jacob and their descendents, and that which has been vouchsafed by their Sustainer unto Moses and Jesus and all the [other] prophets: we make no distinction between any of them. And unto Him do we surrender ourselves.[22]

You could not be a Muslim unless you also revered Moses and Jesus, and respected the Torah and the Gospel. There was no thought of forcing everybody into the Muslim community. Each of the revealed traditions had its own divinely ordained *din* (practices and insights).[23]

The Bible had represented an ongoing dialogue between God and humanity; so did the Qur'an. A *hadith qudsi* (holy tradition) has God say: 'When someone recites or reads the Qur'an, that person is, as it were, entering into conversation with Me and I into conversation with him or her'.[24] The Word is still speaking to men and women; the original revelation continues. Whenever a Muslim quotes from the Qur'an or suddenly recalls a Qur'anic phrase, he or she comes directly into the presence of God. When Muslims memorize the Qur'an, it is as though they take the divine Word into their very depths – an experience not unlike that of Christians when they receive the Eucharist.[25] The text of the Qur'an, beautifully inscribed, represents the presence of God in the midst of the Muslim community. When they hold the holy book in their hands, it is as though they are in contact with the divine. Christians have made similar claims for the man Jesus.[26] Some Muslims have developed a method of exegesis called *tawil* (carrying back), by which they return spiritually to the original Word uttered by Allah before the beginning of time. Like Jews and Christians, they have sought the *batin*, the 'hidden' dimension of Scripture, which lies beneath its earthly, temporal manifestation.

Scripture Now

We are no longer skilled in this type of spirituality in our rationally driven society. Sceptics believe that religious people have always read their scriptures literally, have been forced to believe impossible things, and conclude that the religious enterprise is, therefore, untenable. The faithful are perplexed when the plain sense of Scripture contradicts the discoveries of modern science, or when archaeologists prove that many of the Biblical narratives have no basis in fact. Christian fundamentalists claim that every single word of the Bible is literally true – an entirely new and essentially unsustainable doctrine developed during the late nineteenth century. The abuse of holy writ by extremists has also discredited the concept of Scripture, and some are quick to point out failings in other people's holy books while ignoring similar defects in their own. The strident orthodoxy that is latent in any ideology – secular as well as religious – is increasingly coming to the fore. The religious often use their sacred texts to deride other tra-

ditions and to pour scorn on secularists. Sceptics, in their turn, are vocal in their disdain for faith. There is on all sides a patent lack of the charity that, modern philosophers of language insist, is indispensable if people of different cultural backgrounds, who hold conflicting ideologies, wish to understand each other.[27]

At a turbulent time in human history, this exhibition reminds us that Scripture has not simply been a force for self-righteousness and hatred. For centuries, it has been one of the chief ways in which Jews, Christians and Muslims have reached towards holiness. It was neither an easy nor a straightforward quest; it required ingenuity, hard work and creativity. Like these early adherents to the faiths, we need to find our own way of making that holiness a tangible, shining reality in our own dark world.

Notes

1 H. E. Rollins, ed., *The Letters of John Keats,* 2 Vols (Cambridge, Mass., 1958), I, pp. 184.

2 John 1:1–2.

3 The Hebrew *torah* means 'teaching'. It came to denote the Law that God revealed to Moses and referred also to the epic story of this revelation, which is recounted in the Pentateuch, the first five books of the Bible: Genesis, Exodus, Leviticus, Numbers and Deuteronomy.

4 Michael Fishbane, 'Inner Biblical Exegesis: Types and Strategies of Interpretation in Ancient Israel' in *The Garments of Torah, Essays in Biblical Hermaneutics* (Bloomington and Indianapolis, 1989)

5 Daniel 9:3–4; 10:2.

6 See Daniel 9 *passim.*

7 Isaiah 6; Ezekiel 1, cf. Daniel 9:20–23;10:4–19.

8 Philo, *The Migration of Abraham,* 34–35. A 'Corybant' was a priest of the Phrygian cult of Cybele, which included noisy, ecstatic and extravagant dancing.

9 M.Pirke Avoth 3:2. Yakult on Song of Songs 1.2.

10 Midrash. Rabbah I.10.2.

11 Midrash Rabbah, Numbers 19:6.

12 Psalm 22:1; Mark 15:43. Quotations from the Bible are taken from *The Jerusalem Bible.*

13 Isaiah 7:14; Matthew 1:22–23. Matthew read the Bible in the Septuagint, its Greek translation, which rendered the Hebrew *almah* as *parthenos* or 'virgin'.

14 Luke 4:17–21; Isaiah 61:1–2.

15 Hebrews 11, *passim.*

16 Luke 24:13–32.

17 Gregory the Great, 'Exposition on the Song of Songs', in Denys Turner, *Eros and Allegory: Medieval Exegesis of the Song of Songs* (Kalamazoo, Michigan, 1995), pp. 219–23.

18 D. Barton Christie, *The Word in the Desert: Scripture and the Quest for Holiness in Early Christian Monasticism* (New York and Oxford, 1993), p. 115.

19 Wilfred Cantwell Smith, *What is Scripture? A Comparative Approach* (London, 1994), pp. 46–47.

20 Qur'an 20:114; 75:16–18.

21 Genesis 16.

22 Qur'an 3:84, cf. 2:136. Quotations from the Qur'an are taken from Muhammad Asad, trans;, *The Message of the Qur'an* (Gibraltar, 1980).

23 Qur'an 5:48; 24:35.

24 Cantwell Smith, *What Is Scripture*, p. 90.

25 Wilfred Cantwell Smith, 'Some Similarities and Some Differences between Christianity and Islam' in James Kritzeck and R. Bayly Winder, eds, *The World of Islam: studies in honour of Philip K. Hitti* (London and New York, 1959), pp. 56–58.

26 I John I:1–2.

27 Donald Davidson, *Inquiries into Truth and Interpretion* (Oxford, 1984), p. 137.

Living with Sacred Jewish Texts

Everett Fox

What sets apart a great civilization from a merely impressive one? The difference may be measured as the sum total of three areas: breadth, depth and humanity. 'Breadth' means the extent to which a civilization contributes to many different facets of life, art and knowledge. 'Depth' signifies the intricacy and profundity of its expressions, in feeling, thought, beauty, or technical achievement. Above all stands 'humanity', the degree to which a civilization reflects the pathos of human experience. The great success of the three Western monotheistic religions (those that believe in only one God) lies in their realizing of these three goals. The third is especially significant; in addition to stirring and awe-inspiring conceptions of God, powerful rituals and complex visions of communal life, these religions hold in common a vocabulary of compassion, without which they could not long survive.

The historical expression of Judaism, stretching over three thousand years, gives a strong indication of such a civilization. Jewish texts, whether from ancient, medieval or more modern times, treat virtually every area of life, be it public or private, legal or poetic, political or mystical. They are concerned with every aspect of human behaviour and divine character. Their treatment of these areas includes moving stories and complicated laws and rituals, multi-faceted interpretations and commentaries, and arcane discussions of philosophy and mystical doctrines. And they show a profound awareness of the human predicament, choosing usually to express it through the age-old experience of the people of Israel, instantly recognizable to moderns in its evoking of loss, alienation, group solidarity and a prizing of humane qualities.

Once we get past their content, however, the beautifully calligraphed Jewish works on display in museums, on parchment and paper, are to a certain extent an illusion. They convey the idea of a written medium, of manuscripts and books that are the province of the library and, in their beauty, the museum. But from the very beginnings of Jewish culture, Scripture, that which is written, has served chiefly as a means of preserving the spoken word. As Martin Buber pointed out, the ancient Hebrew word for 'reading' derives from the verb 'to call out' and the Bible exhorts both leaders and laypeople to 'recite these words day and night'. Jewish texts were thus intended not so much to be admired or read but more to be recited, studied, taught, pored over and lived with in dialogue. Over centuries of domination by great powers, physical exile, persecution and social upheaval, sacred texts became a kind of home for the Jew, anchoring him (women were generally not included in study until modern times) to the great ideas, personalities and locales of the past, while at the same time addressing the needs of his own life situation.

Texts formed one of the two basic means of Jewish group- and self-expression, the other being ritual: holy days, prayer, food, and life passages. Yet the two are not to be neatly separated into boxes labelled 'the intellect' and 'daily life'. Traditionally, the study of sacred texts has always been part and parcel of daily life for Jews, while the rhythms of everyday existence have frequently been understood through the prism of texts. Jewish texts were orally grounded, and not just because of a lack of writing material or their expense. As in all great traditions, Jews instinctively understood that teachings and values are to be passed down from one living soul to another. This oral quality is to be recreated by the student, the teacher, the congregant and the translator. Anyone who wishes to taste or recreate the experience of Jewish texts needs above all to *echo* them. This is preferably done with a living person such as a study companion (the traditional mode of Jewish study), but even in print it is desirable for the English text to convey something of the spoken quality of the original.

In my capacity as translator, it is this aspect of the texts that I have found most striking; a few examples will be found below.

The great variety of literature found in Jewish texts is evident already in the Hebrew Bible, commonly known in the Christian West as the 'Old Testament' but termed by Jews as *Tenak*, an acronym for the ancient three-part of division of the collection: *Torah* ('The Teaching', the Five Books of Moses), *Nevi'im* ('The Prophets', Joshua through Kings and the prophetic books such as Isaiah), and *Ketuvim* ('The Writings', mostly poetry, including Psalms, Proverbs, Job, Ecclesiastes and the Song of Solomon). The books contain stories, laws, ritual regulations, architectural details, descriptions of tribal boundaries, royal chronicles, prophecies, musings on the general human condition, genealogical lists and speeches. They range in style from concise and compact in the great biblical stories about Abraham and Jacob, Moses and Samuel, and David and Elijah, to more florid in books such as Esther, to highly poetic yet moving in the Psalms, and to powerful but often obscure in the Prophets. The ideas also vary widely: the classic pattern of command followed by violation and then punishment (usually exile), reflecting an understanding that free moral choices have consequences, is challenged by later books such as Job and Ecclesiastes, which question whether there is true justice in the world.

At the core of the Bible, and its most important section for Jews, are its first five books, which make up about a quarter of the collection. It was edited in its present form probably by the fifth century BC, roughly the era of Pericles in Greece, Buddha in India, and Confucius in China. But its roots go back much further, and it is difficult to establish when large sections were written. In its final form it speaks of a people who had come to regard themselves as having a covenantal relationship with God, and who understood their history as dependent on how faithfully they remained in that relationship. The Torah speaks also to universal themes: liberation and birth, wandering and exile, the highs and lows of leadership, and a strong sense that people know the rules and must abide by them in order to live the good life (the afterlife is not mentioned), on the land promised to their ancestors.

The Torah came to be seen as the Word of God, and once complete, became entwined with Jewish life forever after through the institution of being read publicly in the synagogue at every Saturday morning Sabbath service. The cycle of the five books would be completed every year for some communities; for others, the reading would take three years or more. Regardless of the exact division, this meant that the text was not only studied, but was a living part of the social fabric. Jews knew the stories because they heard them systematically, year after year, and indeed for many centuries they marked their own birthdays not by a numbered day and month but rather by the biblical section that had been read the week of their birth.

The oral quality of the text, preserved in special forms of chant in the synagogue service, is also fully evident in the text itself, although not always preserved in translation. Among the opening lines of the Bible (Genesis 1:3–5), for example, there is already a strong rhythm that is meant to be internalized by an attentive audience. The text opens the description of the world's creation, not in what we would term prose, but thus:

> God said: Let there be light! And there was light.
> God saw the light: that it was good.
> God separated between the light and the darkness.
> God called the light: Day! and the darkness he called: Night!

The sounds say even more than the words do: this god, unlike other deities of the ancient world, is beyond time (we are not told of God's origins), strife (there is no battle scene, as elsewhere), and sexuality (God has no consort). There is only order and benevolent control, conveyed by the quiet and dignified order of the words themselves.

A similar sense of rhythm can be found in the laws set forth, for instance in Exodus 23:9:

> A sojourner you are not to oppress;
> *you* know the feelings of the sojourner,
> for sojourners were you in the land of Egypt!

Here it is not enough simply to set down rules. The full force of language has to be brought to bear in order to ground those rules in the deepest recesses of human emotion, in this case the experience of slavery.

The Torah is thus a document that is *addressed* to an audience. It downplays details of time and place (it is often quite sketchy and vague) in order to focus on the relationship between Israel and God. Throughout the stories we are led to wonder: will the people keep the covenant? Will they do the right thing? Or will they end up like the father and mother of us all, outside Paradise, provided with clothes by their benefactor but doomed to work hard in exile? The five books end on the border of the Land of Israel, looking in, as if to suggest

that the goal is reachable. As such it would have been a meaningful ending to Jews who had lost their homeland in 587 BC after an ill-fated revolt against the Babylonians, and who were either hoping to return or had already returned to begin the process of rebuilding. But in its portrayal of a journey filled with all-too-human challenges, it would successfully strike a universal chord for generations of Jews and Christians to come. The rest of the Bible developed over time, and it was not until perhaps after the destruction of Jerusalem along with the (Second) Temple by the Romans in AD 70 that we can speak of a canon, a closed collection of books that would allow no further additions. Along the way Jews wrote other books, influenced by Greek thinking (Alexander the Great had conquered the area in *c.* 330 BC) in such areas as philosophy, history and the interpretation of texts. Jews also wrote works explaining their history and culture to the classical world.

These contributions, however, did not become mainstream. It was left to one of the political/religious factions that survived the revolts against Rome to create Judaism as it came to be for the next many centuries. It is one of the great paradoxes of religion that the idea of a fixed, written scripture does not always reflect the reality of lived culture. In the case of Judaism, the Torah was studied, revered and practically worshipped (in its scroll form it appears in many synagogues in the physical dress of royalty: purple or blue mantle studded with jewel-like stones, silver crown and other appurtenances of silver), but it is not in fact the main document of Judaism. Whoever wishes to understand what became Judaism, the system, needs to look to the gigantic literature produced by those called simply 'the Rabbis' or 'the Sages', who lived in the first five centuries or so AD, largely under Roman domination. These men were determined to forge out of the raw material of the Bible and their own genius a viable and vibrant religiously based society that would have the fortitude to withstand even Roman domination. In order to do this, they created a unique form of discourse: not prophetic visions or priestly words, but free-wheeling *discussions* of all matters, sacred and secular. The first great creation of these Rabbis, who were not clergy but rather came from all walks of life, was the Mishnah (edited *c.* 200 AD), a large collection of sayings, arguments and counter-arguments that touch on virtually all areas of life (including Temple ritual, which was long gone). Over the next three centuries they spun a much larger fabric which they called a 'sea' of learning, using stories about both biblical personalities and their own lives, sober legal arguments and fanciful imaginings of the world of old and the world to come. Around 500 AD they wrote it all down in multiple volumes that go under the name Talmud, 'Teaching'.

Getting to grips with a Talmudic text can be demanding. While it is possible to read a page of the Bible in a matter of minutes, depending on the difficulty, a page of Talmud may take an hour or considerably more to go through with understanding. Traditionally it is studied with a partner or 'friend' in order to recreate the internal arguments and make sure that the subject in question, whether marriage, business ethics, capital punishment, property law or dietary regulations, has been examined from every conceivable angle. This kind of study leads to sharpness of mind, but also creates an intense community of shared ideas and visions. Along with its companion literature, the Midrash (multiple collections of interpretations of the Bible, much like the interpretations and sermons on their own Scriptures by Christians and Muslims), the Talmud ensured that male Jews, who engaged in this study their whole lives, and their womenfolk, who were taught the stories (but not the legal material) in more popular form, were armoured against an often unfriendly outside world by their own internal world of values. It was a world populated by fanciful characters from the past and even the present, but above all stood God, the great Teacher, who had given the Jewish people the means by which to live properly and through which they could patiently wait out their exile until the promised Messiah would come. This glorious future event would put an end to idolatry, oppression and injustice, would enable all Jews to return to the land of Israel, and would witness the end of history, including wars and all that accompanied them, under the universal kingship of God. It was a heady vision, and it survives for religious Jews (and in altered form for Christians) to this day.

Among the other accomplishments of the Rabbis was the creation of the bulk of Jewish prayers. While prayer books as such did not appear until the tenth or eleventh century, their basic formulas, and many of their actual texts, were created much earlier. Needless to say, this kind of literature is intensely connected to the spoken word, and, since it was intended for everyday folk, contains most of the central ideas the Rabbis deemed necessary for the inner survival of the group. One classic prayer, the Kaddish, began as a conclusion to study, incorporating the hope for the advent of Messianic Age, but over time came to be used as a marker separating parts of the worship service, and eventually became a prayer in which mourners praise God despite their grief. Excerpts below reveal a strong poetic underpinning:

May it be magnified and may it be sanctified,
His great Name,
in the world whose creation He willed,
may His kingdom be fulfilled
in your life and in your days
and in the life of the whole House of Israel,
soon and near in time,
and say: Amen!
…
May it be praised
and may it be blessed
and may it be glorified
and may it be upraised
and may it be elevated,

may it be honoured
and may it be exalted
and may it be extolled,
the Name of the Holy One,
Praised be He!

beyond all words-of-praise, words-of-song,
words-of-blessing, and words-of-comfort
that are uttered in this world,
and say: Amen!

Using such rhythmic words, as liturgical texts almost always do, the worshipper was made to physically internalize the hopes, emotions and language that bound him or her to a historic community over large expanses of time. Existence, while finite for the individual, became tied to the eternity of the people.

In this manner, as Jews entered the Middle Ages, they were able to create new forms of literature alongside renewed forms of the old. As the art of illumination advanced in Europe, Jews adapted it for their own texts and beautified them. Standardized forms of biblical, midrashic and Talmudic texts came into being, some of which are the earliest full versions we possess. At the same time, influenced by several centuries of living among Muslims, Jews explored new areas: philosophy (especially as recovered from the ancients such as Aristotle); secular and religious poetry, often laced with biblical quotations but imitating Arabic models; Hebrew grammar, systematically examined for the first time; and commentary, the quintessential Jewish form, in which a scholar joined the generations before him by contributing something new to the understanding of a classical text. As a result of this last activity, Jewish texts came to have a standard form: main text in the middle of the page, single commentaries to the right and to the left, multiple commentaries below, and tiny marginal notes wherever there was room left on the page. Serious readers thus had before them a series of teachers and resources from different periods and for different levels of understanding, not dissimilar to what we now possess in the age of computing (as modern scholars have noted, Jewish texts contain some of the earliest forms of hyperlinking). Once again, 'community' is the operative word. Jewish study becomes a conversation that stretches over time and place, uniting the Jewish people in all times and places to the extent that they participate in it. One of the major breaks in continuity caused by the modern period (for Jews, roughly since the French Revolution) lies precisely in the loss of that universal practice of sacred study among Jews.

Over the passage of time two other major developments took place. The first reflected the growing need of Jewish communities to know precisely what Jewish law (read: God) expected of them. The Talmud contained profound discussions of points of law, rather in the manner of law school today, but did not present final decisions systematically. That was left up to local authorities, who of course consulted the ancient texts as their first recourse. But people need clear rules by which to live their lives, and so, beginning with the Spanish philosopher and legal authority Moses Maimonides (d. 1204) in Egypt, there were several monumental attempts to lay out the obligations and beliefs that Jews should espouse. Many authorities were upset by the limitations brought on by these works, but Maimonides' own, the *Mishneh Torah*, is still studied, and the *Shulhan Arukh (Prepared Table)* of another Spanish exile, the sixteenth century thinker Joseph Karo, is revered as *the* great post-Talmudic authoritative source. In their printed form, both of these works are laid out as described above, with the comments of later generations alongside.

The second innovation, most startling of all, made use of some ancient esoteric traditions and went well beyond them to create an entirely new way of thinking. Partly as a revolt against what they felt was the excessive rationalism of the medieval philosophers, Jewish mystics, spearheaded by the thirteenth-century visionary Moses de Leon in his *Zohar (Book of Splendour)*, conjured up a fantastic universe behind the world of everyday reality, a universe of hidden and symbolic meanings in which human beings and God communicated through a complex series of steps. God was seen to

possess 'emanations' (multiple levels of personality), which were mirrored in human psychology and anatomy. The mystic himself, especially as interpreted by Karo's contemporary Isaac Luria, now became a key player in helping to 'repair' the broken world, which, like the people of Israel (and, in a sense, God himself) was understood to be in a state of exile.

Classical Jewish texts, then, unfold the ongoing encounter of the Jewish people with their understanding of God and with the civilizations around them. They are united by a rootedness in the language of the Bible and its great themes,

a desire to know the godly way to live, and the exercise of the imagination as a bulwark against a sometimes hostile world. They provide a great thread through all of Jewish history, and a challenge for those who would continue it. In the present century the majority of Jews do not have easy access to the texts, although numerous translations do now exist, especially in English. But Jewish groups large and small continue to grapple with them and to listen for the voices that emerge from them. As such, the dialogue begun in the sonorous phrases of the Bible continues to the present day.

References and Suggestions for Further Reading

Avery-Peck, Alan, and Jacob Neusner, *The Blackwell Companion to Judaism* (Blackwell Publishing Professional, 2003)

Berlin, Adele, Marc Zvi Brettler and Michael Fishbane, eds., *The Jewish Study Bible* (Oxford University Press, 2004)

Buber, Martin, and Franz Rosenzweig, *Scripture and Translation* (Indiana University Press, 1994)

Fine, Lawrence, ed., *Judaism in Practice: From the Middle Ages Through the Early Modern Period* (Princeton University Press, 2001)

Fox, Everett, *The Five Books of Moses: A New Translation with Notes and Commentary* (Schocken Books, 1997)

Glatzer, Nahum N., ed., *The Judaic Tradition* (Behrman House Publishing, 1982)

Goldin, Judah, ed. *The Jewish Expression* (Yale University Press, 1976)

Heilman, Samuel, *People of the Book: Drama, Fellowship and Religion* (second, revised edition, Transaction Publishers, 2001)

Holtz, Barry W., ed., *Back to the Sources* (Simon and Schuster, 1986)

Leviant, Curt, ed., *Masterpieces of Hebrew Literature* (Ktav Publishing House, 1969)

Marcus, Jacob Rader, and Marc Saperstein, eds., *The Jew in the Medieval World: A Source Book, 315–1791* (revised edition, Hebrew Union College Press, 2000)

Mendes-Flohr, Paul, and Jehuda Reinharz, eds., *The Jew in the Modern World* (second edition, Oxford University Press, 1995)

Neusner, Jacob, *An Introduction to Judaism: A Textbook and Reader* (Westminster/John Knox Press, 1991)

From the Paulist Press 'Classics of Western Spirituality' series:

Bokser, Ben Zion, and Baruch Bokser, eds., *The Talmud: Selected Writings* (1989)

Fine, Lawrence, ed., *Safed Spirituality* (1984)

Green, Arthur, ed., *Menahem Nahum of Chernobyl* (1982)

Hammer, Reuven, ed., *The Classic Midrash* (1995)

Matt, Daniel, ed., *Zohar: The Book of Enlightenment* (1983)

The Poet in Performance: The Composition of the Qur'an

F.E. Peters

On the outside the Qur'an is about the same size as the New Testament; inside, the two Scriptures could not be more different. The New Testament is a diverse collection of books by different named authors: four quite distinct biographies of Jesus, a history of the early church, letters to Christian assemblies by Jesus' immediate followers, and an apocalyptic view of the End Time. The entire collection is about Jesus, his life, his work and its consequences. The Qur'an, which has no author's name on its title page, is a collection of 114 *suras* or chapters of varying length, arranged in a manner we cannot quite fathom. These suras have little literary unity, but are obviously the product of a single, powerful religious conviction. To the question ' whose book is this?' Jews, Christians and Muslims all have the same answer: 'God's'. If the question is then rephrased as 'who is the author?' Jews and Christians can provide detailed answers. The Muslim, however, cannot. The Qur'an was revealed to the Prophet Muhammad by God, who pronounced it as inerrantly as he had received it. All that remained was for Muhammad and his immediate followers to collect and rearrange the revealed Words of God. There is no author save God.

To answer the question of who composed the Qur'an and how, we have to rely on the Book itself, and chiefly on its signs rather than its statements. The Muslim tradition that arose in the wake of the Qur'an tells us nothing directly about the making of the Book since it does not believe that in its original form it was either 'made' or 'composed'; indeed, Muslims could not quite decide whether the Qur'an was even created. What they did know is that the Qur'an came from God and was delivered to the Prophet in the words we still find there. The Muslim tradition does tell us, however, what it knew, or thought it knew, of how Muhammad received the Qur'an, how it came to be written down, and, as we have

already seen, how it was finally 'collected' into a standard text, an event that was thought to have occurred less than twenty years after the Prophet's death in AD 632.

There is much in the Qur'an to baffle the reader, but the text, even as we now have it, whether it is written or printed, stands closer to its original author than most else of what we have in either the Bible or the New Testament. In St Paul's letters, however, and in the Qur'an, we stand face to face not merely with a voice, but a full-throated personality. Both works are marked by a distinctive personal style, and for both men we have an external tradition that supplies details on their lives. Paul had no hesitation standing in front of his work. Muhammad, on the other hand, is all but totally concealed behind the Qur'an, except for brief hints in *Suras* (chapters) 93 (6–8) and 80 (1–10). Paul's apostolic career is traced by one of his own followers, Luke, who dedicates a good part of his Acts of the Apostles to him. Acts was probably written in the 80s, twenty years after the death of Paul. Muhammad's standard biography, *The Life of the Envoy of God* was assembled in Baghdad in the 750s out of older materials by Muhammad ibn Ishaq (d. 768). We do not even possess Ibn Ishaq's own work, but rather a cut-down (and cleaned-up) version from the editorial workshop of Ibn Hisham (d. 833), and whatever else we can retrieve from its second-hand use by later Muslim historians.

But it is not merely for biography that we consult this bio-historical tradition. The *Life* professes to give us the 'occasions of revelation', as the Muslims called them: the circumstances surrounding the revelation of at least some of the *suras* of the Qur'an. On this somewhat uncertain historical foundation an imposing edifice of Muslim Qur'an commentary has been erected, a construction as essential as it is suspect. Muslims accept most of the contents of this bio-historical

information at face value, but non-Muslims are far more sceptical. Many of the traditions are patently self-serving or bent on explaining the circumstances surrounding the appearance of the Qur'an, without, however, admitting that it is a matter of very few facts and much surmise.

The Revelations

What is missing from our biographical texts on Muhammad, as well as from the Qur'an itself, is any reference to a preliminary discourse whereby the Prophet explained to the Meccans what had happened to him and what it was that he was about to recite. It may well be that Muhammad preached before he recited, and that the recitation itself was intended for those who had already 'submitted' and who formed the first congregation of believers. But the Qur'an by its content suggests otherwise. Its Meccan *suras*, which are arguably the most liturgical of all, are manifestly addressed to an audience of non-believers, and it was unbelievers who accused Muhammad of being a poet as they listened (and watched) him recite.

The Qur'an is silent on Muhammad's experience of revelation. The only description of what might have been a revelation event occurs in the early Meccan *Sura* 53 (1–8). Muhammad feels constrained to convince the sceptics that he has not 'wandered' – the same word used by God to describe Muhammad's state before his Lord set him morally aright (93: 7). To do so he here cites two of his own personal experiences that were intended to quell doubts about his prophetic authenticity. The first occurred, time and place unspecified, when there appeared to him a heavenly figure, 'one of mighty power', initially on the horizon, but then considerably closer, a football pitch away perhaps, 'and He revealed to His servant what He revealed'. The second time he witnessed the same figure on a more specific landscape, by a 'garden of the dwelling' and 'near the sidra tree'. Some think this is a matter of heavenly geography, a vision attached to an exaltation, but the lack of any explanation of what are to us, and in fact to the Muslim tradition, unknown terms argues rather that it was a matter of very local geography, places that the Meccans knew very well. And then 'he saw one of the greatest signs of his Lord'. Despite later Muslim legend, nothing in the Qur'an makes us think that Muhammad ever mounted to heaven; indeed, the Qur'an suggests quite the opposite (17:90–93; 6:35).

Approaching the Qur'an

Muslims, from the untutored to the most learned, are far more likely to come to the Qur'an as it was originally intended, as listeners; and the rest of us, generally and mistakenly, as readers. For readers the Qur'an presents a number of near-insuperable difficulties. It is not primarily a book in our usual sense of that word, that is, something written or printed. Rather, it is a book in the sense of Scripture, a book written by God to which humans should pay heed. On a more worldly level, it is the record of a literary performance, a 'recitation' that has undergone the same kind of literary transformations that have been worked on the oral tradition in the Bible and the New Testament. The Muslim tradition insists that the Prophet's revelations were written down by some of Muhammad's own contemporaries. That tradition is the product of a quite urban and quite literate society of a different time and place, so it is perhaps natural for them to have thought this, but who would be writing in early seventh-century AD Mecca and why? In the early seventh century AD Mecca's only visible business was a modest local trade with the Bedouin, and it would hardly have required writing skills of any type. Mecca's political institutions were rudimentary to say the least, and were based principally on tribal relationships that had, and have, little need of archives. Also, Mecca's religious myths had all disappeared, perhaps long before Muhammad's own lifetime, so not only would there be no need of religious scribes, there would be nothing for them to do if they did exist.

If the New Testament came into existence in an environment with a relatively high degree of literacy, the same is not true of the Qur'an. Literacy was more widespread in the ancient world in the seventh century AD than it had been in the first, but not everywhere, and hardly so in either Mecca, an isolated town, or Medina, an oasis plantation in western Arabia. There are no traces, literary or archaeological, of writing in those parts, and certainly not in Arabic; indeed, the Arabs were still struggling with the book's script a century or more after the death of Muhammad.

Unmistakably, the Meccans knew about writing – the Qur'an is filled with terms related to that skill, and even calls itself a 'book' and 'something written', though in none of these instances is there evidence that either Muhammad or his audience could have read out the contents of those 'things written'. Even modern and quite literate Islamic societies continue to share the Qur'an's view of writing as possessing a power in itself. While some of the overwhelming prominence

of Arabic calligraphy on exterior and interior walls is doubtless due to the Islamic prohibition against images, it may owe even more to the Qur'an's own 'oral' attitudes towards writing, and their transmission and transformation in a society that has itself long remained oral in its culture.

The Qur'an as Oral Poetry

We must leave off, then, 'reading' the Qur'an and attempt to approach it for what it is – a poem or, perhaps better, a series of poems produced out of a thoroughly oral culture where writing was known and revered, but rarely used, and even more rarely read. For us a poem is a literary piece, something composed on paper, or, if it is composed in the poet's head, it is soon committed to paper and edited and refined there. For oral societies a poem is a master genre, a way of recording and transmitting important events or received wisdom. It is made deliberately memorable by its use of rhythm and rhyme. As Eric Havelock put it, 'a poem is more memorizable than a paragraph of prose, and a song is more memorizable than a poem'. The Qur'an is both a poem and a song, at least in its Meccan *suras*, and it was intended to be memorized.

The Qur'an is the seventh century's largest anthology of prose-poetry. Its components all bear the unmistakable stamp of an oral poet at work, and the work seems to have been only marginally affected by a literary sensibility. There has been some cutting and pasting to be sure, and, for reasons we cannot fathom, some very unliterary rearrangements. The evidence is incontestable that we are in the presence of a product of an oral tradition and in an oral culture. Oral poetry is, by definition, spoken or, more accurately, chanted or sung – what the Qur'an calls 'recited'. The reciter may in fact be the author-composer himself, or else, like the Jewish tannaim, simply one of the reciters who repeat the compositions of others. But whether performed by a composer or a *rawi*, the Arabic 'repeater', who is also known, in the case of the Qur'an, as a *qari* (reciter), there is one feature of the performed oral text that is important in this context: each recitation or performance will be different from the previous one. The performer/reciter is a creator: he reacts to his audience either between performances, when appropriate adjustments are made in the light of the last audience reaction, or during the performance itself as an immediate reaction to the listeners' acceptance or rejection, their understanding or bewilderment, at what they are hearing.

The most prominent feature of the poetical product of an oral culture is its use of formulae – stock phrases that recur and serve metrically to fill out a line or a rhyme. But they have other functions as well. Formulae and repetitions or returns are the full stops and capital letters of the oral composer: they mark beginnings and endings, and thus help to organize the composition. They are also the composer's italics and bold type, emphasizing and drawing attention to important points and themes. As well as verbal formulae, there are also stock images and *topoi* (commonplaces) the composer may draw upon to assist in the process of composition. The Qur'anic recitations had, at any rate, an identifiable style far removed from ordinary speech and language, and ordinary behaviour. There must also have been gestures: many of the dramatic presentations of the Judgment – 50:20–26 and 37:50–56, for example – would be unintelligible without identifying gestures or perhaps changes in vocal register.

The recitation or performance was rarely completely improvised. The poet, who was a skilled professional, devoted time and pains to crafting his work in private before performing it in public. We may even have an oblique glance of Muhammad at work in *Sura* 73 (1–8, with a later insertion at 3–4). But what the poet finally did perform in public was not entirely what he had composed in private: oral poetry of all types gives indications of responding to audience reaction as it unfolded so that the recited work was, in the end, the product of both preparation and 'live' reaction-improvisation, even, we must believe, when the content embodied the words of God. There are on the spot explanations, such as, 'What will make you understand…?' These are obviously cued by audience reaction (101:9–11), or perhaps a lack of it. There are direct answers to both questions and criticisms (2:135, etc.). There was, finally, the charge that the revelations were somewhat too improvised, that Muhammad was in effect making it up as he went along, with one eye steadily fixed on the main chance. Not all of these responses had necessarily to occur in the original performance, however, since these performances were repeated, and there was an opportunity for the poet, or the Prophet, to make adjustments.

Muhammad, Poet and Performer

The Muslim Prophet pronounced as inspiration or opportunity presented itself. He then recited his pronouncements anew for those who had not heard or had not understood, or

perhaps when he had simply changed his mind: twenty-two years is a long prophetic career. So, just as some Galileans heard the Beatitudes more than once, and the Apostles probably many times, the Meccans doubtless heard the *suras* of the Qur'an a number of times, and what we have in our hands, as with the Book of Jeremiah, is the written, and hence edited, record (perhaps) of a series of single performances. But while oral performances of the same composition tend to vary from one telling to another, the oral Qur'an may have become more fixed than most. Its repetition was not simply for comprehension or entertainment. Both the Prophet and his converts believed that what was coming forth as a recitation was God's own words, and, like the Jews and Christians, they used this 'Scripture', this heavenly Book sent down but not yet written down by mortal hands, as liturgical prayer. Muhammad repeated his *suras* often enough for his followers to have them by heart, an act that helped stabilize what would otherwise have been a considerably more variable text.

Muhammad struck his Meccan audiences as a *jinn* (genie)-possessed or *jinn*-inspired poet, or perhaps as a mantic *kahin* (seer), and the impression is reinforced by what seem to be some early Muslim traditions about the Prophet. They relate that Muhammad told his wife Khadija apropos of his revelations, 'I see light and hear a voice. I fear I am becoming a kahin.' The *kahin* and the poet both provided access to what the Arabs called *al-ghayb*, the unseen world, in our terms perhaps the supernatural. Each was a familiar of the *jinn*, the genii of the Arabian spirit world, and both were, on occasion, *majnun* (*jinn*-struck) or, as we might say, inspired or possessed, though the flavour of the Arabic is closer to the latter. To the poet the *jinn* gave the skill to tell the tribal tales of bravery in war, or sorrow in love; the poet was the memory and panegyrist of the tribe, the 'archive of the Arabs', as he has been called. The *kahin* had somewhat more practical skills. His special knowledge made him a tribal counsellor and arbitrator in matters great and small.

It took no great sophistication for the Meccans to recognize him as a poet; what was proceeding from his lips was poetry by any standard: short-lined rhymed verses, chanted not spoken, and with a high emotive content. His performance behaviour too (for example, 'Oh you, wrapped in a cloak!' (74:1–7)), about which we are not very well informed, may likewise have identified him as a poet. His listeners drew the appropriate conclusion, that these were 'old stories' (25:4) and that he must have got his poetry from someone else, and even that what he was reciting had been recited or passed on

to him (25:5–6). We too do not know where this minor merchant of Mecca learnt to make poetry. For the Muslim tradition there was no issue here, so it offered no explanation; both the content and the diction of the Qur'an, its language, style and very tropes, were from God. Hence, the Muslims quite correctly concluded, the Qur'an itself is a miracle, so is literally and literarily inimitable. Muhammad (or God speaking through him) claimed as much in response to his critics: let them try to produce *suras* like it (2:23, etc.)!

Muhammad is called *ummi* in the Qur'an, a word that the Muslim commentators insisted meant 'illiterate'. There are those who disagree about the meaning, but none on the fact of the Prophet's illiteracy. The question of Muhammad's illiteracy is irrelevant; most oral poets, and certainly the best, have been illiterate. So, if a miracle is an event with no natural causes, the Qur'an is indeed a miracle. There was no sensible way by which an untrained Meccan could have produced such sophisticated verse as we find in the Qur'an.

A Change in Style

In our bondage to a written text, we must constantly remind ourselves that there is no 'original' here. The original of the Qur'an is first, the recitation or performance that Muhammad chose to have his followers memorize, and that is very unlikely to have been its first utterance; and then, the 'original' of our Qur'an is the finished *sura* that either Muhammad or someone else had edited. In neither instance was there any concern to preserve what we might think of as the original revelation, the first (and only) words to issue from the Prophet's mouth. As we have seen, that notion, though theologically a cornerstone of belief – the Qur'an is God's unchanging Word – defies every convention of oral poetry and performance. Our Qur'an, like Homer's *Iliad*, is a finished product. But the Qur'an is not the *Iliad*. It was regarded by the one who pronounced and by those who memorized it as the words of God. This may have determined the length of the shorter Meccan *suras*, which had, as we have just seen, the not inconsiderable safeguard of frequent repetition by the faithful, and carefully, in a liturgical setting and with what we may assume was the direct supervision of the Prophet. But with the turn in Muhammad's career at Medina, the *suras* grew longer and more prosaic, and with the loss of the mnemonic aids represented by rhyme and assonance, they would also have become more difficult for all to retain and

repeat with any degree of accuracy. Hence, it is argued, the increasing need for a more stable and fixed written text.

The Writing Down of the Qur'an

The repeaters or reciters were those engaged in the transmission of oral texts, or, as they more likely understood it, their re-performance. The written text is the province of quite another expert, the *katib* (scribe). Many of these latter are not mere copyists, though in an age before mechanical reproduction, there is no such thing as a 'mere' copy, but what concerns us here is the head of the file of scribes, those experts who transformed the oral 'text' of the Qur'an into a written one. That scribal moment occurs twice in the reported traditions on the production of the Qur'an. It occurs first when Muhammad recited or dictated the Qur'an, and some of the believers (Zayd ibn Thabit mentioned chief among them) copied them down as they heard them on whatever material lay at hand. Thus, as the early Muslims understood it, the Qur'an was already being written down, albeit in fragmentary fashion, in Muhammad's own lifetime. The identification of the time and the place of this happening – Medina in the lifetime of the Prophet – are almost certainly wrong. We have just seen how unlikely it was that there should be in Medina in Muhammad's day a scribe skilled enough to have taken down the *suras* as dictation.

The second occasion for this primal scribal activity was twenty or more years later – Zayd was once again involved – when the caliph Uthman was preparing his 'standard edition'. He had collected the existing *mushafs* (codices), the remnants perhaps already in book form. He had also transcribed whatever could be retrieved from the 'hearts' of the believers, memorized portions of different parts of the full 'recitation'. All these now written fragments had to be collated – some of this may have gone on at the earlier transcriptions – and complex editorial decisions made to produce, in written form, a single version of the Qur'an. This became 'standard' by the caliph's decree that all other versions be destroyed and this text used in their place.

Although we do not know precisely how the first Muslim scribes of the Qur'an worked, we can gain some insights from scribes in other societies in a transitional era between an oral and a written culture. First, it should be remarked that the sound system of a language, its pronunciation, is generally far more complex and sophisticated than the system of writing it down. This is particularly so in the early stages of the passage from an oral to a written culture, when the writing system is still being fashioned. This was certainly true of Arabic, whose sounds overwhelmed the few symbols of script in use in the seventh and eighth centuries. Just as it is impossible to believe that the Sumerians and the Egyptians spoke as simply as their cuneiform and hieroglyphic scripts portray them, it is also impossible to imagine the chanted Qur'an being transcribed into the meagre scratchings of early Arabic script, which, among its other shortcomings, had no way of recording vowels, and only a very limited supply of consonant signs.

Eric Havelock has thought about the same problem with respect to the Homeric poems. By writing it down 'in bits and pieces', he suggests, with the results used, in the first instance, 'as promptings to a reciter how to start or, for that matter, how to stop'. This might indeed have been the case with the Qur'an as well – that the defective Arabic writing system could produce only a prompt text to help in memorization or recitation, and not, as is the case with us, as a text to consult. No one was 'looking it up' in the Qur'an for a very long time after the Prophet, and many Muslims still do not so today. As the hand and its symbols are not adequate to the tongue, the scribe has to make choices from among the available symbols to transcribe what he is hearing. His choice may be ambiguous or it may be incorrect, but in either case a distortion will have been introduced into the written text. The distortion will become enlarged and enhanced as the script grows more refined – points to sort out the ambiguous consonant signs, marks to signal the correct vowels to go along with them – when further scribal choices will be made. For the performer, whether the composer or later *rawi/qari*, absolute accuracy is not a great concern, nor indeed was it for his audience.

Jews and Muslims each developed similar systems of annotating the base-line consonantal text through various diacritical marks and symbols. The rabbis came to agree on just how the Hebrew consonantal text should be pronounced, vowels, emphases, pauses and all, and noted it down on the text page (the masoretic text.) Accuracy is the bugbear of a literary text society, and we may therefore conclude that the Jews' and Muslims' apparent concern for 'fixing' their primary oral texts was the product of an increasingly literate society's anxiety over the variable quality of an oral text. Students of oral cultures have pointed out that in an oral tradition there is little impulse or motive from within for committing oral performances to writing, that often that transfer is undertaken by someone well outside the oral tradition, a habitué of the liter-

ary culture, such as the Jewish scribes of Second Temple times. The Bible, complemented by remarks in the Gospels, and with the addition of considerable material evidence from the library of the sectarian Jewish Community of Qumran, on the Dead Sea, gives us a detailed picture of the scribe in the increasingly literate Palestine of the fifth to the first century BC. They were members of a highly specialized profession. The scribe was not merely a copyist, but an editor and somewhat more. If we are searching for such skills and motives in an Islamic milieu, we must go far beyond Muhammad's or even Uthman's Medina. There were skilled and professional scribes in Baghdad, and books and eventually booksellers, and it was there that we witness the appearance of all the major forms of Arabic literature, including all the traditions regarding the Qur'an. It was then too, in a number of Iraqi centres, that the great body of pre-Islamic poetry began to be transcribed from the hitherto oral transmission. Further, with its large and vocal Christian and Jewish communities there was also present in Baghdad an apologetic motive for converting Islam's oral Qur'an into a written book on the familiar scriptural model. We are now in the presence of a scriptural 'book' in the literal sense. The reason, according to the received Muslim tradition, was either the dying off of Qur'anic reciters and the consequent fear of the authentic text disintegrating, or the divergences in and the disagreements over the circulating 'texts', with no indication whether they were oral or written.

Conclusions

Everything that follows confirms the unlikeliness of the existence of a fixed text of the Qur'an any time in the seventh or eighth centuries. The first time any part of the Qur'an appears in writing is in a dated (AD 690) inscription on the inside of the Dome of the Rock in Jerusalem, and the texts there do not always agree with what is in our Qur'an. In 1972 a cache of previously unknown Qur'an manuscripts was found in a mosque in Sana'a in the Yemen, and these have proven to be the oldest yet known, from before AD 750. They are still under study, but preliminary reports say that they differ from our 'standard' text not only in their readings, but in the order of the *suras* as well. And finally, the debate over *qirâ'ât* (readings), or, How to Recite the Qur'an, was still going on in the tenth century, when Ibn Mujahid (d. 936), a Baghdadi scholar, signalled seven basic versions that he regarded as acceptable.

Even then, some continued to recite the Book in their own preferred fashion, and with the government's backing he had one recalcitrant flogged into compliance. Even more revealingly, Ibn Mujahid declared that the Uthmanic consonantal text was now obligatory, two and a half centuries after Uthman himself was supposed to have made the same declaration. The reason why there was a debate, and why there are still variant ways of reciting the Qur'an – though they are now winnowed down to two – is that Islamic society during the tenth century and for a long time afterwards had one foot in the culture of writing and the other still in the oral culture of the Prophet and his successors.

We are now in a position to trace the idealized steps in the evolution of Scripture, and the scenario applies equally well to both the Jewish and the Muslim traditions. First, there is a Book in heaven. It is authoritative because it is written by God Himself. At some point God speaks the contents of the heavenly Book to His prophet – in Israel God also gives a written copy or summary to Moses – to be recited to His Chosen People. This occurs in the pre-literate or oral stage of the society, when communication and memory are primarily or uniquely through the spoken word. But as writing becomes more common, the revelation is committed to writing out of a fear, common to oral societies in transition, that the original oral version would be lost or become 'inaccurate'. Thus, the recited Torah/Qur'an becomes the written Torah/Qur'an. The Book was written down, then copied and finally printed, and both the Bible and the Qur'an now circulate widely in societies where both the oral and the literary cultures still exist side by side. Yet the oral quality of the revelation never quite disappears; the Book continues to be recited, even though written copies are available. Since the evolution of the Bible took place over an extended period of time, we are able to trace the stages of its development from a heavenly to a recited to a written book in the text itself. The primary composition of the Qur'an, on the other hand, took place in a mere twenty-two years. There is still present in it the notion of a heavenly Book, but for the rest, the context is still entirely oral-traditional. The Bible becomes a written text during the course of its own evolution; the Qur'an, we think, only afterwards, and we cannot be certain how much later. The Qur'an clings more tenaciously to its orality: the *hafiz*, the Qur'an memorizer who has the whole text by heart, is a revered and still common figure in Islamic society.

The Catalogue

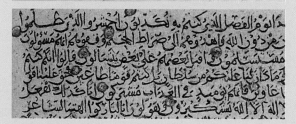

The Sacred Texts

The Jewish Sacred Text

The Jewish Bible has three parts: the Torah, or Pentateuch; the *Neviim*, or Prophets, and the *Ketuvim*, or Writings, which includes eleven diverse books such as Psalms, Proverbs, and the Song of Solomon. It is sometimes referred to as the *Tanakh*, an acronym based on the first letters of each of these sections: T(orah), N(eviim) and K(etuvim). The Torah, consisting of Genesis, Exodus, Leviticus, Numbers, and Deuteronomy, is the most sacred part of the Hebrew Bible because, according to tradition, Moses wrote it by divine dictation. The Torah scroll (*Sefer Torah*) intended for the synagogue ritual must always be handwritten on parchment, prepared from the skin of a permitted animal, using permanent ink and a Hebrew square script. It must not contain vowels or any other symbols or diacritics, and must be unadorned. The long strip of parchment is usually wound onto two wooden rollers that enable easier handling of the scroll during public reading. Both the text and the object itself are considered to be holy, so when the Torah scroll is not in use it is kept in the Holy Ark, the most sacred place in a synagogue. The Torah is divided into fifty-four pericopes or portions, each one named after its first characteristic word(s). A pericope is read aloud from the Torah scroll each week in the synagogue during the Sabbath service. The ritual of the reading of the Torah scroll is also performed on Mondays, Thursdays and festivals.

Detailed rules for preparing Torah scrolls and their use in synagogues are found in the *Mishnah* and in the Talmud. In Rabbinical Judaism, the *Mishnah* (literally, repetition) is considered to be the oral Torah, as given to Moses, which was then compiled and recorded around the second century. The Talmud (a Hebrew word derived from 'study' or 'learning') consists of the *Mishnah* together with further interpretative commentaries or *Gemara* (completion) assembled in the fourth and fifth centuries. The text of the Torah can also be written in a book format or codex. Unlike Torah scrolls, biblical codices, such as the Lisbon Bible displayed in this section, include vowel points indicating where the vowels are to be placed. Many medieval Torah codices also include glosses, masoretic notes, rabbinic commentaries, and pictorial matter. Masoretic notes (from the word for 'tradition') contain rules of pronunciation, spelling, and intonation intended to preserve the biblical text and to ensure its accurate transmission. They are typically written in the margins and between text columns in script smaller than the biblical text, and include indications of syntax, stress and melody.

The Christian Sacred Text

Christians believe that Jesus is the Christ or Messiah predicted in Jewish scriptures, and the Christian Bible or sacred text therefore consists of two parts: the Old Testament consisting of the Law and the Prophets and other writings of the Jewish Bible, and the New Testament, concerning the teachings of Jesus and his apostles. The first four books of the New Testament are the Four Gospels, thought to have been written by Sts Matthew, Mark, Luke, and John. The word 'gospel' is possibly derived from the Old English translation of the Greek *euangelion* or 'good news'; their authors are commonly known as the Four Evangelists. The other twenty-three books of the New Testament include the Acts or accounts of the Apostles, which recounts the life of the church immediately after Jesus's death, letters to early Christian communities or individuals from the Apostle Paul and other early Christian leaders, and an apocalyptic account, or Revelation. The development of this accepted group of texts over time, and the differences between Roman Catholic and Orthodox and Protestant Bibles are explored in a later section. Although the Bible was translated into many languages from an early date, all of the books of the New Testament are generally thought to have been written originally in Greek. It is therefore appropriate that the beautiful tenth-century copy of the New Testament displayed in this section is also a manuscript in the Greek language.

The Islamic Sacred Text

The Qur'an is the sacred book of Islam. According to the Muslim faith, it contains the actual word of God as revealed through the archangel Gabriel to the Prophet Muhammad in the Arabic language. He received the divine revelation from about 610 until his death in 632, first at Mecca and subsequently at Medina, where he had emigrated in 622. The text of the Qur'an is traditionally read aloud, as instructed in the first revelation that Muhammad received: 'Recite in the name of your Lord' (chapter 96, verse 1). Indeed, the word 'Qur'an' comes from the Arabic verb 'to recite'.

Early believers originally memorized the revelations to the Prophet. However, the first caliph, Abu Bakr (r. 632–4), who succeeded Muhammad on his death, ensured that the revelations were recorded in writing by ordering Muhammad's secretary, Zayd ibn Thabit, to compile them in book form. Tradition has it that the original compilation of the text was collected from the oral recollections of Muhammad's early followers, and also from early transmissions written on fragments of readily available materials, such as parchment, papyrus, stone, camel bone, palm leaves and leather.

The Lisbon Bible

Lisbon, Portugal, 1482
Genesis 1

The Lisbon Bible is one of the most
accurate of biblical manuscripts, and as
such it has been used in a number of
modern critical editions. It may even
have been designed specifically as a
model text. It is the most accomplished
dated manuscript of the Portuguese
school of medieval Hebrew illumina-
tion. Its three volumes comprise all
twenty-four books of the Hebrew
Bible. The biblical text was copied
by Samuel ben Samuel Ibn Musa for
the manuscript's patron, Yosef ben
Yehudah al-Hakim. The sumptuous
decorations display Italian, Spanish
Mudejar and Flemish influences.

This is the frontispiece to *Be-reshit*,
meaning 'In the beginning', from the
opening words of Genesis, the first
book of the Torah: 'In the beginning
God created the heavens and the earth'
(1:1). The initial word is inscribed in
gold letters in a mauve filigree panel
surrounded on three sides by multi-
coloured foliage. Samuel, the scribe,
copied the biblical text in two columns
in a characteristic Sephardi style of
Hebrew writing, using a reed pen.
Remarks on and lists of peculiarities in
the text are known as masoretic notes;
these were written in minute script by
a second, unnamed scribe, who mod
elled them into micrographic circular
patterns. Micrography is the practice of
using minute script to create abstract
shapes or figurative designs.

BL Or. MS 2626, Vol. 1, f. 23v

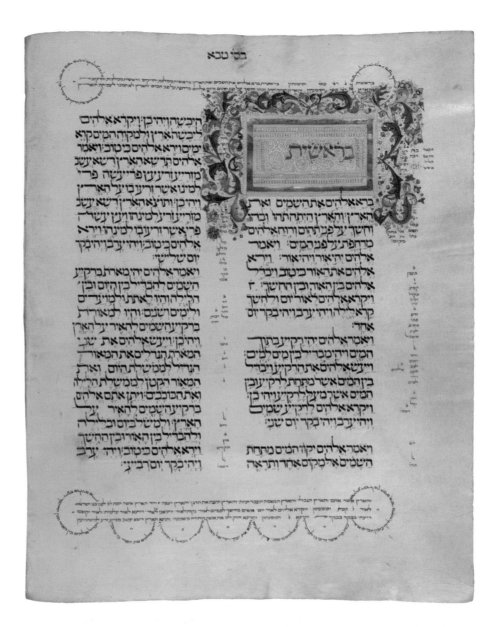

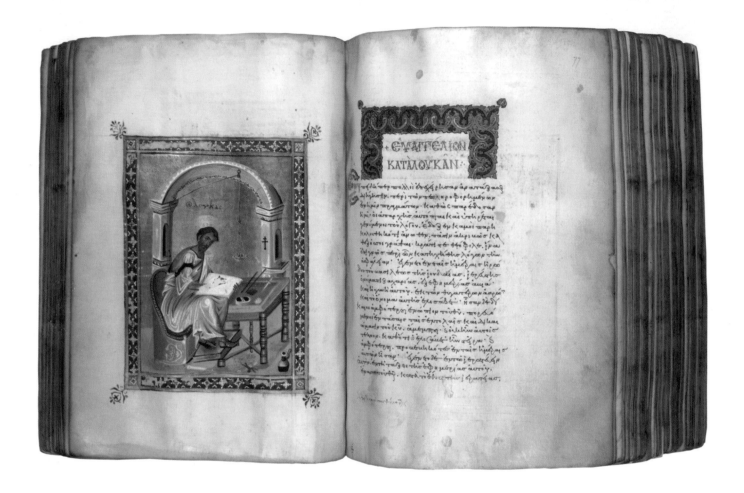

The New Testament

Constantinople, mid-tenth century
Luke I

From an early period Christians incorporated imagery into their copies of the holy Scriptures. One of the most common types was the Evangelist portrait, placed at the beginning of each Gospel. These images of the authors were based on classical author portraits, which served to legitimize and authenticate the text. In this impressive copy – arguably the most beautiful New Testament in Greek in the British Library – the Evangelist St Luke is bent over his book, with his writing implements ready to hand. The burnished gold background is as bright today as when it was first made over 1000 years ago. The front cover of the book is also richly decorated, making it both inside and outside a fitting physical symbol of the Word of God it contains. It was made at a high point in the history of the capital of Eastern Christendom, and demonstrates the unbroken tradition of the use of Greek as the literate language of the Eastern Mediterranean.

BL Add. MS 28815, ff. 76v-77

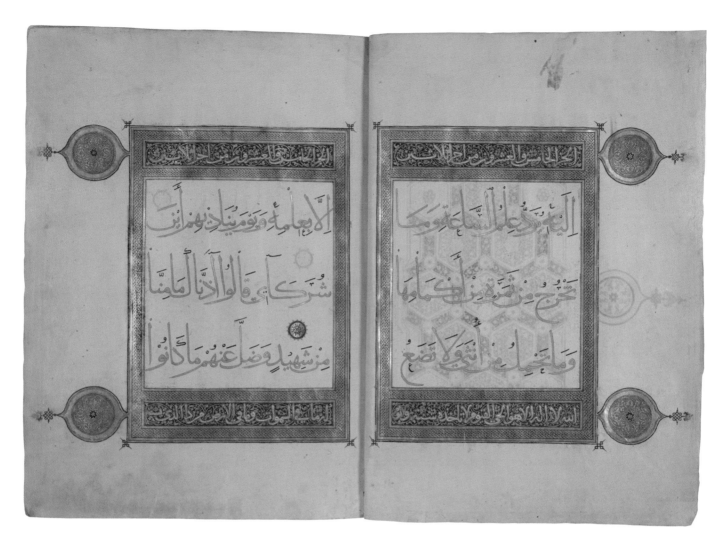

A Royal Qur'an

Mosul, Iraq, 1310
Chapter 41, *Fussilat* (Explained in detail), verse 46

This lavishly illuminated Qur'an was commissioned by the Il-Khanid Sultan, Uljaytu (r. 1304–17). The commissioning certificate of this Qur'an traces Uljaytu's ancestry back to Genghis Khan. It was beautifully calligraphed by 'Ali ibn Muhammad al-Husayni. The opening pages contain the text in a central panel within a rectangular frame, written in gold *muhaqqaq* script with vowel signs in black ink. *Muhaqqaq* was a popular script for larger Qur'ans of the Mamluk and Il-Khanid periods, its angular and cursive features giving the calligrapher an opportunity to combine fluidity with rigidity.

The conventional use of panelling to carry inscriptions is integral to the rectangular frame surrounding the text, as is the decorative palmette that extends from each of the panels into the margin. The inscription in the top panels records that this Qur'an section is volume twenty-five of a thirty-volume Qur'an, while the lower panels contain part of the 'Throne Verse' (chapter 2, verse 255). This is one of the few complete parts of this multi-volume set to have survived intact.

BL Or. MS 4945, ff. 2v–3

Dissemination, Division and Difference

These three faiths all originate in the Middle East. According to the Torah, Abraham, founder of the Jewish nation, was born in the southern Mesopotamian town of Ur of the Chaldees (now in modern Iraq). By God's command he then migrated to Canaan, a region corresponding roughly to modern day Israel and Lebanon. Jesus of Nazareth was born in Bethlehem, in Israel, around the year that now defines the beginning of the common or Christian era (CE, AD). The Prophet Muhammad lived in Mecca, in present day Saudi Arabia, until 622 when he led his followers on a journey to Medina called the *Hijrah* (migration). This event marks the year in which the Islamic calendar begins (AH).

From the Middle East each faith spread throughout the world. Some of that geographic diversity is represented specifically in this section. Elsewhere in this catalogue there are manuscripts and other objects from Europe, North and West Africa, the Indian subcontinent and China, as well as from the Middle East.

In addition to geographic diversity is the diversity that comes from within the faiths themselves. Some of the many denominations or sects of each faith are explored here. Jewish manuscripts are particularly prominent in this section, because it is important to set out clearly the different historical strands within Judaism before examining its textual and artistic traditions.

Judaism

In early Jewish history Palestine and Babylonia were the two major centres of religious authority. Each developed a different liturgy, or rite for public worship. In the Middle Ages central and northern European Jews known as Ashkenazi (derived from the Hebrew word for Germany) followed a rite from the Palestinian tradition. The Ashkenazi rite gradually spread to other Jewish communities in Western Europe and far beyond. Jews living in Spain and Portugal, known as Sephardi (from the late Hebrew word for Spain) adopted Babylonian liturgical practices. Sephardi custom spread to North Africa, the Balkans, Holland, Italy, some areas of Germany and Austria, and other parts of the world where Spanish and Portuguese Jews had settled after their expulsion from Spain and Portugal at the end of the fifteenth century. What distinguishes the Sephardi from the Ashkenazi tradition is not the statutory prayers as such, but the order and wording of certain prayers, as well as some differences in liturgical poetry and rituals. Both traditions are consistent with Orthodox Judaism, believing that the Torah was given by God to Moses at Mount Sinai, and combining the written and oral Torah.

Both Ashkenazi and Sephardi traditions are illustrated here: a Pentateuch written in Ashkenazi square script, a printed Sephardic prayer book with some text in Ladino, the language of the Sephardim, and a rare miniature printed Ashkenazi daily prayer book. The wide geographic range and cultural diversity of the Diaspora is particularly apparent from the manuscripts included: a specially prepared Chinese Torah scroll, an Ethiopian Psalter and an impressive Pentateuch, one of the very few Hebrew manuscripts to survive from medieval Portugal.

The second aspect of Jewish life highlighted is the presence of sects and reform movements. Among the earliest of these were the Samaritans, who may have split from mainstream Judaism as early as the fourth century BC, and have continued to the present. The Samaritan example here is a Pentateuch written in Damascus in 1339. Another group of Jews to emerge in the Middle Ages were the Karaites (literally, 'people of the Scripture'). Their distinctive tradition is limited to the written Hebrew Bible alone, illustrated here by a Russian Pentateuch with a translation in the Tatar dialect.

Reform Judaism originated in Germany in the nineteenth century, and denied the divine inspiration of the Torah. Instead, the movement accepted the critical theory that the Bible was written by separate authors, combined over time. Most radically, it totally rejected the idea of a return to Zion and the rebuilding of the Temple in Jerusalem, as articulated in the Hebrew Bible. This drastic shift was later reversed in the aftermath of the Holocaust and the establishment of Israel.

The first Jewish Reform Temple opened in 1818 in Hamburg, and a copy of its first Reform prayer book is included in this section. The Reform movement in Britain began in 1836, when some members of the Bevis Marks Synagogue in London attempted innovations to both liturgy and worship. Ignored by the synagogue leadership, this group's determination led ultimately to the founding of the first British Reformed synagogue. The Reform faction in Britain has been more traditionalist than both the nineteenth-century German Reformists and the current Jewish Reform movement in the United States, with which it has no links. Liberal Judaism in Britain is closer in creed and practice to the German and American Reform movements than it is to British Reform Judaism. Its founders in 1902 included Lily Montague, a charismatic aristocrat, and the biblical scholar Claude Montefiore. Like the German Reform movement fifty years earlier, it sought to make radical innovations in worship, with the use of more English in services, musical accompaniment, and equal participation by men and women. What was initially intended as a supplement to the existing Orthodox and Reform services ended up as a newborn religious movement, leading to the creation in 1911 of the first Liberal synagogue in Britain. The Liberal movement tends to embrace a more open outlook, particularly on more challenging and controversial issues. This is illustrated in the modern Liberal prayer book, in the exhibition open to prayers

for the United Nations Sabbath, with a prayer for the Lord to bless the United Nations and help it achieve world peace.

Christianity

Christianity today includes a multiplicity of denominations and sects, despite the continuing vitality of the Ecumenical Movement, wide participation in the World Council of Churches, and extensive interdenominational discussions focused on reunion. Some of these divisions occurred in the first centuries of Christianity, during a period in which several important church councils were held to decide complex theological points of doctrine. A sixth-century Syriac copy of ecclesiastical laws formulated at fourth- and fifth-century church councils illustrates some of the decisions taken at these councils. A significant division within Christianity occurred with the so-called 'Great Schism' between the Eastern and Western churches, led traditionally from Constantinople and Rome, respectively. Political, ecclesiastical and theological differences developed over the centuries. In 1439 representatives of both churches met in Florence to attempt to resolve the differences, including the vexed questions of whether the Holy Spirit proceeds from the Father and the Son ('filioque') or from the Father through the Son, questions of transubstantiation, purgatory and hell, of papal supremacy, and of the order of precedence among the Eastern patriarchs. This section includes an impressive copy of the papal bull that announced an imposed agreement reached on these issues, complete with the papal authorization and the signature of the Byzantine emperor. However, the union was not subsequently ratified by an Eastern synod, and has never been implemented, resulting in the final breach and continued division between the Eastern Orthodox and Roman Catholic churches.

Another major split within Christendom illustrated in this section is that between England and Rome. In 1534, after protracted and unsuccessful negotiations with the pope over the proposed annulment of his first marriage, King Henry VIII (r. 1509–47) was declared the head of a new Church of England, repudiating the pope's authority. The so-called 'Great Bible' was printed in London five years later. The king's new status as head of the English church is dramatically illustrated on its title page, where the king distributes Bibles to his subjects. The Bible also represents another aspect of the English Reformation – the order that every parish should have a large reading copy of the Bible in English.

Islam

After Muhammad's death in 632, Islam spread rapidly. During the period of the Umayyad caliphate that ruled from Damascus (661–750), Islam spread west from Egypt to Libya, Tunisia, Algeria and Morocco. It also expanded into the Iberian Peninsula, becoming the dominant power in Spain from 711. A rare thirteenth-century Qur'an from Granada illustrates this period of rule in the West, prior to the Christian Reconquista largely completed by Ferdinand and Isabella in 1492. Islam also reached India at an early date (the first mosque was built there during the lifetime of Muhammad). A sixteenth-century Indian patron commissioned the beautiful Qur'an written in gold, black and blue included in this section. Islam in South East Asia is represented by a Malay Qur'an, produced on paper manufactured in Europe. Its expansion through trade is demonstrated by part of a remarkable Chinese Qur'an originally made in thirty volumes, written in a particular script associated with Chinese calligraphy, often referred to as sini, or Chinese Arabic.

Within Islam, there are two principal divisions. The largest denomination is of Sunni Muslims, who regard the leader or caliph Abu Bakr (r. 632–4) as Muhammad's rightful successor, chosen by the people. However, Shi'a Muslims recognize the succession of Muhammad's cousin and son-in law, 'Ali (r. 656–61). A standard or 'alam used in the Shi'a processional ceremonies on 'Ashura, the tenth day of the first month of the Muslim year commemorating the martyrdom of 'Ali's son, Husayn, is included in the last section. Sufism is another sect within both branches of Islam, a mystical tradition encompassing a diverse range of beliefs and practices.

Wahhabism is another religious and spiritual reform movement within Islam illustrated by the last manuscript in this section. It is a history of the Najd region in present day Saudi Arabia, the region where the founder of this movement, Muhammad ibn 'Abd al-Wahhab, was born in 1703. Based on legal interpretations that are conservative and literal in approach, Wahhabism forbids all practices that might be considered innovations, and rejects, for example, the Sufi custom of venerating saints. Over the generations Ibn 'Abd al-Wahhab's teachings became the religious force behind the formation of what is today the kingdom of Saudi Arabia.

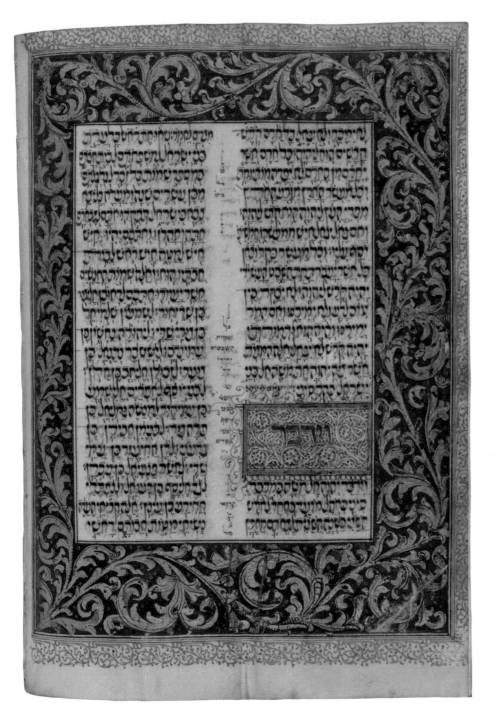

Portuguese Pentateuch

Lisbon, Portugal, fifteenth century
Numbers 1

The Pentateuch comprises the first five books of the Jewish Bible, and is known as the Torah or the Five Books of Moses. The illuminations in this manuscript show a marked stylistic affinity with those found in the Lisbon Bible (see page 35), suggesting that they were probably from the same workshop. What differs here is the style of Hebrew handwriting used to copy the main body of the text. The square calligraphy that is commonly used for copying Hebrew Bibles is here replaced by an elegant, semi-cursive, north African Sephardi hand, showing the influence of Arabic *maghribi* script.

The word written in gold letters in the exquisite filigree panel spells *Va-Yedaber* (And the Lord spoke) from the opening verse: 'And the Lord spoke unto Moses in the wilderness of Sinai…' (Numbers 1:1).

The sacred text is in two columns separated by masoretic notes (commentary on peculiarities in the text), and surrounded by a finely embellished outer border of large acanthus scrolls.

This is one of only about thirty medieval Hebrew manuscripts that survive and express the rich cultural life of Portuguese Jews before their expulsion or forced conversion from 1497.

BL Add. MS 15283, f. 114v

Torah Scroll from Kaifeng

China, seventeenth century
Genesis 35:1

This scroll was specially prepared for the Chinese Jews of Kaifeng, probably between 1643 and 1663, and was used in the synagogue there until around 1800. In 1851 it was acquired in Kaifeng by missionaries, and in 1852 was presented to the British Museum. The scroll is made up of ninety-four strips of thick sheepskin sewn together with silk thread, rather than with the customary animal sinew. It has 239 columns of unvocalized text copied in a Hebrew square script similar to that used by the Jews of Persia.

The Jewish community of Kaifeng and its synagogue existed for 700 years (*c.* 1150-1850). Of the fifteen Torah scrolls that were once held in the Kaifeng synagogue only seven complete scrolls have survived.

BL Add. MS 19250

Hebrew Psalter in Ethiopic Script

Ethiopia, eighteenth century
Psalm 1

Only the opening word was written in Hebrew characters. The rest of the manuscript contains Hebrew text copied in an eighteenth-century Ethiopic script. The list of church furnishings written in Italian in the manuscript suggests that it may have belonged to a clergyman possibly on a teaching mission in Ethiopia. Obviously the scribe and the owner mastered both languages and may have been one and the same person.

BL Add. MS 19342, f. 1

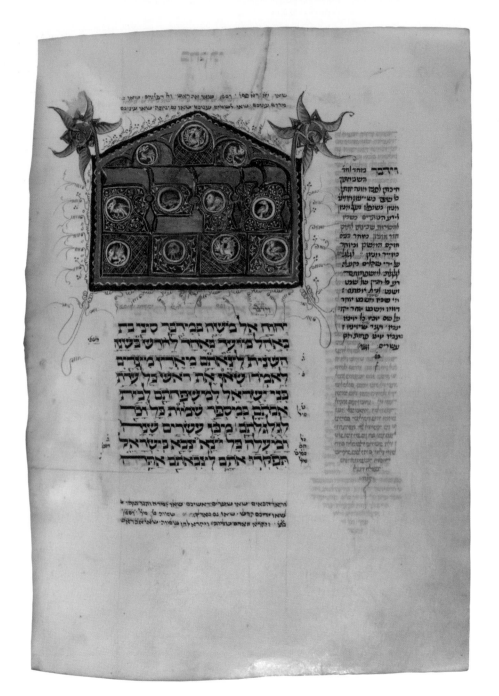

Pentateuch with Rashi Commentary

Germany, first half of the fourteenth century
Numbers 1

Rashi (an acronym of Rabbi Solomon ben Itshaki, 1040–1105, of Troyes, France) is considered the greatest medieval commentator on the Hebrew Bible. His unique commentary is still an essential companion to study of the biblical text.

This is the beginning to the fourth book of the Torah, known in the Christian Bible as Numbers. The opening word in gold letters inside the window-shaped panel reads *Va-Yedaber*, from the verse 'And the Lord spoke…' (Numbers 1:1). The panel ground was divided into eleven decorated red and blue compartments featuring circular medallions with animals and grotesques. The illuminations reveal Germanic influences. The biblical text was copied in a single column in vocalized Ashkenazi square script (a Hebrew style of writing in Franco-German lands). The masoretic notes were penned close to the sacred text, whereas Rashi's commentary was added in columns of minute, semi-cursive script in the outer margins. Rashi's commentary had a significant influence on Christian scholars from the twelfth century onwards, such as the Franciscan scholar Nicholas of Lyra (1270–1349), who in turn was a major source for Martin Luther (1483–1546).

BL Or. MS 2696, f. 257v

Pentateuch with Aramaic Translation by Onkelos

Northern Italy, *c.*1460–70
Leviticus 1

The opening word to Leviticus (*Va-Yikra*, from 'And the Lord *called* unto Moses') is in gold letters against a lapis lazuli tooled ground. An elegant border composed of stylized flowers, birds and golden dots surrounds the sacred text separating it from the Aramaic *targum* (a translation from the Hebrew Bible) copied in the left-hand column. The translation is introduced by a small word panel of mauve ink tracery surmounted by a golden ornamental vase with floral sprigs. The Renaissance-style illuminations may be by Christian artists, or by Jews copying Christian models.

Onkelos (*c.*35–*c.*120) was a Roman convert to Judaism. He is thought to be the author of the Onkelos Targum, which is regarded as the authoritative translation of the Torah (Pentateuch). Written in the eastern Aramaic dialect (Babylonian), it is essentially a paraphrase rather than a strictly literal translation. During the Talmudic period (*c.* fifth to sixth century) it was customary to read this translation in the synagogue, alternating each verse with a verse from the Torah in Hebrew. In the post-Talmudic era (*c.* seventh to eleventh century) Aramaic ceased to be the spoken language of the Jewish world, so this custom declined, except in Yemenite communities, where it has been kept alive to this day. Perhaps because the Onkelos Targum was seen as a significant source for Jewish biblical exegesis (interpretation), it continued to be copied in medieval Biblical manuscripts alongside the Torah text and various commentaries, as in this example.

BL Harley MS 7621, f. 142v

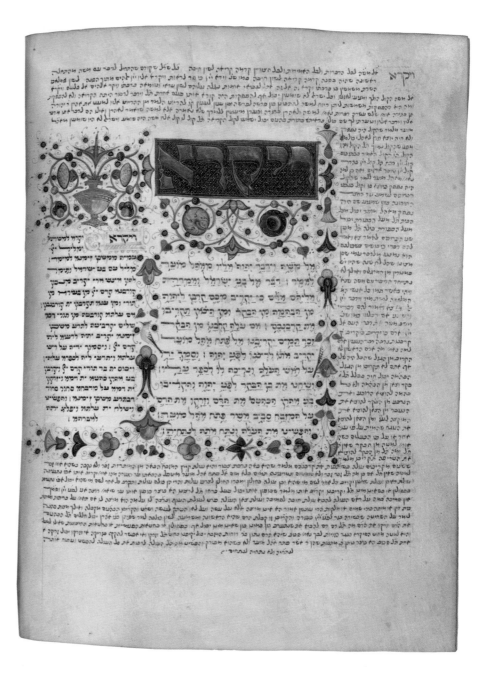

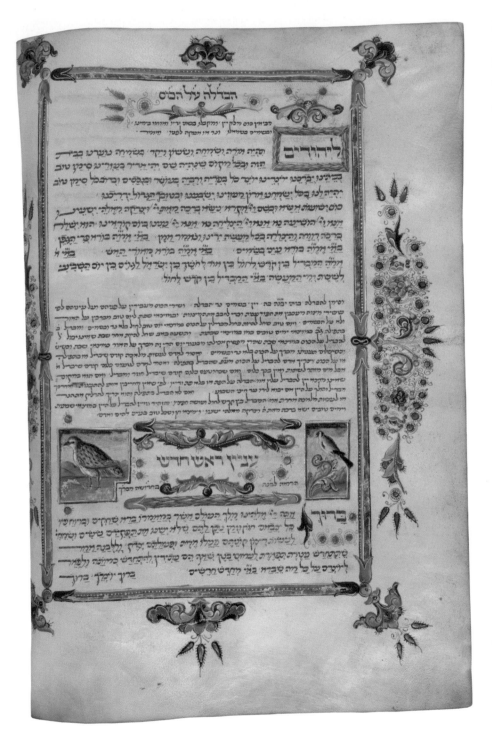

Festival Prayers According to the Roman Rite

Italy, fifteenth century
Sabbath liturgy and Rosh Hodesh

This page from an Italian *mahzor* (book of festival prayers) contains the end of the Sabbath liturgy and the blessing for *Rosh Hodesh* (literally 'head of the month') or New Moon.

In early Jewish history Palestine and Babylonia were the two major centres of religious authority. The Roman rite belongs to the Palestinian liturgical group, and has preserved the remnants of that tradition. It was followed largely in Italy and certain communities in Salonika and Constantinople. Although the Ashkenazi and Roman customs form part of the same group, noticeable differences exist in some of the regular prayers.

The text is handwritten in a partially vocalized, semi-cursive script, surrounded by a finely embellished, multicoloured border. The elegant Italianate-style decorations, with plant, animal and bird motifs, may have been created in a Christian workshop.

BL Add. MS 16577, f. 27v

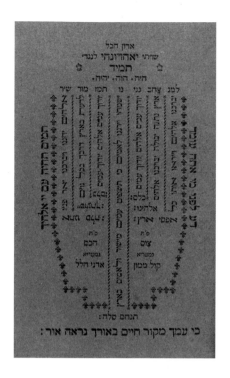

Daily Prayers According to the Spanish Rite

Vienna, Austria, printed by Anton Schmid, 1838
Psalm 67

Menorah is the name given to Psalm 67 when, as here, its
seven verses are shaped as a seven-branched candlestick,
a reminder of the Temple candelabrum. Often inserted or
printed in prayer books, *Menorot* (the plural) were intended
to help worshippers become conscious of the divine presence.
Reading Psalm 67 in this form had amuletic and messianic
implications. It was meant to protect the reader from
harm, but at the same time it symbolized the relighting of
the Temple candelabrum, thus spiritually anticipating the
restoration and redemption of the messianic Temple. The
book contains some text in Ladino (the language of the
Sephardim), showing that it was meant for the Spanish
Jewish community of Vienna. The liturgy in this *siddur*
(book of daily prayers) follows the Spanish or Sephardi
rite, a branch of the Babylonian liturgical tradition. In the
Sephardi liturgy Psalm 67 (or 93 in some editions) is
included in the daily afternoon prayers.

BL C.49.b.15, f. 5r

Daily Prayers According to the Ashkenazi Rite

Venice, Italy, 1598
Musaf shel Shabat

This rare, miniature Ashkenazi *siddur* (daily prayer book) was
printed by Giovanni di Gara, a very prolific Christian printer.
He issued over 270 different Hebrew books between 1564 and
1610. This opening shows the start of the *Musaf shel Shabat* –
the additional Sabbath service. The book also includes the
Psalms and *Ma'amadot,* which are daily selections from the
Bible, *Mishnah* and Talmud read after the morning prayer.

The exquisite contemporary binding is made of dark
green velvet applied with gilded brass and silver-mounted
motifs featuring lion's head bosses and corner mounts cast
with angels' heads and engraved foliage. The attached
chain suggests that this *siddur* was used as a pocket-book.

The Ashkenazi rite was originally used by medieval
German-speaking Jews, and gradually spread to other
Jewish communities in Western Europe and beyond.

BL C.49.a.13

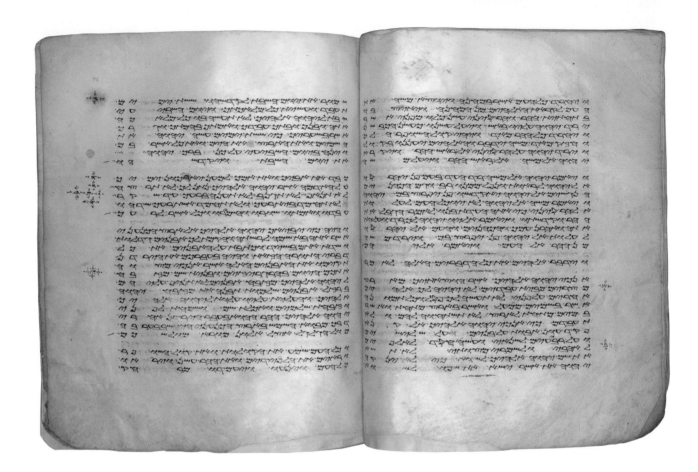

Samaritan Pentateuch

Damascus, Syria, 1339
Exodus 20

This is one of the most significant Samaritan manuscripts in the British Library's collections, and reveals the Samaritan scribal tradition of copying manuscripts of the Pentateuch. It was written in Samaritan majuscule Hebrew characters by the scribe Abraham ben Jacob ben Tabya ben Sa'adah ben Abraham of the Pijma family, and is typical of the Damascene scribal tradition. The Decalogue (Ten Commandments in Exodus) is indicated by an alphanumeric marking in the margin at the left of the text.

The Samaritans (from the Hebrew *Shomronim*, the 'Observant Ones') are a religious and ethnic sect, claiming to be the descendants of the Israelites who were not exiled by the Assyrians in 722 BC. The precise date of the Samaritans' split from mainstream Judaism is unknown, but it is likely to have been complete at the close of the fourth century BC.

BL Or. MS 6461, ff. 69v–70

Karaite Pentateuch

Ortakoi (near Constantinople), printed by Arav Oglo, 1832–5
Numbers 1

Karaite Jews accepted the Hebrew Bible but rejected rabbinic teachings and are not therefore part of mainstream Judaism. The nineteenth century witnessed a tremendous improvement in the Russian Karaites' social status and economic situation. This was largely achieved through successfully distancing themselves from the rest of the Jewish population.

This *Humash* (Pentateuch) was a celebration of their newly acquired social privileges. Its publication was sponsored by twelve important Russian Karaites led by Abraham Firkovitch (1786–1874), a bibliographer, amateur archaeologist and famed collector of manuscripts. It was printed without a title page, and contains introductory poems to each of the five main sections. The poems were compiled by the copy editors and translators. By printing it with a Judeo-Tatar translation (the local Karaite Crimean dialect) the book was intended to convey a forceful message to the Tsarist authorities, namely, that the Karaites had their own Bible and shared little with other Jews. On the right is a poem by Itshak ben Shemu'el, introducing the book of Numbers, while on the left is the opening section to Numbers with the Judeo-Tatar translation.

BL 1944.f.12, pp. 438–9

United Nations Sabbath

Reader

Almighty God, we pray for Your blessing upon the United Nations. May its efforts to unite the world be rewarded with success, and may it become an ever more effective means of achieving international order and peace.

To those who represent the Member States and Organisations, to the Secretary-General and his staff, and to those who serve in the specialised agencies, grant wisdom and courage, patience and restraint, that through their labours the aims of the United Nations, and the hopes of humanity, may be fulfilled.

The Preamble of the United Nations' Charter

We, the peoples of the United Nations, determined to save succeeding generations from the scourge of war, which twice in our lifetime has brought untold sorrow to mankind, and to reaffirm faith in fundamental human rights, in the dignity and worth of the human person, in the equal rights of men and women and of nations large and small, and to establish conditions under which justice and respect for the obligations arising from treaties and other sources of international law can be maintained, and to promote social progress and better standards of life in larger freedom,

and for these ends to practise tolerance and live together in peace with one another as good neighbours, and to unite our strength to maintain international peace and security, and to

280

The First Reform Prayer Book

Hamburg, Germany, 1819
Evening prayer for Sabbath and festivals

Reform Judaism has its origins in nineteenth-century Germany, in response to the Haskalah Jewish Enlightenment movement, which advocated more secularization and closer assimilation into the European culture. As a result, progressive German Jews saw an opportunity to reform Jewish beliefs and practices that had hitherto been unchallenged. For example, they denied the divine authorship of the Torah, and rejected many religious laws on circumcision and diet. Reform services also underwent drastic changes. They revised the daily prayer book, adding prayers and sermons in German, and choral singing with organ accompaniment.

The first Jewish Reform Temple opened in 1818 in Hamburg, and soon issued this, its first prayer book. It combines abbreviated Hebrew prayers and parallel German translations, reflecting the spirit of the newly created Reform faction. This temple, with its unconventional service and prayer book, met with a wave of protests from Orthodox German rabbis, but to no effect.

BL 1973.d.11, p. 2

A Liberal Prayer Book

Union of Liberal and Progressive Synagogues, London, 1967
United Nations Sabbath

Liberal Judaism in Britain is closer in creed and practice to the German and American Reform movements than it is to British Reform Judaism. The Liberal movement tends to embrace a more open outlook, particularly on more challenging and controversial issues.

The opening here is from '*Avodat ha-Lev* (Service of the Heart) – prayers for daily, Sabbath and Festival services. It asks the Lord to bless the United Nations and help it to achieve world peace. It is followed by the Preamble of the United Nations Charter. This edition was edited by Rabbis John Rayner and Chaim Stern, and superseded earlier editions by Israel Mattuck, the first Liberal rabbi, appointed in 1912. He had been strongly influenced by the American Reform movement. Rayner and Stern, on the other hand, adopted a more traditional approach, although they did modernize the language.

BL X.108/7785, p. 280

Collection of Ecclesiastical Laws in Syriac

Mabug, eastern Turkey, 501

This manuscript contains 193 ecclesiastical laws that were formulated at four key Church councils: Nicaea, held there in 325, Constantinople, held in 381, Ephesus, held in 431, and Chalcedon (now a district of modern Istanbul), held in 451. These ecumenical councils were called to debate great theological issues and seek unity of Christian belief. Certain Eastern churches, including the Syrian, Armenian and Ethiopian churches, and the Coptic church in Egypt, rejected the doctrines propounded at the Council of Chalcedon concerning the divine and human natures of Christ, resulting in a division that continues to this day.

BL Add. MS 14528, f. 119v

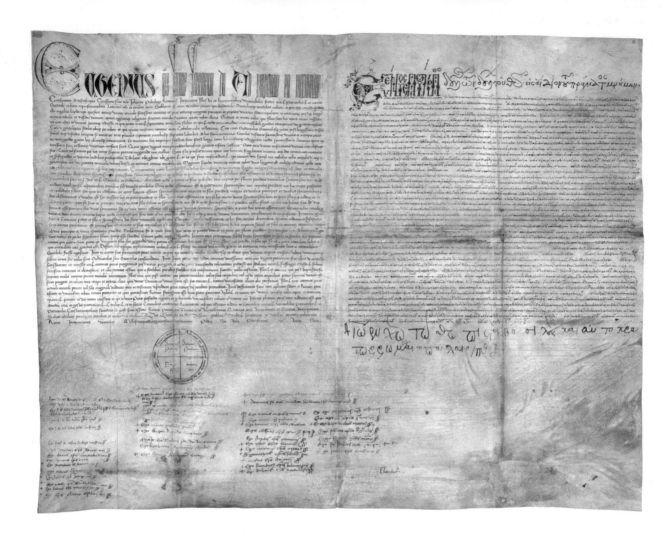

Union between the Latin and Greek Churches

Florence, Italy, 1439
Bull of Union

At a lengthy ecumenical council in Florence in 1439 an agreement was reached to end the schism between the Latin and Greek churches that had developed over time. This copy of the bull documents the agreement, resolving the vexed questions of whether the Holy Spirit proceeds from the Father and the Son (*filioque*) or from the Father through the Son, of transubstantiation, purgatory and hell, of papal supremacy and of the order of precedence among the Eastern patriarchs. The Latin version of the text is on the left, and the Greek version on the right. Below is the papal authentication, and various signatures, including that of the Byzantine Emperor John VIII Palaeologus (r. 1425–48), in red under the Greek text. This is one of only eighteen surviving copies. Despite reaching agreement on the points of difference, the union was not subsequently ratified by an Eastern synod, so it has never been implemented.

BL Cotton MS Cleopatra E III, ff. 80v–81

The Great Bible

London, issued by Miles Coverdale
and Richard Grafton, 1539
Title page

In 1534 England broke with the
Church of Rome: King Henry VIII
(r. 1509–47) was declared the head of
the Church in England, and the pope's
authority was repudiated. As part of
this English Reformation, the king's
vice-regent Thomas Cromwell
(*c.*1485–1540) ordered that every
parish church should have a copy of
'one book of the whole Bible of the
largest volume in English'. That
translation was the one prepared by
his friend Miles Coverdale (1488–1569)
under Cromwell's direct patronage.
It is usually known as the 'Great Bible'
or sometimes 'Cromwell's Bible'. The
printing of it started in Paris, but most
of the printed copies were confiscated
by the Inquisition there and burnt.
In 1539 the printing was completed
by Richard Grafton (*c.*1511–73) in
London. This copy of that edition
demonstrates that the Bible was indeed
of great size, and designed for public
reading. On its title page the king is
shown distributing English Bibles to
his subjects.

BL C.18.d.1, f*1

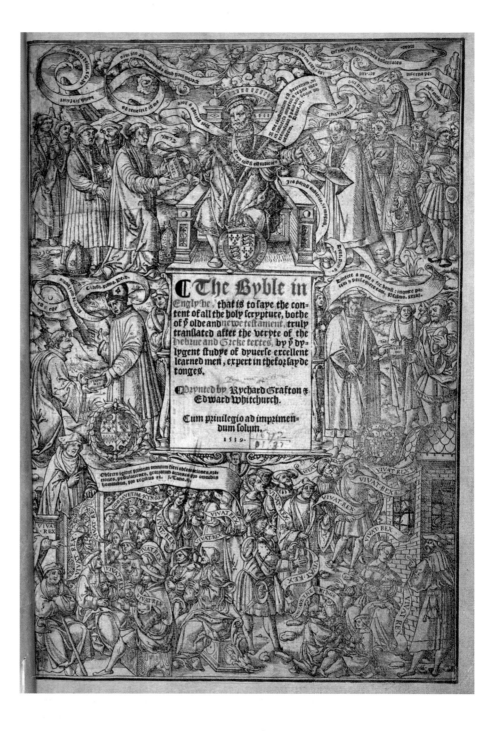

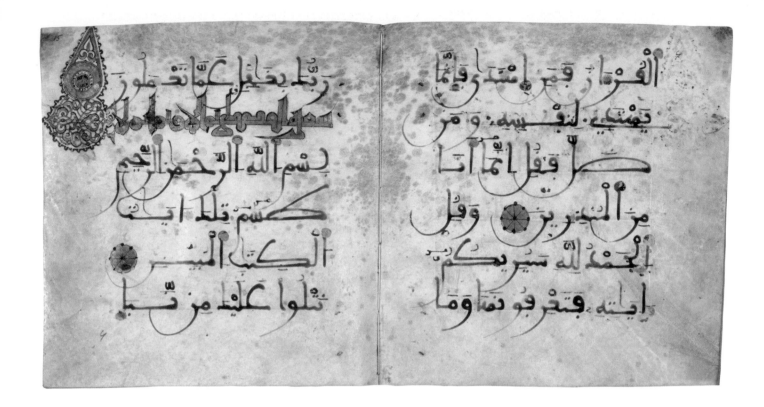

A Qur'an that survived the Christian Reconquest of Spain

Granada, Spain, thirteenth century
Part 39 of a Qur'an in sixty parts
Chapter 27, *al-Naml* (The Ant), verse 92 to Chapter 28,
al-Qasas (The Narrative), verse 3

During the period of the Umayyad caliphate that ruled from Damascus (661–750), Islam spread west from Egypt to Libya, Tunisia, Algeria and Morocco. It also expanded into the Iberian Peninsula, becoming the dominant power in Spain from 711. Examples of early Andalusian manuscripts from southern Spain are rare, most having been lost during the later Christian reconquest. Qur'ans produced in Spain and North Africa were written on parchment in a regional style of script known as *maghribi*. This script, named after the province of Maghreb in North Africa, became the accepted script for copying Qur'ans and other texts in North Africa and Andalusian Spain. A number of features differentiate the *maghribi* from other Arabic scripts, particularly in the way the letters *fa'* and *qaf* are written. Its vowel signs, as seen in this Qur'an, are usually penned in red or blue, with the letter *hamzah* (the glottal stop) also indicated by coloured dots. The ornamental chapter heading is in western *kufic* script, the regional version of *kufic* developed in Tunisia during the tenth century, and from which the *maghribi* script originated.

BL Or. MS 12523C, ff. 14v–15

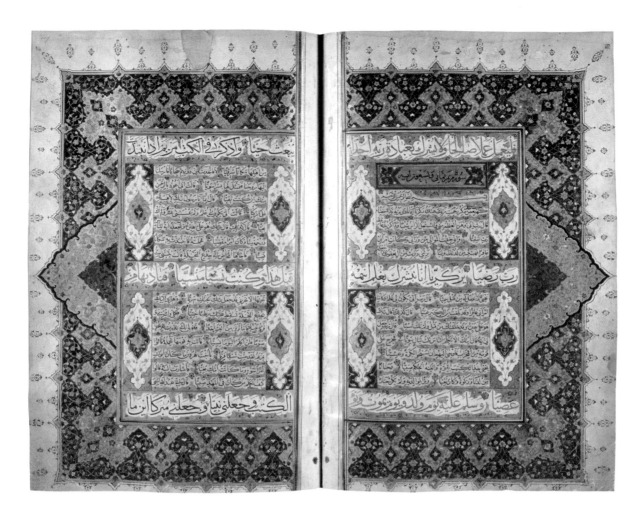

A Qur'an from India

India, sixteenth century
Chapter 18, *al-Kahf* (The Cave) verse 110 to Chapter 19,
Maryam (Mary), verse 31

The centre text pages of this Indian Qur'an are distinguished by their carpet page design. The text here is split up with alternating scripts in various coloured inks. The first, middle and last lines are written in *muhaqqaq* script, alternating in gold and blue on a white ground, while the two main panels of text are in black *naskhi* script on a gold ground with red and blue flowers. In this Qur'an the use of various colours for different scripts is purely for decoration and variety.

BL Add. MS 18497, ff. 118v–119

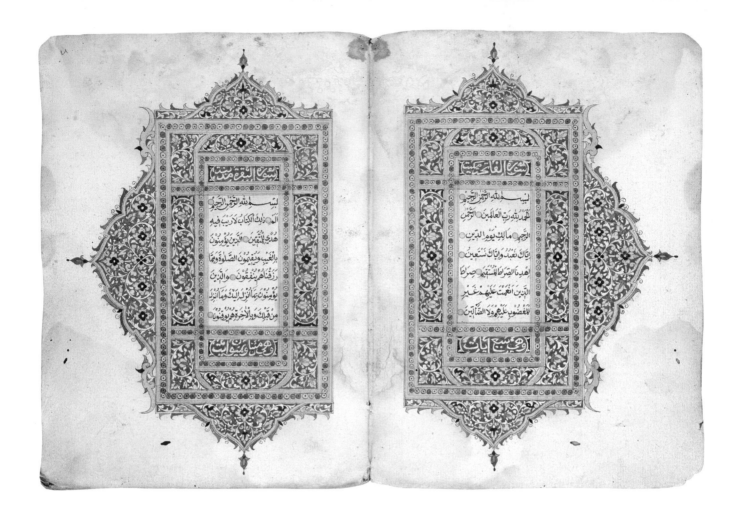

A Qur'an from the Malay Peninsula

Malay Peninsula, east coast, nineteenth century
Chapter 1, *al-Fatihah* (The Opening) and the beginning of
Chapter 2, *al-Baqarah* (The Cow)

Malay Qur'ans from the late sixteenth century onwards were often produced on paper manufactured in Europe. European paper was a popular medium for manuscripts here, as in other parts of the Muslim world, because it was a commodity in the exchange of goods. European paper differs from that made in the Middle East in being watermarked. The letters AG are often found as watermarks in the paper of Malay Qur'ans. These are the initials of Andrea Galvani, the nineteenth-century Italian papermaker who worked in Pordenone, a centre of paper-making near Venice. A distinctive characteristic of Malay Qur'ans is the use of vibrant

colour as an integral part of the design. This Qur'an uses a broad range of colours, the most prominent of these being red, yellow, green and blue, with white for emphasis. This opening of the volume has the text encased in central panels. The rectangular frames are elaborately ornamented on three sides only, with wave-like arches protruding into the margins. The script is a traditional *naskhi* in black, with yellow roundels to mark the end of each verse.

BL Or. MS 15227, ff. 3v–4

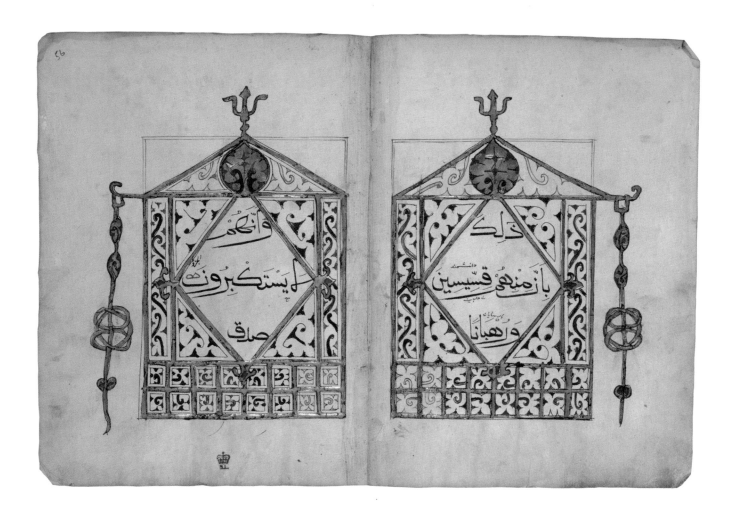

A Qur'an from China

China, seventeenth century

Part six of a set originally in thirty volumes

The influence of local style and culture is predominantly evident in those Qur'ans produced in China, particularly in their adaptation of symbols to Chinese art and culture. Examples of this include the final pages of this Qur'an in which the diamond in the centre of the lantern motif has become the vehicle for the text on its decorated pages. The structure of the lantern is outlined in gold and set within a rectangle delineated by a double red line. The impression of a Chinese lantern is further reinforced by pendulous tassels attached to the hooks on the outer side of the structures. The script used here is a variation of *muhaqqaq*, penned in a way that suggests the brush strokes associated with Chinese calligraphy, and is often referred to as *sini* (Chinese) Arabic.

BL Or. MS 15256/1, ff. 55v–56

'Wahhabi' manuscript

Saudi Arabia, 1853

'Uthman ibn 'Abd Allah ibn Bishr al-Hanbali's *'Unwan al-majd fi ta'rikh al-Najd* (A History of the Najd Region from the Mid-eighteenth to Mid-nineteenth Century)

Wahhabism began as a religious and spiritual reform movement. Its founder, Muhammad ibn 'Abd al-Wahhab (1703–92), was born in the Najd, present-day Saudi Arabia. Based on the legal interpretations of Ahmad ibn Hanbal and Ibn Taymiyah, which are conservative and literal in approach, Wahhabism is puritanical in its outlook. It forbids all practices that might be considered innovations, such as the Sufi custom of venerating saints. Ibn 'Abd al-Wahhab was protected by the Najdi chieftain, Muhammad ibn Sa'ud, with whom he concluded a treaty. Over the generations his teachings became the religious force behind the formation of what is today the kingdom of Saudi Arabia. His teachings are preserved in this history of the Najd by the chronicler 'Uthman ibn 'Abd Allah ibn Bishr. This manuscript is the only known copy of his work.

BL Or. MS 7718, ff. 1v-2

Establishing the Sacred Texts

This section considers the content and development of the sacred texts, their place in religious law and their associated texts. Holy Scriptures, for both Jews and Christians, developed over centuries. For Muslims, however, it is different. The revelations, that they believe Muhammad received from God, were compiled by his followers a few years after his death, and codified definitively in the Qur'an some twenty years later by order of the third caliph 'Uthman ibn 'Affan.

Virtually all of the Jewish Bible was originally written in Hebrew; whereas the books of the New Testament are generally thought to have been written in Greek. The Hebrew Bible was translated into Greek at an early point for Hellenistic Jews. An authoritative Aramaic version, the Onkelos Targum, continued to be copied in medieval biblical manuscripts alongside the text of the Torah, as seen in the fifteenth-century Italian copy in the previous section. The Christian Bible was also translated into other vernacular languages from an early period. St Jerome's Latin Vulgate (from common or popular) was commissioned by Pope Damasus in 382 and became the standard version of the Bible in the West for over a thousand years. For Muslims, however, the Qur'an is inimitable, because it contains the actual word of God as revealed to the Prophet Muhammad in Arabic. Therefore, a translation of the Qur'an can only ever be considered an interpretation.

The Jewish Canon

A canon (from the Greek *kanon*, meaning rule) is the list of books that are recognized as authoritative by a particular religious tradition. The canon of the Hebrew Bible was determined at different periods that correspond to its three main sections. The Torah, traditionally ascribed to Moses, was apparently accepted as Scripture between the end of the Jews' exile in Babylon in 538 BC, and the separation of the Samaritans into a separate sect, probably around 300 BC. The books of the Prophets were written over time; their number seems to have been finalized by the end of the third century BC. The canon of the Writings was finally determined by rabbis in Palestine by the end of the first century, after the fall of Jerusalem to the Romans in AD 70.

The exhibition includes two early Hebrew biblical manuscripts. One is a Middle Eastern copy of the Torah in codex form that includes the most authoritative set of masoretic notes, compiled by Aaron Ben Asher (d. *c.* 960), a scholar working in Tiberias, Palestine. Printed Rabbinic Bibles are particularly important for their textual accuracy and multiple commentaries, as represented here with the second Rabbinic Bible printed by Daniel Bomberg in Venice.

Also in this section are two texts that were excluded from the Jewish canon. The canon was closed to books written after the time of the priest and reformer Ezra (fl. fifth to fourth centuries BC), and so the book of Ecclesiaticus was excluded on the basis of its date, even though it was highly regarded by early Jewish commentators. This book is a collection of moral and ethical teachings similar to those in Proverbs, and was originally compiled by Yeshua Ben Sira in the second century BC. The second of these texts is the book of Tobit, a story of piety and morality originally written in Aramaic.

The Christian Canon and Translations

Both of these books were included in the Greek Septuagint, the most influential Greek version of the Hebrew Scriptures. The term Septuagint means seventy in Latin, and is so-called from the tradition that around seventy scholars translated it in Alexandria for one of the Ptolemaic kings in the third century BC. The Septuagint contains seven books that are excluded from the canon of Jewish Scripture: Judith, the Wisdom of Solomon, Tobit, Ecclesiasticus (Sirach), Baruch, and the two books of Maccabees. These books were accepted by early Christians, who developed their canon based on the Greek rather than the Hebrew version of the Jewish Scriptures. The books remain part of Roman Catholic and Orthodox Bibles, and are called apocryphal (from *apokryphos*, hidden). However, the Protestant reformers used copies of the Jewish Hebrew canon of Scripture as the basis for their translations, and accordingly these books did not form part of Protestant Bibles.

The canon of the Christian New Testament is formed of the writings that came in the early Christian period to be recognized as inspired. Although initially there were many gospels in circulation, the four attributed to Sts Matthew, Mark, Luke and John were widely accepted as canonical from an early date. The Chester Beatty papyrus of the Four Gospels is crucial evidence of this: it demonstrates that these Four Gospels were circulating together in the form of a small booklet from at least the third century. Two of the gospels ultimately not included in the canon are also included. The Unknown Gospel, uniquely preserved in a second-century papyrus fragment, relates several of the same stories as the Four canonical Gospels in a similar historical manner. Part of the Gospel of Thomas, in a second third-century papyrus fragment, does not narrate the life of Jesus but presents a collection of his sayings.

Another approach to the text of the Four Gospels was to combine them into a single continuous narrative. The earliest version was written by the second-century author Tatian, and is known as the Diatessaron (from the Greek meaning 'through

four'). For a time it became the standard gospel text used in the Eastern church, but it was suppressed in the fifth century. The Chester Beatty Syriac copy of a commentary on the Diatessaron, which preserves portions of the text as well, is a unique survival of this alternative approach.

The New Testament canon appears to have been largely settled by the end of the third century, although uncertainty about the books of James, Hebrews, 2 John, 3 John, Jude, 2 Peter and Revelation continued. The British Library holds two of the three earliest and most important manuscripts of the combined Old and New Testaments in Greek: the fourth-century Codex Sinaiticus, and the fifth-century Codex Alexandrinus. (The third, Codex Vaticanus, is in Rome.) Codex Sinaiticus is the earliest surviving copy of the complete New Testament canon, although it also includes two non-canonical early Christian texts, an epistle ascribed to the Apostle Barnabas, and the Shepherd, by the early second-century Roman writer Hermas.

In the East, Syriac, a dialect of Aramaic, was once the principal language of Christian texts other than Greek. The Peshitta or 'simple' version of Syriac became the official translation of the Bible used by Syriac-speaking churches in the fifth century, as in the copy shown here. Another early translation is a remarkable survival: seventh-century manuscripts supposedly found in a pot buried near the pyramids at Giza. They are copies of the Acts of the Apostles, two Gospels, the Pauline Epistles and the Psalms in Coptic, the Egyptian language written in Greek letters. Armenian is another important early Christian language. Armenia adopted Christianity as its official religion in 301, the first country to do so. Two examples of the Four Gospels in Armenian are included in this section.

In the West, near the end of the fourth century, the biblical scholar St Jerome completed a new authoritative Latin translation that replaced the versions then circulating. As part of his project he completed three slightly different translations of the Psalms, including one made from the Hebrew rather than the Greek text. A twelfth-century monastic copy of the Bible from the Meuse valley is an unusual example of the inclusion of each of Jerome's three versions of the Psalms.

In the medieval period many other translations of the Christian Bible were completed, including into Church Slavonic, such as the splendid copy of the Four Gospels written for Tsar Ivan Alexander (1331–71), at the height of Bulgarian cultural and political power. In England, a paraphrase of the Old Testament in Old English was completed in the eleventh century, and vividly illustrated in the Old English Hexateuch, made in Canterbury. A unique twelfth-century Psalter from Sicily presents parallel translations of the Psalms in Greek, Latin, and Arabic, and was probably used by Arabic-speaking Christians in the royal chapel in Palermo.

Further English translations were made by several scholars in the Reformation. The translation of the New Testament by William Tyndale (c. 1494–1536) was the first to be circulated in print, but as a result of its suppression only three copies are known to survive. In contrast, the Authorized or King James Version was a royal commission, translated by around fifty scholars at the order of King James I (r. 1603–25). It was first printed in 1611 and was intended to be read in all churches. It remains the most widely published text in the English language.

Qur'ans

The Qur'ans in this section of the exhibition are all written in Arabic. One is a very early copy, written in the eighth century in the region of Hijaz that includes the holy places of Mecca and Medina. As in other ancient fragments, there are no vowel sounds or other aids to pronunciation in it, and the end of each verse is indicated by small dashes. Another important early Qur'an is written in *kufic* script (after the town of Kufa in Iraq) and uses red dots to represent the vowels of the text. A slightly later Qur'an is written in the Eastern version of this script, which coincided with the change from parchment to paper in the Islamic Near East. One of the earliest printed Qur'ans published in Europe is also included, made in Germany in the seventeenth century. The introduction in Latin demonstrates that it was intended primarily for study by Christian scholars and linguists.

Law and other texts

In Judaism, the Torah is supplemented by the Talmud (*Mishnah* and *Gemara*) which is the basis for all codes of rabbinic law. A copy of the *Mishnah* printed in Naples in 1492 was the first printed text of it in its entirety, and includes also a commentary by Moses Maimonides (1135–1204). The compilation of the Palestine (or Jerusalem) Talmud was made around the middle of the fourth century, and the more complete and authoritative Babylonian Talmud was written in around 500. An exceptionally rare manuscript copy of the Babylonian Talmud written in an Ashkenazi hand is included in this section, as well as a copy of Maimonides's code, regarded as the greatest contribution to Jewish law ever made by one individual. Rules governing Christian Church organization and practice in the Latin West were systematized by the jurist Gratian in the twelfth century. An elaborately decorated fourteenth-century copy of Gratian's compilation from Barcelona is included here.

In Islam, the most important source for determining legal decisions after the Qur'an is the Hadith, the collected traditions based on the sayings and actions of Muhammad and his followers. Two fourteenth-century collections are displayed in this section. The first is a copy of one of the most famous of the six Hadith collections, that made by Muslim ibn al-Hajjaj (817–75), a large reference work. The second is a smaller collection made in Morocco that includes the basic tenets and conduct of Islam as a work for personal reflection. Tradition suggests that to bring together forty Hadith in one compilation is itself a meritorious act. An example of a compendium of the formal legal opinions and decisions known as *fatwas* illustrates the application of this Qur'anic-based system, known as Shari'a law.

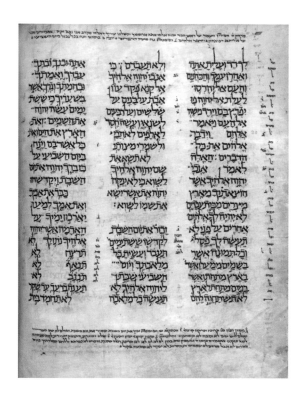

An Early Codex of the Torah

Palestine or Middle East, *c.* ninth century
Exodus 20

This manuscript is one of the oldest surviving Hebrew Bible codices (a codex is a manuscript written in book form rather than a scroll). This is an early form of the masoretic text, compiled by Aaron Ben Asher, a tenth-century scholar from Tiberias, Palestine. The *Masorah* is a body of rules of pronunciation, spelling and intonation of the biblical text, intended to preserve it and transmit it correctly. Ben Asher's text is considered to be the most authoritative version of the Hebrew masoretic Bible.

The exhibited page contains the Ten Commandments (Exodus 20), one of the earliest codes of religious and moral precepts. According to tradition, they were carved by God on two stone tablets and given to Moses on Mount Sinai some 3000 years ago. The sacred text was copied in three columns in a beautiful Hebrew vocalized (with vowels) square script. The *Masorah* was added in the margins and between the text columns in smaller unvocalized script (without vowels).

BL Or. MS 4445, f. 61v

The Dead Sea Scrolls

The Dead Sea Scrolls were found between 1947 and 1956 in eleven caves at Wadi Qumran on the northwest side of the Dead Sea. The collection comprises over 800 documents. About 85% of the texts contained in the scrolls have been identified. About 30% are of books of the Hebrew Bible, 25% extracts from other books not found in the canonical Hebrew Bible, and 30% commentaries and religious rules and regulations. Some believe that they originally belonged to a particular Jewish sect, the Essenes, but others dispute this. They are reckoned to date from the mid-second century BC to the first century AD.

Their discovery has transformed Hebrew textual scholarship. They provide a glimpse of a much earlier stage in the evolution of the Hebrew Bible, being nearly a thousand years older than the previously earliest known surviving manuscripts. Different versions of books of the Hebrew Bible were still circulating in the mid-first century AD. The book of Isaiah (the only book of the Hebrew Bible preserved in its entirety in the scrolls) shows over a thousand variants from the standard text. Remarkably at such a late date the Hebrew Biblical canon was not yet closed.

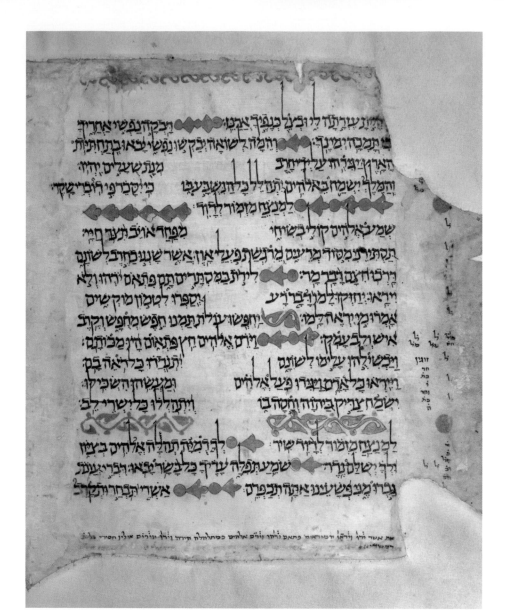

First Gaster Bible

Egypt?, ninth or tenth century
Psalm 64

The book of Psalms in this Bible was written in a single column on each page, each line being divided in two unequal halves. The book of Psalms, which comprises 150 sacred hymns, forms part of the *Ketuvim* (Writings), the third main division of the Hebrew Bible. Gilded stylized leaves, scrolls, spirals and foliage outlined in red mark the end of verses in the middle of the page. Combinations of the same motifs were used to separate each psalm, as can be seen in the fifth line from the top. Additionally, a band composed of similar decorative elements adorns the upper margin. This style of decoration was influenced by Islamic art, particularly designs and motifs found in illuminated Qur'ans. This very rare early Bible is named after its previous owner, Dr Moses Gaster (1856–1939), a scholar and spiritual leader of Sephardic Jews in London.

BL Or. MS 9879, f. 14v

Hebrew Bible

Naples, Italy, *c*.1492
Joshua 1

The book of Joshua forms part of
Nevi'im or Prophets, the second main
division of the Hebrew Bible. The panel
contains the first word *Va-Yehi* from
the verse 'Now it came to pass after
the death of Moses…' (Joshua 1:1).

The vocalized sacred text was printed
in the centre in a single column. Sur-
rounding it is a woodcut ornamental
border of a hunting scene. Winged
cherubs (one riding a stag and another
a horse), a peacock, hounds chasing
a deer and a hare, and a blank coat of
arms were engraved within an elabo-
rate foliage setting. This particularly
handsome kind of border, which draws
on embellished pages in illuminated
manuscripts, was used by both Jewish
and Christian printers in Naples at this
time. This elegant copy of the Hebrew
Bible was printed on vellum by Joshua
Solomon Soncino, one of the leading
fifteenth-century printers of Hebrew
books, and the first such to use decora-
tive material in his publications.

BL C.49.d.1, f. 126r

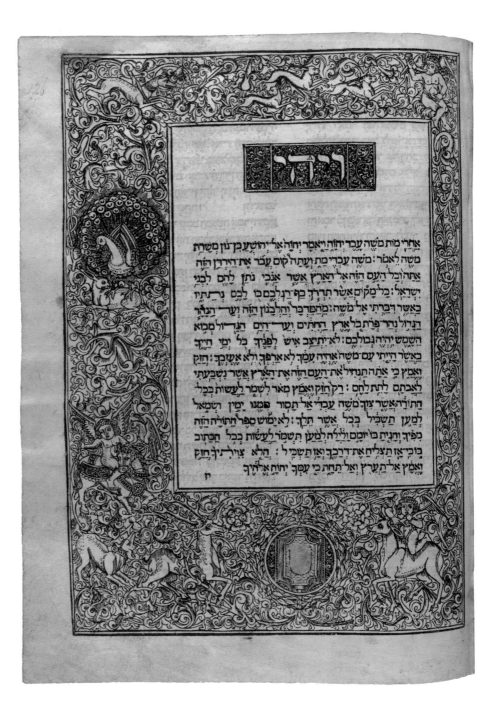

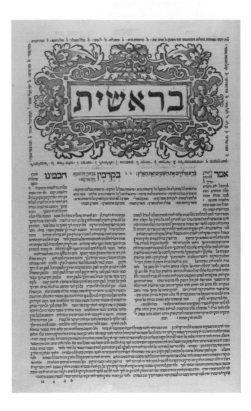

Pentateuch

Faro, Portugal, 1487
Numbers 8:1–12:16

This is the only surviving copy of the first book in any language to be printed in Portugal. These pages contain the opening of the Torah portion *Be-ha'alotekha* (Numbers 8: 1–12:16), from the verse: '…when thou *lightest* the lamps, the seven lamps shall give light in front of the candlestick…'. Its beginning (first column column on the right-hand page) is marked with *parashah*, the Hebrew word for 'portion' or 'pericope'. The Torah is divided into fifty-four portions or pericopes, with each one named after its first characteristic word(s).

The exhibited page has two justified columns of sacred text printed in a vocalized Hebrew square type. As customary in Hebrew Bibles printed before 1501, chapter, verse and folio numbers are lacking.

BL C. 49.c.1, f. 73v

The Second Rabbinic Bible

Venice, Italy, 1524–5
Genesis 1

This Bible was printed in Venice by Daniel Bomberg, who was probably the greatest sixteenth-century printer of Hebrew books. This particular edition, the first to include the *Masorah,* was edited by Abraham ben Hayim and became the standard masoretic text for all subsequent editions of the Hebrew Bible. It was consulted by the translators of the 1611 Authorized or King James English translation of the Old Testament, and by the famed biblical scholar Robert Kittel in his 1913 critical edition of the *Biblia Hebraica.*

The initial word, *Be-reshit* ('In the beginning…') is set within a decorative woodcut frame. The square surrounding it is made up of lines of masoretic notes. The inner columns contain the biblical text and the Aramaic translation attributed to Onkelos. In the outer columns are the commentaries of Rashi and Abraham Ibn Ezra, two of the greatest medieval interpreters of the Hebrew Bible.

BL Or. 73.e.20, v.1, f. 8r

Fragment from Ecclesiasticus

Cairo, Egypt, tenth to eleventh century

This fragment was a nineteenth-century discovery in the Genizah (a depository of sacred books no longer in use) from the Ben Ezra Synagogue in Cairo. It comes from Ecclesiasticus, also known as the Wisdom of Ben Sira, a non-canonical Hebrew book (i.e. excluded from the Hebrew Bible), which, until the end of the nineteenth century, was known only from references in rabbinic literature and from Greek translations. Ecclesiasticus is a collection of moral and ethical teachings, similar to the Book of Proverbs, and was originally compiled by Yeshua Ben Sira in about 180–175 BC.

In this very rare fragment the author advises his son on how to behave at a banquet, on the importance of getting a wife, and how to gain genuine friends. It was written on paper in a Persian style of Hebrew writing, with added marginal corrections and variants from another manuscript.

BL Or. MS 5518

The Book of Tobit

London, 1714

The apocryphal book of Tobit is a story of piety and morality, which was originally written in Aramaic (a language related to Hebrew) around 200 BC. The original version was lost, and the surviving Greek translation is acknowledged as the standard text. Early fragments of Tobit in the original Aramaic were discovered at Qumran (where the Dead Sea Scrolls were also found) in 1955. Latin, Syriac and later Hebrew variants of the text are also known to exist. Although the book of Tobit never formed part of the Hebrew Bible, translations of it have survived in a number of Hebrew manuscripts. Hebrew translations of Tobit appeared in print in Constantinople in 1516 and 1519, and in the Walton Polyglot Bible issued in 1653–7 in London (see page 87).

BL Harley MS 5713, f. 12r

The Chester Beatty Papyri

According to one recent assessment: 'the Chester Beatty Biblical Papryi remain the single most important find of early Christian manuscripts so far discovered and individually they have provided scholarship, and by extension the laity, with direct contact with the formative years of Christianity.' The American mining engineer, industrialist, and book collector A. Chester Beatty (1875-1968) collected this group of biblical papyri in the early 1930s, including leaves from an early copy of the Four Gospels (see opposite). This biblical papyrus is the only surviving example of the Four Gospels and Acts written on papyrus in one volume. It is also the earliest witness to the Gospel of St Mark, thought to be the first of the Four canonical Gospels to be written.

The origin of the papyri is uncertain, but they probably came from Egypt, and from the ruins of a church or monastery. Beatty acquired three papyri with portions of the New Testament in Greek, eight with portions of the Old Testament, and one with a number of non-biblical texts. All of the papyri date from between the second and fourth centuries, and may have survived because they were buried in jars for safe-keeping. Created the first honorary Irish citizen in 1957, Beatty left his Library in trust for the public and was also a generous donor to British libraries. His collection is now housed in Dublin Castle.

Four Gospels and Acts

Egypt, *c.*250
Luke 12:18–37

On its discovery in 1931, this remarkable survival became the earliest known Greek manuscript of the Four Gospels by at least 100 years. Originally comprising around 220 leaves arranged in gatherings of two leaves, the manuscript demonstrates that Christians used the book (or codex) form for their Scriptures, rather than the roll format, from an early date. The papyrus fragments also show that the Four Gospels circulated together. Most of the surviving fragments of the text consist of sections of the Gospels of Sts Luke and John, but enough of the text from the other two Gospels and Acts remains to enable the overall content and structure of the codex to be identified. The texts that they preserve reveal that there were slightly different versions of the Gospels circulating by the beginning of the third century. For example, verse 24, starting ten lines down, includes the additional words 'the birds of heaven' in the phrase 'Consider the ravens: They do not sow or reap', language that is similar to that found in St Matthew's account (6:26).

Chester Beatty Library, Dublin, Biblical Papyrus I, f. 13

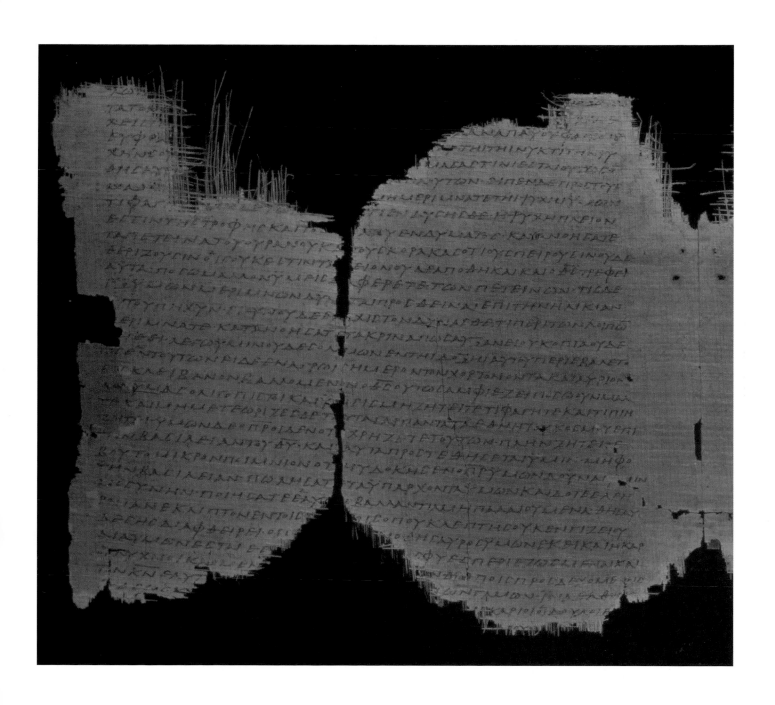

Codex Sinaiticus Project

The British Library is currently leading an ambitious international project focused on Codex Sinaiticus, the overall goal of which is to make the whole surviving Codex accessible to a global audience for the first time. Using innovative digital and web-based technology and drawing on the expertise of leading scholars, conservators, and curators from the UK, Europe, Russia, Egypt and the US, the project will reunite in virtual form all four surviving parts of the Codex, now dispersed between London, Leipzig, St Petersburg and Sinai. The Codex Sinaiticus Project encompasses four strands: conservation, digitisation, transcription and scholarly commentary, and dissemination of the work. Additionally, the British Library is coordinating research into the full history of the Codex. The results of this research will be published as part of the products of the Project. The project will be developed between 2006 and 2010 with the support of major benefactors and funders.

Codex Sinaiticus

Egypt or Palestine?, fourth century
Mark 15:16 – 16:8

Codex Sinaiticus (The Book from Sinai) is justly famous for its preservation of the earliest surviving copy of the complete New Testament, and as the earliest and best witness for some books of the Old Testament. In antiquity and textual importance it is the equal of Codex Vaticanus in Rome, and generally superior to Codex Alexandrinus (see page 68). As one of the earliest luxury codices to survive in large part, it also forms one of the most important landmarks in the history of the book. The Codex is named after the monastery of St Catherine near the foot of Mount Sinai in Egypt, where it was preserved for many centuries. Its pages are remarkable for both the layout of the text in four columns, and the density of later corrections to the main text. Shown here is the end of Mark, ending with verse 8 of chapter 16. Importantly, Codex Sinaiticus omits the final verses of Mark (16:9–20), as does the Armenian copy shown on page 74.

BL Add. MS 43725, f. 227v

ΤΗΝΠΕΙΡΑΝΚΝΕ
ΔΙΛΥCΚΟΥCΙΝΑΥ
ΠΟΡΦΥΡΑΝΚΑΙΠΕΡΙ
ΤΙΘΕΑCΙΝΑΥΤΩΠΛΕ
CΑΝΤΕCΑΚΑΝΘΙΝ
CΤΕΦΑΝΟΝ ΚΑΙΗΡ
CΑΝΤΟΑCΠΑΖΕCΘ
ΑΥΤΟΝ ΚΑΙΛΕΓΕΙΝ
ΧΑΙΡΕΒΑCΙΛΕΥ ΤΩΝ
ΙΟΥΔΑΙΩΝ
ΚΑΙΕΤΥΠΤΟΝΑΥ
ΤΟΥ ΤΗΝΚΕΦΑΛΗΝ
ΚΑΛΑΜΩ ΚΑΙΕΝΕ
ΠΤΥΟΝΑΥΤΩ ΚΑΙ
ΤΙΘΕΝΤΕCΤΑΓΟΝΑ
ΤΑ ΠΡΟCΕΚΥΝΟΥΝ
ΑΥΤΩ·
ΚΑΙΟΤΕ ΕΝΕΠΑΙCΑΝ
ΑΥΤΩ ΕΞΕΔΥCΑΝ
ΤΟΝ ΤΗΝ ΠΟΡΦΥ
ΡΑΝ ΚΑΙΕΝΕΔΥCΑΝ
ΑΥΤΟΝΤΑ ΙΜΑΤΙΑ
ΠΑΥΤΟΥ· ΚΑΙΕΞΑ
ΓΟΥCΙΝΑΥΤΟΝ Ι
ΝΑCΤΑΥΡΩCΩCΙΝ·
ΚΑΙΕΓΓΑΡΕΥΟΥCΙΝ
ΠΑΡΑΓΟΝΤΑ ΤΙΝΑ
CΙΜΩΝΑ ΚΥΡΗΝΑΙ
ΟΝ ΕΡΧΟΜΕΝΟΝ·
ΑΠ ΑΓΡΟΥ ΤΟΝ ΠΑ
ΤΕΡΑΛΕΞΑΝΔΡΟΥ
ΚΑΙ ΡΟΥΦΟΥ ΙΝΑΑ
ΡΗ ΤΟΝCΤΑΥΡΟΝ·
ΑΥΤΟΥ·
ΚΑΙΦΕΡΟΥCΙΝΑΥ
ΤΟΝ ΕΠΙΤΟΝ ΤΟΛ
ΓΟΘΑΝ Ο ΕCΤΙ
ΜΕΘΕΡΜΗΝΕΥΟ
ΜΕΝΟΝ ΚΡΑΝΙΟΥ
ΤΟΠΟC
ΚΑΙΕΔΙΔΟΥΝΑΥΤ
ΕCΜΥ ΡΝΙCΜΕΝ
ΟΙΝΟΝΟCΔΕΟΥΚ
ΛΑΒΕΝ
ΚΑΙCΤΑΥΡΟΥCΑΝΤΕC
ΑΥΤΟΝ ΔΙΑΜΕΡΙΖ
ΤΑΙ ΤΑ ΙΜΑΤΙΚΙΑ ΑΥ
ΤΟΥ ΒΑΛΛΟΝΤΕC

ΚΛΗΡΟΝ ΕΠ ΑΥΤΑ
ΤΙCΤΙΑΡΗ·
ΗΝΔΕΩΡΑΤΡΙΤΗΚ
ΕCΤΑΥΡΩCΑΝΑΥ
ΤΟΝ·
ΚΑΙΗΝΗΕΠΙΓΡΑΦΗ
ΤΗCΑΙΤΙΑCΑΥΤΟΥ
ΕΠΙΓΕΓΡΑΜΜΕΝΗ·
ΟΒΑCΙΛΕΥCΤΩΝΙ
ΟΥΔΑΙΩΝ·
ΚΑΙCΥΝΑΥΤΩCΤΑΥ
ΡΟΥCΙΝΛΥΟΛΗCΤΑ
ΕΝΑΕΚΔΕΞΙΩΝ ΚΑΙ
ΕΝΑΕΞΕΥΩΝΥΜΩΝ
ΑΥΤΟΥ
ΚΑΙΟΙΠΑΡΑΠΟΡΕΥ
ΟΜΕΝΟΙΕΒΛΑCΦΗ
ΜΟΥΝΑΥΤΟΝ ΚΙ
ΝΟΥΝΤΕCΤΑCΚΕ
ΦΑΛΑCΑΥΤΩΝΚ
ΛΕΓΟΝΤΕCΟΟΥΧΟ
ΚΑΤΑΛΥΩΝ ΤΟΝ
ΝΑΟΝ ΚΑΙΕΝΤΡΙ
CΙΝΗΜΕΡΑΙCΟΙΚΟ
ΔΟΜΩΝ ΟCΩCΟΝ
CΕΑΥΤΟΝ ΚΑΤΑ
ΒΑΑΠΟΤΟΥCΤΑΥ
ΡΟΥ
ΟΜΟΙΩCΚΑΙΟΙΑΡ
ΧΙΕΡΕΙCΕΜΠΑΙΖΟ
ΤΕCΠΡΟCΑΛΛΗΛΥ
ΜΕΤΑΤΩΝΓΡΑΜ
ΜΑΤΕΩΝ ΕΛΕΓΟΝ·
ΑΛΛΟΥCΕCΩCΕΝ
ΕΑΥΤΟΝΟΥΔΥΝΑ
ΤΑΙCΩCΑΡΟΧC
ΟΒΑCΙΛΕΥCΙCΡΑΗΛ
ΚΑΤΑΒΑΤΩΝΥΝ
ΑΠΟΤΟΥCΤΑΥΡΟΥ
ΙΝΑΙΔΩΜΕΝ ΚΑΙ
ΠΙCΤΕΥCΩΜΕΝ
ΚΑΙΟΙCΥΝΕCΤΑΥ
ΡΩΜΕΝΟΙCΥΝΑΥ
ΤΩΝΕΙΔΙΖΟΝΑΥ
ΤΟΝ
ΚΑΙΓΕΝΟΜΕΝΗCω
ΡΑCΕΚΤΗCΟCΚΟ
ΕΓΕΝΕΤΟCΚΟΤΟC

ΤΗΝΓΗΝΕΩCΩΡΑ
ΕΝΑΤΗC
ΚΑΙΤΗ ΕΝΑΤΗΩΡΑ
ΕΒΟΗCΕΝΟΙCΟΦ
ΝΗ ΜΕΓΑΛΗ ΕΛΩΙ
ΕΛΩΙΛΕΜΑCΑΒΑΚΤΑ
ΝΕΙ ΟΕCΤΙΝΜΕΘΕΡ
ΜΗΝΕΥΟΜΕΝΟΝ
ΟΘCΟΥ ΟΘCΟΥ
ΕΙCΤΙ ΕΚΑΤΕΛΙΠΕC
ΜΕ
ΚΑΙΤΙΝΕCΤΩΝΠΑ
ΡΕCΤΩΤΩΝΑΚΟΥ
CΑΝΤΕCΕΛΕΓΟΝ·
ΙΔΕΗΛΕΙΑΝΦΩΝΕΙ·
ΔΡΑΜΩΝΔΕΤΙCΚΑΙ
ΓΕΜΙCΑCCΠΟΓΓΟΝ
ΟΞΟΥCΠΕΡΙΘΕΙCΚΑ
ΛΑΜΩ ΕΠΟΤΙΖΕΝ
ΑΥΤΟΝΛΕΓΩΝΑ·
ΦΕCΙΔΩΜΕΝΕΙΕΡ
ΧΕΤΑΙΗΛΕΙΑCΚΑΘΕ
ΛΕΙΝΑΥΤΟΝ·
ΟΔΕΙCΑΦΕΙCΦΩΝΗ
ΜΕΓΑΛΗΝΕΞΕΠΝΥ
CΕΝ·
ΚΑΙΤΟΚΑΤΑΠΕΤΑCΜ
ΤΟΥΝΑΟΥΕCΧΙCΘΗ
ΕΙCΔΥΟΑΠΟΑΝΩ
ΘΕΝΕΩCΚΑΤΩ·
ΙΔΩΝΔΕΟΚΕΝΤΥΡ
ΩΝ ΟΠΑΡΕCΤΗΚ
ΕΞΕΝΑΝΤΙΑCΑΥΤΟΥ
ΟΤΙΟΥΤΩCΕΞΕΠΝΥ
CΕΝ ΕΙΠΕΝ ΑΛΗΘΩ
ΟΥΤΟCΟ ΑΝΟCΟΥΙ
ΥΙΟCΟΥ ΗΝ
ΗCΑΝΔΕ ΚΑΙΓΥΝΑΙ
ΚΕC ΑΠΟΜΑΚΡΟΘΕ
ΘΕΩΡΟΥCΑΙ ΕΝ ΑΙC
ΚΑΙ ΜΑΡΙΑΗΜΑΓΔΑ
ΛΗΝΗ ΚΑΙ ΜΑΡΙΑΗ
ΙΑΚΩΒΟΥΤΟΥΜΙ
ΚΡΟΥ ΚΑΙΙΩCΗΜΗ
ΤΗΡΚΑΙCΑΛΩΜΗ
ΑΙ ΟΤΕΗΝΕΝΤΗΓΑ
ΛΕΙΛΑΙΑ ΗΚΟΛΟΥΘΟΥ
ΑΥΤΩ ΚΑΙΔΙΗΚΟΝΟΥ

ΝΟΥΝΑΥΤΩ ΚΑΙ
ΑΛΛΑΙΠΟΛΛΑΙΑΙCΥ
ΑΝΑΒΑCΑΙΑΥΤΩ ΕΙC
ΙΕΡΟCΟΛΥΜΑ·ΗΔΗ
ΚΑΙΗΔΗΟΨΕΙΑCΓΕ
ΝΟΜΕΝΗCΕΠΕΙΗΝ
ΠΑΡΑCΚΕΥΗ ΟΕ
CΤΙΝΠΡΟCΑΒΒΑΤ
ΕΛΘΩΝΙΩCΗΦ
ΟΑΠΟΑΡΕΙΜΑΘΧΙΑ
ΕΥCΧΗΜΩΝΒΟΥ
ΛΕΥΤΗCΟCΚΑΙΑΥΤ
ΗΝΠΡΟCΔΕΧΟΜ
ΝΟCΤΗΝΒΑCΙΛΕΙ
ΑΝΤΟΥΘΥ ΤΟΛΜΗ
CΑCΕΙCΗΛΘΕΝΠΡC
ΤΟΝΠΕΙΛΑΤΟΝ ΚΑΙ
ΗΤΗCΑΤΟΤΟCΩΜΑ
ΤΟΥΙΥ
ΟΔΕΠΕΙΛΑΤΟCΕΘΑΥ
ΜΑΖΕΝΕΙ ΗΔΗ ΤΕ
ΘΝΗΚΕΝ ΚΑΙΠΡΟC
ΚΑΛΕCΑΜΕΝΟCΤΟ
ΚΕΝΤΥΡΙΩΝΑ ΕΠΗ
ΡΩΤΗCΕΝ ΑΥΤΟΝ
ΕΙΠΑΛΑΙΑΠΕΘΑΝΕΝ
ΚΑΙΓΝΟΥCΑΠΟΤΟΥ
ΚΕΝΤΥΡΙΩΝΟCΕ
ΔΩΡΗCΑΤΟΤΟΠΤΩ
ΜΑΤΩΙΩCΗΦ·
ΚΑΙΑΓΟΡΑCΑCCΙΝ
ΝΑ ΚΑΘΕΛΩΝΑΥ
ΤΟΝ ΕΝΕΙΛΗCΕΝΤΗ
CΙΝΔΟΝΙ ΚΑΙΕΘΗ
ΚΕΝΑΥΤΟΝ ΕΝΜΝΗ
ΜΑΤΙΩΗΝΛΕΛΑΤ
ΜΗΜΕΝΟΝ ΕΚΠΕ
ΤΡΑC ΚΑΙΠΡΟCΕΚΥ
ΝCΕΝΛΙΘΟΝΕΠΙ ΤΑ
ΕΠΙ ΤΗΝ ΘΥΡΑΝ ΤΟ
ΜΝΗΜΕΙΟΥ
Η ΔΕ ΜΑΡΙΑ ΗΜΑΓΔΑ
ΛΗΝΗ ΚΑΙ ΜΑΡΙΑΗΙ
ΙΑΚΩΒΟΥ ΚΑΙΙΩCΗ
ΜΗΤΟΡ ΑCΙΑΥ
ΜΑΤΑΙΔΕΛΑΡΟΙΤ
ΕΑΙ ΜΑΤΕΘΕΙΝΑΥ
ΤΟΝ

ΗΔΕCΑΒΒΑΤΟΜΕΓΑΛΗΕΝΕΙΟCΟΛΗΜΑΙΑΗΩCΘ
ΤΟCΕΘΕΡΩΝΙΜΩΡΑCΑΠΟΥΤΗΚΜΩΝΑΓΑΤΝΟΜΟC
ΝΟΥΤΟΥCΕCΕΛΛΟΥ

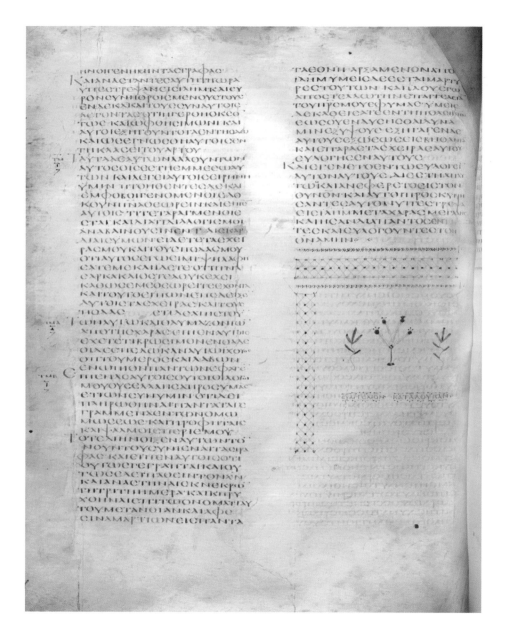

Codex Alexandrinus

Constantinople or Asia Minor, fifth century
End of Luke

Codex Alexandrinus is one of the three earliest and most important manuscripts of the entire Bible in Greek, the others being Codex Sinaiticus (see page 66) and Codex Vaticanus in Rome. It is therefore of enormous importance in establishing the biblical text. It is also one of the earliest books to employ significant decoration to mark major divisions in the text. On the left-hand exhibited page the end of the Gospel of St Luke is marked by a tailpiece (distinctive ornamental panel) with stylised decoration. Similar tailpieces accompany the titles of each of the books of the Bible throughout the manuscript. The codex is named after the capital of Greek Egypt, Alexandria, where it formed part of the patriarchal library at the beginning of the fourteenth century, although its origin is unknown. In 1627 Cyril Lucar, Patriarch of Constantinople and a former Patriarch of Alexandria, presented the codex to King Charles I.

BL Royal MS 1 D VIII, f. 41v

Fragment of a Greek roll

Egypt, third or fourth century
Revelation 1: 4–7

Unearthed in the rubbish tips of the
ancient city of Oxyrhynchus (south of
Cairo), this fragment from a papyrus
roll includes one of the earliest copies
of part of the book of Revelation. It
was apparently written by an early
Christian living in Middle Egypt, who
reused a papyrus roll of the Greek text
of the book of Exodus and wrote on its
blank reverse. Although the roughness
of his script tells us that he was not a
professional book producer, its clarity
suggests that he intended his manu-
script to be read by others, presumably
other members of a Christian commu-
nity. It is possible that he was a Jewish
convert to Christianity, who had
available a family copy of the Old
Testament. This fragment includes St
John's opening greeting to the seven
churches in Asia.

BL Papyrus 2053 verso

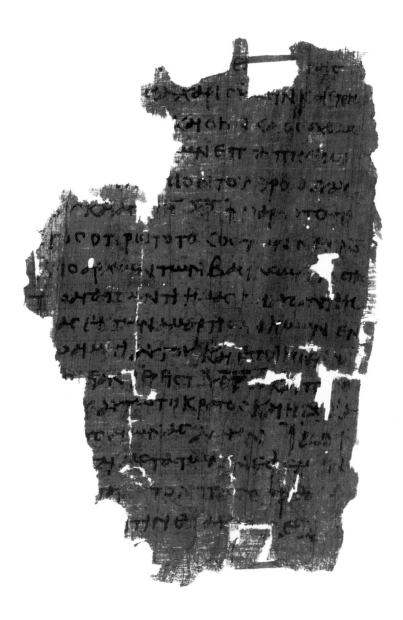

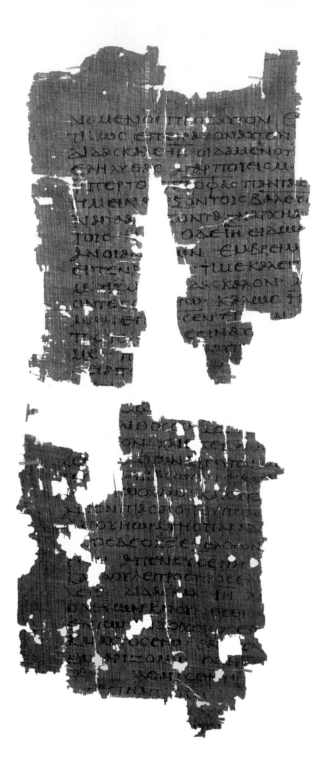

The Egerton Gospel

Egypt, first half of the second century
Fragments of an unknown gospel

These fragments from a papyrus codex are parts of one of the two earliest surviving Christian books. Together with a small portion now in Cologne, they form all of what is currently known of the so-called Unknown Gospel. This text relates several of the same stories as the Four canonical Gospels in a similar historical manner. It is unmarked by the heretical doctrines and sensationalism typical of many non-canonical Christian writings, and appears to be a very early elaboration on the Gospel story. The text in the lower fragment corresponds with passages in chapters 8 and 10 in St John's Gospel. On the reverse it relates the story of Christ's healing of the leper in words that diverge significantly from the accounts found in the Gospels of Sts Matthew, Mark and Luke, and includes a mysterious passage that is without parallel in the canonical Gospels.

BL Egerton Papyrus 2 recto

Gospel of Thomas

Oxyrhynchus, Egypt, third century
Preface and Sayings of Jesus

This fragment from a papyrus roll preserves the beginning of a collection of Christ's sayings, known as the Gospel of Thomas, in the original Greek text. A full Coptic version was discovered at Nag Hammadi, Egypt, in 1945–6. Unlike the canonical Gospels, the Gospel of Thomas does not relate events in Jesus's life, but comprises a collection of 114 sayings of Jesus, perhaps as the first attempt at recording part of an oral tradition. Some of these sayings are close to those found in the canonical Gospels, while others are new and obscure. The opening words, as reconstructed from the present fragment, are 'These are the secret sayings which Jesus the Living spoke and Didymus Judas Thomas wrote'. Each saying is marked by a *paragraphus* (horizontal line). These sayings are associated with the Gnostics sects who believed that salvation could be attained by *gnosis* or knowledge, as is the 'Faith of Wisdom' text on the following page.

BL Papyrus 1531 verso

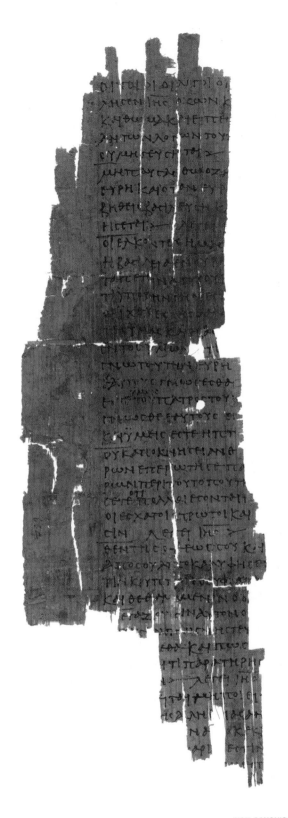

The Askew Codex

Egypt, fourth(?) or seventh(?) century
The Faith of Wisdom ('Pistis Sophia')

The *Pistis Sophia* is an important Gnostic text, in which the structure and hierarchies of heaven are revealed through the teaching of the risen Jesus Christ. The text asserts that Jesus remained on earth after his Resurrection for eleven years, and during this time was able to teach his disciples certain mysteries. It takes the form of a question and answer dialogue between Jesus, the disciples and St Mary Magdalene, and is dominated by Christ (who is the incarnation of the Gnostic saviour) and Sophia (the female personification of divine wisdom.) This rare copy – the best-known of the five surviving copies – was discovered in 1733 in Egypt, and is written in Sahidic Coptic, the language spoken in Upper Egypt at the time of Christ.

BL Add. MS 5114, ff. 72v-73

A Gospel Harmony

Syria, *c.*490–510

*Commentary of St Ephraim (Ephrem)
on the Diatessaron of Tatian*

The second-century Christian Tatian
composed the Diatessaron (from the
Greek meaning 'through four'),
combining the Four Gospels into a
single narrative account. It became, for
a time, the standard Gospel text used
in the liturgy in Eastern churches as an
alternative to the use of the different
accounts of the Four Gospels of
Sts Matthew, Mark, Luke and John.
However, it was suppressed in the fifth
century; for example, Rabula, the
Bishop of Edessa (r. 411–35), ordered
that every church should have a copy
of the separate Gospels, and more than
200 copies of the Diatessaron were
removed from Cyprus by Bishop
Theodoret (r. 423–57). Consequently,
no complete copy of it in Syrian has
survived. However, substantial
quotations from it are preserved in this
commentary, written by St Ephraim,
a Syrian teacher (*c.*306–73). This copy
almost certainly comes from the Coptic
monastery of Deir es-Suriani in Wadi
Natrun, Egypt.

Chester Beatty Library, Dublin, Syriac MS 709, f. 42

The Four Gospels
in Armenian

Armenia, ninth to tenth centuries
Mark 16:1–8; Luke

At the beginning of the fourth century, Armenia became the first nation to adopt Christianity officially. The first book to be translated into Armenian was the Bible, which is known as *Astuadsashuntch*, or 'breath of God'. It was translated by two scholars, the Patriarch-Catholicos St Sahak (*c.*350–439) and his helper Mesrop Mashtots (*c.*361–439). This copy of the Four Gospels is an early surviving example of that translation. It is also important because, like Codex Sinaiticus (see pages 67-8) and like all Armenian manuscripts before the thirteenth

century, it omits the so-called 'longer ending' of Mark, or verses 9–20 of chapter 16. However, the decision to leave out these verses in this manuscript seems to have been a variation from the original plan, for the scribe has spread and spaced out verses seven and eight to fill an entire column, visible on the left of the image. This space must originally have been planned for the remaining verses of the chapter.

BL Add. MS 21932, ff. 118v-119

The Four Gospels in Armenian

New Julfa, Isfahan, 1587
God Creating Eve

The inscription in the image describes
the moment in the Creation story,
when God creates Eve from the side
of Adam. The full figure of God
dominates the picture placed in an
architectural setting, depicting the
moment when He caused Adam to fall
into a deep sleep, took one of his ribs
and 'made a woman from the rib'
(Genesis 2:22). God is holding Eve
with one hand and blessing with the
other, while Adam on the right of the
frame stands with head reclining for-
ward, eyes shut, hands clasped, and his
cloak lifted slightly exposing his legs
and ribs. The sources of the four rivers
of paradise – Pishon, Gihon, Tigris, and
Euphrates are represented in the lower
margin. The artist Hakob Jughayetsi
(of New Julfa, Isfahan, 1550–1613) has
prefaced the cycle of Gospel pictures
representing the main events in the
life of Christ with images depicting the
story of the Creation, as if to emphasise
the link between the Old and the New
Covenants, and the Old and New
Testaments.

John Rylands University Library, Manchester,
MS Arm.20, f.9

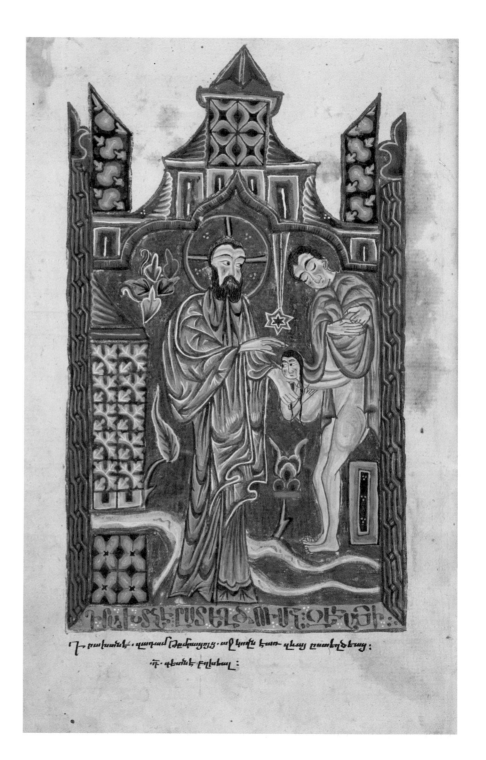

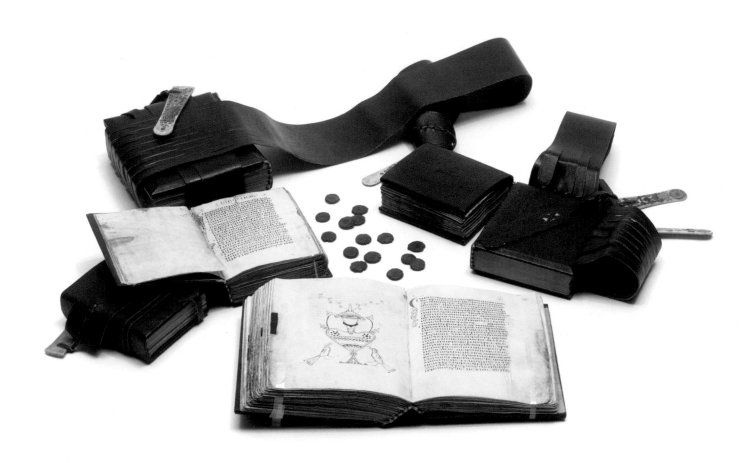

The Bible in Coptic

Egypt, early seventh century
Acts, Pauline Epistles, Gospels of John and Matthew, and the Psalms

By tradition, St Mark brought Christianity to Egypt around the middle of the first century. The Coptic language, derived from the Greek word for Egypt, is written in a modified form of the Greek alphabet. It was one of the first languages into which the New Testament was translated, as early as the second century. These manuscripts in Coptic are said to have come from a pot found buried near the pyramids at Giza. The texts are in near perfect condition and must hardly have been used before their burial. They are dated, in part, by the coins that were found with them, the latest of which are those of the Emperor Maurice Tiberius (r. 582–602). Their burial may have been made for safekeeping during the Persian occupation of Egypt (*c.* 616–26), when many Coptic clergy fled from the invaders.

Chester Beatty Library, Dublin, Coptic MSS 813, 814, 815; CBL Cpt 815.5.1-15

The Bible in Syriac

Amid, Turkey, 463/4
Genesis 29:25–30:2

Syriac is the dialect of Eastern Aramaic
that was spoken in the early Christian
period in the principality of Edessa,
which corresponds to present day
northern Syria and Iraq, and southern
Turkey. It is written in the same
alphabet of twenty-two consonants as
Hebrew, but also with characters of its
own. The earliest Syriac books were
biblical translations, and it has been
debated whether one or more of the
Four Gospels was originally composed
in Syriac. The Peshitta or 'simple'
version became the official translation
used by Syriac Churches in the fifth
century. This important copy of the
first five books of the Bible is in this
version, and was signed and dated by
its scribe John the deacon writing
at Amid, the seat of a bishop (now
Diyarbakir in eastern Turkey). It is the
oldest known copy of part of the Bible
dated by its scribe.

BL Add. MS 14425, f. 31

'Old Latin' Genesis

North Africa or Italy, fifth century
Genesis 5: 29 – 6:2

This is a great rarity. Together with only a few other manuscript fragments and some quotations embedded in early writings of Fathers of the Church, this fragment provides an insight into the content of the 'Old Latin' Bible that was in circulation in the early Christian era. Whereas the Latin versions of the New Testament made before St Jerome's translation survive in many manuscripts, early versions of the Old Testament appear to have been replaced, as intended, by St Jerome's translation. The present fragment probably formed part of a parchment manuscript of the first five or eight books of the Bible. Within its short text, the ages given for Lamech, son of Methuselah, agree with Greek manuscripts of the Septuagint, indicating that it was probably a translation from this Greek translation rather than from the Hebrew text.

BL Papyrus 2052 recto

Vulgate Gospels

Northern Italy, sixth century
Mark 1

St Jerome's translation is known as the Vulgate (from the Latin *vulgata*, meaning 'common' or 'popular'). Although this manuscript retains elements of the previous 'Old Latin' translation, it forms one of the earliest surviving copies of St Jerome's Vulgate. It shows the continuing efforts of the Church to replace the many earlier Latin versions of the Bible with one authorized version. In addition to the Four Gospels, this manuscript contains probably the earliest complete set of the canons compiled by Eusebius, Bishop of Caesarea, in the first half of the fourth century. These Canon tables formed a vital aid to readers who wished to locate parallel passages within the Gospels. The letters and Roman numerals in the left margin refer the reader to the tables, and to parallel passages in the other Gospels.

BL Harley MS 1775, f. 144

The Floreffe Bible

Meuse valley, southern Netherlands, mid or third quarter of the twelfth century
Psalms 1-2

In 382 Pope Damasus commissioned the scholar St Jerome to prepare a new authoritative text that could replace the various 'Old Latin' versions of the Bible. As part of his project to complete a new Latin translation, St Jerome prepared three slightly different translations of the Psalms. In 384 he completed a first translation from the Greek text of the Old Testament, the Septuagint. This version is known as the *Romanum* translation, and was soon replaced by St Jerome's later translations, except in England, where it continued to be used up to the Norman Conquest. St Jerome's second revision, completed between 386 and 391, is known as the *Gallicanum*. This quickly became the standard version of the text. Finally, between 391 and 393 St Jerome produced a translation directly from the Hebrew, the *Hebraicum*. In this large Bible, made for the Premonstratensian abbey of Floreffe (part of an order of canons found at Prémontré), each of the versions is presented in parallel columns of text. It is one of a small group of large 'triple Psalters', many produced in a scholarly milieu. The abbreviated headings identifying the different versions are apparent in the upper margin.

BL Add. MS 17738, f. 14

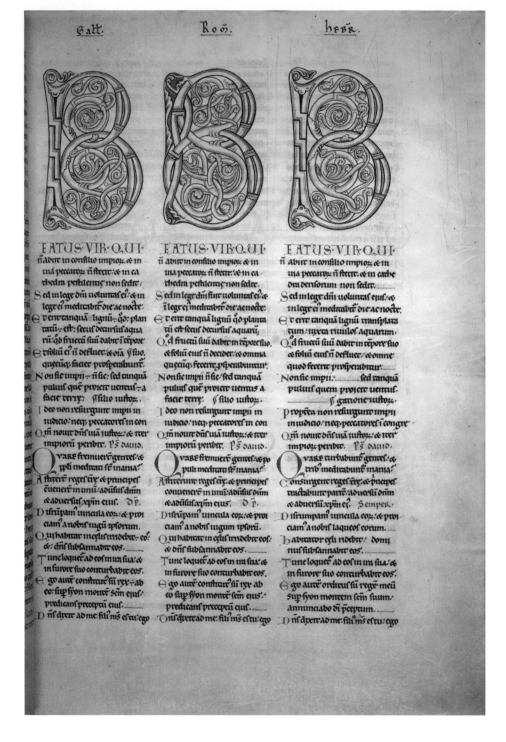

The Gospels of Tsar Ivan Alexander

Turnovo?, Bulgaria, 1355–56
Last Judgment

This manuscript is the most celebrated surviving example of Bulgarian medieval art, and contains a remarkable sequence of 366 illustrations of the life and teachings of Jesus. According to a long inscription at its end, the volume was copied in 1355–56 by a monk named Simeon, and was encased in a binding encrusted with precious stones. Simeon wrote that it was created 'not simply for the outward beauty of its decoration…[but] primarily to express the inner Divine Word, the revelation and the sacred vision', and that it was 'illuminated with the life-giving images of the Lord and His glorious disciple Jesus'. It was commissioned by Tsar Ivan Alexander (1331–71), and the adoption of a Byzantine imperial model for its decoration may have been a deliberate aesthetic choice to promote Bulgarian imperial ambitions. Simeon compares the translation of the Gospels into 'our own Slavonic language' with the discovery of the Cross by Constantine's mother, Helena. In the lower left-hand corner is the figure of the Tsar interceding with St Mary, the mother of Jesus.

BL Add. MS 39627, f. 124

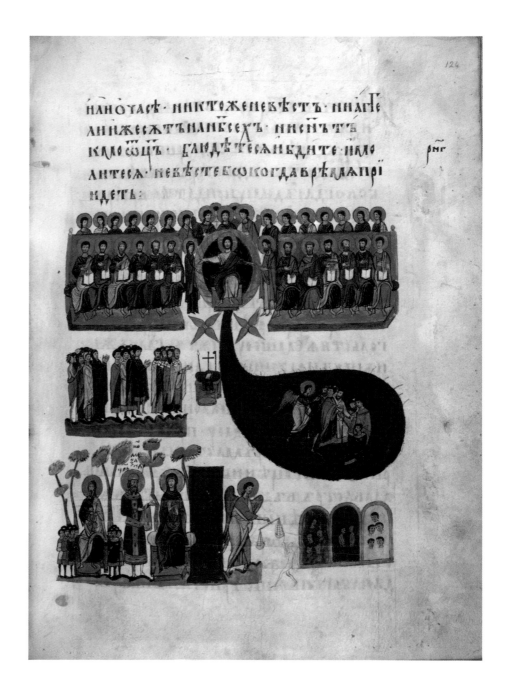

The Harley Trilingual Psalter

Palermo, Italy, between 1130 and 1154
Psalm 81 (80)

When this manuscript was produced, the court of the Norman king of Sicily, Roger II (r. 1130–54), formed a crossroads at which Greek, Latin and Arabic cultures met. The Psalter with its parallel texts was probably used at the royal chapel in Christian services that included converts from Islam. Many of the major Latin Psalm divisions have marginal comments in Arabic, as here, which marks this Psalm as that to be said on Fridays, corresponding to the Latin divisions of the Psalms to be read for that day. The Greek text is taken from the Septuagint (the Greek version of the Hebrew Bible adopted by Christians), and the Latin is the Gallican translation of St Jerome. The Arabic translation of the Psalms was made from the Greek by a deacon of the Melkite Church of Antioch (a Byzantine Eastern Orthodox church), Abu'l-Fath 'Abdall-h ibn al-Fadl ibn 'Abdall-h al-Mutr-n al-Antaki, in the eleventh century.

BL Harley MS 5786, f. 106v

The Four Gospels in Coptic and Arabic

Nitria, Egypt, 1308
Matthew 1

An incomplete manuscript of the Four Gospel in Bohairic, the dialect predominant in the Wadi-al-Natrum and several monasteries, such as the Red Sea monasteries and the White monastery near Sohag, plays an important role in the preservation of the Coptic heritage. Bohairic is the only dialect that continues to be used today as the liturgical language of the Coptic Orthodox Church. The Bible was translated into Coptic by the second half of the third century, from Greek. The earliest manuscript copies of the Four Gospels in Arabic date from the late eighth or ninth centuries, and were made from a variety of languages, including Syriac, Greek and Coptic. Perhaps the oldest dated Arabic copy of the Four Gospels is in the library at Mount Sinai, dated 859. In this bilingual Coptic-Arabic copy of the Four Gospels, the Arabic is presented in a parallel column to the right of the Coptic text.

BL Or. MS 425, f.8

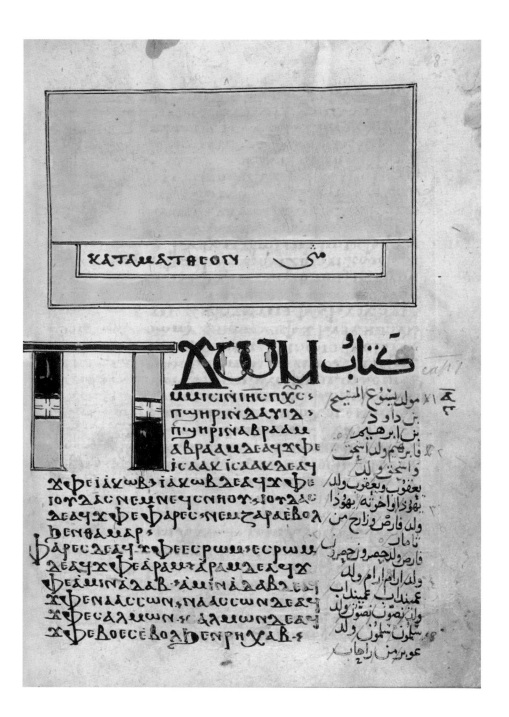

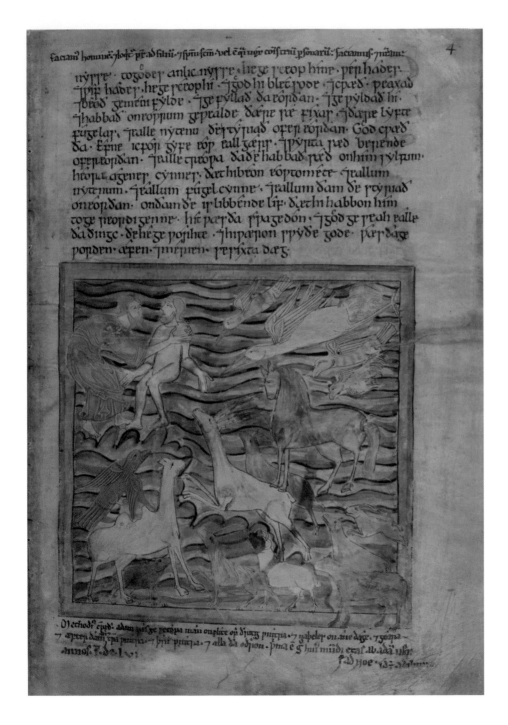

The Old English Hexateuch

Canterbury, England, first half of the eleventh century
Adam naming the animals

As the earliest copy in English of part of the Old Testament and with over 400 illustrations, this manuscript is both remarkable and unique. Its Old English versions of Genesis, Exodus, Leviticus, Numbers, Deuteronomy and Joshua are partly the work of the Benedictine monk Aelfric (d. 1020). His scholarly paraphrases of the first books of the Old Testament were undertaken in the late tenth century and aimed to offer the layperson an insight into the sacred text of the Vulgate. The dominance of the vivid illustrations may indicate that this copy was commissioned for a layperson. Here God instructs Adam to give names to the animals, illustrating Genesis chapter 2.

BL Cotton MS Claudius B IV, f. 4

Tyndale New Testament

Worms, Germany, 1526
John 1

Although numerous partial and complete English translations of the Bible existed, the one by the scholar William Tyndale (*c.*1494–1536) was the first to be widely distributed in print. It was based on Erasmus's Greek New Testament and Luther's German translation. In 1523 Tyndale applied to the Bishop of London for permission to print the New Testament in English. Having been refused, Tyndale left for Germany, where his translation was printed in Worms in 1526. Copies were smuggled into England and Scotland in bales of cloth, and quickly circulated. However, the work was condemned equally quickly by the Bishop of London as 'in the English tongue, that pestiferous and moste pernicious poyson dispersed throughout all our dioces of London in great nomber' – and the bishop himself preached a sermon condemning its errors at a public burning of copies at St Paul's Cathedral. As a result of its systematic destruction, this is one of only three copies of the small book known to survive.

BL C 188.a.17, f. cviv

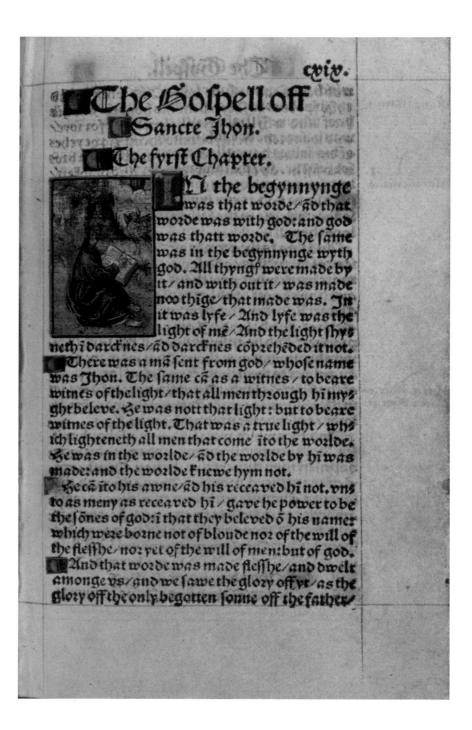

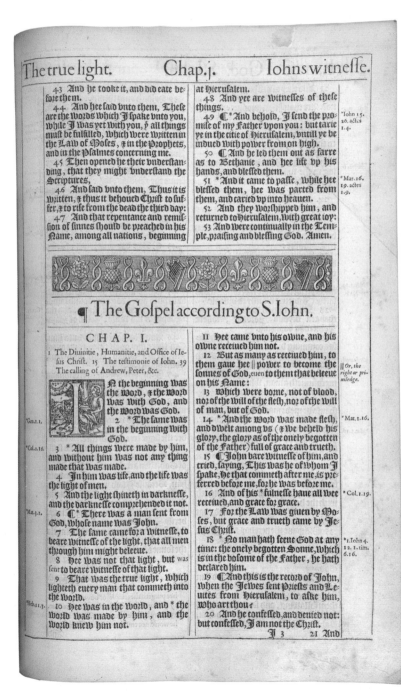

King James Bible

London, England, published by
Robert Barker, 1611
John 1

The King James or Authorized Version of the Bible remains the most widely published text in the English language. It was the work of around fifty scholars, who were appointed in 1604 by King James (r. 1603–25), and dedicated to him. The committee drew on many sources, including Tyndale's New Testament (on the previous page). They commented: 'Truly, we never thought, from the beginning…that we should need to make a new translation, nor yet to make of a bad one a good one; but to make a good one better, or out of many good ones, one principal good one.' It was first printed in 1611, and was 'appointed to be read in churches'. For this purpose, it was published in a large format, suitable for public use, and without illustrations. The use of the antiquated 'black letter' font was intended to add status and authority to the new version.

Walton Polyglot Bible

London, published by Thomas Roycroft 1654–57
Samuel I:31 and Samuel II

The page on the left shows the end of Samuel I, chapter 31 and beginning of Samuel II. The parallel columns outlined in red contain from left to right: Hebrew with a linear Latin translation, the Latin Vulgate, and the Greek version with Latin translation. Right beneath are the Aramaic version in Hebrew characters (Targum Jonathan), and its Latin rendition. On the facing page are the Syriac and Arabic variants of the same texts, with their respective Latin translations.

Polyglots were used for studying the history of the biblical text and its interpretation. The earliest known biblical polyglot contained six variants and was compiled by Origen around the second century. Issued in six volumes between 1654 and 1657, the Walton Polyglot comprises nine languages, although no single biblical book was printed in all

nine. These are: Hebrew, Greek, Samaritan, Aramaic, Latin, Syriac, Ethiopic, Arabic and Persian. Brian Walton engaged a team of erudite contemporary scholars, such as Edmund Castell and Edward Pococke to aid him in his task.

Considered as the last and most scholarly ever printed, the Walton Polyglot was the second book in England to be published by subscription. The editor Brian Walton managed to raise £9000 for its production by asking for down-payments of £10 per set. The Polyglot was originally dedicated to Oliver Cromwell, but since he died during printing, it was subsequently dedicated to King Charles II. Copies including the 'republican' and the 'royal' prefaces have survived.

BL Or.72.d.1. Vol.2, pp. 308–9

One of the Earliest Qur'ans in the World

Arabia, Mecca or Medina, eighth century
Chapter 26, *al-Shu'ara'* (The Poets), verse 183 to Chapter 27,
al-Naml (The Ant), verse 3

To the best of our knowledge, this Qur'an was produced in
the Hijaz region, which includes the holy places of Mecca and
Medina. The text is penned on parchment in an early style
of Arabic script called *ma'il*, one of a number of early Arabic
scripts collectively named 'Hijazi' after the region in which
they were developed. The word *ma'il* itself means 'sloping', in
this case to the right. It is also notable for its lack of diacritical
marks, the spelling symbols that distinguish between letters of
similar shape. In this Qur'an, as in other ancient fragments,
there are no vowel signs or other aids to pronunciation,
and the end of each verse is indicated by six small dashes in
two stacks of three. The chapter heading in red ink has been
added later in *naskhi* script, and differs from the rest of
the text.

BL Or. MS 2165, ff. 76v–77

An Early Kufic Qur'an

Near East, probably ninth century
Chapter 29, *al-'Ankabut* (The Spider), verses 24–25 (on the
right); Chapter 31, *Luqman*, verses 22–25 (on the left)

As demonstrated in early ninth- and tenth-century Qur'ans
written in *kufic* script, the choice of script can have a major
influence on the shape of the volume. With its very short
vertical and elongated horizontal strokes, the *kufic* style is
certainly suited to the oblong format of Qur'ans produced
in the Near East. This strikingly angular script takes its name
from the town of al-Kufah in southern Iraq, which was one
of the earliest centres of Islamic learning, and where the
script probably developed. *Kufic* Qur'ans of the ninth and
tenth centuries were written on parchment and characterized
by the use of red dots to represent the vowels of the text, and
short black diagonal strokes to distinguish different letters
of similar shapes. In this Qur'an green dots denote the letter
hamzah (the glottal stop); gold ornaments mark the end of
each verse.

BL Or. MS 1397, ff. 18v–19

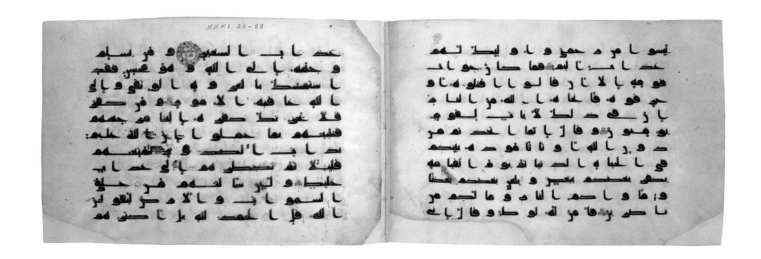

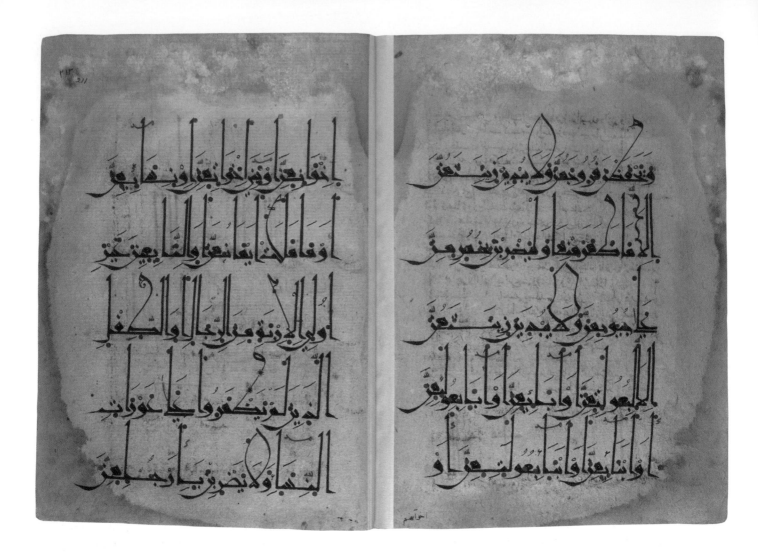

An Eastern Kufic Qur'an

Iraq or Persia, eleventh or twelfth century
Chapter 24, *al-Nur* (Light), verse 31

Eastern *kufic* script, first developed by the Persians, is characterized by long upright strokes and short strokes inclining to the left. Specific styles were evolved within eastern *kufic*, such as the 'Qarmatian' used here in this Qur'an. The name of this style is possibly derived from the Arabic verb *qarmata* which suggests that the script should be finer and the letters closer together. The appearance of eastern *kufic* coincided with the change from parchment to paper in the Islamic Near East, and also with the reappearance of the vertical format, thus underlining the relationship between the physical shape of the volume and the script of the manuscript. In this Qur'an red dots indicate vowels; the other spelling symbols represent a later system of vocalizing that is still in use today.

BL Or. MS 6573, ff. 210v–211

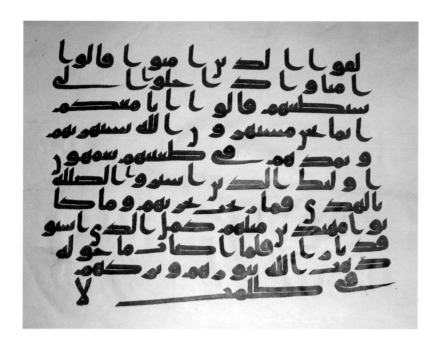

'Uthman's Qur'an

A new copy made on animal skin of the early Qur'an manuscript kept in Tashkent, the capital of Uzbekistan, 2004

The original manuscript is believed by Muslims to be one of the five standard copies of the Qur'an commissioned by the 3rd Caliph 'Uthman about 650. 'Uthman was anxious to establish the correct reading of the Qur'an, as different memorized versions had circulated since the Prophet Muhammad's death in 632. Although some variations continued to be permitted, essentially the wording of the Qur'an was fixed within twenty-five years of the Prophet's death. As this new copy shows, the original Qur'an is of an impressive size and written in a wonderfully large, confident *kufic* hand.

The original Qur'an was taken back to his capital Samarqand in Uzbekistan by the Mongol Emperor Timur (Tamerlane) in the late fourteenth century. In 1868 when the Russians invaded Central Asia they took the Qur'an back to St Petersburg. It was only restored to Uzbekistan on its independence from the Soviet Union in 1991.

Tashkent Islamic University, Facsimile Copy, 2004

An Early European Printed Edition of the Qur'an in Arabic

Hamburg, Germany, 1694
Title page

Published by the Officina Schultzio-Schilleriana in 1694, this is one of the earliest printed Qur'ans in Arabic. It has an introduction in Latin by Abraham Hinckelmann. It was intended primarily as the basis of a philological study of the Arabic language for Christian scholars and linguists.

BL Or. 77.b.32

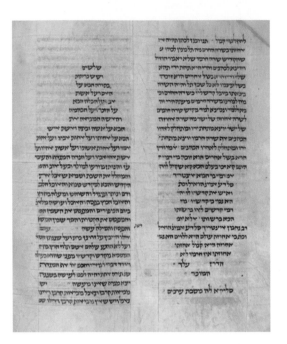

The First Complete Printed Mishnah

Naples, Italy, 1492
Kilayim

Redacted around 200 by Judah the Prince, the *Mishnah*, meaning 'repetition', is the earliest authoritative body of Jewish oral law, and records the views of rabbinic sages known as the *Tannaim* (from the Aramaic 'tena', meaning to teach). The *Mishnah* supplements the written law (the Torah), but its laws lack all scriptural references. A noteworthy characteristic is the inclusion of laws pertaining to the service in the Temple of Jerusalem, even though the Temple had been destroyed over a hundred years earlier. This edition, printed in Naples in 1492 by Joshua Solomon Soncino, was the first to contain the complete text of the *Mishnah*.

This page is from the tractate *Kilayim* (translates as 'of two kinds'), which deals with the laws regarding forbidden mixtures of species in agriculture, breeding and clothing. It forms part of *Zera'im* (Seeds), one of the six divisions or orders of the *Mishnah*. Added to the text is Moses Maimonides' commentary translated from the original Arabic. The diagrams show ways of dividing up plots of land to grow permitted types of seeds and mixed species.

BL C.50.e.6 f. 23r

Babylonian Talmud

Origin unknown, *c.* thirteenth–fourteenth century
Gemara

The Talmud, which contains the *Mishnah* (oral law) and the *Gemara* (Completion, written in Aramaic), developed in two major centres of Jewish scholarship: Babylonia and Palestine. The Jerusalem or Palestinian Talmud was completed *c.*350, and the Babylonian Talmud (the more complete and authoritative) was written down *c.*500, but was further edited for another two centuries. The Talmud served as the basis for all codes of rabbinic law. During the Middle Ages it was the target of relentless condemnation, vilification and censorship by the Christian Church. Vicious hostility to its allegedly offensive and blasphemous contents led to frequent public burnings, the first in Paris in 1242. As a result, very few complete manuscripts of the Talmud have survived, and the remaining fragmentary ones are also rather scarce. This manuscript (in square Ashkenazi hand) is an exceptionally rare specimen, which, fortunately, has not been censored or mutilated. It shows the end of tractate 'Arakhin (Valuations), which deals with issues relating to the upkeep of the sanctuary, and the start of tractate *Keritot* (Excisions), which discusses sins that incur divine punishment.

BL Add. MS 25717, f. 72v

The Bomberg Talmud

Venice, Italy, 1520–23
Bava Batra, chapter 5

Single tractates of the Babylonian Talmud had been printed before 1500 in Italy, Spain and Portugal, but it was not until 1519 that the famed Christian printer Daniel Bomberg of Antwerp was awarded the papal monopoly to print the entire Talmud at Venice. The printing took four years to complete and was done under the supervision of Bomberg's Jewish head printer, Cornelius Adelkind.

As illustrated in this opening from the tractate *Bava Batra*, chapter 5 (which deals with the selling of ships), each page of the Bomberg Talmud contains a section of the *Mishnah* followed by the relevant *Gemara*. In the inner margin of the page is Rashi's commentary, while in the outer margin are the *Tosafot* (supplementary comments to Rashi's commentary by rabbinic scholars of the twelfth and thirteenth centuries). At the end of each tractate Bomberg printed additional commentaries, the most notable being Maimonides' on the *Mishnayot* (chapters of a *Mishnah* tractate).

To this day, the layout and pagination in the Bomberg edition have served as models to all subsequent printed editions of the Talmud. The copy of the Bomberg Talmud held in the British Library collection apparently originated in the Royal Library and its tractate on divorce may have been used in the case of King Henry VIII's divorce from Catherine of Aragon.

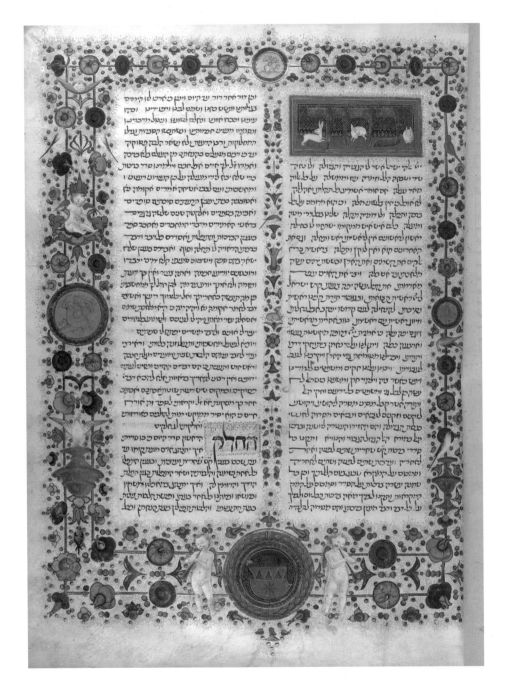

The Code of Law of Jacob ben Asher of Toledo

Ferrara?, Italy, 1475
Frontispiece to Orah Hayim

The *Arba'ah Turim* (the 'Four Rows' or 'Four Pillars') is a legal code that was compiled in the fourteenth century by Jacob ben Asher of Toledo (1270–1340). It incorporated all the Jewish laws that had accumulated since the twelfth century. Unlike former codifiers, Jacob ben Asher excluded laws that had no practical application in his time.

The opening is from *Orah Hayim* ('Way of Life'), the code's first division, from a manuscript copied in Italy in the fifteenth century. This division deals with laws relating to the daily conduct of a Jew. The scribe, Hayim Barbut, penned the text in a fine, semi-cursive Hebrew Sephardi script in two columns. The splendid Renaissance-style decoration boasts an embellished, initial word panel encapsulating the gilded word *Barukh* (Blessed be), and multicoloured florid borders interspersed with birds, vases, gilded medallions and cherubs. The coat of arms featured in the lower border probably belonged to Yoav Emmanuel, the patron who commissioned the manuscript.

BL Harley MS 5716 Vol. 1, f. 8

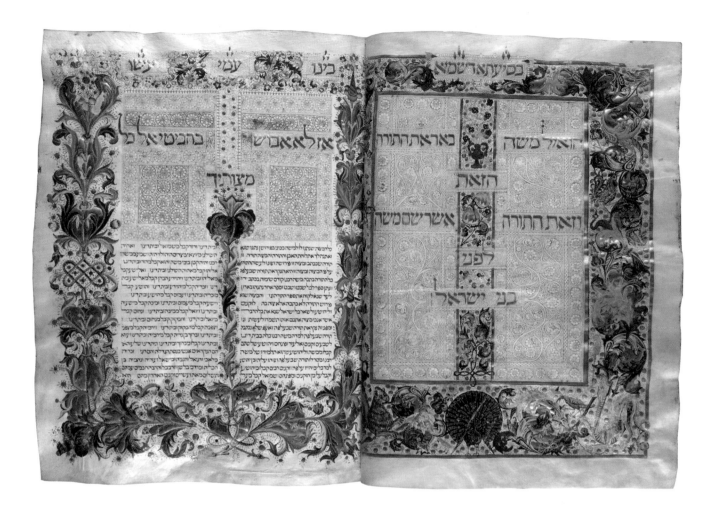

The Code of Law of Moses Maimonides

Lisbon, Portugal, 1471–72

These stunning introductory pages are from a fifteenth-century manuscript of the *Mishneh Torah* (Repetition of the Law or the Second Law), which was copied in Lisbon by Solomon ben Alzuk for Don Joseph Ibn Yahya, who was an adviser to the kings of Portugal. The *Mishneh Torah* is a monumental legal code compiled between 1170 and 1180 by Moses Maimonides, the greatest Jewish medieval authority, while living in Egypt. The code was divided into fourteen books, each dealing with a specific area of human activity and the laws relating to it.

The biblical verse penned in ornamental script on the right page means 'Moses interpreted this Law which he set before the children of Israel' (Deuteronomy 4:44). Written in two columns on the facing page is the introductory section to the Code. The meaning of the gilded words above it is: 'Then should I not be ashamed when I have regard unto all Thy commandments' (Psalms 119:6).

The sumptuously illuminated borders with vegetal and animal motifs enhanced in burnished gold, the monumental gilded lettering and the elaborate filigree penwork are the hallmarks of a workshop that was active in Lisbon from 1469 to 1496 and produced some thirty Hebrew manuscripts.

BL Harley MS 5698, ff. 11v-12

Lives of Saints (*Menologion*)

Georgia, 1061
Life of St Theodosius

In the Eastern Orthodox Church, the lives or acts of saints are collected in books like this one and read in churches on the anniversary of the saint's birth or death. This manuscript, written in the Georgian language, contains the *Lives of Saints* arranged for the entire 365 days of the year. It was completed at the Monastery of St Saba by the scribe Mikel Chikhuareli, and by command of the abbot Giorgi Djvareli. This is the reading for the feast of St Theodosius I 'the Great' (346–95), who was emperor of Rome from 379 to 395. It was Theodosius who called the ecumenical council of Constantine in 381, and he enacted a series of decrees outlawing Arianism and other heresies, and restricting pagan sacrifices.

BL Add. MS 11281, f. 210v

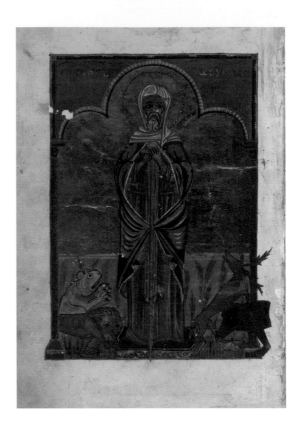

Armenian Lives of the Fathers of the Desert

Syria, 1614
St Antony

Christian monasticism originated in Egypt, where St Antony (*c*.251–356) is usually regarded as its founder. The earliest use of the term *monachos* for a Christian monk occurs in a Coptic papyrus document dated to 324. According to Athanasius's *Life* of the saint (written *c*.357), Antony embarked on the monastic life at the age of twenty after hearing the following reading in church: 'If you want to be perfect, go, sell your possessions and give to the poor, and you will have treasure in heaven. Then come, follow me.' (Matthew 19:21).

The scribes Minas and Melkon copied this manuscript on paper during the reign of Shah Abbas in Persia (1588–1629), who, according to them, 'began by favouring the Christians with all the craftiness of a wizard, and ended by inflicting all manner of evil on the Christian population'.

BL Add. MS 27301, f. 5v

Gratian's Decretum

Barcelona, Spain, mid-fourteenth century
Causa 14

Church law, known as canon law (from the Greek word *kanon*, meaning 'rule'), sets out the rules governing Church organization and Christian practice. In the early Christian period collections of the decisions of various councils, the letters of popes, and episcopal statutes were circulated separately. Around 1140 the jurist Gratian sought to systematize and harmonize them. His work, generally known as the *Decretum*, became the first general textbook of canon law. It attracted commentaries, or glosses, as in this copy. Part II of Gratian's work consists of thirty-six *causae* (cases) that describe situations and develop questions from them. This case concerns the receipt of funds by clerics: the pope sits with an open book instructing tonsured men, while money changes hands to the left. This case has six questions. Each begins with a large foliate initial in gold that corresponds to one in the surrounding gloss indicating the start of the commentary on that question.

BL Add. MS 15274, f. 201v

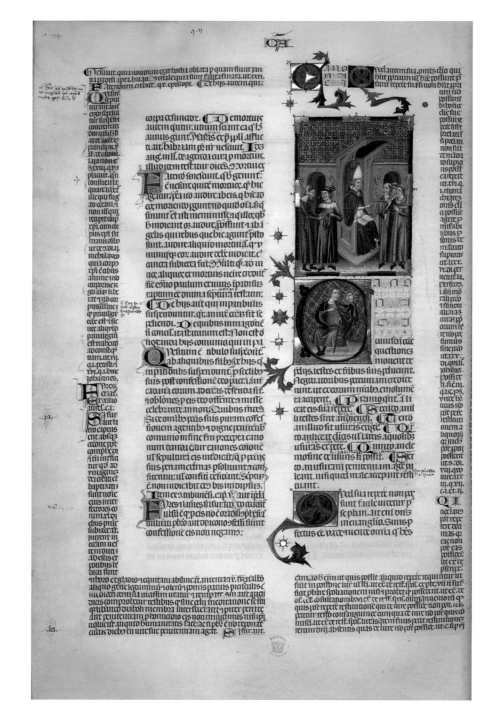

Hadith Collection

Near East, 1374
Muslim ibn al-Hajjaj, known as
al-Sahih (the Authentic)

The Hadith is the collected traditions
based on the sayings and actions of
Muhammad and his followers. Of the six
canonical Hadith collections – and widely
accepted by Sunni Muslims – the two
most famous are those of Muslim ibn
al-Hajjaj (817–75) and Muhammad ibn
Isma'il al-Bukhari (810–70), both of
which have the same title *al-Sahih* (The
Authentic). The opening here is the be-
ginning of Book 23, the 'Book of Drinks',
in which the first chapter deals with
the prohibition on drinking wine. Each
Hadith usually begins with the chain of
the narrators going back to the time
of the Prophet Muhammad and his
companions, which is then followed by
the text of the tradition itself.

BL Or. MS 6437, f. 107v

Forty Hadith

Morocco, fourteenth century

This manuscript, written in *maghribi* script, contains a
compilation of forty Hadith in the handwriting of Abu 'Inan
Faris al-Marini, the Marinid Sultan of Morocco (r. 1348–59).
In addition to the six canonical Hadith collections (which by
their nature are large reference works), numerous smaller
collections, such as this one, comprise the basic tenets and
conduct of Islam, and can be read easily and reflected on.
Tradition suggests that to bring together forty Hadith into
one compilation is an act meritorious in its own right.

Bibliothèque Nationale, Rabat, No. 3582d, ff. 7-8

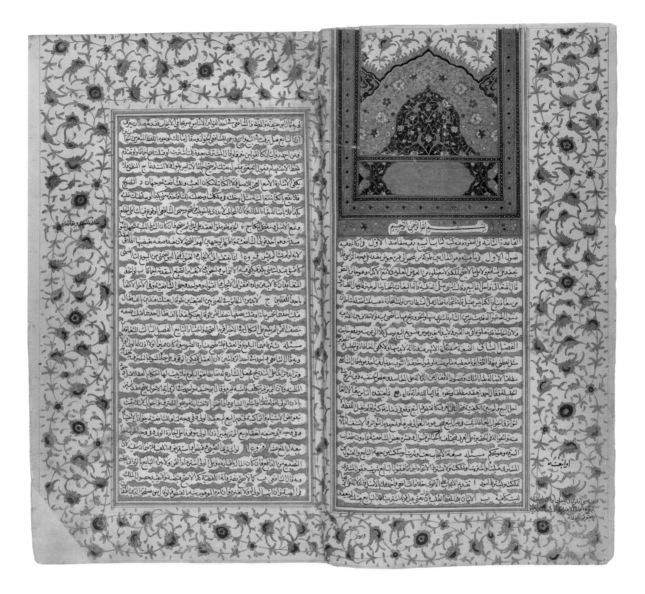

Shi'ite Fatwas

Persia, late seventeenth century

The *Kitab Tadhkirat al-Fuqaha'* (Memorandum for Jurists) is a compendium of formal legal opinions and decisions (*fatwas*) on legal cases according to the Shi'ite school of law. It was compiled by al-Hasan ibn Yusuf, called al-Mutahhar al-Hilli (d. 1325). This volume deals with legal definitions, and gives examples regarding transactions of sales, loans and pledges. This manuscript was copied by the scribe Qasim ibn Husayn Shirazi. The opening double page has an illuminated floral headpiece in the style of the Safavid period in Iran (1501–1732), with colours predominantly in gold, blue and pink. The wide margins are illuminated with bold floral and arabesque decorations in gold and blue, and the text is within gold cloud bands.

BL Or. MS 13890, ff. 2v–3

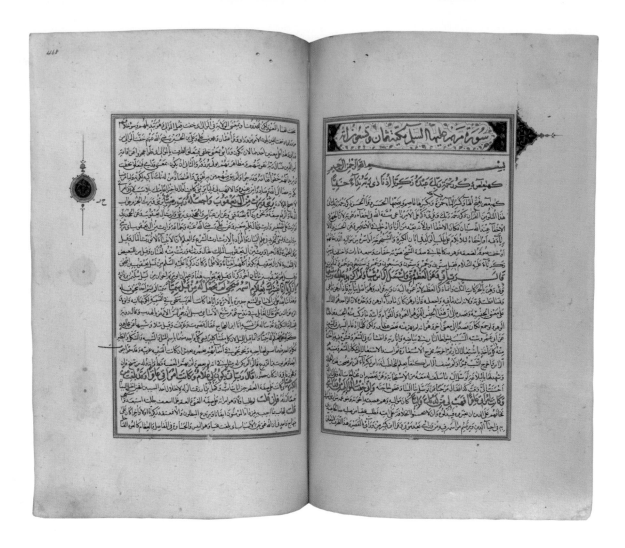

Commentary on the Qur'an

Persia, 1482

Mahmud ibn 'Umar al-Zamakhshari, *Al-Kashshaf 'an haqa'iq al-tanzil* (The Revealer of the Truth of Revelation)

Al-Zamakhshari (1075–1144) is the author of one of the most important commentaries on the Qur'an, and is widely studied in Islamic religious institutions. His work analyses the meaning of each phrase of the Qur'an, providing philosophical, philological and lexicographical explanations of the text. The page layout of this manuscript is influenced by Qur'ans of the Timurid dynasty in Iran (1370–1506), exhibiting delicacy and refinement in its illumination and calligraphy, while incorporating within the page a commentary on the Qur'an text. The opening shows the beginning of chapter 19, *Surat Maryam* (Mary), the title of which is written in gold *thuluth* script in the cartouche of the horizontal panel. Different coloured scripts are used to differentiate the commentary from the sacred text: the writing penned in gold *thuluth* is the Qur'anic verses, and the writing in black *naskhi* script is the commentary. The marginal medallion indicates the end of a fifth verse.

BL Or. MS 5102, ff. 467v–468

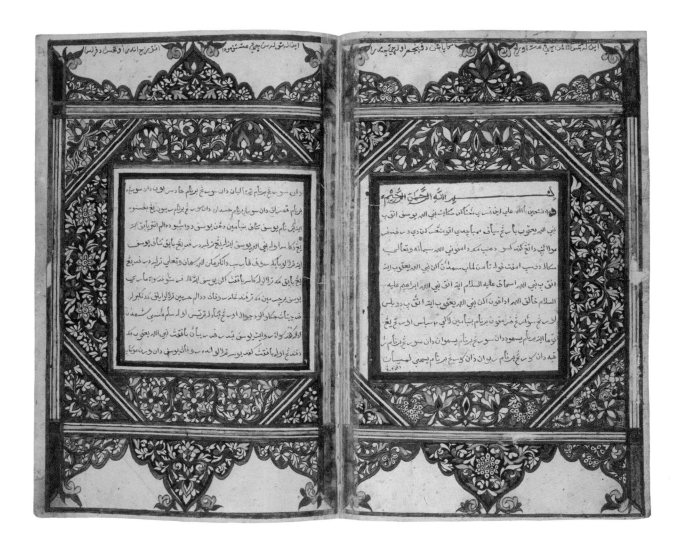

The Story of the Prophet Joseph
(Hikayat Nabi Yusuf)

Malay Peninsula, 1802

The biblical Joseph is honoured as a prophet in Islam. His
story as related in chapter 12 (*Surat Yusuf*) of the Qur'an is
based mainly, if not completely, on the book of Genesis,
chapters 37 and 39–47. The Qur'anic version became the basis
for many folkloristic tales about Joseph. These are presented
in various literary treatments, which have become popular
and widespread throughout the Islamic world, as this Malay
manuscript testifies.

BL Malay MS D. 4, ff. 3v-4

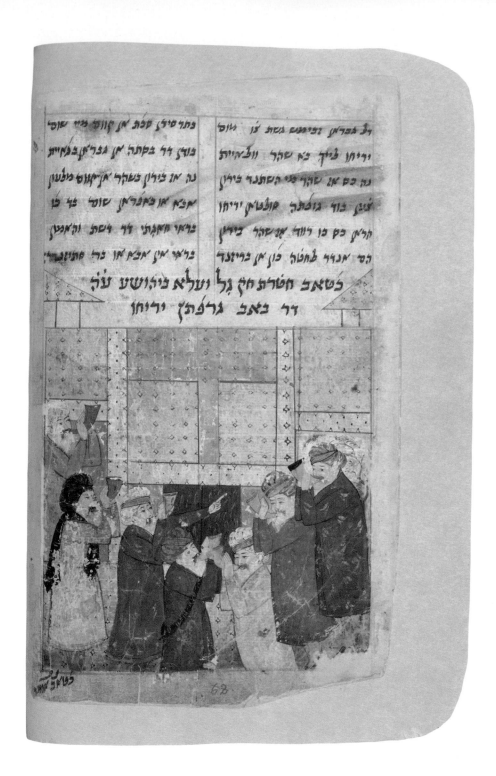

Book of Conquest

Persia, seventeenth century
Joshua captures Jericho

The *Fathnama* (Book of Conquest) is
essentially a poetical paraphrase by the
Jewish-Persian poet Imrani of Shiraz
(1454–1536) of narratives from the
books of Joshua, Ruth and Samuel.
Imrani strived to elevate the biblical
tale to the standard of the Persian epic,
and his works combine Jewish and
Muslim legendary material and literary
elements. This manuscript was written
in Judeo-Persian (i.e. Persian in
Hebrew characters), and has coloured
illustrations in the Persian style. This
opening is from the book of Joshua.
Since God forbade Moses to set foot in
the Promised Land, Joshua led the
Israelites in the conquest of Canaan.
This scene depicts Joshua's capture of
the city of Jericho, and shows seven
priests encircling the town's walls
blowing rams' horns.

BL Or. MS 13704, f. 31v

Illuminating the Word in Colours and Gold

Sacred texts were beautified, illuminated, or illustrated in each of the three faiths. These manuscripts and printed books are works of art in their own right, enhancing the text they transmit and decorate. One of the striking features these manuscripts share is the use of stylized calligraphy to record the text. In these copies both whole words and individual letters in Hebrew, Arabic, Greek or Latin become elements of design. In some cases letters become monograms, running together to form detailed patterns, as in the first word of St John's Gospel in the Odalricus Peccator Gospel Lectionary. In Christian manuscripts, letters are often further elaborated by interwoven figures or animals, as in the first letter of a Psalter from the birthplace of Benedictine monasticism, Monte Cassino in southern Italy. The justly famous Lindisfarne Gospels is an extreme example of this tendency, in which the first words of each Gospel are expanded to fill an entire page, and are intricately decorated with complex patterns.

In the most luxurious codices, the sacred text is further beautified through the use of gold ink. A French copy of the Four Gospels in Latin is written entirely in gold, as are the sumptuous volumes of Sultan Baybars' Qur'an, made in Cairo in the early years of the fourteenth century. The exhibition presents a rare opportunity to display a majority of the seven volumes of this Qur'an together, allowing their magnificent double frontispieces of carpet pages as well as their exquisite text to be admired. Manuscripts like these, together with others such as the Duke of Sussex's Italian Pentateuch, reflect a desire by each faith to underline the preciousness of the text by writing and decorating it in the most precious of materials.

Ideas about the use of other types of decoration, however, are very different from one faith to another. In the Christian tradition almost anything is possible, from literal or allegorical illustration to individual narrative images or letters, and story-telling biblical picture books where text is minimal. This was true in both Eastern and Western Christendom. For example, an impressive Gospel lectionary in Syriac incorporates scenes from the life of Christ in the body of the readings. In Islam, on the other hand, all figurative imagery in a Qur'an and other religious texts is strictly prohibited. Nevertheless in certain geographical areas, copies of other works, such as books of poetry, did include figurative imagery, as in the sixteenth-century copy of Nizami's *Khamsa* here, which features an image of Muhammad's ascent into heaven. Copies of the Jewish Haggadah, a ritual book used during Passover, were also often illustrated. A spectacular example is known as the Golden Haggadah because its extensive series of illustrations are painted on burnished gold grounds. In the last part of this section several pairings of manuscripts from the three faiths provide an opportunity for direct comparison of some of these areas of commonality and difference.

Judaism

Adorning the Torah is permitted only if it is written in a codex – not if it is written as a scroll, where strict rabbinic rulings on letter shaping, text layout, and decoration apply. In biblical codices, however, Jewish scribes developed the unique art of micrography, the weaving together of minute lettering into abstract, geometric, and figurative designs. This practice began around the ninth century in Egypt and Palestine, and then spread to Europe. It was particularly popular between the thirteenth and fifteenth centuries, and two examples of this beautiful and complex patterning from France and Germany are included here.

Within the Jewish tradition depictions of the human form in biblical manuscripts are relatively rare. This is based on a strict interpretation of the Second Commandment against graven images or likenesses (Exodus 20:4). However, Jewish manuscripts and books display other types of decoration and illumination in addition to micrography, including decorative word panels, carpet pages and margin pericope (or section) markers. Because Hebrew lacks capital letters, often the entire word at the beginning of biblical texts was painted or decorated, as in the fourteenth-century copy of the Former and Latter Prophets with words in coloured rectangular panels, and the luxuriously illustrated page in the Lisbon Bible with gold decorated panels. This technique extended to the decoration of the *Tetragrammaton* (God's name, YHWH, or Yahweh), which in the Hebrew Spanish Bible is enclosed within a square surrounded by other verses proclaiming God's magnificence, omnipotence and universality.

Narrative biblical scenes in Jewish manuscripts occur most frequently in Haggadot, perhaps because they were intended for private use at home, and primarily for educational purposes. In addition to the Golden Haggadah mentioned earlier, illustrated copies from Germany, Italy and Spain are exhibited in this section. Figurative imagery also appears in a festival prayer book from southern Germany featuring women with animal heads, an intriguing distortion of human facial features characteristic of illuminated Hebrew manuscripts from that area. Its artists may have been Christians, as was probably the case for the North French Miscellany. Even in these other types of books, however, images depicting God are extremely rare. His presence was sometimes represented by, for example, His hand only, as in the scene illustrating the Sacrifice of Isaac in the Hispano-Moresque Haggadah. Nevertheless, the section ends with an Italian printed copy in which the face of God is depicted appearing to Moses – no satisfactory explanation for the inclusion of this exceptional image has yet been provided.

Christianity

Although Christian imagery is now widespread, there have been periods when its use was questioned. In the Western church, Pope Gregory the Great (*c.* 540–604) encouraged its adoption, arguing that pictures were the books of the illiterate, helping them to learn about their faith. In the East, however, the Byzantine Emperor Leo III the Isarian (717–741) issued an edict in 726 declaring all images to be idols and ordering their destruction. This debate about the use and function of images is now known as the Iconoclast (literally, image-breakers) controversy. After periods when this ban was temporarily relaxed or reversed, it came to an end formally in 842 with the accession of the Empress Theodora (r. 842–56), who restored the use of icons (images to be venerated). This event is still celebrated as the Feast of Orthodoxy in the Eastern Church on the first Sunday in Lent. The first two Christian items in this part of the catalogue illustrate these events, including images of the important figures in the debate. The Theodore Psalter is also a precious example of a surviving 'marginal Psalter', in which artists included a visual Christian interpretation of the Psalms in the margins of the text. These Psalters were usually small and easy to handle.

Christian manuscripts illustrate the inventiveness of artists and patrons, and the incredible range of possibilities of decoration, illustration, commentary and allegory. Medieval books were handmade, giving scribes and artists the chance to create a unique object, with an individual approach to layout, presentation and illumination. Some drew on the heritage of the classical world, as seen in the sophisticated painting in two sets of fragments: the Cotton Genesis, with an extensive cycle of images, and the Golden Canon Tables, which set out lists of parallel sections in the Four Gospels. New approaches to illustration were also developed, some closely related to interpretations of the biblical text, as in the Theodore Psalter. A full border surrounding the first words of John's Gospel in the English Grimbald Gospels comments on the text by presenting the blessed and angels looking upwards at the Virgin holding the Christ Child, perhaps foreshadowing John's discussion of the Incarnation in the first chapter. In an Ethiopian copy of the Octateuch and the Four Gospels, the artist interprets the Temple in Jerusalem as if it were a circular Ethiopian church. The illustration could also be literal, as in the Harley Psalter, in which the accompanying pictures correspond directly to the verses of the Psalms, translating them virtually phrase by phrase into visual form. Images dominate other books probably designed for a lay readership, with the text paraphrased or providing captions for biblical picture books. In an important early example, the Old English Hexateuch in the previous section, the vivid images fill almost the entire page, accompanied by the earliest surviving translation of some parts of the Old Testament in English. The pictures in a later English example, the Holkham Bible Picture Book, also dominate each page, although by this point the accompanying captions are in Anglo-Norman French, the language then most familiar to contemporary English nobles.

Islam

Islam disapproves of human or animal representation in a religious context, and so it finds its ultimate artistic expression in sacred calligraphy and illumination. The Qur'an has played a pivotal role in the development of this art form. In all areas of Islamic art, whether in architecture, metalwork, woodwork, textiles, ceramics or book production, phrases from the Qur'an and other religious works imbue the objects with a sanctity that reflects the reverence and piety of artists and artisans towards their work. Qur'an manuscripts vary in their style of calligraphy and illumination depending on their place and date of production. As in the other traditions, many of their decorations also have a functional role in the reading of the text. Since Arabic script has no capital letters, Qur'an illumination often emphasizes key words and headings, indicating chapter headings, ends of verses, verse counts, the beginning of sections and the fourteen places where the believer should prostrate during the recitation of the Qur'an.

The many Qur'ans in the catalogue also illustrate the wide range of possible script types – either used alone or in combinations – that could be used to record the sacred text in different parts of the Islamic world. These include one of the earliest examples of the popular and easily legible *naskhi* (meaning 'copying') script developed by the Abbasid vizier and calligrapher Ibn Muqlah in the tenth century. Another, earlier type of script, *thuluth* (or 'one-third') in which one-third of each letter slopes, is employed in an Afghani example. This manuscript also features *kufic* script (after the town of Kufa in Iraq, a major Islamic centre in the early period) in the ornamental directions for reading the text. An Indian Qur'an is written in the distinctive *bihari* script, named after the province in northern India where it was developed. In a Persian Qur'an a classic *naskhi* script alternates with an interlinear Persian translation, written in the *nasta'liq* script, developed in Persia in the late fifteenth century. The magnificent carpet pages (so-called because of their resemblance to intricate Eastern carpets) in the exhibited Qur'ans illustrate the artistic creativity and sophistication possible within the constraints of non-figurative decoration. Characterized by the extensive use of interlocking geometric patterns, many also include interwoven floral motifs, as in the fourteenth-century Moroccan example. Carpet pages are another shared characteristic of manuscripts from each faith, as some of the pairings at the end of this section demonstrate.

Pentateuch with Prophetetical Readings and the Five Scrolls

France or Germany, thirteenth to fourteenth century
Ruth 4: 13-22

Unique to Jewish art, micrography is the weaving of minute lettering into abstract, geometric and figurative designs. This practice started around the ninth century in Egypt and Palestine, and then spread to Europe and Yemen, its heyday being between the thirteenth and fifteenth centuries. It was initially used in biblical codices. Perhaps because the strict rabbinic rulings on letter shaping, text layout and decoration applied to Torah scrolls but not to codices, scribes felt freer to use them as a medium for artistic expression. The *masorah*, customarily written in the margins of pages, offered the artist ample scope for ornamentation. But rather than copying its text in plain lines, scribes began to pattern it into a variety of forms and shapes.

In this example the masoretic annotations were fashioned into an elaborate frame composed of architectural structures, lush scrolls of foliage, and fabulous creatures. Copied within the frame in a fine Ashkenazi hand is the end of the book of Ruth (4: 13–22), which provides the lineage of King David. The Five Scrolls are Ruth, the Song of Songs, Ecclesiastes, Esther and Lamentations.

BL Add. MS 21160, f. 300v

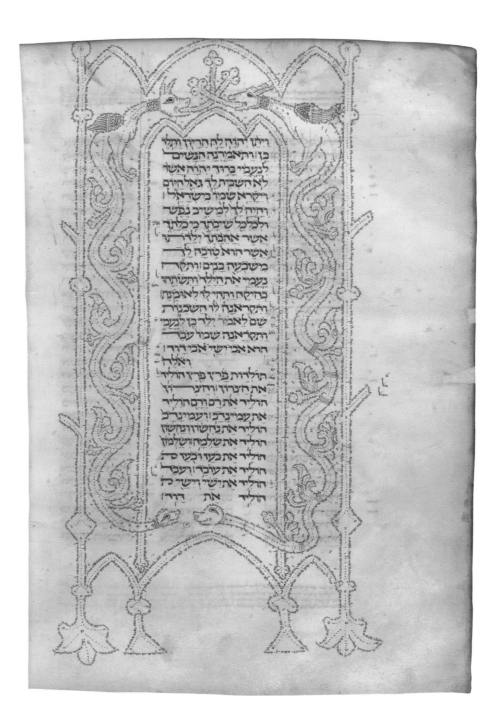

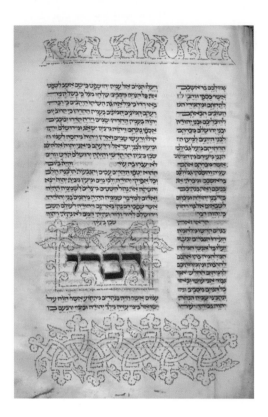

The Former and Latter Prophets and the Hagiographa

Probably Germany, *c.* thirteenth century
Amos 1

This manuscript features an intricate and eye-catching array of Gothic patterns woven in micrography. These include heraldic symbols, grotesques, mythical beasts and floral motifs, which became typical in micrographic manuscripts from Germany and France from the thirteenth–fifteenth centuries. In this example the scribe has created a row of birds' profiles and elaborate tracery in the upper and lower margins, and a charming panel composed of fabulous creatures and foliage to shelter the opening word.

BL Or. MS 2091, f. 245r

Hebrew Script

Spain, 1307
Moses Maimonides, Guide to the Perplexed

Medieval Jews living in Islamic countries used Arabic extensively, commissioned works and sometimes copied texts in Arabic, and owned Arabic books. These cross-cultural contacts had a significant impact on the art and calligraphic styles of Hebrew manuscripts created there. The influence of early Arabic cursive writing is clearly noticeable in this fourteenth-century manuscript, in which the text was penned in a Sephardi current cursive script. The shapes of the Hebrew letters, the order and direction of the strokes and the general layout of the calligraphic text bear remarkable affinities with the Arabic manuscript on page 112. Halfway down the page a word was written diagonally. This scribal practice, intended to keep the left margins aligned, was most probably borrowed from Arabic copyists, and became a fashionable decorative device, particularly in Hebrew manuscripts copied in the Yemen.

BL Royal MS 16 A XI, f. 187v

Hebrew Spanish Bible

Solsona, Catalonia, 1384
Tetragrammaton

This illuminated ornamental design evokes the ceiling of a temple dome, and is imbued with the divine presence, despite totally lacking representational imagery. This powerful effect is achieved through the use of inscriptions derived chiefly from the Hebrew Bible. The central roundel contains the *Tetragrammaton* (God's name, Yahweh), which is enclosed within a square whose borders comprise verses from Jeremiah 10:6–7, Psalm 68: 34–36 and Psalm 105:2. They proclaim God's magnificence, omnipotence and universality, as do the inscriptions inside the square. One of these is the beginning of the *Shema'*, the pivotal prayer in the Jewish liturgy, which conveys the monotheistic essence of Judaism – 'Hear, O, Israel! The Lord is our God, the Lord is One!' (Deuteronomy 6:4). The names of the four archangels (Uriel, Michael, Gabriel and Raphael) and the angelic classes, written around the circular feature, add a mystical dimension to the entire composition.

This manuscript belongs to a group of Spanish Hebrew Bibles known as *Mikdashyot* (Temples of the Lord). The Hebrew Bible was regarded as a substitute for the destroyed Temple in Jerusalem, and these codices were usually prefaced with depictions of the Temple utensils. This Bible once belonged to a synagogue in Jerusalem and was later taken to Aleppo. Known as The King's Bible, it was the only Hebrew manuscript in the collection donated to the British Museum by King George IV in 1823.

BL King's MS I, f. 2r

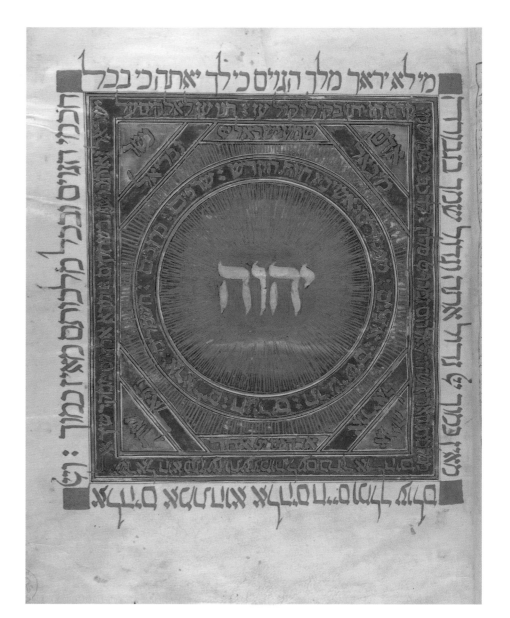

Four Gospels

Northern France or Paris, third quarter of the ninth century
Luke 3:33 – 4:5

The text of this deluxe manuscript is written throughout in gold, interrupted only by the full-page decorated openings of each Gospel. The layout of the genealogy of Christ described in St Luke is particularly striking, set out in two parallel columns with the words *qui fuit* (who was [the son of]) followed by the ancestor's name spaced and aligned in rows. After the last name *d[e]i* (of God), the red Roman numerals in the centre of the page indicate the beginning of the next chapter. This division corresponds to an earlier system than the modern biblical chapters developed in the thirteenth century. In the left margin the small gold Roman numerals give references to parallel sections in the other Gospels.

BL Harley MS 2797, f. 92

Monte Cassino Psalter

Southern Italy, first quarter of
mid-twelfth century
Psalm 74 (73)

Intricate and dense interlace, featuring
interwoven white beasts and bright
animal heads, is a characteristic
feature of manuscripts associated with
Monte Cassino, where St Benedict
(*c.* 480–543) developed his monastic
rule. Appropriately, the large initials
in this Psalter mark the Benedictine
division of the Psalms, rather than the
more common Roman divisions. These
are the divisions marking the groups
of Psalms to be recited in the Divine
Office, a cycle of eight daily devotions
or services. For monks and other
members of religious orders, this cycle
began at Matins in the middle of the
night, and ended with Compline im-
mediately before bed. The distinctive
Beneventan script employed here
was developed in southern Italy, and
includes many unique letter forms,
such as the tall looped 'e' visible in
the first word of the last line (*medio*).

BL Add. MS 18859, f. 39

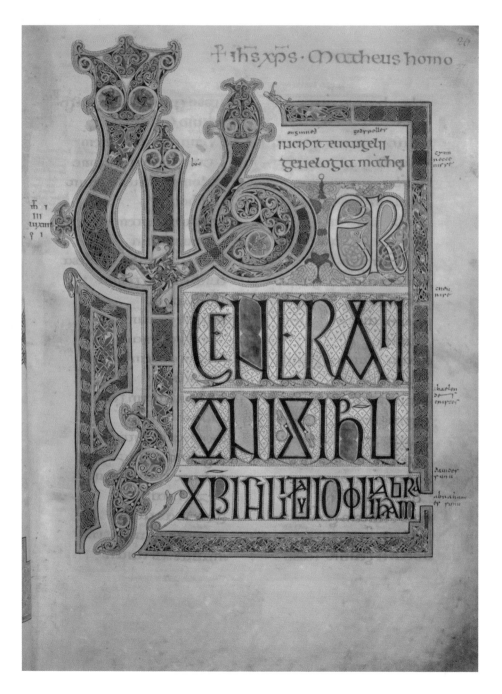

The Lindisfarne Gospels

Lindisfarne, England, between 698 and 721
Matthew 1

The Lindisfarne Gospels is probably the work of one remarkably gifted artist, who produced both words and images, giving the manuscript a coherent sense of design. According to an inscription added at the end of the manuscript some time later, that artist was a monk called Eadfrith, who was Bishop of Lindisfarne between 698 and 721. These Gospels are a spectacular example of the abstracted decoration characteristic of Anglo-Saxon art. The artist's superb power of invention is particularly evident in the opening pages of each Gospel, in which a portrait of the Gospel's author is followed by a 'carpet page', which is covered with intricate patterns. Opposite it, the first letters of each Gospel become elements of design, elaborated by interlace and spiral patterns strongly influenced by contemporary metalwork. Its writing and intricate decoration has been interpreted as an act of personal spirituality and devotion. Indeed, the later inscription records that 'Eadfrith, bishop of the Lindisfarne church, originally wrote this book for God and for St Cuthbert and – jointly – for all the saints whose relics are in the island'.

The Saint John's Bible

Great Britain, contemporary
Matthew 21

Perhaps something of the motivation of the medieval artists in creating beautiful copies of biblical texts may be revealed by the comments of a modern calligrapher, who is currently copying the Bible by hand. In 1998 Saint John's Abbey and University in Collegeville, Minnesota commissioned a group of scribes under the direction of Donald Jackson, Senior Scribe to Her Majesty's Crown Office, to produce a copy of the Bible on parchment. It will be the first commissioned handwritten, monumental, illuminated Bible in the modern era, written in the modern English New Revised Standard translation. Jackson commented that 'the continuous process of remaining open and accepting of what may reveal itself through hand and heart on a crafted page is the closest I have ever come to God. Now, I am led to the making of the Bible as a celebration of the Word of God for the twenty-first century in modern scripts, and I realize now it is the thing I have been preparing for all my life.'

Saint John's Abbey and University, Collegeville, Minnesota, f. B3fr

21

hen they had come near Jerusalem & had reached Bethphage, at the Mount of Olives, Jesus sent two disciples, saying to them, "Go into the village ahead of you, and immediately you will find a donkey tied, and a colt with her; untie them and bring them to me. If anyone says anything to you, just say this, 'The Lord needs them.' And he will send them immediately." This took place to fulfil what had been spoken through the prophet, saying,

"Tell the daughter of Zion,
Look, your king is coming to you,
humble, and mounted on a donkey,
and on a colt, the foal of a donkey."

The disciples went and did as Jesus had directed them; they brought the donkey and the colt, and put their cloaks on them, and he sat on them. A very large crowd spread their cloaks on the road, and others cut branches from the trees and spread them on the road. The crowds that went ahead of him and followed were shouting,

"Hosanna to the Son of David!
Blessed is the one who comes in the name of the Lord!
Hosanna in the highest heaven!"

When he entered Jerusalem, the whole city was in turmoil, asking, "Who is this?" The crowds were saying, "This is the prophet Jesus from Nazareth in Galilee." Then Jesus entered the temple & drove out all who were selling and buying in the temple, & he overturned the tables of the money changers and the seats of those who sold doves. He said to them, "It is written,

'My house shall be called a house of prayer';
but you are making it a den of robbers."

The blind & the lame came to him in the temple, and he cured them. But when the chief priests & the scribes saw the amazing things that he did, and heard the children crying out in the temple, "Hosanna to the Son of David," they became angry and said to him, "Do you hear what these are saying?" Jesus said to them, "Yes; have you never read,

'Out of the mouths of infants and nursing babies
you have prepared praise for yourself'?"

He left them, went out of the city to Bethany, and spent the night there. In the morning, when he returned to the city, he was hungry. And seeing a fig tree by the side of the road, he went to it and found nothing at all on it but leaves. Then he said to it, "May no fruit ever come from you again!" And the fig tree withered at once. When the disciples saw it, they were amazed, saying, "How did the fig tree wither at once?" Jesus answered them, "Truly I tell you, if you have faith & do not doubt, not only will you do what has been done to the fig tree, but even if you say to this mountain, 'Be lifted up and thrown into the sea,' it will be done. Whatever you ask for in prayer with faith, you will receive."

When he entered the temple, the chief priests and the elders of the people came to him as he was teaching, and said, "By what authority are you doing these things, and who gave you this authority?" Jesus said to them, "I will also ask you one question; if you tell me the answer, then I will also tell you by what authority I do these things. Did the baptism of John come from heaven, or was it of human origin?" And they argued with one another, "If we say, 'From heaven,' he will say to us, 'Why then did you not believe him?' But if we say, 'Of human origin,' we are afraid of the crowds; for all regard John as a prophet." So they answered Jesus, "We do not know." And he said to them, "Neither will I tell you by what authority I am doing these things.

"What do you think? A man had two sons; he went to the first and said, 'Son, go and work in the vineyard today.' He answered, 'I will not'; but later he changed his mind and went. The father went to the second & said the same; & he answered, 'I go, sir'; but he did not go. Which of the two did the will of his father?" They said, "The first." Jesus said to them, "Truly I tell you, the tax collectors & the prostitutes are going into the kingdom of God ahead of you. For John came to you in the way of righteousness and you did not believe him, but the tax collectors and the prostitutes believed him; and even after you saw it, you did not change your minds and believe him. Listen to another parable. There was a landowner who planted a vineyard, put a fence around it, dug a wine press in it, and built a watchtower. Then he leased it to tenants and went to another country. When the harvest time had come, he sent his slaves to the tenants to collect his produce. But the tenants seized his slaves & beat one, killed another, and stoned another. Again he sent other slaves, more than the first; and they treated them in the same way. Finally he sent his son to them, saying, 'They will respect my son.' But when the tenants saw the son, they said to themselves, 'This is the heir; come, let us kill him & get his inheritance.' So they seized him, threw him out of the vineyard, and killed him. Now when the owner of the vineyard comes, what will he do to those tenants?" They said to him, "He will put those wretches to a miserable death, and lease the vineyard to other tenants who will give him the produce at the harvest time." Jesus said to them, "Have you never read in the scriptures:

'The stone that the builders rejected
has become the cornerstone;

Qur'an

Iraq or Persia, 1036
Chapter 37, *al-Saffat* (The Ranked Fliers), verse 20 to Chapter 38, *Sad* (The Letter Sad), verse 35

This Qur'an is written on paper and penned in a cursive script, proportional in style, known as *naskhi*. This script was first developed in the tenth century by the Abbasid vizier and calligrapher Ibn Muqlah (886–940), and later perfected by Ibn al-Bawwab (d. 1022), the master calligrapher who continued his tradition. *Naskhi* became one of the most popular styles for transcribing Arabic manuscripts, being favoured for its legibility. This Qur'an is one of the earliest dated examples in this style of script. Its illumination is both decorative and functional. Gold roundels within the text mark the end of each verse. Small palmettes in the margin are in the form of the Arabic letter *ha'* and indicate the end of a fifth verse, *ha'* having the numerical value of five in the Arabic alpha-numeric system. The overlapping roundels mark the end of a tenth verse.

BL Add. MS 7214, f. 52v

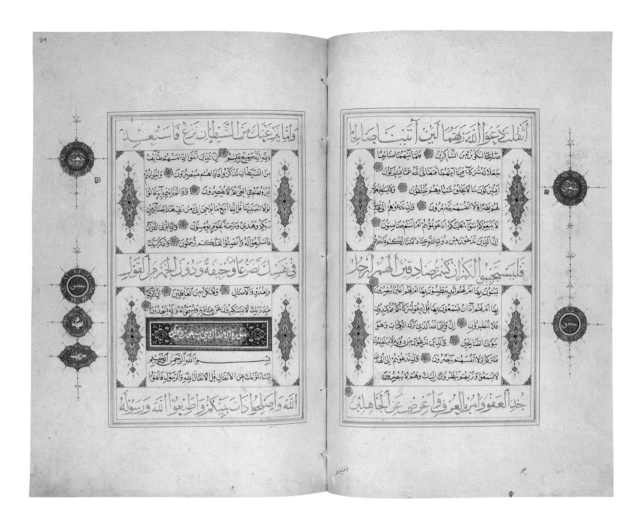

An Afghani Qur'an

Herat, Afghanistan, sixteenth century
Chapter 7, *al-A'raf* (The Heights), verse 189 to Chapter 8,
al-Anfal (The Spoils), verse 1

In this Qur'an the area allotted for the text is partitioned within a rectangular framework, thus enabling a number of scripts to be used on the same page. The calligrapher has used four different styles of Arabic script. The first, middle and last lines within the overall framework are in gold *thuluth* script; the remaining lines in the two larger compartments are in black *naskhi*; white *ruq'ah* script is employed for the chapter heading within the horizontal panel; and following convention, *kufic* is the preferred script in the ornamental directions for reading the text. It should be noted that the positioning of the rectangular framework provides wide margins for these inscribed ornaments, in the form of medallions, to join up and thus form a functional verse counter. The word *sajdah* (prostration) within the pear-shaped medallion is placed close to the chapter heading to remind the worshipper that it is necessary to prostrate at this point in the reading, while the oval-shaped ornament containing the word *hizb* in *kufic* script indicates the beginning of a sixtieth section of the text (the meaning of the word *hizb*).

BL Or. MS 13087, ff. 83v–84

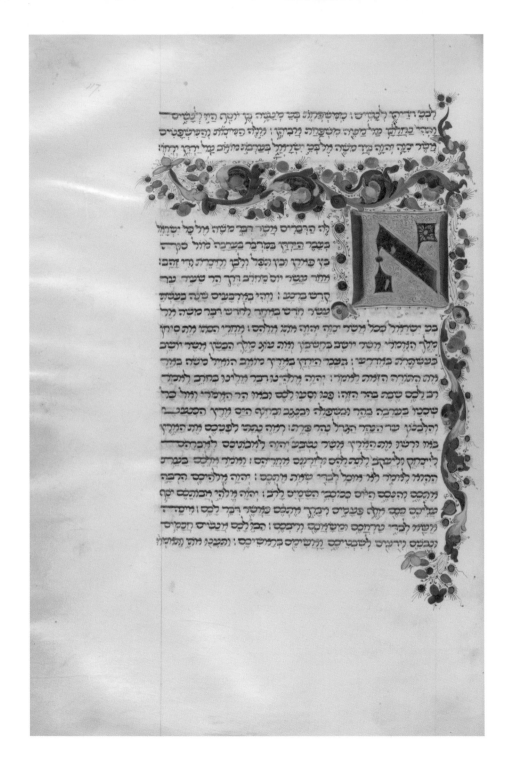

Duke of Sussex's Italian Pentateuch

Italy, *c.*1400
Deuteronomy 1

The Hebrew alphabet lacks capital letters, so whole words at the beginning of texts, rather than just first letters, were usually painted or decorated. This is a rare example of the embellishing of initial letters, a practice commonly associated with Latin manuscripts, but skilfully adapted here by an anonymous Jewish scribe. Further evidence of contemporary influences can be noted in the ornamental letters, which seem to emulate Gothic script, and equally in the textual semi-cursive Hebrew handwriting, which shows affinities with Italian Latin scripts.

Inside a pink scroll-like panel the ornamental initial letter *Alef* (from the opening word *Eleh,* Deuteronomy 1:1) was moulded in gold leaf. Surrounding the text on two sides are luxuriant foliage scrolls embellished with golden dots and inlays. Like so many of these manuscripts, the identities of the scribe and artists who contributed to this one are unknown.

BL Add. MS 15423, f. 117r

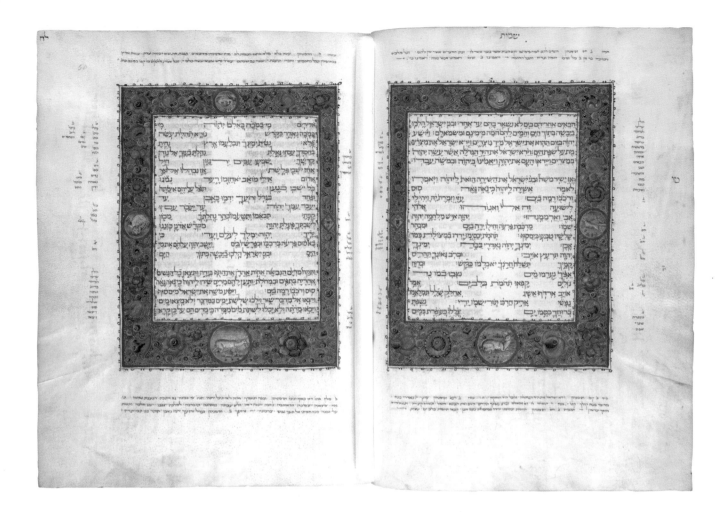

Duke of Sussex's Italian Bible

Ferrara?, Italy, 1448
Song of the Sea, Exodus 15:1–18

According to tradition, this epic hymn was sung by Moses and the Israelites after their miraculous Red Sea crossing. It has usually been written in the form of 'bricks', a practice going back to Talmudic times that is still in use today. What is particularly arresting in this double opening is the sumptuous, burnished gold border embellished with vibrantly coloured flowers interspersed with animal medallions.

This codex was probably copied and illuminated in Ferrara for a wealthy client. The Spanish-born Jewish scribe Moses Akrish, who copied it, had settled and worked there. He probably entrusted the illuminations to a local Christian workshop.

BL Add. MS 15251, ff. 49v–50

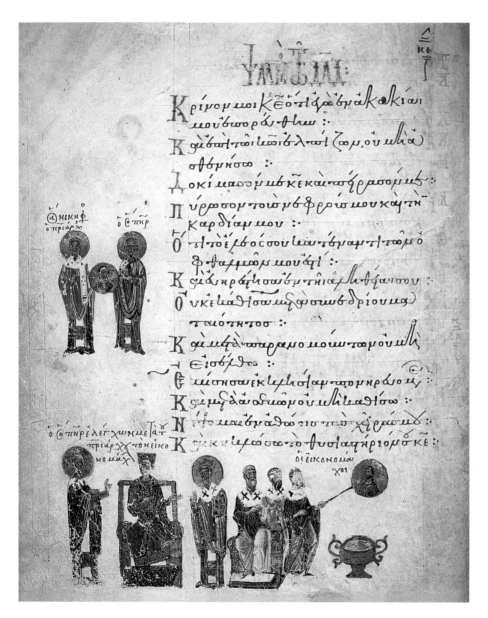

The Theodore Psalter

Constantinople, 1066
Psalm 26 (25)

Both the Theodore Psalter and the Icon
of the Triumph of Orthodoxy illustrate
important episodes and individuals
from the pivotal dispute within the
Eastern Church over the role of
images within Christian worship. This
profusely illustrated manuscript of the
Psalms is possibly the most significant
surviving manuscript illuminated in
Constantinople. It was made for abbot
Michael of the Studios monastery
there, and is named after its scribe
and illuminator, the monk Theodore,
who came to Studios from Caesarea
in Cappadocia. Working closely with
the abbot, Theodore produced 435
marginal illustrations that act as a
commentary on the text of the Psalms.
In the lower margin of one page a
group of prelates, one holding a long
brush, are shown in the process of
whitewashing an icon. By the time this
Psalter was made, the Iconoclasts had
been deposed and excommunicated.
They were therefore deemed an
appropriate subject for the artist's
visual commentary on Psalm 26 (in
modern numbering) in which the
Psalmist states ' I abhor the assembly
of evildoers' (Psalm 26:5).

BL Add. MS 19352, f. 27v

Icon of the Triumph of Orthodoxy

Constantinople, *c.*1400
Virgin and Child and Saints

The subject of this icon is the Triumph
of Orthodoxy, a feast or holy day
celebrated in the Eastern Orthodox
Church. It depicts prominent *Iconodules*
(from the Greek *eikonodoulos* 'one who
serves images'), including perhaps the
most famous advocate of the venera-
tion of images, St Theodore (759–826),
who as abbot provided an organisa-
tional structure for the Studios
monastery in Constantinople that
became the model for Byzantine
monasticism. He is pictured in the
centre, holding a small icon, directly
below the central icon of the Virgin
and Child. He also appears in the
marginal scene in the Theodore Psalter
(left) made for a later abbot of Studios.
Directly to the left of the Virgin
and Child is the Empress Theodora
(r. 842–56), who was responsible
for the reintroduction of icons. Both
she and her small son, the Emperor
Michael III (r. 842–67) appear in
imperial dress. To the right is St Metho-
dios I, Patriarch of Constantinople
(r. 843–7), who implemented the
new policy on icons.

British Museum, P&E 1988, 4-11.1C

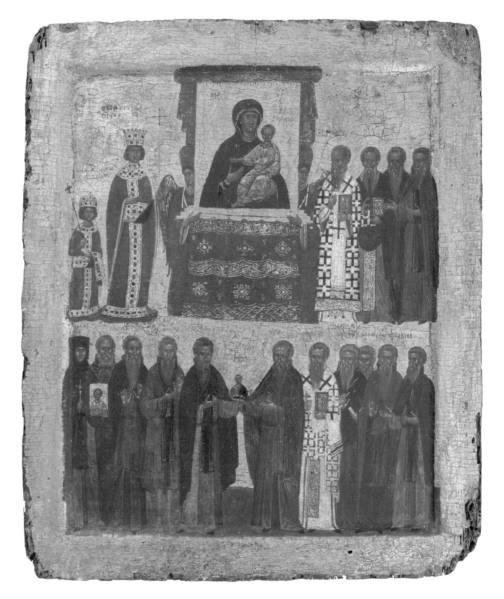

The Cotton Genesis

Egypt?, fifth or sixth century
Abraham with angels

Although tragically damaged by fire in 1731, this manuscript in Greek still forms a landmark in the history of biblical illustration. When first produced, it contained a uniquely full sequence of over 300 illustrations of the book of Genesis. Its survival has raised the question of whether other books of the Bible were profusely illustrated in the early Christian period. It also retains crucial evidence of the highly accomplished technique of late antique book painting, despite the shrinking of the parchment leaves in the fire to about half their original size. In this fragment Abraham greets, or possibly pleads with, the angels sent by God to destroy Sodom. Parts of the Greek text written in majuscule letters are legible above and below the image.

BL Cotton MS Otho B VI, f. 26v

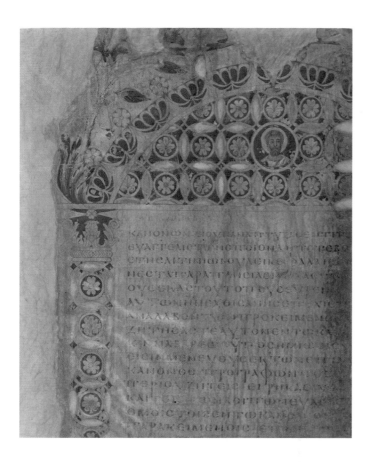

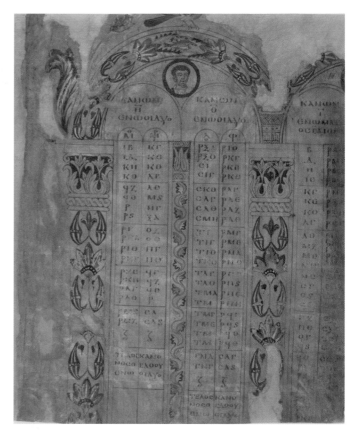

The Golden Canon Tables

Constantinople?, sixth or seventh century
Preface, Canon tables 8-10

These two leaves are all that survives of an extraordinary deluxe manuscript of the Four Gospels. Written on gold, and painted with great skill, they are arguably the most splendid fragments to survive from the early Christian period. Their text is part of the Canon tables, a concordance that enables the reader to trace similar passages in the other Gospels, together with the preface explaining how to use them. The tabular layout presented artistic opportunities for embellishment; most commonly, an architectural frame was created around the text. Here the frames are augmented by medallion busts of the Apostles. On the right are Canon tables eight to ten, identifying the parallels between Sts Matthew and Mark, and between Sts Luke and John, as well as passages that occur in only one Gospel. An efficient tool for study and comparison, the tables in their decorated frames also served as an elegant introduction or 'gateway' to the Gospels.

BL Add. MS 5111, ff. 10–11

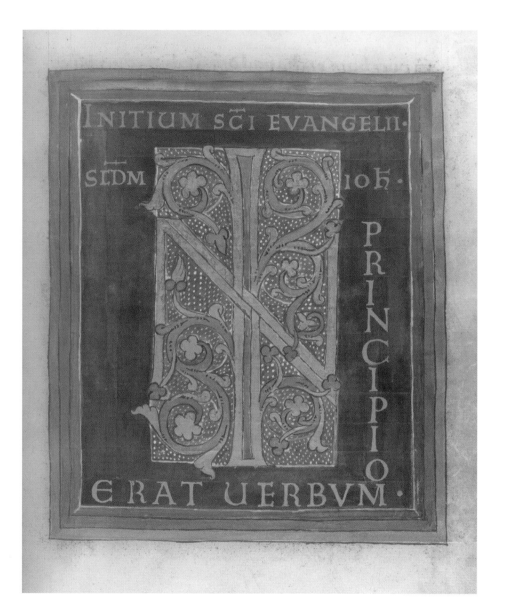

The Odalricus Peccator Gospel Lectionary

Lorsch?, near Worms, Germany,
first quarter of the eleventh century
John 1

In this opulent lectionary with initials
and illustrations in silver and gold,
each Gospel text is arranged according
to its use in services throughout the
liturgical year. It takes its name from a
prominent inscription at the beginning
of the manuscript written in gold:
'God, be merciful to Odalricus, a
sinner'. Odalricus may be the manu-
script's scribe or artist, or perhaps its
patron. The book includes portraits of
the Evangelists and richly decorated
text. In the centre of the rectangle the
first word of St John's Gospel '*In*' is
so highly patterned and decorated with
foliage and precious materials as to be
almost obscured.

BL Harley MS 2970, f. 8

The Grimbald Gospels

Canterbury or Winchester, England,
first quarter of the eleventh century
*Saints adoring the Virgin Mary and Christ;
John 1*

Decoration and embellishment can be
functional as well as beautiful, enabling
a reader to find textual divisions. As in
many medieval copies, the beginning
of each Gospel in this richly decorated
manuscript takes up an entire page,
with the first phrase or verse in capital
letters. The gold letters at the start of
St John '*In prin[cipio erat] verbum et
verbum erat apud D[eu]m et D[eu]s erat
verbum*' (In the beginning was the
Word, and the Word was with God,
and the Word was God) are sur-
rounded by the further elaboration
of a full border. At the top of the page
angels hold a gold medallion of the
Virgin and Child, perhaps a reference
to the incarnation of Christ described
later in St John's first chapter.

BL Add. MS 34890, f. 115

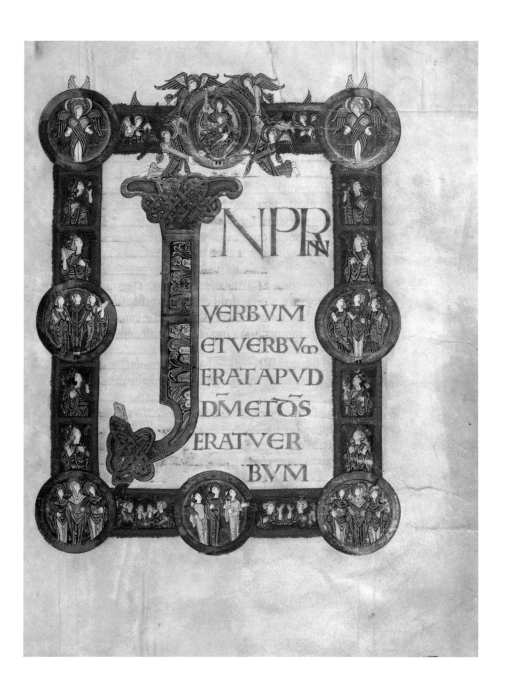

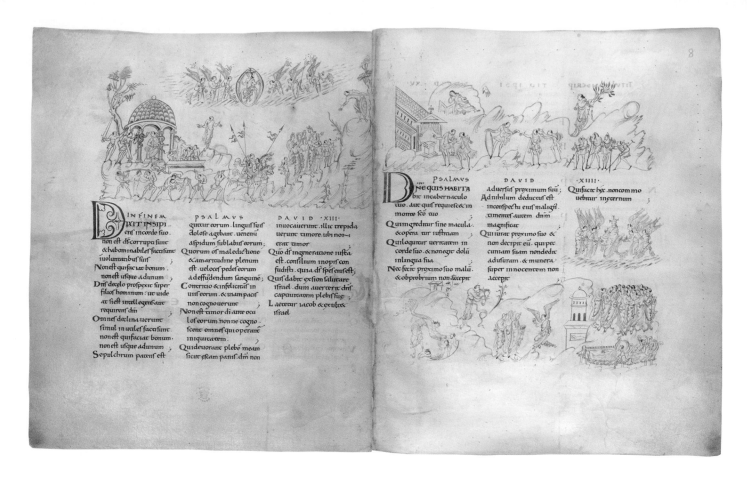

The Harley Psalter

Canterbury, England, first half of the eleventh century
Psalms 14–15 (13–14)

This manuscript, one of the greatest masterpieces of late Anglo-Saxon book decoration, is the earliest of three surviving copies of a remarkable Carolingian manuscript, the Utrecht Psalter, which was apparently brought to Canterbury in the late tenth century. Its line drawings are much livelier and more full of movement than those of the Carolingian original. In other respects the greater part of the illustrations are remarkably true to its model, which illustrates the Psalms by translating them virtually phrase-by-phrase into visual form. On the left, 'the Lord looks down from heaven' seated in the sky surrounded by angels, to find that men are 'evildoers', shown fighting (Psalm 14:2–4). The Psalmist then asks 'who may dwell in your sanctuary?' and on the next page, Psalm 15 is illustrated by those who 'whose walk is blameless' including a man (in the centre of the upper image), representing those who 'lend money to the poor without interest'.

BL Harley MS 603, ff. 7v–8

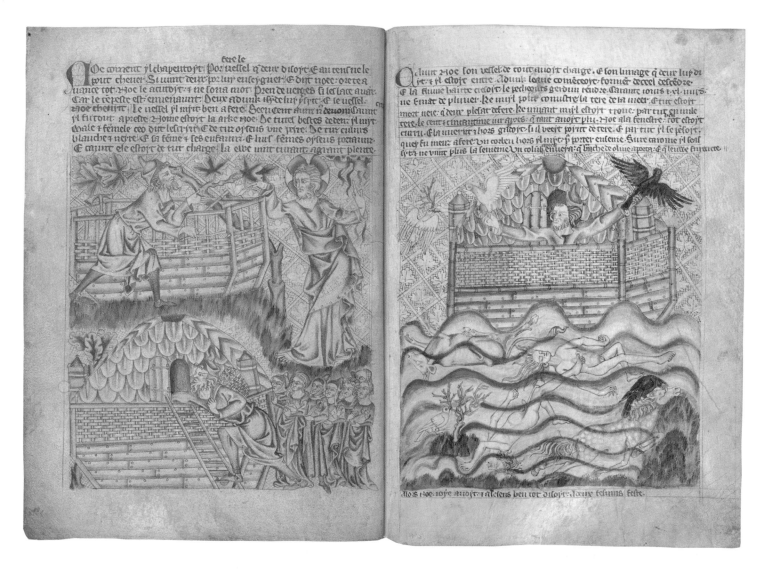

The Holkham Bible Picture Book

London?, England, second quarter of the fourteenth century
Noah and the Ark

Within the unique sequence of illustrations preserved in the Holkham Bible Picture Book, apocryphal episodes and details drawn from late medieval life have been woven into a biblical narrative extending from Creation to the Last Judgment. The Dominican friar for whom they were made, perhaps as a teaching aid for the rich and powerful, is depicted at the opening of the Bible instructing the artist, 'Now do it well and thoroughly, for it will be shown to important people'. To help in his instruction the illustrations are accompanied by brief explanatory texts in Anglo-Norman French, the literary language most familiar to contemporary English nobles. Separate episodes are sometimes conflated in a single illustration, as with the dove on the right, which is seen being released by Noah, finding an olive branch and returning with it in its mouth.

BL Add. MS 47682, ff. 7v–8

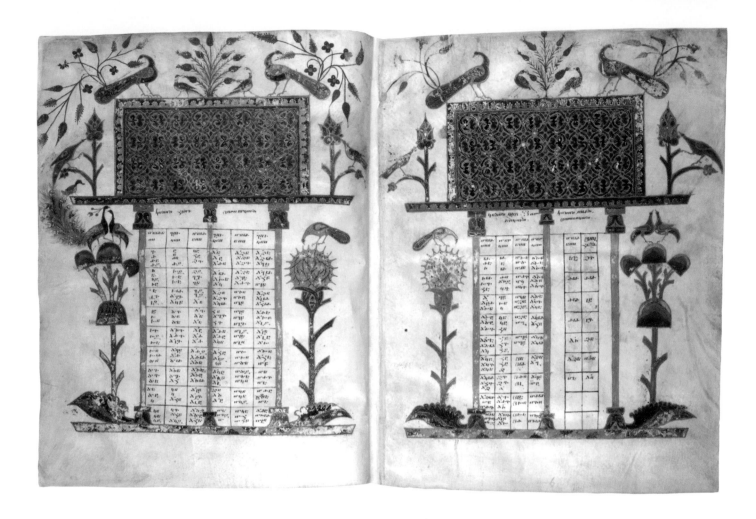

The Awag Vank' Gospels

Armenia, 1200–2
Canon tables 5-6 (left), and 7-10 (right)

Like the Golden Canon Tables (see page 119), the Eusebian Canon tables reproduced here enabled readers to locate parallel passages in different Gospels. The columns identify passages common to two Gospel accounts, except for the column on the far right, which is the last table identifying passages that occur in only one Gospel. This copy of the Four Gospels is the most important Armenian manuscript in the Library's collection. It is lavishly illuminated, as demonstrated by the rich and inventive decoration of these tables, including trees and plants, and peacocks and partridges. It was commissioned for the monastery of Awag Vank', near Erzindjan (modern Erznka) in Armenia, and created there. Like so many manuscripts in this exhibition, particularly those from Armenia, these Gospels have had a chequered life. An inscription in the manuscript dated 1605 comments on the persecution of Christians, noting that '...we have been destroyed from the foundations, and we have fled and come to the metropolis Constantinople, and we have brought this wonderful Gospel with us'.

BL Or. MS 13654, ff. 5v-6

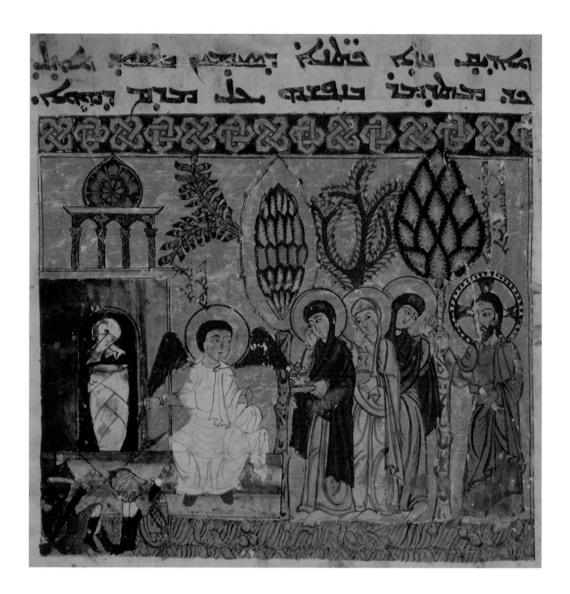

Syriac Gospel Lectionary

Northern Iraq, 1216–20
Holy Women at the Tomb

This is one of the finest examples of the very few extant large, profusely illustrated Syriac codices produced in northern Iraq between *c*.1190 and 1240. The image of the Holy Women visiting the tomb of Christ illustrates the text of St Matthew, in which he recounts that at dawn on the first day of the week St Mary Magdalene and the other Mary went to the tomb and saw an angel, who said to them: 'Do not be afraid, for I know that you are looking for Jesus, who was crucified.

He is not here; he has risen, just as he said' (Matthew 28: 5–6). The manuscript shows a strong Byzantine influence in the choice of texts and style of illustrations. However, many of the details of the illustrations, such as trees, rocks, architecture, and much of the clothing, are Islamic in style.

BL Add. MS 7170, f. 160 (detail)

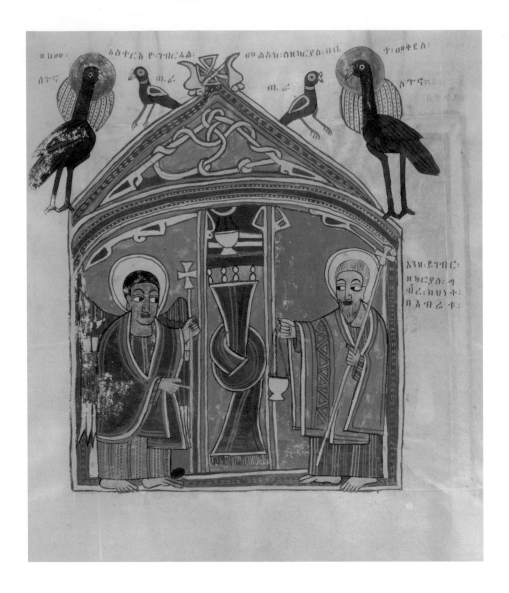

Octateuch, Gospels and Ecclesiastical Works

Ethiopia, late seventeenth century
Annunciation to Zacharias

The Gospel of St Luke begins with a description of the events surrounding the birth of St John the Baptist. According to his account Zacharias, a priest, was burning incense in the Temple of the Lord when the angel Gabriel appeared to him and told Zacharias that he would have a son, who would 'make ready a people prepared for the Lord' (Luke 1:17). This event is shown here: Zacharias is on the right, holding a censer. The Temple in Jerusalem is shown as

if it were a circular, Ethiopian church. Inside, both the angel and Zacharias hold staves with crosses, similar to the processional crosses that are used in Ethiopian services (for a sixteenth-century example, see page 169). Ostriches on either side of the roof recall pairs of peacocks in images representing the Fountain of Life, often represented in Canon tables.

BL Or. MS 481, f. 99

The Four Gospels in Armenian

Tayk, 1313
Sts Gregory and Ephraim

The two saints shown here standing side by side represent the two most prominent figures in Eastern Christianity. St Gregory, called the Enlightener is shown wearing ecclesiastical vestments coloured black and white, holding a book adorned with coloured stones. St Ephraim the Syrian stands next to him, wearing the garments of a monk, coloured in dull green and brown, with a hood over his head adorned with a cross.

St Gregory (*c.*240–332) was brought up as a Christian while an exile in Cappadocia. In 280 he returned to Armenia and succeeded in converting King Trdat to the Christian faith, which then became the state religion of the country in 301. St Ephraim, the Syrian (306–73), was the son of a pagan priest at Nisibis, his native town, who was ordained a deacon by St James of Nisibis, and accompanied him to the Council of Nicaea in 325. St Ephraim's voluminous exegetical, dogmatic, and poetical works, include a commentary on the Diatessaron by Tatian (see page 73). The unique features of this exceptional manuscript are that the entire text of the Gospels is in classical Armenian, the illuminations have inscriptions in Georgian, and the saints depicted in the miniatures are those representing the church before the schism of 451, that is, those accepted by the undivided church.

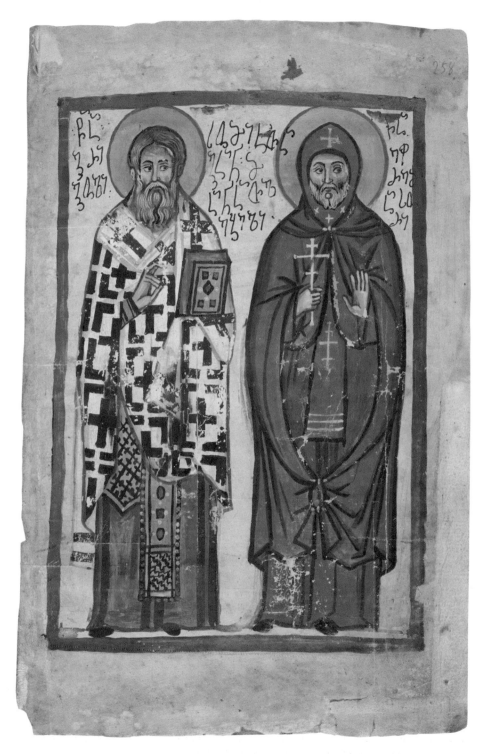

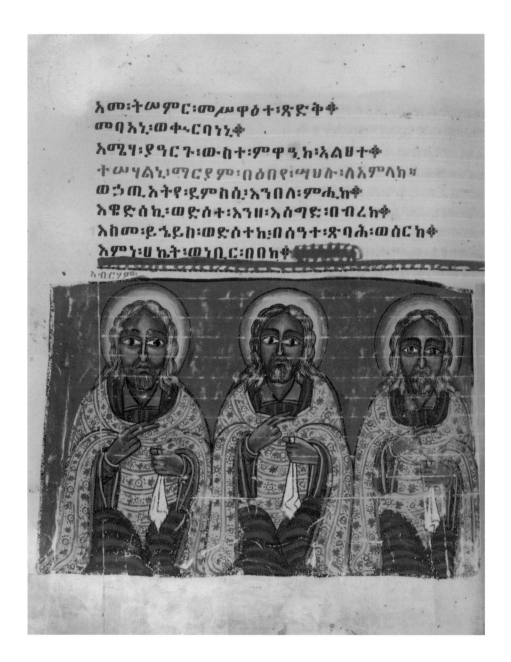

Psalter, Hymnal and Song of Songs

Ethiopia, eighteenth century
The Holy Trinty

The Holy Trinity is one of the most popular themes in Ethiopian painting. In this depiction there are three images of men who are facially identical, with long white wavy hair. They are dressed as Ethiopian clergymen, and each holds a handkerchief in his left hand and makes the sign of blessing with the other.

BL Or. MS 538, f. 51v

A Book of Homilies

Egypt, 989–990
The Repose of St John
St John; Virgin and Child

This manuscript contains a collection
of hagiographical texts, including the
apocryphal work entitled the *Repose of
Saint John*. The copy is decorated with a
number of full-page images, including
this one of a standing St John, holding
a book, probably his Gospel, and the
Virgin suckling the Christ Child. The
text was copied by Philotheos the Dea-
con at Hrit in the Faiyum oasis, south
of Cairo. Although the Virgin holds her
breast with her hand, her index finger
is extended pointing to the Child, who
is seated frontally, and she is seated on
a throne. This imagery may be a modi-
fication of the standard Byzantine im-
agery of the Virgin as *Hodegetria* (One
who shows the way), in which the
Virgin points to the Child as the
Messiah, shown as a small adult
rather than an infant.

BL Or. MS 6782, f. 1v

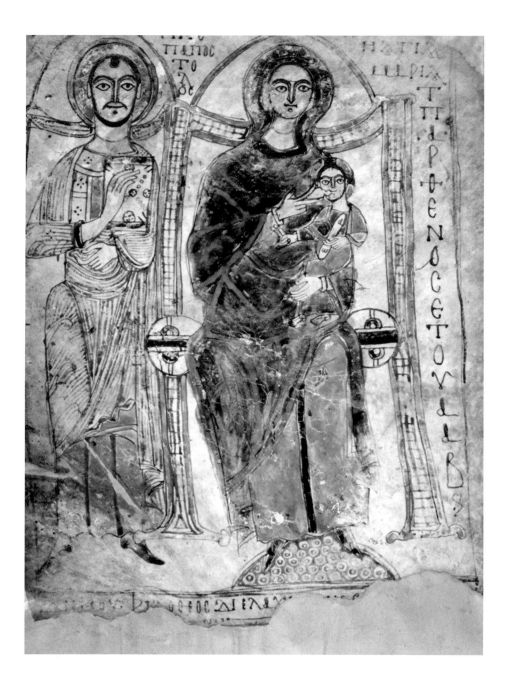

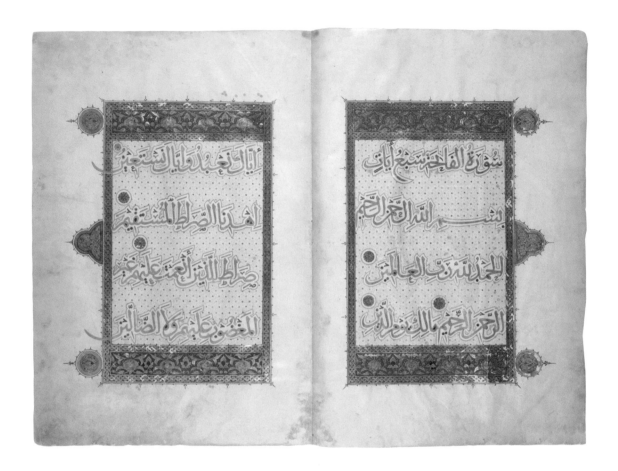

Sultan Baybars' Qur'an

Cairo, 1304–6
Chapter 1, *al-Fatihah* (The Opening)

Produced in Cairo, this Qur'an is named after the Mamluk ruler Rukn al-Din Baybars al-Jashnagir (r. 1309), who commissioned it. It is the earliest dated Qur'an of the Mamluk period. During this time Rukn al-Din Baybars was not yet a sultan, but a high chamberlain in the court of al-Nasir Muhammad (r. 1299–1340). Only later, between 1309 and 1310, did he acquire the title of al-Muzaffar Baybars, or Sultan Baybars II.

The calligraphic script used in this Qur'an is *thuluth*, written throughout in gold. This was a rare choice for copying an entire Qur'an, as it was generally used for ornamental headings. The calligrapher was Muhammad ibn al-Wahid and this Qur'an is the only surviving example of his work. The Baybars Qur'an was sumptuously illuminated by a team headed by the master illuminator Abu Bakr, who was also known as Sandal. It presents the sacred text in seven volumes – a rare arrangement – each containing a *sub'* (seventh) of the Qur'an text. Each volume has a magnificent double frontispiece, these carpet pages being illuminated in the Mamluk style characterized by the extensive use of geometric patterns and gold filigree work.

BL Add. MS 22406, ff.2v-3

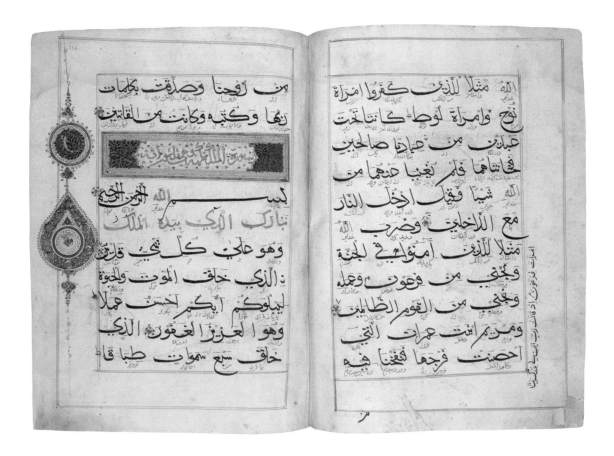

Qur'an with Interlinear Persian Translation

India, early sixteenth century

Scripts in various styles and colours were employed not only for decorative purposes: they often had a more functional role, highlighting specific words or sentences. This was to help the reader to identify the hierarchy of the texts where there is more than one text on the page, and was particularly important for those pages that carry not only the sacred text, but also a translation of the original Arabic. An example of this is demonstrated in this Qur'an from India, copied around 1500, during the rule of the Delhi sultans. The text, in black ink, is in a variety of *naskhi* script known as *bihari*, named after the province of Bihar in northern India with which this style of script became associated. The Persian translation is written between the lines and is penned in red *naskhi* in a minute hand (not intended to diminish the status of the sacred text). Emphasis is given to the word *Allah* (God), the name being highlighted in blue throughout the text, and in gold where mentioned in the pious *basmalah* or invocation (In the name of God) beneath the illuminated chapter heading.

BL Add. MS 5551, ff. 135v–136

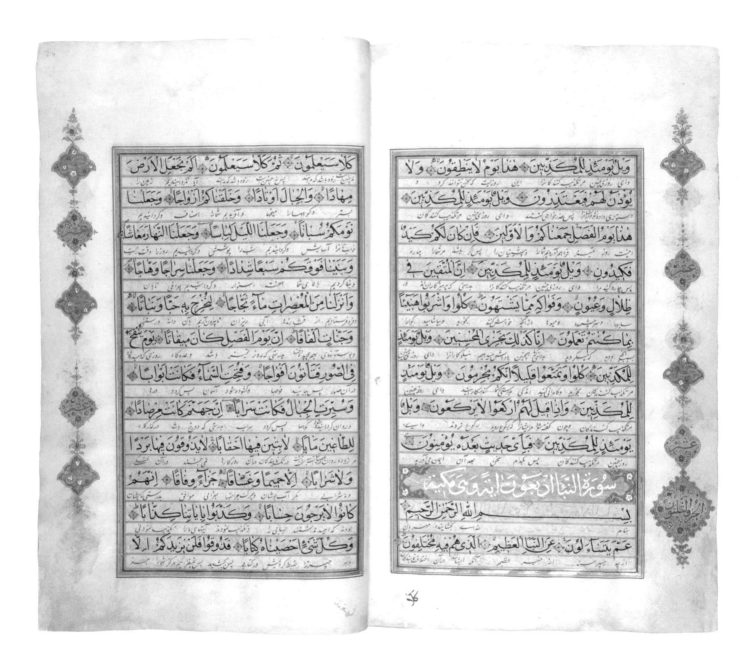

Qur'an with Interlinear Persian Translation

Persia, seventeenth century
Chapter 77, *al-Mursalat*
(The Emissaries), verse 34 to
Chapter 78, *al-Naba'* (The Tidings),
verse 30

While using different scripts and coloured inks to differentiate between the original Arabic text and its translation, the two texts are here presented together within a rectangular structure that resembles the *mistarah* (ruling frame) used by scribes for ruling lines on paper. The Qur'an text in black *naskhi* script alternates with its interlinear Persian translation written in a small red *nasta'liq* – a Persian script developed in the late fifteenth century. The individual marginal medallions in this Qur'an join up to form a verse counter, the ornamental instructions here being in *thuluth* script rather than in archaic *kufic*. The alternating scripts find their counterpart in the marginal ornaments, where the gold on blue of the fifth verse marker contrasts with the blue on gold of the tenth verse marker.

BL Or. MS 13371, ff. 313v–314

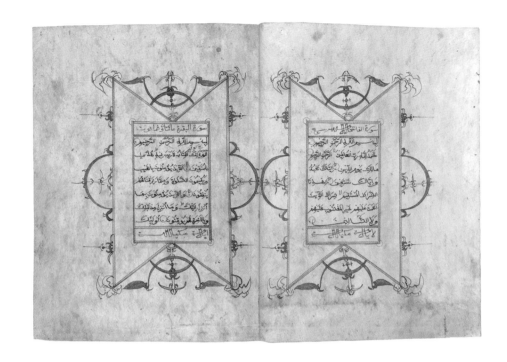

Qur'an

Java, nineteenth century
Chapter 1, *al-Fatihah* (The Opening) and the beginning of Chapter 2, *al-Baqarah* (The Cow)

The decorated first opening of text here is unusual in the simplicity and starkness of its abstract design, with each ornamental frame – dramatically outlined in black and red ink – fully symmetrical on a central axis. While the text area on each page is enclosed within a lozenge with a v-shaped indentation at top and bottom, the simplicity of the design, with its restrained use of colour, is maintained and remains uncluttered, despite the ornamental tendrils and finials, and the large and small semicircles that protrude into the margin.

Qur'an manuscripts in the Malay world were written on paper. Being locally produced, the paper used for Qur'ans in Java was of a particular kind called *dluwang*, made from the beaten bark of the mulberry tree.

BL Add. MS 12312, ff. 1v–2

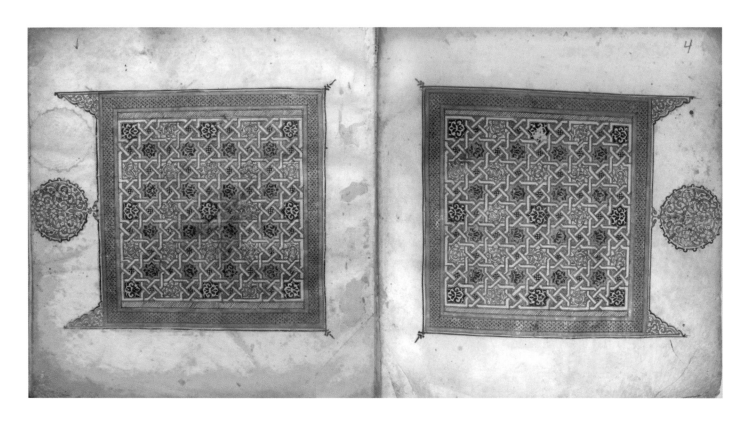

Carpet Page from a Qur'an

Morocco, fourteenth century
Part 23 of a Qur'an originally in thirty volumes

The design of this magnificent carpet page and the style of its
illumination are typical of decorative frontispieces produced
in North Africa and Andalusian Spain. Gold, red, blue and
green are the colours most often used in the decoration of
manuscripts from this region. The most prominent feature of
this carpet page is the geometric frame formed by the inter-
locking squares and octagons outlined in white ink and filled
in with arabesques – namely, interwoven flowing patterns of
floral motifs. Gold interlaced strapwork borders the whole of
the frame, to which has been attached a large medallion of
gold filigree outlined in blue.

The Royal Library, Marrakesh, Manuscript No. 4, ff. 4v-5

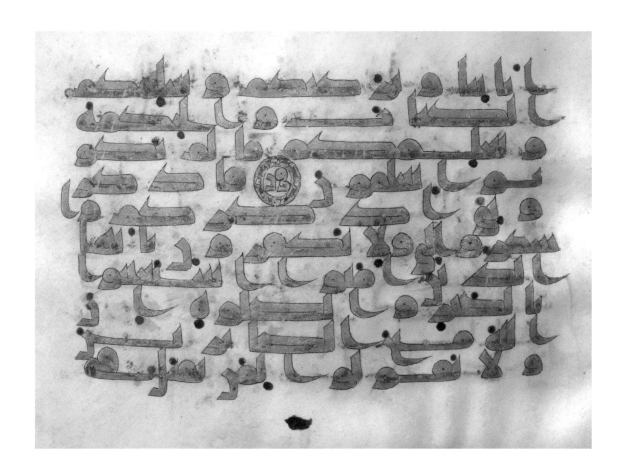

Qur'an in Gold Kufic Script

Morocco, *c*. twelfth century

The use of parchment as a choice of material for writing Qur'ans continued in North Africa until the fourteenth century, no doubt because the introduction of paper manufacture came late to this region. The effect here of gold script on parchment, together with the red and blue dots indicating the vowel signs, which aid pronunciation, is visually striking. The script in this manuscript is a fine example of old *maghribi-kufic*, the origins of *maghribi* having been derived from western *kufic*, which developed in Tunisia during the tenth century.

The Royal Library, Marrakesh, Manuscript No. 286, f.32

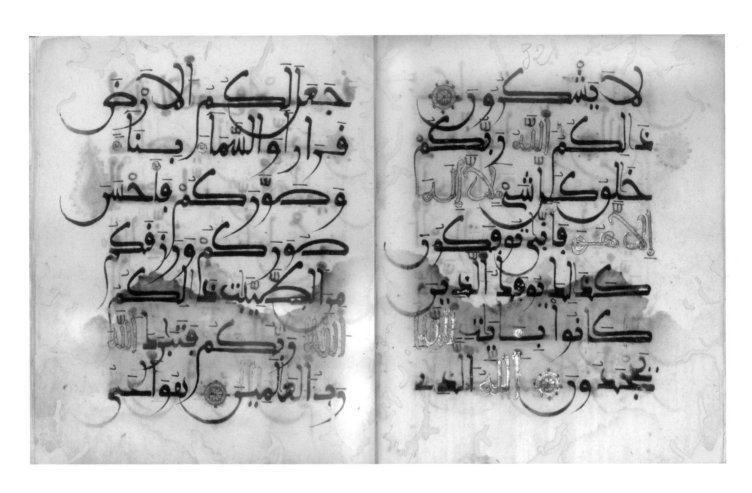

Qur'an

Morocco, sixteenth century
Illumination of the Divine Name

The *maghribi* script written here on parchment, with its
sweeping curves below the line and the pronounced round-
ness and lengthening of some of its letters, gives these pages a
sense of space and movement. Most striking in this Qur'an is
the use of gold to give prominence to the name of *Allah* (God)
when it appears in the text. This is a visual highlighting of the
divine name, which is reminiscent of the practice *dhikr Allah*
(among Sufis in particular) of verbally invoking God's name.

The Royal Library, Marrakesh, Manuscript No. 616, ff. 32v-33

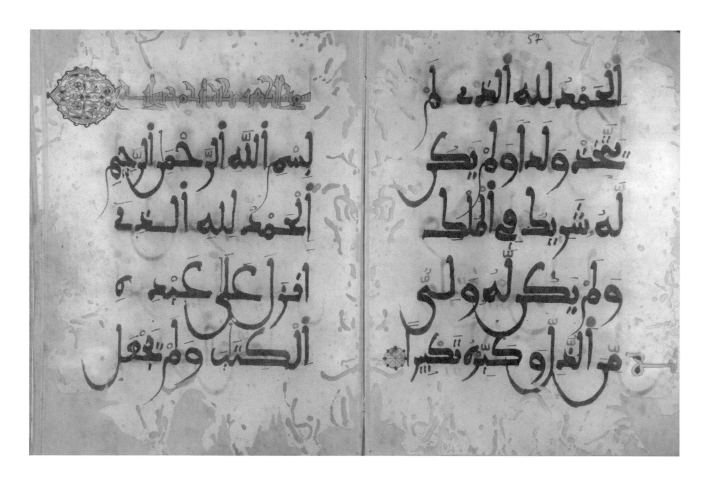

Section from a Ten-volume Qur'an

Morocco, thirteenth century

This Qur'an was copied in Marrakesh about the year 1256 in the handwriting of Abu Hafs 'Umar al-Murtada, the Almohad Sultan of Morocco, who reigned from 1248 to 1266. It is written on parchment in an old *maghribi* script.

Bibliothèque Nationale, Rabat, No. 47 1755, ff.57v-58

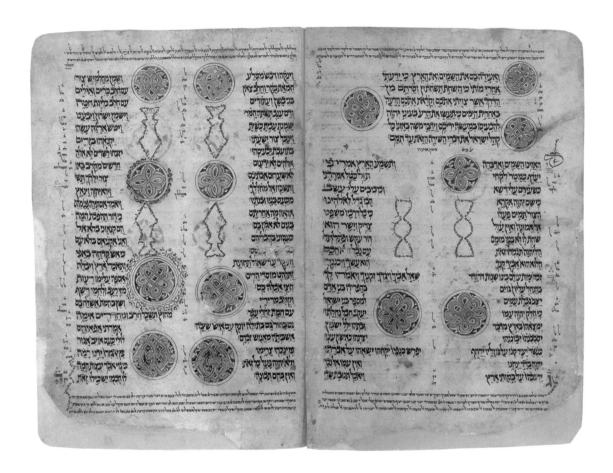

Medallions in a Jewish Manuscript

San'a Pentateuch
Yemen, 1469
The poem *Give Ear*; *Deuteronomy 32*

Penned in Hebrew square script in a typical Yemenite hand is a section from Shirat Ha'azinu – *Give Ear* – a lyrical poem Moses recited in front of the Israelite congregation before his death (Deuteronomy 32). The masoretic notes, which record peculiarities in the biblical text, were added in the lower and upper margins and between columns. Although the scribe did not sign his name in the colophon, the calligraphy and layout of the manuscript evoke the style of Benayahu ben Se'adyah ben Zeharyah ben Margaz, a major Yemeni scribe (d.1490). Hebrew manuscripts from Islamic lands were devoid of figurative imagery and their decoration was generally a combination of typically Jewish elements and adapted Islamic motifs. This is an example of non-figurative art, with Islamic-style fillers and decorative micrography.

BL Or. MS 2348, ff.151v-152

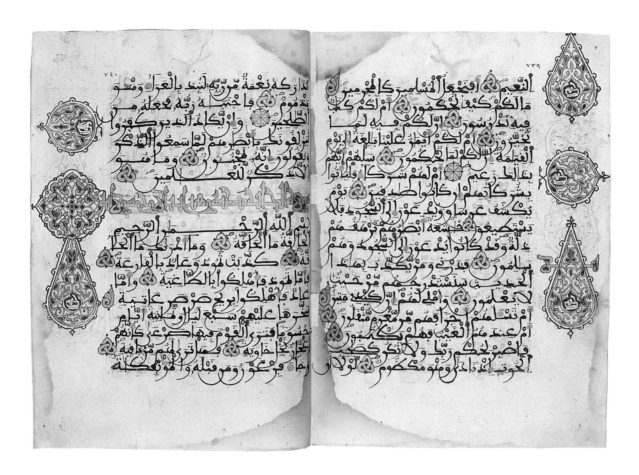

Medallions in an Islamic Manuscript

Moroccan Qur'an
Morocco, 1568
Chapter 68, *al-Qalam* (The Pen), verse 34 to Chapter 69,
al-Haqqah (The Reality), verse 9

This Qur'an is written in *maghribi* script. The illumination in the margin and within the text is not only decorative, but also functional. The pear-shaped medallions, their gold arabesque designs outlined in blue and picked out in red and green, contain the word *khams* (five) in white *kufic* script, each positioned near the line of text that contains the end of a fifth verse. The marginal large roundels containing the word *'ashr* (ten) in white *kufic* script are functionally placed to indicate the end of a tenth verse. The letter *ha'* in gold is also inserted

within the text to mark the end of a fifth verse, *ha'* having the numerical value of five in the Arabic alpha-numeric system. A tenth verse is indicated by the insertion of a gold roundel, while gold knots indicate the end of the other verses. It was commissioned by the Sharifi Sultan, 'Abd Allah ibn Muhamamad.

BL Or. MS 1405, ff. 370v–371

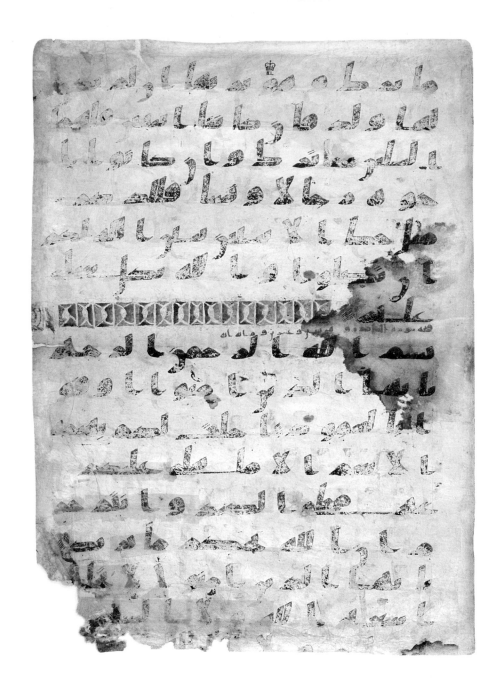

Illumination in An Early Qur'an Manuscript

Qur'an
Arabia, eighth century

Early Qur'ans usually distinguished between the end and beginning of chapters by leaving between them a recognizable space that could be filled with a horizontal illuminated band, as seen in this fragment. When chapter headings were later introduced, the wording stated the name of the chapter, the number of verses and whether the particular chapter was revealed in Mecca or Medina. In this fragment the chapter title in red ink is a later addition.

BL Add. MS 11737, f. 1

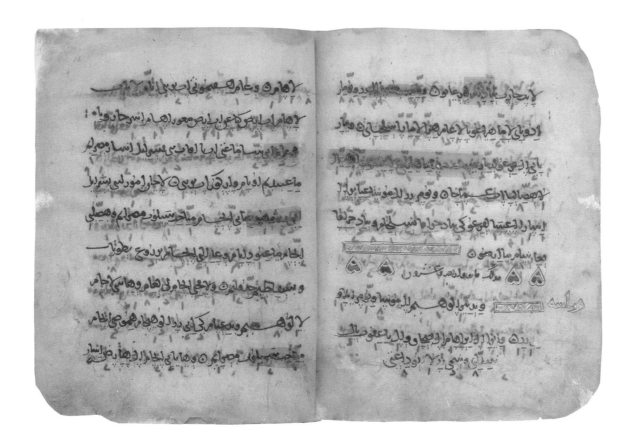

Illumination in a Jewish Manuscript

Karaite Book of Exodus
Palestine or Egypt, *c.* tenth century
Exodus 5:21–6:8

In this manuscript the Hebrew biblical text was written in Arabic *naskhi* script. The vowels were added in red ink, while the accents and diacritical marks were added in green. As in early Qu'rans, the ornamentation here is functional, consisting primarily of decorative fillers that indicate the end of verses, the beginning of chapters and other major textual divisions. The right-hand page shows the end of Exodus 5, marked by gilded zigzag bands and heart-shaped motifs. The pericope *Va-Era* (starting in Exodus 6:2) is introduced by a golden, intertwined chain and the Hebrew word *parashah* (portion), which was inscribed in large Arabic characters in the margins.

Why the Karaites (a Jewish sect founded in the eighth century) transcribed the Hebrew Bible into Arabic remains uncertain. Perhaps this represented an attempt on their part to arrive at a correct reading tradition for the Bible which they considered far superior to the masoretic version.

BL Or. MS 2540, ff. 15v–16

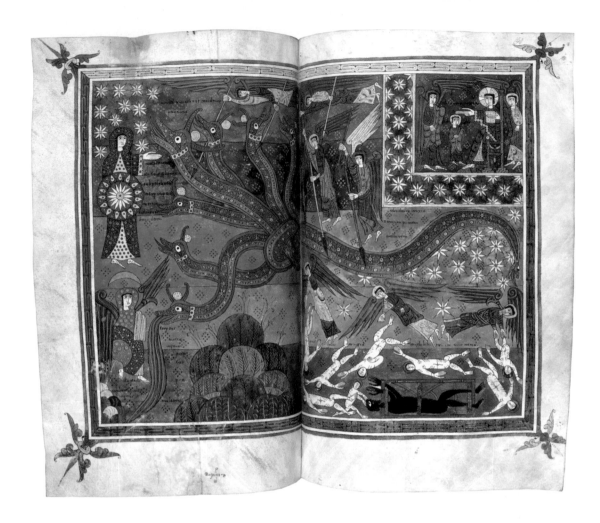

Apocalyptic Vision in a Christian Manuscript

The Silos Apocalypse
Silos, Spain, 1109 (decoration)
The Dragon (Serpent) and the Woman of the Sun

The Silos Apocalypse is one of over twenty copies of a commentary on the book of Revelation illustrated in medieval Spain. It includes eighty-two images accompanying the Latin text of St John's vision of the Apocalypse, executed in a bold and dramatic style. This powerful opening is a vision of a great battle between good and evil. It illustrates events described in chapter twelve, in which a great dragon with seven heads and ten horns sweeps away a third of the stars with his tail. He confronts a woman 'clothed with the sun' who is given the wings of an eagle to fly into the desert, shown in the lower left. She appears again immediately above this, with twelve stars encircling her head, and the sun in the centre of her body. St Michael and his angels fight the dragon, 'that ancient serpent called the devil, or Satan', who in the form of Satan in the lower right, is shown cast down and locked in a form of stocks, with other fallen angels around him. In the upper right the child of the woman, 'who will rule all the nations', is brought to the throne of God, being blessed by a seated figure with a cruciform halo.

BL Add. MS 11695, ff. 147v–148

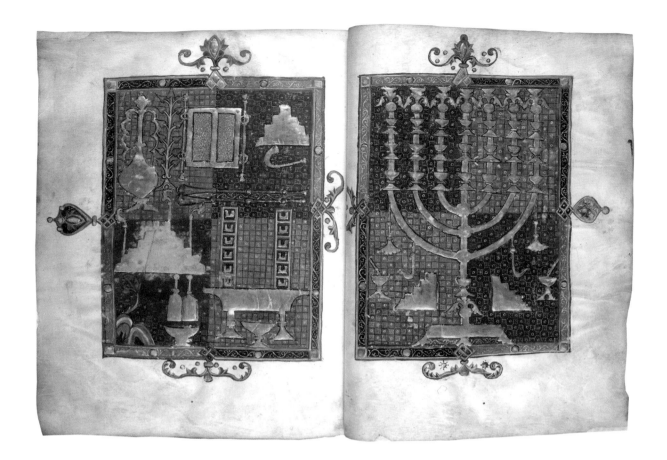

Messianic Vision in a Jewish Manuscript

Duke of Sussex's Spanish Bible
Catalonia, Spain, mid-fourteenth century
Temple vessels

The magnificently painted utensils in these carpet pages are effectively a combination of the contents of the Desert Tabernacle, the Solomonic and Herodian Temples and the future Messianic Temple, as described in biblical and other sources (Rashi and Maimonides). The *menorah* (seven branched candlestick), the Ark of the Covenant, the Jar of Manna and other furnishings that once stood in the Temple, were executed in raised burnished gold on coloured tooled grounds.

The stylized Mount of Olives painted in the lower outer corner on the left-hand page alludes to Zechariah's messianic vision (Zechariah 14:4). Known as *Mikdashyah* (Lord's Sanctuary), the Hebrew Bible was regarded by the Jews of Spain and North Africa as a substitute for the destroyed Temple in Jerusalem. Representations of its holy vessels and the Mount of Olives thus expressed the traditional Jewish longing to rebuild the Temple in messianic times. The theme of messianic hope inherent in these images evolved against the background of heated Jewish-Christian religious polemics and fierce Jewish persecutions in late medieval Christian Spain. Accordingly, the portrayal of the sacred vessels can also be seen as a forceful statement of Jewish continuity, self-definition and resilience. The messianic imagery found in these particular Hebrew Bibles is unique. Crystallized in Spain in the thirteenth century, it had no apparent antecedent in Christian and Jewish art.

BL Add. MS 15250, ff. 3v–4

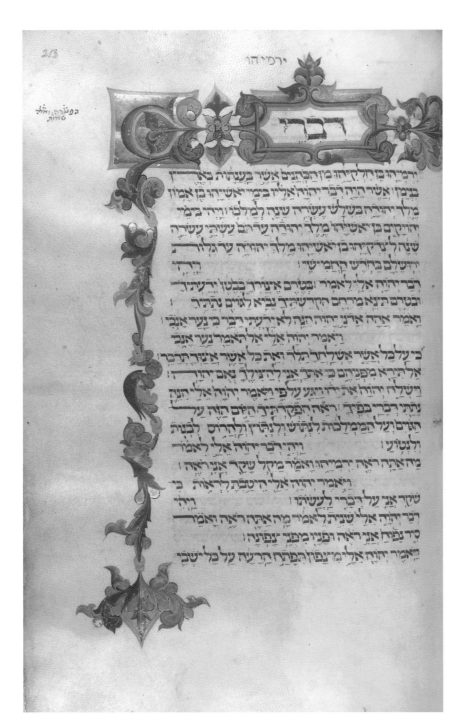

The Decorated Word in a Jewish Manuscript

Former and Latter Prophets
Italy, fourteenth century
Jeremiah 1

This codex abounds in finely embellished initial word panels that mark the beginning of each of the prophetical books, a common feature in medieval Hebrew manuscripts. Since the Hebrew alphabet lacks upper-case characters, Jewish scribes usually decorated the first words of text rather than letters. *Divre* (meaning 'the words of') is the opening word of the book of Jeremiah, and was inscribed in a rectangular panel bordered by foliage in rich shades of pink, red, green and dazzling blue. The elegant decoration, enhanced with gold leaf inlays, evokes an Italianate style, suggesting that the codex was probably made in Italy. Although the scribe wrote the text in a typical German hand, the manuscript's structure – quires of five sheets each – also suggests an Italian origin. This style of script may have been used because migrant Jewish scribes often retained their native handwriting while adopting decorative techniques from their new environment.

The Decorated Word in a Christian Manuscript

Four Gospels
Northumbria, England, eighth century
Mark 1

Although on a less lavish scale than the Hebrew Former and Latter Prophets (left), the first words of this text, *Initium ev[angelii]* (Beginning of the Gospel) also become ornament, with the first letter '*I'(n)* adorned with a bird's beak. As in the Jewish book, decorative blocks of text such as these serve to help the reader find divisions in the text: in this manuscript a similar panel appears at the beginning of each of the other Gospels. It was made in the north of England around the same time as the famous Lindisfarne Gospels (see page 110), to which it is related textually. While it is also similar stylistically to that work, the decoration of these Gospels is much more restrained, indicating that the copy may have been designed primarily for use in services rather than for display.

BL Royal MS 1 B VII, f. 55

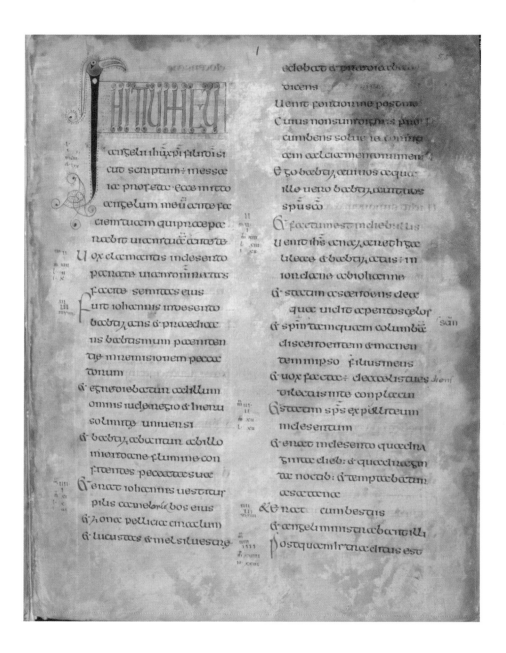

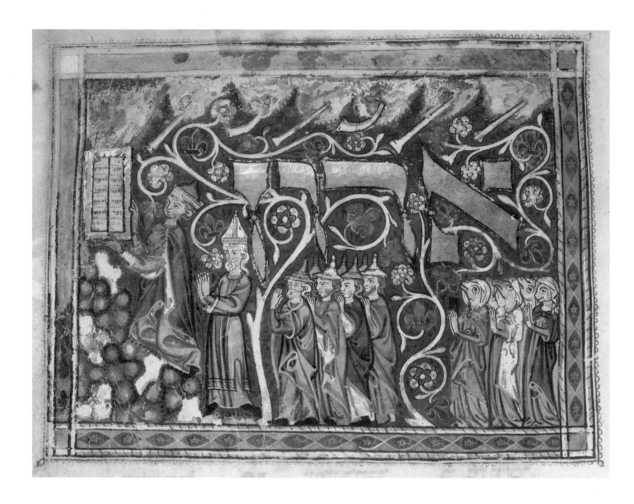

Moses in a Jewish Manuscript

Festival Prayer Book
Southern Germany, *c.*1320
Moses receiving the Law

This decorated word panel shows Moses holding the Tablets of the Law on Mount Sinai (on left of the image) while Aaron and the Israelites stand in prayer. Trumpets pierce the clouds and announce the solemnity of the occasion. Aaron, brother of Moses and the first Jewish high priest, wears a bishop's mitre, which suggests the work of Christian illuminators. The men wear the typical medieval Jewish pointed hat, and have ordinary human features, whereas the women are depicted with animal heads. The distortion of human facial features

was characteristic of illuminated Hebrew manuscripts from southern Germany in the Middle Ages. The rationale for these distortions has not been explained satisfactorily. Perhaps, under the influence of the pietistic movements of the period, artists invented these devices mainly to evade the stern prohibition on painting the human form.

BL Add. MS 22413, f. 3r

Moses in a Christian Manuscript

La Somme le roi
Paris?, France, last quarter of the
fourteenth century
Moses receiving the Law

As in the German Festival Prayer Book
(left), this French copy of *La Somme le
roi* includes a full-page depiction of
Moses receiving the Law from God.
Sometimes known as the *Book of Vices
and Virtues,* this text was compiled in
1279 for the French king Philip III ('the
Bold', r. 1270–85) by his Dominican
confessor Frère Laurent. It comprises
a manual of moral instruction, with
treatises on various subjects, including
the Commandments, the Creed, and
the Vices and Virtues. Moses is shown
(upper left) receiving the tablets from
the hand of God. In the lower register
Moses returns from the mountain and
sees his people worshipping a golden
calf. In the upper right he smashes the
tablets. In these images, as is common
in medieval art, Moses is shown with
horns because, after his subsequent
meeting with God, his face became
radiant, or in the Latin translation,
cornutum, meaning 'shining' or
alternatively 'horned'.

BL Add. MS 28162, f. 2v

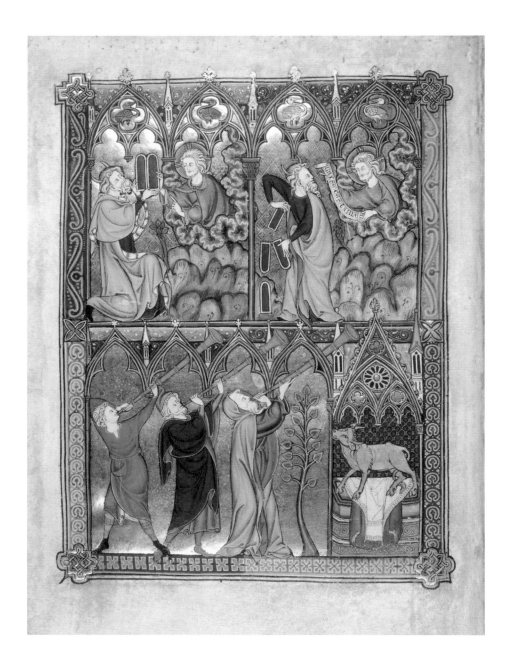

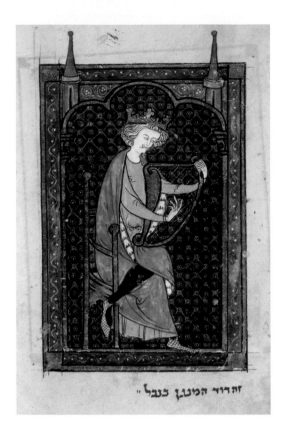

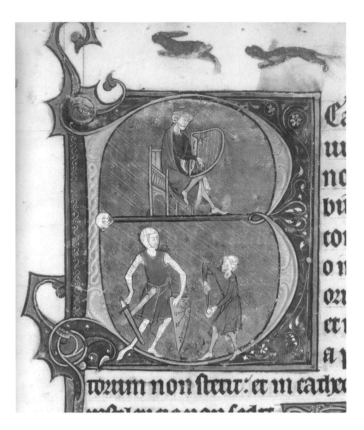

King David in a Jewish Manuscript

The North French Miscellany
Northern France, *c.*1278–98
David playing the harp

King David is a popular subject in Christian and Jewish art, and appears in countless medieval illuminated manuscripts as a shepherd, warrior, writer and in various other guises. Traditionally seen as the author of the book of Psalms, David was also known as a talented musician (I Samuel 16:17; II Samuel 23:1). The Psalms were to be sung with musical accompaniment, and their opening verses often indicate what instruments were used. In this image David is shown crowned, wearing a bright red cloak lined with royal ermine. He is seated crossed-legged in a golden chair playing the harp. Perhaps inspired by imagery in contemporary *Bibles moralisée*s, the biblical miniatures in this Hebrew manuscript were apparently executed by Christian illuminators belonging to three important thirteenth-century Parisian workshops.

BL Add. MS 11639, f. 117v

King David in a Christian Manuscript

Psalter
Paris?, France, last quarter of the thirteenth century
David playing the harp; David and Goliath

The initial at the beginning of Psalm 1 in this French Psalter in Latin is in two registers, and contains two images of King David. In the upper part he plays a harp; in the lower he is depicted just before he killed Goliath with a stone from his slingshot. The inclusion of these scenes in the Psalms became standard in deluxe copies of medieval Christian Psalters and Bibles. Interestingly, almost exactly the same image of David playing his harp can be seen left, in the French copy of a miscellany written for a Jewish patron in Hebrew.

BL Yates Thompson MS 18, f. 9 (detail)

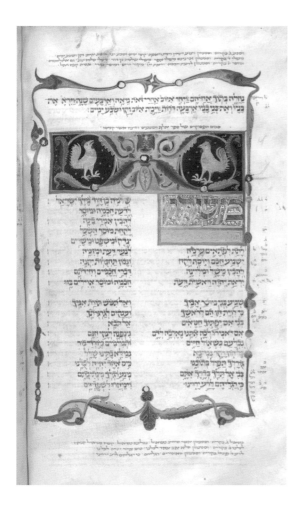

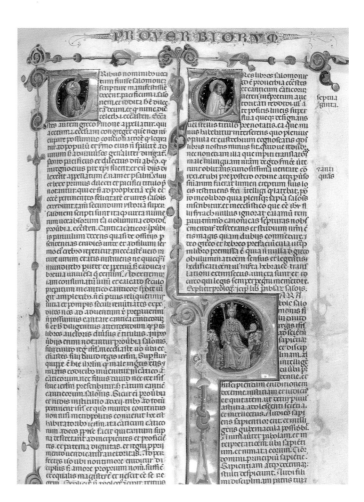

Italian Decoration in a Jewish Manuscript

Italian Hebrew Bible
Italy, *c.*1300
Proverbs 1

The decorated panel exhibited here is composed of a central foliate motif flanked by two blue medallions occupied by decorative, red-crested cockerels facing each other. Beneath it, within a blue and red filigree panel, is the opening word *Mishle* (Proverbs). An outer frame with foliage and grotesques surrounds the text columns. The decoration is typical of the region and the period, and displays fantastic beasts and predominantly blue, grey and red-brown serrated leaves. It is likely that Christian artists were in charge of the decorations. The masoretic notes were added outside the ornamental border.

BL Harley MS 5711, f. 241v

Italian Decoration in a Christian Manuscript

The Bible of Clement VII
Naples, Italy, first half of the fourteenth century
Proverbs 1

The similar origin and date of this Bible and the Italian Bible in Hebrew (left) are obvious from their decoration, despite the difference in their languages and scripts. However, while the two cockerels at the beginning of the Hebrew text are perhaps purely decorative, the Latin text begins with a personification of Wisdom – a crowned woman holding a sceptre and orb. Religious figures also adorn the centre of the first letter 'T' of each of the prologues on this page.

BL Add. MS 47672, f. 233 (detail)

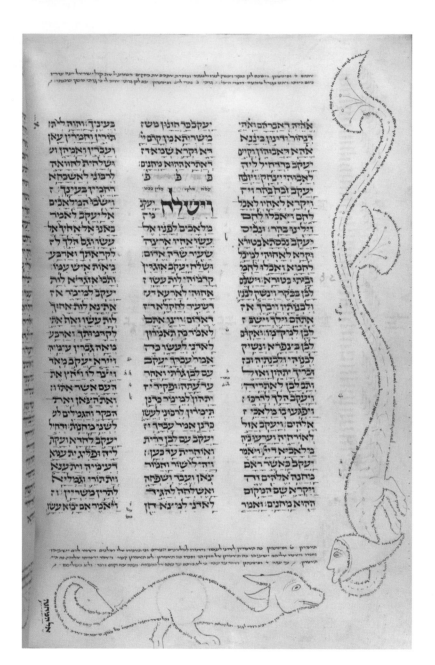

Marginal Creatures in a Jewish Manuscript

Duke of Sussex's German Pentateuch
Germany, *c.*1300
Genesis 32:4

Hybrids, legendary beasts, griffons, dragons and other imaginary creatures were often painted in Hebrew medieval illuminated manuscripts, particularly in Germany. The imagery was probably modelled on contemporary Latin bestiaries. In this example the marginal figures (a hybrid facing a dragon-like creature) are outlined in micrography, a Jewish scribal practice using minute lettering to create abstract and figurative designs. In medieval Hebrew manuscripts, the masoretic notes were the most commonly used texts in artistic micrography. Penned close to the textual columns, these were complex annotations on the biblical text, which kept it intact and safeguarded its correct transmission over the centuries. On this page the masoretic notes were penned in both plain script and decorative micrography. The large bold word in the middle column marks the beginning of the weekly pericope (a Torah portion) *Va-Yishlah,* from the verse 'Jacob *sent* messengers…' (Genesis 32:4). In the lower left corner, behind the creature's tail, is a catchword, a scribal device intended to ensure the correct order of sheets and leaves in a manuscript.

BL Add. MS 15282, f. 45v

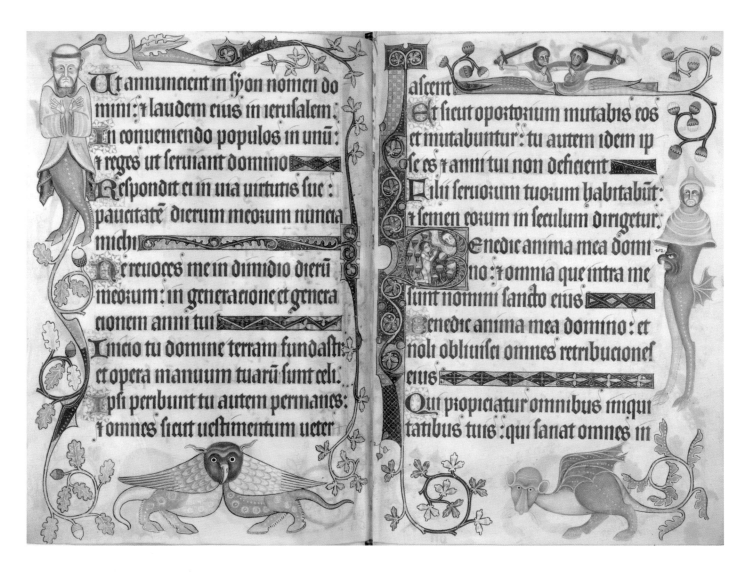

Marginal Creatures in a Christian Manuscript

The Luttrell Psalter
England, second quarter of the fourteenth century
Psalm 103 (102)

The extraordinary marginal illustrations in this manuscript have attracted the interest of scholars and public alike. They adorn a Psalter, a copy of the Psalms, usually preceded by a calendar and followed by various prayers. This copy is known as the Luttrell Psalter after its original owner, identified by his arms and an inscription below a portrait of a knight that reads: 'Lord Geoffrey Luttrell had me made'. As in the Duke of Sussex's German Pentateuch (left), the marginal images in-clude fanciful or imaginary creatures. Many of these must have been products of the artist's imagination, and seem unre-lated to the text they accompany. Like those in the Hebrew manuscript, they also terminate in leafy foliage. On this page they form a striking contrast to the more clearly religious imagery of a praying man that appears in the initial.

BL Add. MS 42130, ff. 179v-180

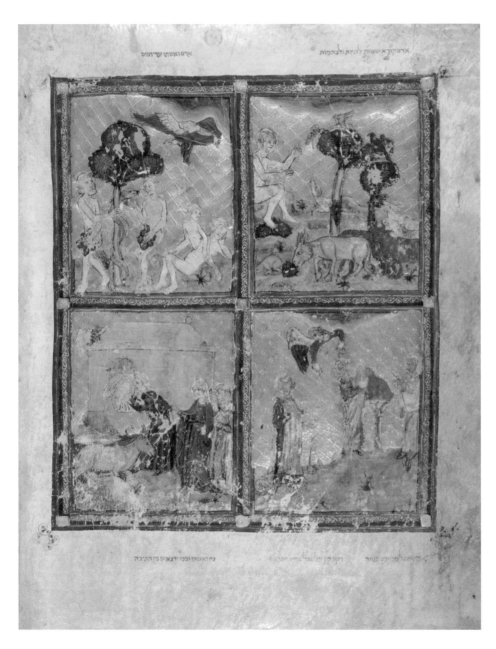

Scenes from Genesis in a Jewish Manuscript

The Golden Haggadah
Northern Spain, probably Barcelona,
c.1320
Scenes from Genesis

Haggadah (Telling) is the holy text
for Passover Eve telling the story of
the Jews' exodus from slavery in
Egypt. This is one of the earliest and
most lavish examples from Jewish
Spain: the tooled gold leaf backgrounds
of its miniatures have given the manu-
script its name. The episodes depicted
in these miniatures are largely based
on Genesis chapters 2–8.

This page shows (anticlockwise
from top right): Adam naming the
animals, the Creation of Adam and
Eve, the Temptation, Cain and Abel
offering a sacrifice, Cain slaying Abel,
and lastly Noah, his wife and sons
coming out of the ark. God's image
is totally absent in all the miniatures.
Instead, angels are seen intervening
at critical moments.

Although quite common in Spanish
medieval Haggadot, painted biblical
narratives never appear in Hebrew
biblical codices. Perhaps because it was
mainly intended for use at home, and
its purpose was educational, Jewish
scribes and artists felt completely free
to illustrate the Haggadah. The Golden
Haggadah displays the best in contem-
porary illumination, and may be com-
pared to manuscripts commissioned for
the royal court of Barcelona.

BL Add. MS 27210, f. 2v

Scenes from Genesis in a Christian Manuscript

The Egerton Genesis
Southern England, third quarter of the fourteenth century
Scenes from Genesis

Together with nineteen other leaves, this page forms part of a picture book of Genesis. Like the narrative images in the Golden Haggadah (left), most pages are divided into four separate scenes. However, differences in style and technique are apparent between them, reflecting their different origins. In addition, the figure of God is depicted in the Christian manuscript (in the lower left scene). On this page (upper left) Abraham's brother Nahor marries Milcah, their niece, and Abraham marries Sarah. Next, Terah (Abraham and Nahor's father) journeys with Abraham, Sarah and Lot to Harran. Below, God appears from a cloud to Abraham at Shechem, where Abraham builds an altar. In the lower right, Sarah and Abraham continue their journey into Egypt.

BL Egerton MS 1894, f. 6v

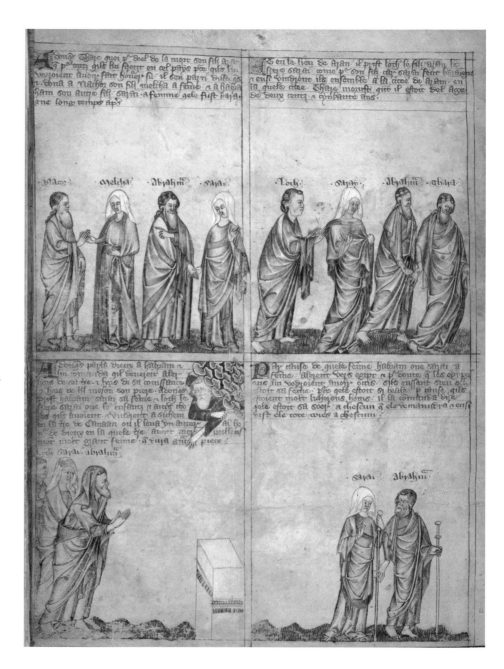

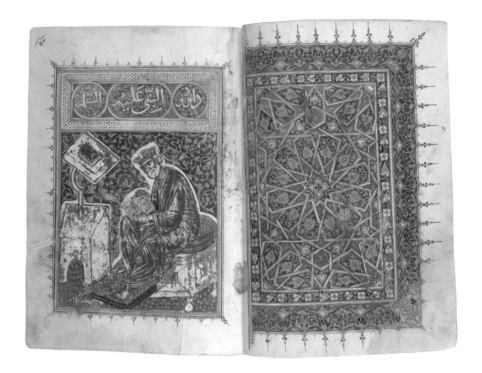

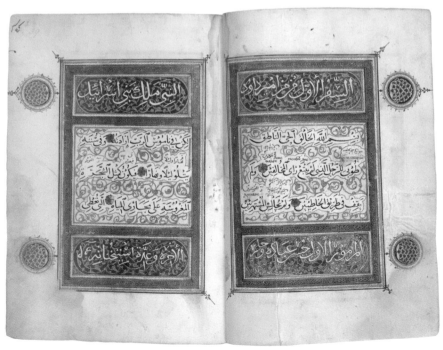

Islamic Style Carpet Page in a Christian Manuscript

Psalms in Arabic with glosses in Coptic
Egypt, early sixteenth century
Psalm 1

This manuscript produced for the
Coptic Christian community in
Egypt is similar in style of layout and
illumination to that of a Qur'an (see
opposite, below). Just as in a Mamluk
Qur'an, its decorative first page is
divided into three sections. The middle
section contains the text within a flow-
ing, cloud-like motif against a back-
ground of scrolls. While Islam normally
forbids the representation of human
and animal forms in religious art, this
manuscript, from a Christian tradition
of figurative art in religious works,
depicts David in the preceding opening,
as well as a traditional carpet page in
the Islamic geometric style (top). The
figure of David seated holding a book
before a desk is surely drawn from
traditional Byzantine Evangelist
portraits.

BL Arundel Or. MS 15, ff. 37v–38 and 38v–39

Islamic Style Carpet Page in a Christian Manuscript

The Four Gospels in Arabic
Palestine, 1337
Luke

BL Add. MS 11856, ff. 94v–95

Carpet Page in an Islamic Manuscript

Mamluk Qur'an
Egypt, fourteenth century
Chapter 7, *al-A'raf* (The Heights),
verses 88–89

The first opening of this Qur'an manuscript contains all that remains of the double carpet pages and first page of text. The leaf that was originally between them has been lost. As in most Mamluk Qur'ans, the frame of the first text page is divided into three sections, the middle section containing the text within a flowing, cloud-like motif against a background of scrolls. The general effect of the carpet page design is that of a rich tapestry, based on a ten-angled, star-shaped medallion with gold and white outlines extending to form a trellis of overlapping polygons, which alternate in gold and blue. This was part nine of a Qur'an originally in thirty volumes.

BL Or. MS 848, ff. 1v–2

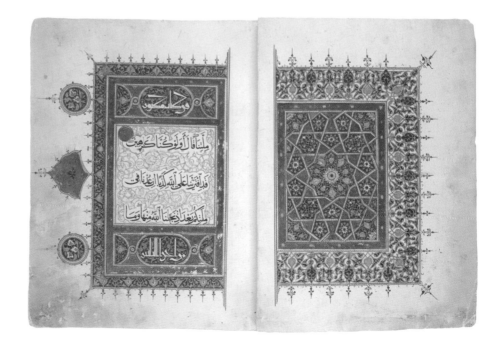

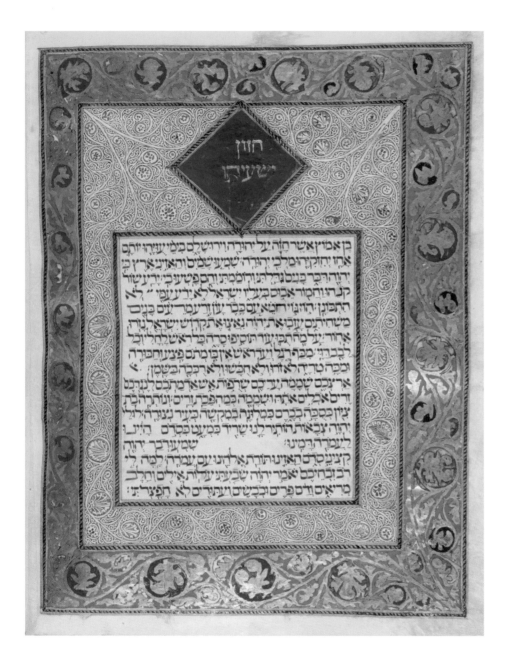

The Illuminated Margin in a Jewish Manuscript

Hebrew Bible in three volumes
Lisbon, Portugal, 1482
Isaiah 1

This is probably the most luxurious and sumptuously illuminated page in the Lisbon Bible, introducing the book of Isaiah as well as the major prophets (Isaiah, Jeremiah and Ezekiel). The illuminations, which combine Spanish Mudejar (Islamic), Flemish and Portuguese motifs, were apparently executed in a workshop that was active in or around Lisbon between 1469 and 1496.

In the central rectangle the sacred text is immaculately penned in a Hebrew square script. Shielding the text is a frame boasting intricate, lacy arabesques and a unique lozenge-shaped initial word panel. On its deep blue background are the opening words of Isaiah – *Hazon Yesha'yahu* (The vision of Isaiah) inscribed in letters of gold.

This Lisbon Bible follows a long tradition of Hebrew biblical manuscript production in which figurative imagery is entirely absent. Medieval biblical manuscripts created in the Iberian Peninsula were influenced by the Oriental elements that often adorn Hebrew biblical codices from Egypt and Palestine, such as carpet pages, micrography and pericope markers.

BL Or. MS 2627, Vol. 2, f. 136v

The Illuminated Margin in a Christian Manuscript

Catalan Old Testament
Catalonia, Spain, 1465
Genesis 1

Like the frontispiece to Isaiah in the Hebrew Lisbon Bible (left), this copy of part of the Old Testament in Catalan has a fully decorated border around its first page of text. Made at about the same time and also in the Iberian Peninsula, the content of the border is nevertheless quite different. Starting in the lower left, the events of the first six days of Creation are depicted, beginning with the creation of light, followed by the creation of the firmament on the second day, the creation of land and foliage on the third, the sun and the moon on the fourth, the creation of birds and fish on the fifth, and ending with the creation of Adam in the upper right-hand corner. In a rectangular frame, God rests on the seventh day, directly above the beginning of the text.

BL Egerton MS 1526, f. 3

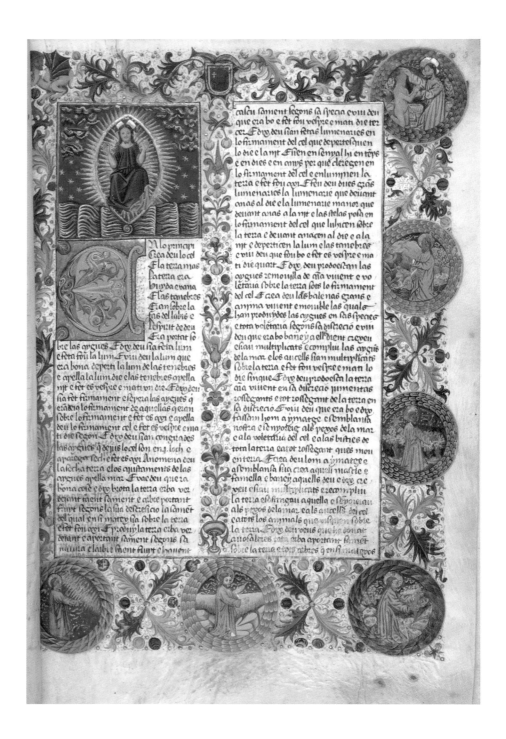

King David in a Jewish Manuscript

The Leipnik Haggadah
Altona, Denmark (now Germany),
1740
Psalm 116:8–10

רַגְלִי מִדֶּחִי : אֶתְהַלֵּךְ לִפְנֵי יְיָ
בְּאַרְצוֹת הַחַיִּים : הֶאֱמַנְתִּי כִּי
אֲדַבֵּר אֲנִי עָנִיתִי מְאֹד : אֲנִי
אָמַרְתִּי בְחָפְזִי כָּל הָאָדָם
כֹּזֵב

פֵּירוּשׁ אברבנל

Dressed in magnificent finery, King
David kneels in prayer in a sumptuous
palatial chamber. The harp leaning
against the table and the book of
Psalms open in front of him allude to
his fame as a musician and Psalmist.
The scene is imbued with divine light
emanating from a bright cloud, which
contains the words *Ruah ha-kodesh* (the
Holy Spirit). The text in square Hebrew
writing above the image is from Psalm
116:8–10. The text column on the
left is the commentary of the Jewish
exegete Isaac Abarbanel (1437–1508).

The eighteenth century witnessed a
'renaissance' of Hebrew illuminated
manuscript art. This fine Passover
Haggadah (ritual book for the eve of
Passover) is the work of Joseph ben
David of Leipnik, an influential
eighteenth-century Moravian scribe-
artist active in Hamburg and Altona.
Between 1731 and 1740 he produced
some thirteen Haggadot. Like other
Haggadah manuscripts of that period,
the miniatures in this manuscript
were modelled on the engravings in
the 1695 and 1712 printed editions
of the Amsterdam Haggadah.

BL Sloane MS 3173, f. 27r

King Henry VIII as David in a Christian Manuscript

The Psalter of Henry VIII
London?, England, between 1530
and 1547
Psalm 53 (52)

Jean Mallard, Henry VIII's 'orator in the French tongue', wrote and illuminated this Psalter for the king in the French style. As indicated by the many marginal notes added in Henry's own hand, the volume became the king's personal copy of the Psalms. As in the Hebrew Leipnik Haggadah (left), the Psalmist David is pictured as a king with a harp. However, the sumptuous sixteenth-century interior also betrays the fact that this is not an ordinary image of David – it is also a portrait of Henry himself. His jester, or court fool, William Somer (or Sommers, d. 1559) is also included in the scene. This is appropriate, for Psalm 53 (in modern numbering) begins: 'The fool says in his heart, "There is no God" (*Dixit inspiens in corde suo: non est Deus*).'

BL Royal MS 2 A XVI, f. 63v

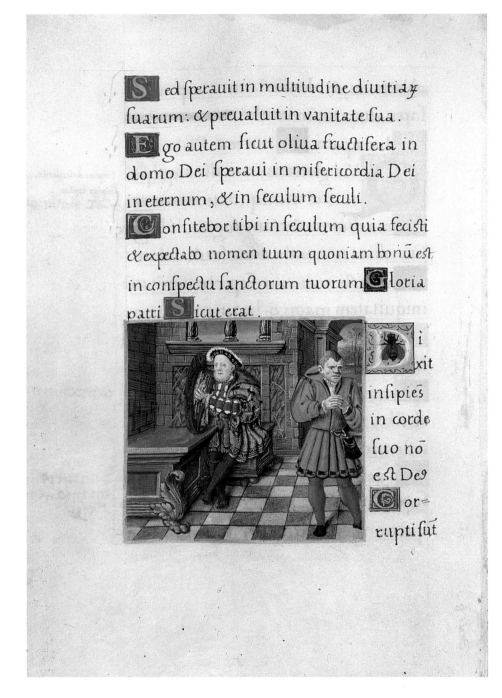

Picturing God's Presence in a Jewish Manuscript

Hispano-Moresque Haggadah
Castile, Spain, c.1300
The binding of Isaac

Because of the stern injunction against representing God, images depicting Him are rarely found in Jewish book art. However, artists did find other ways of depicting God's presence, as in this illustration of one of the most momentous episodes in the Hebrew Bible. According to the biblical text (Genesis 22:1–13), God put Abraham to the test by ordering him to sacrifice his beloved son Isaac. He was stopped from slaying the boy by an angel of God calling from heaven.

In this illustration there is no trace of God's angel. Isaac is shown lying down on a brick altar. Holding the knife in his right hand, Abraham tries to keep Isaac steady, while pressing his left hand firmly over his son's mouth. Miraculously, from behind a dark blue drape, God's hand appears, pointing a warning finger at Abraham and stopping him in his tracks.

BL Or. MS 2737, f. 93v

Picturing God in a Jewish Book

Passover Haggadah
Trieste, Italy, printed by Jonah Cohen, 1864
Moses

Depictions of God's face and figure are common in Christian biblical illustrations, but such representations are strictly forbidden in Judaism and Islam. The portrayal of God is therefore extremely rare in Jewish art, this engraving being an exceptional case. In a bucolic landscape Moses kneels before the burning bush in which God's bearded face is clearly discernible. The artist responsible for these engravings was K. Kirchmayer. It is not clear how this particular illustration was allowed.

BL 1974, f. 14, p. 35

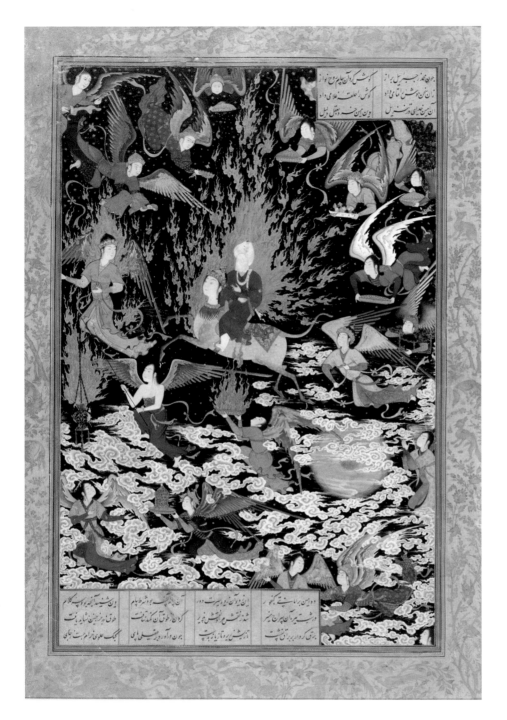

Picturing the Prophet in an Islamic Manuscript

Nizami's *Khamsa* (Five Poems)
Tabriz, Iran, 1539–43
Muhammad's ascent into heaven

Calligrapher Shah Mahmud Nishapuri (d. 1564–5) created this for Shah Tahmasp (r. 1524–76). This miniature depicts the ascent to heaven of the Prophet Muhammad on his steed, Buraq, guided by the archangel Gabriel, with an escort of angels. The image of the ascension is often depicted in religious Islamic painting, particularly in Persian manuscripts, and is often found in secular literature, as in this manuscript of the poems of the celebrated Persian poet, Nizami. According to tradition, the face of the Prophet Muhammad has been whitened out. The origin of the ascension legend goes back to various passages throughout the Qur'an. It is also believed that the ascension was preceded by a night journey on a winged horse, which carried the Prophet Muhammad from the *Ka'bah* in Mecca to Jerusalem.

BL Or. MS 2265, f. 195

Religious Life: Encountering the Sacred

The objects and manuscripts in this section illustrate aspects of religious and cultural life. One focus is the use of these objects in worship. In this context, the type and function of objects are quite different, reflecting the different beliefs explored in the other parts of the catalogue. Nevertheless, in each faith the sacred text or extracts from it have been used as talismanic devices in their own right – carried around on a believer's person, or placed in a home or synagogue, and possessing quasi-magical powers. Similarly, each faith celebrates certain life events, such as marriage, and includes festivals within its calendar. The faiths also share a belief in the holiness of certain places. Two of those held in common are examined in this section: Jerusalem and Mount Sinai in Egypt. Pilgrimage to these sites and to places specific to Christians and Muslims is also explored. Although expressed in different forms and beliefs, these shared characteristics between the faiths perhaps reflect a shared human need for worship, protection, celebration and commemoration.

Worship

Jewish worship is centred on readings from a Torah scroll, the most sacred and venerated object in Judaism. A Sephardi example opens this section, with associated objects from different parts of Europe. These include a hand-shaped pointer for readings, so that fingers don't touch the scroll; and the scroll's mantle, decorated with silver bells. A shield suspended from the scroll is a reminder, like the mantle, of vestments worn in the past by the high priest. A beautifully embroidered curtain from an Ark, in which the scroll is stored, illustrates its importance in the synagogue. Another essential object indicates the direction of prayer, facing towards Jerusalem. This is known from the Hebrew word for East (*Mizrah*), the direction of prayer for Jews in the West.

The dramatic wooden sculpture shown here is a rare survival, and was originally placed on a rood screen, the partition that separated the nave from the choir in most medieval churches in northern Europe. This type of sculpture gave the screen its name: rood in Anglo-Saxon means cross. The figures of Christ crucified flanked by his mother St Mary and his disciple St John the Evangelist reminded worshippers of Christ's sacrificial death and his subsequent Resurrection. The Ethiopian processional cross does this also.

Cathedrals and churches in the West were typically oriented to the East, like synagogues and mosques. The high altar was placed in the eastern part of the church. Apart from this, the form of the church building could vary greatly; and Christian services need not even be held in a church. However, whenever the Eucharist or Communion is celebrated, an altar or Communion table will usually be present.

For the Eucharist or Communion, the chalice used to hold the wine is equated with the blood of Christ. This is illustrated on the remarkable silver English or Norwegian chalice, which is engraved with the words '*From hence is drunk the pure flow of the Divine Blood*' in Latin. The consecrated host (bread or wafer) may be kept in a pyx, as in the thirteenth-century Limoges example. In the Ethiopian church priests use communion spoons to offer Communion to the faithful, in a departure from the practices of other Christian churches.

Muslims pray five times a day facing towards Mecca, at dawn, at noon, in the late afternoon, at sunset and in the evening. These daily prayers may be performed with others in a mosque, or wherever a Muslim happens to be. The daily prayers follow a fixed formula with passages from the Qur'an and pious phrases, accompanied with bowing, kneeling and prostration at required places within the ritual. On Fridays, a special congregational prayer called *jum'ah* replaces the noon prayer. Traditionally this prayer is preceded by a sermon delivered by the Imam.

In Islamic society, the mosque is a place of worship, often part of a complex with a religious school and library. A feature of all mosques is a prayer niche in one of the walls, known as the *mihrab*, indicating the direction of Mecca and the *Ka'bah*. The pulpit (*minbar*) from which the Imam gives his Friday sermon is often designed in the form of a small tower with steps. Some mosques are also ornamented with lamps, traditionally suspended from the ceiling by chains; their use is primarily symbolic.

Protective Powers

The power of the sacred word to protect the believer is illustrated here from all the faiths. For example, Jewish amulets are included, together with plaques for the home or synagogue, which are often given inscriptions to imbue them with magical or protective powers. Some of the names of God have been developed or explained through the mystical system of Kabbalah, from a Hebrew word meaning 'to receive' or 'to accept'. One of these, the 42-letter divine name, is inscribed on a plaque from India. A Syrian silver bracelet has a kabbalistic prayer for protection, and an Italian amulet is inscribed with another name of God, *Shadai*. The magical formulae and incantations included in one of the earliest manuals of practical Kabbalah demonstrate Jewish nterest in mystical philosophy and practices.

Amulets may also be carried by Christian travellers and the devout. The example from Constantinople, an illustrated prayer scroll, has prayers to protect against evil influence or bad luck, accompanied by a talismanic image. The sacred text itself was also carried. An eighth-century copy of the Four Gospels, for example, was probably

worn around the neck to protect its wearer. A further use of the sacred text is revealed by a copy of a Gospel buried with St Cuthbert, bishop of Lindisfarne. According to an eye witness account, when the coffin was opened in the twelfth century the Gospel book was discovered inside. It was then displayed to the congregation during a service, emphasising its associative power and importance.

Like the small Irish Pocket Gospel, the two miniature Qur'ans displayed may also have been primarily intended to protect the owner, rather than for reading. Tiny Qur'ans were also carried by travellers as protective amulets and good luck charms. The magnificent Persian gold filigree cover and jade case demonstrates that they were often encased in a jewel-like box for safekeeping. Nomadic tribesmen in west Africa carried loose leaves of a Qur'an, which were kept between boards so that they could be easily stored in a pouch or saddlebag.

Festivals

In Jewish households, Saturday – the Sabbath (from the Hebrew *Shabat*) – is a day of rest and the holiest day of the week. The ceremony of *Kidush* welcomes the beginning of the Sabbath on Friday at dusk. An unusual ceremonial goblet made of a coconut to hold wine during the ceremony is included here, as is a hanging Sabbath lamp from the period when a special lamp was needed to provide light over the 24-hour Sabbath day. The Sabbath ends with the *Havdalah* ceremony, illustrated by a thirteenth-century Spanish spice box used in this ceremony. The catalogue also features several copies of medieval Haggadot, in this and the previous section. These service books are used for recitations during Passover, the major spring festival in the Jewish year. In addition to manuscripts, the catalogue includes a magnificent modern silver Passover *seder* set, used to hold the ceremonial foodstuffs. The Ramsgate Esther Scroll with a silver jewelled case is another contemporary piece. Decorated scrolls such as this one are used for home readings of the book of Esther during the spring festival of Purim.

Christmas and Easter are the two central Christian festivals, celebrating Jesus's birth and his death and Resurrection. Easter is a 'moveable' feast celebrated on the first Sunday after the paschal full moon. A sixth- or seventh-century talismanic medallion, possibly from Jerusalem, depicts the star of Bethlehem that led the Magi to the place of his birth. The events of Easter morning, when Christians believe that Jesus rose from the dead, are depicted in an English Psalter, in which the risen Christ in shown stepping out of His coffin.

As in Judaism and Christianity, Islam celebrates a number of major festivals throughout the year. *'Id al-fitr*, which falls on the first day of the month of *Shawwal*, marks the end of Ramadan, the month of fasting. *'Id al-adha* commemorates Abraham's readiness to sacrifice his son, Isma'il (Isaac, in the Jewish tradition), and is celebrated on the tenth of *Dhu al-hijjah*, the last month of the Muslim calendar. *Laylat al-qadr* ('the Night of Destiny') commemorates the night during which the Prophet Muhammad received his first revelation. This is believed to have occurred on one of the last ten nights of Ramadan, probably the 27th of the month. Illustrated here are images from *'Ashura*, which takes place on the 10th day of Muharram, the first month of the Muslim calendar. It is equivalent to the Jewish Yom Kippur ('the Day of Atonement') but, unlike Yom Kippur, fasting is voluntary. For Shi'ite Muslims *'Ashura* commemorates the martyrdom of Iman Husayn and his followers at Kerbela in Iraq in 680, and a metal standard, or *'alam*, used in such processions is also included.

Holy Places

The final part of the catalogue focuses on holy places, including two that are important to each of the three Abrahamic faiths: Jerusalem and Mount Sinai. Pilgrimage to holy places is another activity common to each faith, although its popularity and importance within each has varied historically. Both ancient and medieval Jews and Christians went on pilgrimage to Jerusalem. For Jews, it was a religious requirement during the Second Temple Period (538 BC–AD 70). Christians went on pilgrimage there in search of the sacred, in order to seek forgiveness for past or future sins by obtaining indulgences; to obtain a cure for illness; to fulfil a vow; as a penitential act, and perhaps as a way of seeing more of the world. Itineraries of the route are included in this section. The map by Matthew Paris, a monk of St Albans, includes a representation of the church of the Holy Sepulchre, today administered primarily by the Greek Orthodox, Catholic, and Armenian churches. For Muslims, Jerusalem is the third most holy city, with the al-Aqsa mosque their third holiest place of worship. This is because they believe that Muhammad ascended to heaven from the site on which the mosque now stands.

Another site important to each of the faiths is Mount Sinai in Egypt. According to the book of Exodus, it was here that Moses encountered God in the Burning Bush and later received the Tablets of the Law, an event depicted in manuscripts seen earlier. From the fourth century Christians were venturing there on pilgrimage to the Monastery of Saint Catherine, the longest continuously active Christian monastic community. According to tradition, the Prophet Muhammad also visited this site, and the monastery complex includes a mosque.

Evidence of a completed pilgrimage could take the form of a token or badge, some of which could be worn to protect the wearer on the return home, or a flask to carry oil or holy water. Several intricate tokens from the English Christian shrine of Canterbury are exhibited, as well as an example of the ubiquitous scallop shell originally associated with the cathedral of St James in Santiago de Compostela, but which came to stand for Christian pilgrimage more generally. In the Islamic tradition, a completed pilgrimage is often confirmed by a written certificate. A decorated scroll shown here confirms that Maymunah completed the *hajj* (pilgrimage) to Mecca – the holiest place in Islam – in 1432–33, fulfilling the fifth pillar of Islam, which requires this journey once in a lifetime for every Muslim who is able to make it.

Torah Scroll

Origin unknown, *c.* fifteenth century
Genesis 48

The *Sefer Torah* (Book of the Torah), the most sacred and venerated object in Judaism, is a parchment scroll containing the Five Books of Moses (the Pentateuch). The preparation of the parchment and the writing of a Torah scroll must be done in compliance with strict rules laid down in the Talmud, and the slightest error or deviation renders the scroll unfit for use. The text must be written by a trained *sofer* (scribe) who would normally take a year and a half or more to complete the task. The Torah scroll is copied without vowels, and all decorations or embellishments are forbidden. The ritual of *Keri'at ha-Torah* (Reading of the Torah or Reading of the Law) is performed weekly on the Jewish Sabbath, on Mondays and Thursdays, and on Jewish festivals.

When not in use, the scrolls of the Torah are invariably stored in the *Aron ha-Kodesh* (Holy Ark), a cabinet or section that is deemed the holiest place in a synagogue. It is customary to 'dress' the Torah scroll with various ornaments, such as a mantle, a breastplate, silver bells and occasionally a crown.

BL Add. MS 4707

Torah Mantle and Silver Bells

Portugal and England, *c.*1719

As the Torah scroll is considered the holiest object in Judaism, it is beautifully 'dressed' and, when not in use, is housed in the synagogue Ark. During services the dressed scroll is carried in procession around the synagogue before and after the reading. Its traditional cover, called a 'cloak' or 'mantle', is a reminder of the high priest's tunic, and has two small holes at the top for the wooden rollers or staves on which the scroll is rolled. The silver bells or finials recall those attached to the hem of the high priest's robe. In some Oriental and Sephardic communities the sacred Torah scroll is kept in a *tik*, an arch-shaped, ornate leather or metal case that opens like a book.

The mantle and bells shown here were commissioned by Moses Mocatta's sons in 1719, and have remained in the family's possession ever since. The magnificently embellished mantle was made in Portugal by the finest embroiderers of the time. The central panel is a 'self-portrait' of the mantle itself in the Ark in which it was kept. The decorative silver bells were made in London. At the outset of the Spanish Inquisition in 1492, the Mocatta family adopted a Spanish name, Marchena, and survived as Marranos (crypto-Jews), resuming the name of Mocatta before coming to London in 1671, shortly after the readmission of the Jews to England.

Private Collection

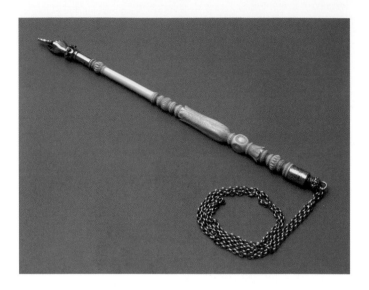

Torah Shield

Augsburg, Germany, 1761–63

A Torah shield is an ornamental metallic tag that is suspended by a chain from the upper staves of the scroll over the front of the mantle. It is also known as a 'breastplate', a reminder of the breastplate worn by the high priest (Exodus 28:13–30). Its purpose is to designate which scrolls should be used on particular occasions, such as special Sabbaths and festivals, when more than one scroll may be used. This type of Torah ornament was initially used in Ashkenazi synagogues, but was later adopted by Sephardi communities, the earliest known example dating from the early seventeenth century.

This silver-gilt shield is inscribed with the Tablets of the Law in Hebrew and the Ten Commandments. Flanking them are columns surmounted by a pair of lions with a crown above. The lower oblong panel contains the festival labels. The lower border is decorated with engraved floral motifs and three pendant bells.

The Jewish Museum, London, Barnett 142

Jewelled Pointer

Unknown origin, nineteenth century

During the reading of the Torah it is not permitted to touch the sacred parchment with the hands, so it is customary to use a pointer shaped as a *yad* (hand) to follow the dense words. This can be made of metal (usually silver), wood or other materials, and has a pointing finger at the end of it. This magnificent specimen is of ivory and gold, the gold pointing hand with diamond ring and jewelled bracelet. It previously belonged to Sir Moses Montefiore (1784–1885), one of the most prominent British Jews of the nineteenth century.

The Montefiore Endowment, Ramsgate

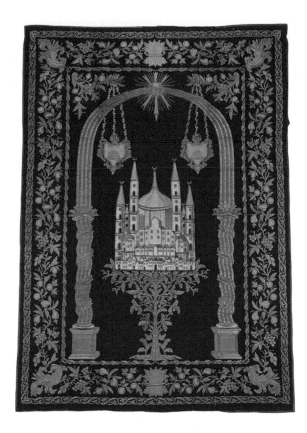

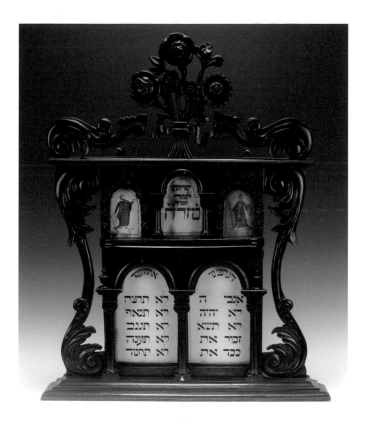

Ark Curtain

Turkey or the Balkans, late eighteenth century
Red flannel embroidered with silver thread, sequins and mica

The Ark curtain (*parokhet* in Hebrew) forms part of the synagogue furnishings. It conceals the doors of the Ark of the Law where the scrolls of the sacred Torah are kept. During the Sabbath service, on festivals and other occasions, the curtain, which is often beautifully embroidered, is drawn to reveal the Torah scrolls placed upright in the Ark.

The central feature of this curtain shows an oak tree supporting a city with minarets that represent Jerusalem and its Temple. Above them is an arch supported by a pair of twisted columns and flanked by two oriental lamps hanging from floral garlands. All around is a border of acorns, figs and corn sheaves. The decorative elements suggest an Ottoman influence, so the curtain was probably created in Turkey or the Balkans.

The Jewish Museum, London, Barnett 44

Mahogany Mizrah with the Ten Commandments

Origin unknown, nineteenth or twentieth century

A *Mizrah* ('East') is the name of an object or a plaque hung on the eastern wall of a synagogue or a private room to indicate the direction of prayer, so that worshippers may face towards Jerusalem. This applies to synagogues in the Western world; in Babylonia for instance the *Mizrah* would hang on the western wall of a synagogue. The upper middle panel of this *Mizrah* contains the inscription *Shiviti Adonai le-negdi tamid* ('I have set the Lord always before me'; Psalms 16:8), which can also be found in *Shiviti* amulets. The word '*Mizrah*' is inscribed underneath. Moses and Aaron's portraits appear in the flanking panels, with the Ten Commandments below.

The Jewish Museum, London, Barnett 8

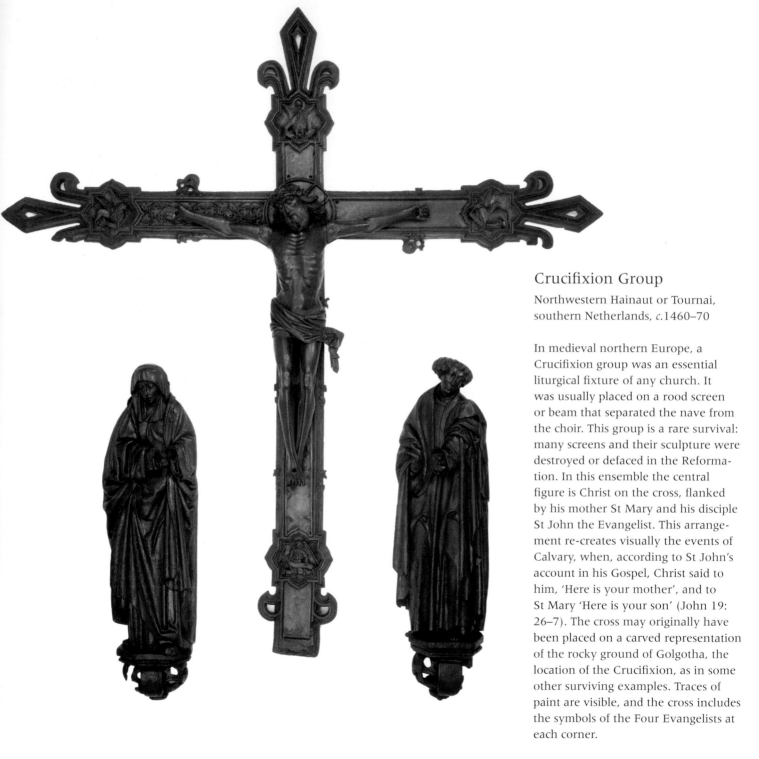

Crucifixion Group

Northwestern Hainaut or Tournai, southern Netherlands, *c.*1460–70

In medieval northern Europe, a Crucifixion group was an essential liturgical fixture of any church. It was usually placed on a rood screen or beam that separated the nave from the choir. This group is a rare survival: many screens and their sculpture were destroyed or defaced in the Reformation. In this ensemble the central figure is Christ on the cross, flanked by his mother St Mary and his disciple St John the Evangelist. This arrangement re-creates visually the events of Calvary, when, according to St John's account in his Gospel, Christ said to him, 'Here is your mother', and to St Mary 'Here is your son' (John 19: 26–7). The cross may originally have been placed on a carved representation of the rocky ground of Golgotha, the location of the Crucifixion, as in some other surviving examples. Traces of paint are visible, and the cross includes the symbols of the Four Evangelists at each corner.

Victoria and Albert Museum, London, 714, 714A, 714B–1895

Bronze Incense Burner

Syria, *c.* sixth to seventh century

A censer or incense burner symbolizes the human soul: the spiritual fire burns its worldly desires and sends up its prayers to God as a pleasing fragrance. The Psalm recited in some liturgies in conjunction with burning incense is 'May my prayer be set before you like incense' (Psalm 141:2). This censer is decorated with scenes from the Gospels: the Annunciation, the Nativity, the Baptism of Christ, the Crucifixion and the Visit of the Women to the Sepulchre. These scenes represent not only the major events in the life of Christ, but are also some of the principal feast days of the Christian Church. The Syriac inscription (on the underside of this burner) states that it was dedicated by 'John, son of Qasim'.

Ashmolean Museum, Oxford, AN 1970.591

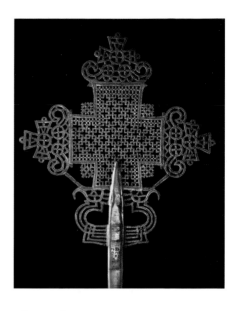

Pierced Bronze Processional Cross

Ethiopia, sixteenth century or earlier

The inscription reads: 'This is the cross of our Father, Takla Haymanot'. St Takla Haymanot (*c.*1215–*c.*1313), whose name means 'Paradise of the Father, the Son and the Holy Spirit', is a celebrated Ethiopian saint, blessed at his birth by the Archangel Michael and later renamed by him. He was credited with miracles from the age of eighteen months onwards, and later converted many Ethiopians to Christianity. One of the legends of his life tells how he was descending on a rope from a mountain-top monastery when the rope suddenly broke. Six wings promptly appeared on the saint's body and flew him safely to the bottom of the mountain.

The British Museum, MLA 68/10–1/16

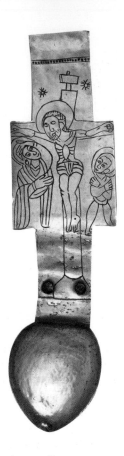

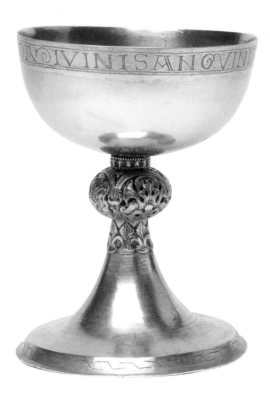

Ethiopian Silver Communion Spoon

Gondar, Ethiopia, 1733

The Ethiopian Church understands in a very literal way Christ's order, 'Take and eat; this is my body' and 'Drink of it, all of you. This is my blood of the covenant' (Matthew 26:26–28). The bread and wine become the body and blood of Christ after the transubstantiation that they believe takes place during the Communion service. The priest uses such a spoon to offer the Communion to the faithful, in a departure from the practices of other Christian churches. The spoon is engraved with typical Ethiopian decoration, here an image of the Crucifixion, and Sts Mary and John the Evangelist.

Victoria and Albert Museum, London, 186–1869

Chalice

England or Norway, *c.*1200

In Christian worship the chalice is associated with the blood of Christ. Paul remarks, 'Is not the cup of thanksgiving for which we give thanks a participation in the blood of Christ?' (1 Corinthians 10:16). This concept is illustrated textually on this chalice, which is inscribed in Latin: 'From hence is drunk the pure flow of the Divine Blood'. From an early period chalices were made of precious metals, representing the precious nature of the Eucharist, or Communion, that part of a Christian service in which Christians believe that they partake of Christ's sacrifice by means of consecrated bread and wine. This one was probably a chalice used by bishops and priests in the Mass. It came from Grund in northern Iceland, and may have belonged to cathedral in nearby Holar. It was probably brought there from England.

Victoria and Albert Museum, London, 639–1902

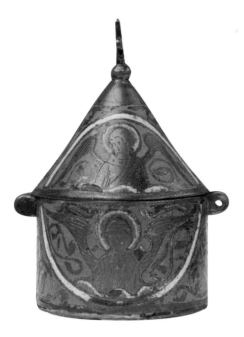

Pyx

Limoges, France, first half of the
thirteenth century

The elevation by the priest of the host, or
consecrated bread wafer, is a central focus
of the Mass. The consecrated host has
traditionally been kept in a pyx (from the
Greek *pyxis*, a boxwood receptacle). In
the Middle Ages these were most com-
monly made in the form of a circular
container with a conical top, as in this ex-
ample. This pyx is one of many surviving
metalwork vessels made in the important
centre of Limoges for export throughout
Europe. Like the portable altar and the
crosier (see page 175 and right), it is dec-
orated with *champlevé* enamel. On this
vessel the decoration is simpler, consisting
of angels in large circles extending from
the lower portion to the hinged cover.
The angels may refer to Christ's presence
both in heaven and as transubstantiated
into the host, a doctrine affirmed by the
Fourth Lateran Council in 1215.

Victoria and Albert Museum, London, M9-1931

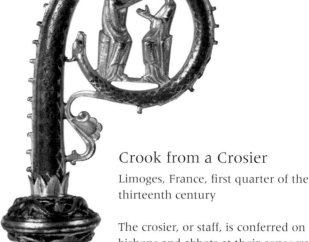

Crook from a Crosier

Limoges, France, first quarter of the
thirteenth century

The crosier, or staff, is conferred on
bishops and abbots at their consecra-
tion or investiture, and symbolizes
both the authority of their office
and their responsibilities to their
respective flocks. In the medieval
period in the West, the top of the staff
was curved, resembling a shepherd's
crook. This form has obvious associa-
tions with Christ's claim to be the Good
Shepherd, and his admonition to the
apostle Peter to 'take care of my sheep'
(John 21:16). This crook, which is now
separated from its staff, is decorated
with bright *champlevé* enamel forming
the body of a dragon with scales and
serrated edges, and the figure of the
Coronation of the Virgin enclosed in
the curve. This imagery may indicate
that the crosier was used in a church
dedicated to St Mary, for crosiers often
contained imagery associated with the
patron saint of the churches in which
they were used.

Victoria and Albert Museum, London, 288–1874

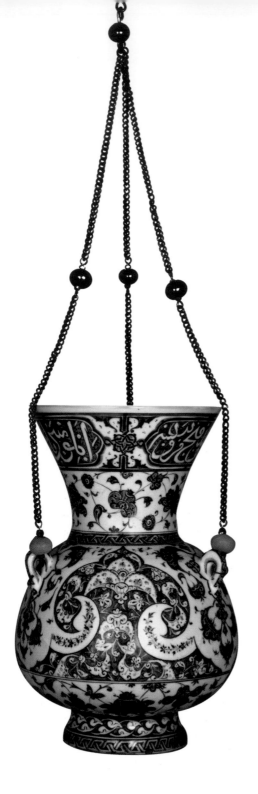

Ceramic Mosque Lamp

Iznik, Ottoman Turkey, *c.*1510
Blue, white painted and glazed pottery

Mosque lamps, such as this one from Ottoman Turkey, were usually suspended from the ceiling by chains, their use being primarily symbolic rather than practical. Though their purpose was to enhance the beauty of the mosque, their shape and design are clearly influenced by Mamluk mosque lamps whose use was essentially functional. Another influence, particularly in the decoration of these Ottoman mosque lamps, is Chinese porcelain, which was highly regarded by the Ottoman sultans during this period. Chinese influence is clearly evident in the bold indented trefoils filled with smaller trefoils, the cloud bands and the delicate trails of foliage. The cartouches under the rim carry various inscriptions including the words 'Allah, Muhammad, 'Ali' (God, the Prophet Muhammad and 'Ali) and also a quotation from chapter 61, part of verse 13, of the Qur'an.

British Museum, Godman Bequest G.1983.4

Silver Hanging Sabbath Lamp

Antwerp?, mid-eighteenth century

Before light fixtures were invented, it was customary in Jewish households to light a Sabbath lamp at sundown on Friday. Since any form of labour is forbidden during the day of rest, Sabbath lamps were specially crafted to provide light over a twenty-four-hour period. Made mostly from metal (brass or silver), they were suspended from the ceiling on chains. Seven-wick lamps were most common, but lamps with eight, nine or ten wicks were also produced. The precursor of the ceremonial Sabbath lamp was a star-shaped domestic oil lamp used in medieval Europe by Jews and Gentiles alike. The German name *Judenstern* (Star of the Jews), by which the European Sabbath lamp was known, goes back to at least the sixteenth century. Sabbath lamps remained in use until the early part of the nineteenth century.

Seen here is a silver lamp of the Ashkenazi type, made of three typical components: a circular suspension cap, a nine-burner, star-shaped reservoir with chased flowers and scrolls suspended by seated eagles, and a chased circular drip bowl. The suspension chains possess three-flanged oval links and central rosettes.

The Jewish Museum, London, Barnett 377

Coconut Goblet

England?, nineteenth century

In Jewish households Saturday – the Sabbath (from the Hebrew *Shabat*) – is the Jewish day of rest and the holiest day of the week. The Sabbath begins on Friday an hour before dusk, ending at sundown the following day. In the home this special day is welcomed with a ceremony known as *Kidush* (Hebrew for 'sanctification'). This entails lighting of Sabbath candles eighteen minutes before sunset, blessing wine, ritual hand-washing followed by a benediction, then blessing and partaking of bread sprinkled with salt.

It is customary to taste the wine used in the *Kidush* ceremony from a goblet made of silver or other precious metal. Occasionally, ceremonial goblets were manufactured from glass or, as seen here, coconut shell. This rare specimen has a rosewood stem and base mounted with silver-gilt bands. The scenes depict men drinking and are accompanied by a Hebrew inscription alluding to Joseph's goblet (Genesis 44); they also show three angels visiting Abraham to announce Isaac's birth (Genesis 18:1), and the binding of Isaac (Genesis 22).

The Jewish Museum, London, Barnett 401

Spice Box

Spain, thirteenth century
Copper gilt

Spice boxes are used at the close of the Jewish Sabbath (at dusk on Saturday) during a ritual ceremony known as *Havdalah,* meaning 'separation'. The ceremony is intended to distinguish between the holiness of the Sabbath and the start of the weekdays, and includes three blessings for spices, light and wine. The fragrance of the aromatic spices raises the spirits, helping one to keep the memory of the Sabbath fresh while facing a new week. During the Middle Ages spices were apparently dried in towers, which might explain why spice boxes often take that shape. This spice box has Moorish keyhole arches and is Spanish in style. It was later used as a Christian reliquary, and only subsequently identified as an exceptionally rare thirteenth-century Spanish spice box. Jews were banished from Spain in 1492, and, as a result, few Jewish objects from that period survive. It is very likely that the original box was much taller.

Victoria and Albert Museum, London, M.2090–1855

Glass Bottle for Sabbath Wine or Oil

Egypt or Syria, eighteenth or nineteenth century

Etched on the body of this bottle is an exhortation from Exodus 31:16–17 to keep the Sabbath holy: 'Wherefore the children of Israel shall keep the Sabbath, to observe the Sabbath throughout their generations for a perpetual covenant. It is a sign between Me and the children of Israel for ever; for in six days the Lord made heaven and earth, and on the seventh day He ceased from work and rested'.

The lettering on the neck of the bottle emulates Arabic script, but since it is effectively meaningless, its role is merely decorative. During the Middle Ages and the Ottoman period, glass manufacturing was, after metalwork, one of the commonest Jewish crafts in Islamic lands. The artists' names seldom appear on surviving specimens, but this object names Mordecai Shiqfaati as the craftsman.

The Jewish Museum, London, Barnett 368

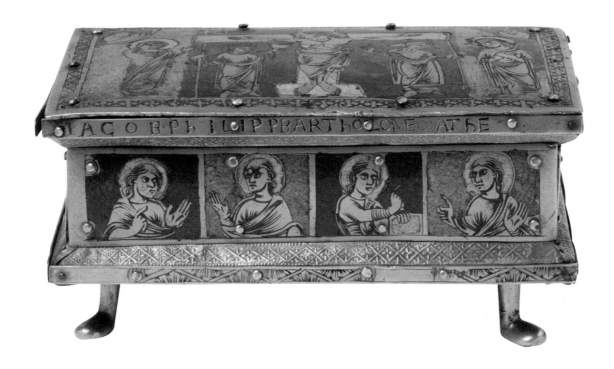

Portable Altar

Northern Germany, last quarter of the twelfth century

Consecrated portable altars allow Mass to be celebrated in places without fixed altars. This one is richly decorated with images related to the celebration of the Eucharist. The image on the top is the Crucifixion, with a personification of the Church (*Ecclesia*) on the left collecting the blood of Christ in a chalice, and of Synagogue (*Synagoga*) on the right. The figure of Synagogue is blindfolded, representing the Jews' inability to recognize or 'see' the divinity of Christ. These figures are flanked by the Virgin and St John the Evangelist. Around the sides are figures of the twelve Apostles, with their names in Latin above. The images are made of *champlevé* (raised ground) enamel. This technique involves hollowing out a design engraved into metal, which is then filled with enamel (glass in powder form mixed with metal oxides to form different colours).

Victoria and Albert Museum, London, 4524–1858

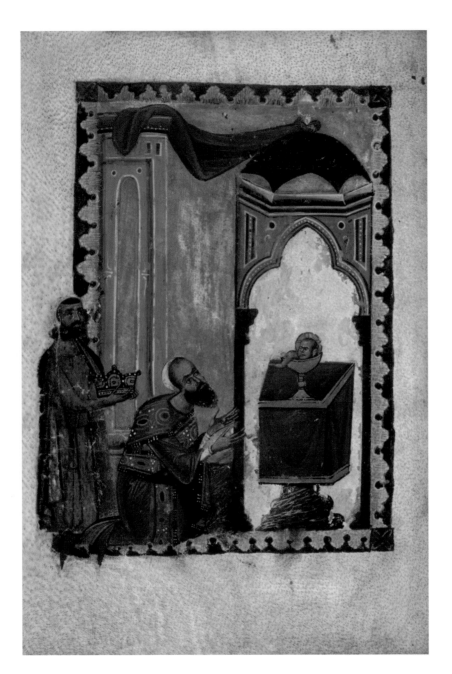

The Breviary of King Levon III

Sis (Cilician Armenia), 1269–89
King Levon III Praying

The richly robed king kneels in prayer before a niche containing a red-draped, gold-edged altar on a rocky pedestal, on which is placed a golden chalice. From the chalice emerges the haloed head of the infant Jesus, his right arm extended in blessing. The king's uncle stands to the left, holding the king's crown. This image, from a Breviary, or service book of King Levon III of Armenia (r. 1270–89) illustrates the mystical transformation of Christ in the Mass.

BL Or. MS 13993, f. 9v

Book of Hours

Arnhem, northern Netherlands, second half of the fifteenth century
Sacrifice of Isaac

An example of what has been termed the medieval 'best seller', or book of hours, is written in a vernacular language, Dutch, rather than in Latin. It demonstrates that these manuscripts were produced for different levels of society – for those literate in Latin, as well for others who preferred to have their prayer books written in their native language. Although its decoration includes gold, it is more modest in appearance than many of the other manuscripts exhibited. Indeed, although the borders of its major sections are decorated by hand, the central images were not painted, but are woodcuts that were pasted into the book. This one, showing the Sacrifice of Isaac, may even be recycled from a Missal, or service book, as it is a decorated gold initial 'T', perhaps originally intended for the *Te igitur* (Thee therefore), the first words of the canon of the Mass. It is likely that its intended owner was a lay person, and perhaps a member of the mercantile rather than aristocratic class.

BL Add. MS 17524, f. 157v

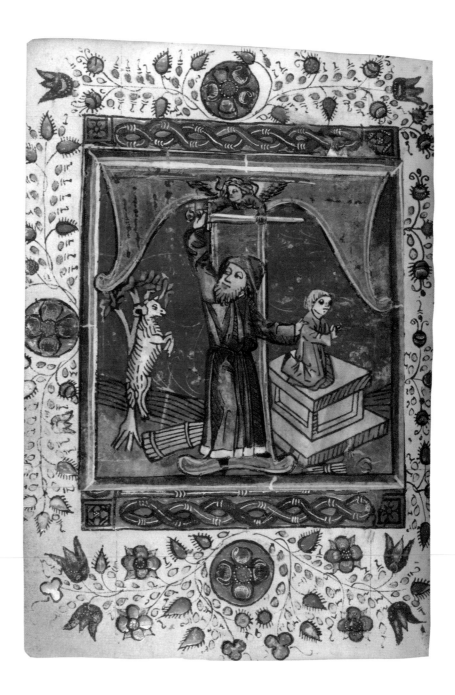

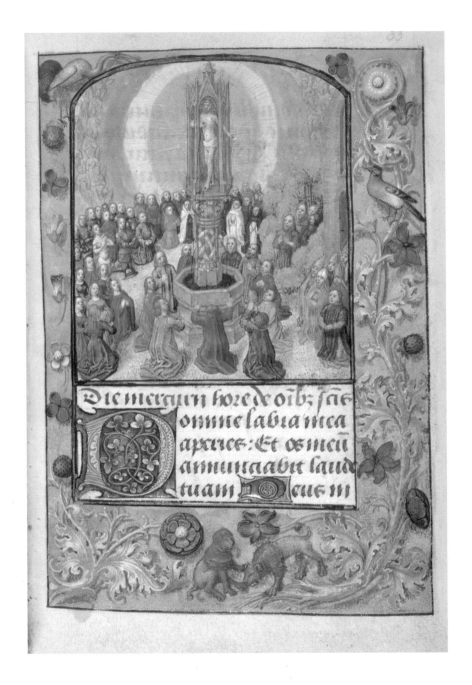

Hours of All Saints

Flanders, probably Ghent, 1480s
The Fountain of Life with All Saints

Other than biblical texts, the book of
hours is the most commonly surviving
religious text from the Middle Ages.
The contents vary considerably, but
all include the Little Hours of the
Virgin Mary, a sequence of eight short
services to be recited in private at
specified times each day, and based
loosely on the sequence of daily offices
performed by members of religious
communities. Many luxury copies
survive, with full-page images before
each hour and at other major textual
divisions or prayers. This tiny copy
includes further short services for each
day before the Hours of the Virgin.
Those for Wednesday are for All Saints
(indicated in the rubric in red), and
begin with a depiction of the Fountain
of Life, in which Christ appears in the
centre of a fountain that resembles a
medieval sacrament house and is
surrounded by kneeling worshippers.
Like the first Hour of the Virgin, this
office begins with a quotation from
Psalm 51:15 (in modern numbering)
*Domine labia mea aperies et os meu[m]
annunciabit laude[m] tuam* (O Lord,
open my lips and my mouth will
declare your praise).

BL Add. MS 17026, f. 33

Decorated *Shiviti* plaque

India, nineteenth century

This is called a *Shiviti* from the first Hebrew word in the verse *I have set the Lord always before me* (Psalm 16:8) displayed in three scalloped medallions at the top. It is also called a *Menorah* because the verses of Psalm 67 were patterned as a seven-branched candelabrum, a reminder of the Temple Candelabrum. The mystical inscriptions and the 42-letter Divine name added in the margins endow it with protective powers. *Shivitis* or *Menorot* traditionally hung on synagogue walls close to the Holy Ark to help worshippers concentrate on prayer and feel God's presence, but they could also be used in the home to protect it, or as personal amulets. *Shivitis* can be found in prayer books, either printed within the text or as loose sheets.

BL Or. MS 14057 (50)

Menorah plaque

India, nineteenth century

Here the *Tetragrammaton* (the four-letter Divine Name which must not be pronounced and is invested with magic powers) was written in an oval cartouche, which is supported by a pair of yellow lions rampant. Pairs of lions were a common motif in this type of votive tablet. Angels' names, biblical and mystical verses, for protection against harm, were inscribed around the candelabrum-shaped text. *Menorot* and *Shivitis* were equally popular with Ashkenazi and Sephardi Jews.

BL Or. MS 14057 (114)

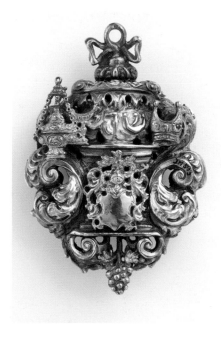

Amulet

Syria, nineteenth century

This is a silver amulet, to be worn as a bracelet. The hinged and scalloped side-plates are chased with bands of Hebrew characters forming a Kabbalistic prayer. Amulets (*kame'ot*) were believed to be magically potent, and were usually worn close to the body. The commonest amulets were those intended to offer protection against illness and childbirth, which in earlier times were fraught with anxiety and fear. Others were meant to ward off the Evil Eye, or were considered generally beneficial. Jewish amulets often contained elaborate Kabbalistic inscriptions, angelic names, or variants of the Divine name. Other ornamental features used on amulets included geometrical designs, such as the Star of David, triangles, squares or pentacles.

The Jewish Museum, London, Barnett 613

Amulet

Italy, *c*.1680

This silver-gilt amulet, pierced and chased with scrolling foliage and applied motifs, shows the Tables of the Law, the *menorah* (seven-branched candlestick), censer and mitre – all significant in Jewish worship. The central escutcheon, meant for the owner's name, was left blank. The use of *Shadai*, one of God's Hebrew names (Genesis 17:1), as an inscription endows the object with protective powers, and might explain why in Italy these amulets were called *Shadai*.

The Jewish Museum, London, Barnett 593

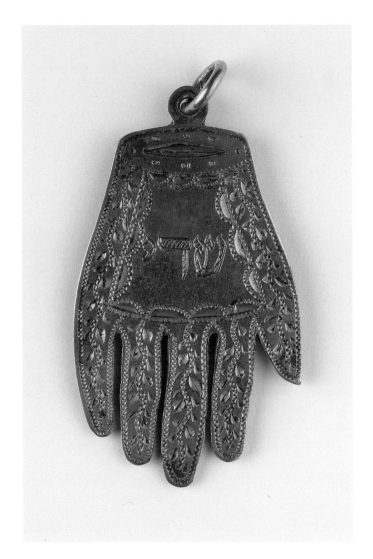

Khamsa Amulet

Morocco, early twentieth century

This amulet is a silver, asymmetrical cut-out hand, decorated with foliage sprigs on the fingers and inscribed with the divine name *Shadai*. A Muslim symbol, the *Khamsa* or Hand of Fatima became one of the most popular charms among Jews from Islamic countries. The shape of the open hand, for instance, was a reminder of the outstretched hands of a priest delivering the Jewish priestly blessing. The number five, to which Muslims attributed magic powers, had similar connotations in Judaism. The letter *he* is the fifth letter of the Hebrew alphabet, so its numerical value is five. This is also the case for the *Monogrammaton* (the one-letter Divine name), which, according to tradition, had tremendous protective powers.

The Jewish Museum, London, Barnett 599

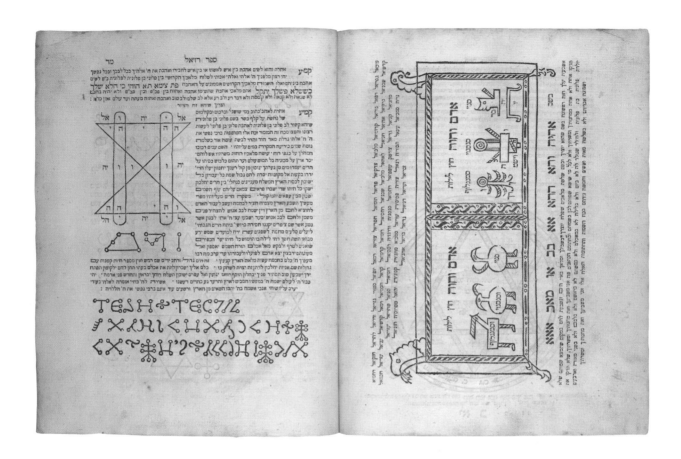

Early Printed Kabbalah (Sefer Raziel)

Amsterdam, 1701
First printed edition by Moses ben Abraham Mendes Coutinho

Sefer Raziel ha-Malakh (The Book of the Angel Raziel) was probably compiled in the thirteenth century by Eleazar of Worms, a German Jewish pietist. According to legend, the knowledge contained in this book was handed down by Raziel the angel to Adam after his expulsion from paradise. It is basically an anthology of mystical, cosmological and kabbalistic texts written in Hebrew and Aramaic, and is regarded as one of the earliest manuals of practical Kabbalah. *Sefer Raziel* gained wide popularity, particularly for its magic formulae, incantations and numerous amuletic templates.

An additional reason for its popularity was the belief that its owner's home would be protected from fire and other dangers. In this copy the right-hand page shows an illustration of an amulet intended to protect women in childbirth and newborn babies from harmful spirits, in this case, Lilith, mother of all demons. In the lower section of the left-hand page is a Kabbalistic alphabet, the characters of which are reminiscent of the alphabet Jews had used some 2500 years earlier.

BL 1967.e.5, ff. 43v–44

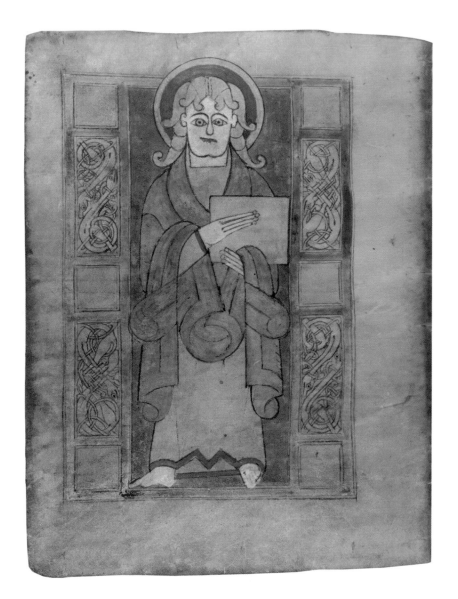

Four Gospels

Ireland, eighth century
Evangelist portrait of Luke

The small size of this Latin copy of the Gospels made it easily portable; it was perhaps carried in a *cumdach* (ornamental satchel) or hung around the neck. Commonly referred to as a 'Pocket Gospel', it is one of several surviving Irish examples produced for private use, which may have been carried around by priests for easy reference, or worn to protect the wearer. The frontal portrayal of St Luke holding his Gospel is the only surviving part of the original decoration. In a distinctively Irish interpretation of an Evangelist portrait, it includes animal interlace in the framing panels.

BL Add. MS 40618, f. 21v

Mercian Prayer Book

Mercia, England, first half of the ninth century

Apocryphal letter of Christ to Abgar

The theme of the prayers, Gospel readings and charms in this Anglo-Saxon prayer book is the figure of Christ as healer. Indeed, some scholars have suggested that it may have served as a quasi-practical tool for a physician. It includes an apocryphal or supposed exchange of letters between Christ and Abgar, King of Edessa (4 BC–AD 50). In his letter the king tells Christ that news of His miraculous cures has led Abgar to believe, so he requests that Christ come to cure him of his illness. In reply, Christ blesses Abgar and promises a life-giving cure through one of his disciples. In the Middle Ages these texts acquired a powerful, talisman-like quality of their own. For, as in this copy, the owner of the manuscript becomes the recipient of the letter, receiving for himself Christ's blessing and promise of health and life.

BL Royal MS 2 A XX, f. 12v

The Cuthbert Gospel

Northern England, last quarter of the seventh century

This manuscript retains its original binding – the earliest surviving in the West. Symeon of Durham (fl.*c.*1090–*c.*1128), a monk of Durham, records that a small Gospel book was found in the coffin of St Cuthbert (*c.*635–87), bishop of Lindisfarne, when his body was transferred (or translated) to a new shrine in the east end of Durham cathedral in 1104. This is that book, probably placed with the body in 698. According to Symeon, the manuscript was lifted up and displayed to the assembly during the twelfth-century translation ceremony. This action emphasises the power of the Gospel as object as well as Word, perhaps serving as a kind of talisman to protect believers. The manuscript was formerly held in the library of Stonyhurst College, Lancashire, and then known as the Stonyhurst Gospel. It is currently on loan to the British Library.

BL Loan MS 74 (upper cover)

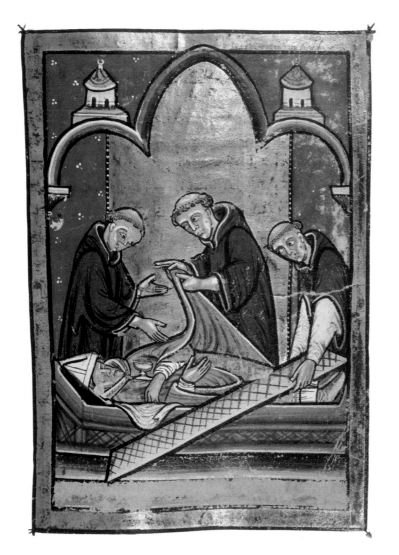

Prose Life of St Cuthbert

Durham ?, England, last quarter of the twelfth century
St Cuthbert's tomb being opened

In his *Life* of St Cuthbert the historian Bede (673/4–735) relates that when St Cuthbert's tomb at Durham was opened the saint's body was found

> 'intact and whole, as if it still had life, and so flexible in its joints that it seemed the body of a man sleeping rather than dead. Moreover all the clothes that he was wearing were not only undefiled, but although they were old seemed to be pristinely new and of wondrous brightness.'

The moment of this discovery when three monks open the tomb is shown here. The manuscript was perhaps produced in Durham at a time when the cult of St Cuthbert was being promoted by the Benedictine monks of the cathedral and its bishop Hugh du Puiset (*c.*1125–95), earl of Northumberland and nephew of King Stephen. Its extensive illuminated cycle of illustration demonstrates the importance of the body and relics of St Cuthbert, the most renowned and venerated of all English saints in the early Middle Ages.

BL Yates Thompson MS 26, f. 77

Armenian Prayer Scroll or Amulet

Constantinople, 1655
Selection of prayers, St Sargis on horseback

Armenian travellers and pious persons carried amulets such as this one, containing prayers by the early church Fathers, magical formulae, stories of healing and miracles from the Gospels, and prayers against sickness and for protection against spells. New owners of such scrolls removed the name of the previous owner from the end of each prayer and substituted their own. This scroll was copied by 'the sinful Gasper for the servant of God Martiros.' The text is illustrated with depictions of saints, angels and scenes from the life of Christ. The image here is of the victorious St Sargis, a general in the Persian army martyred during the reign of the Emperor Julian (r. 361–3). In the Armenian Church St Sargis is a popular talismanic image. His feast day, sixty-three days before Easter, is now sometimes celebrated by the unmarried by eating a piece of salty bread, so that the saint can reveal their future spouse to them in their dreams as the person who offers them a drink.

BL Or. MS 14028

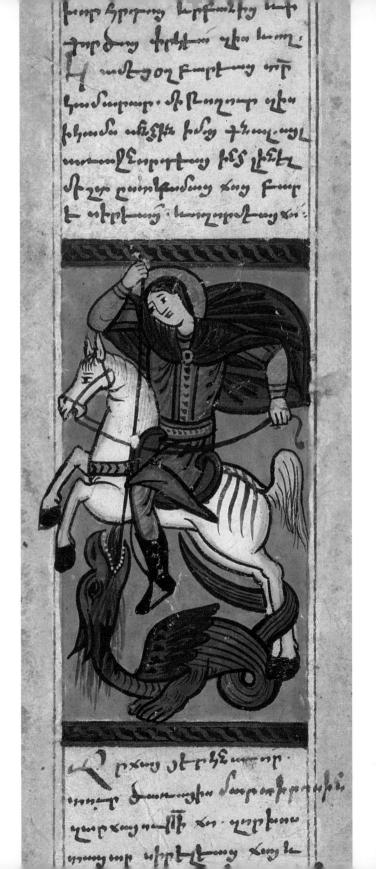

A Miniature Qur'an

Shiraz, Persia, dated 950/1543
Chapter 6, *al-An'am* (The Cattle), verse164 to Chapter 7,
al-A'raf (The Heights), verse 17

Miniature Qur'ans were not meant primarily for reading.
They were usually carried by travellers as protective amulets
and good luck charms, and were often encased in a jewel-like
box for safekeeping. These Qur'ans come in various shapes –
square, rectangular, often octagonal – and are written in a
minute style of *naskhi* script known as *ghubar*, the Arabic
word for 'dust', the texture of the calligraphy being so fine
that it is likened to powder. This script is particularly suitable
for text that needs to be accommodated as neatly and as
densely as possible within the confines of a small page.

BL Or. MS 2200, ff. 91v–92

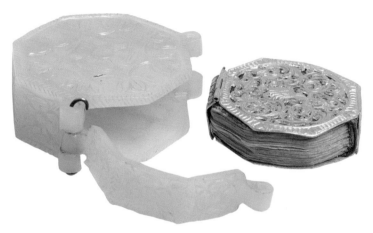

A Miniature Qur'an with Gold Filigree Cover and Case in White Jade

Persia, seventeenth century

BL Loth 36

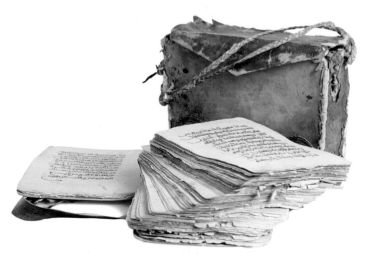

Loose Leaves from a Qur'an with a Saddlebag

West Africa, nineteenth century

Another distinct region of the Islamic world, significant for
the production of Qur'an manuscripts, is sub-Saharan and
West Africa. In these areas Qur'ans were made to be portable
so that they could be carried by nomadic tribesmen. Hence,
the leaves were generally unbound, kept loose between
boards, as this made them easier to store in a pouch or
saddlebag.

BL Or. MS 13706

An Italian *Ketubah*

Ancona, Italy, 1776

The tradition of the *Ketubah* (Jewish marriage contract) dates back 2000 years, making it one of the earliest documents granting women legal and financial rights. This *Ketubah* records the marriage of Moses Michael ben Judah from Ascoli and Esther, daughter of Joshua Sabbetai, in Ancona. A thriving port on the Adriatic, Ancona was the site of a prosperous and cultured Jewish community, and one of the major centres of *Ketubah* decoration in Italy. One of their distinctive marks was the pointed upper border, known as an 'ogee arch'. Another typical feature, with many variations, was a wider external frame with roundels incorporating the signs of the zodiac and narrative biblical scenes.

This contract includes a depiction of Jerusalem in the lower vignette with the following legend: 'If I forget thee, O Jerusalem, let my right hand forget her cunning' (Psalms 137:5), which is often recited at Jewish ceremonies. Hebrew scriptural verses from Proverbs 12:4 and Psalms 128:3 alluding to the wife's attributes and her fertility appear in the upper perimeter inside the crown and in the heart-shaped cartouche placed beneath it.

BL Or. MS 12377M

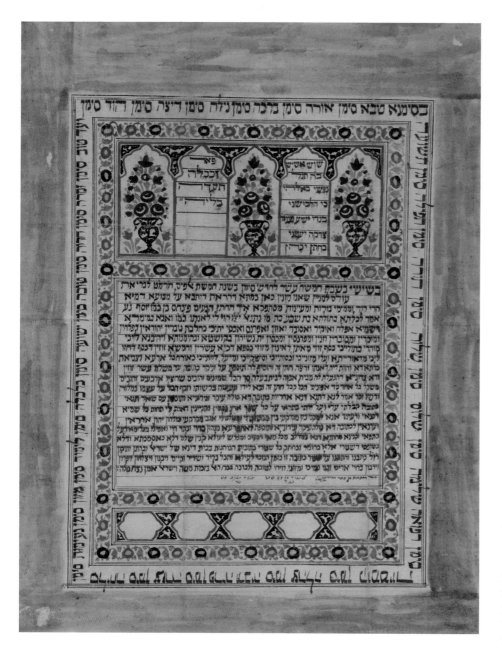

An Afghani *Ketubah*

Herat, Afghanistan, 1889

This *Ketubah* records the marriage of Pinhas, son of Yosef, to Bat-Sheva', daughter of Netan'el. Islamic and Persian elements can be detected in the decoration, which is typical of nineteenth-century Jewish marriage contracts from that area.

The text of the contract was written on lines outlined in red ink within a brightly coloured floral border. An arcade with five arches, three of which are occupied by blue floral vases, crowns the calligraphic text. The scriptural verse in the other two arches is from Isaiah 61:10 and translates thus: 'I will greatly rejoice in the Lord, my soul shall be joyful in my God; for he hath clothed me with the garments of salvation, He has covered me with the robe of victory, as a bridegroom putteth on a priestly diadem and as a bride adorneth herself with her jewels.'

The five blank medallions outlined in orange in the lower section of the document were purposely reserved for the five witnesses' signatures, but only three signed their names at the end of the contract. The fivefold element customarily used in Herat Jewish contracts was apparently borrowed from Muslim folk belief, where the number five possessed magic and protective qualities. Also standard here is the exterior frame with a lengthy inscription of good wishes to the couple.

BL Or. MS 15893

Bridal Canopy

London, twentieth century
Hand-embroidered by Tamara Zlotogoura

The *hupah* (bridal canopy) traditionally used at Jewish weddings is originally mentioned in the Hebrew Bible (Joel 2: 16; Psalms 19:6). It symbolizes the new home that the bride and groom will build together, and is usually made of cloth and held up by four poles. During the ceremony, the rabbi conducting the marriage service, the couple and their closest relatives stand under the canopy. The structure is open on all sides, as was patriarch Abraham's tent, a clear allusion to the hospitality of a Jewish home.

The elaborate *hupah* shown here was hand embroidered in gold and bronze threads on pure silk ivory dupion. It is embellished with exuberant floral and foliage garlands, and stars of David. Around the pelmet there are quotations about the bride and groom and the blessings of matrimony.

Private Collection

An Islamic Marriage Contract

India, 18 November 1840
The marriage of the last Mughal ruler, Bahadur Shah II (r. 1837–57) to Zinat Mahall Begam

This *kabin-nama* (marriage contract) opens with the religious wording in Arabic traditionally associated with marriage. It records that the marriage was legally performed openly with the consent of the bride and bridegroom. It states that the bridegroom agreed to pay a *kabin* (jointure or settlement) of 1,500,000 current rupees, of which one-third is to be paid immediately and two-thirds at any time during their married life, and that the marriage took place in the presence of two free, adult and righteous witnesses. Bahadur Shah, who is also remembered as a great Urdu poet, was deposed by the British twenty years later in the aftermath of the Indian Mutiny. With his family he was exiled to Rangoon, Burma, in 1858, thus ending 300 years of the Mughal Empire. He died four years later, his widow in 1886.

BL IO Islamic 4555

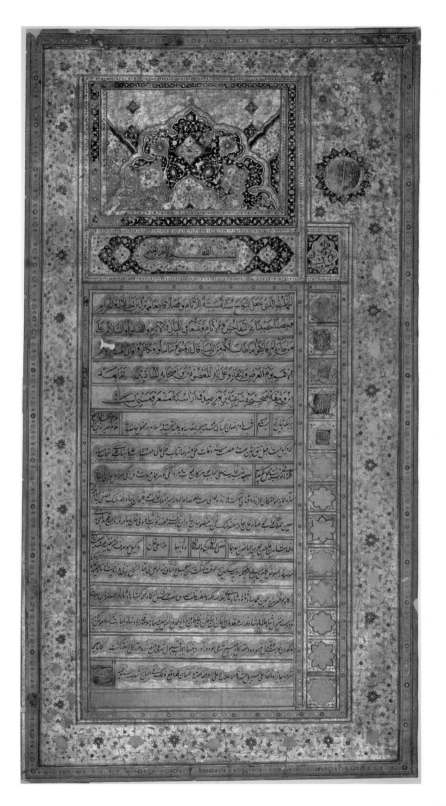

The Tristan da Cunha Bible

Boston, USA, 1831

End of the Apocrypha and family record

Corporal William Glass of Kelso, Scotland, was the founding settler of Tristan da Cunha, a small volcanic island nearly 1800 miles west of Cape Town, discovered in 1506 by the Portuguese navigator Tristão d'Acunha. Glass settled on the island in 1817 with his South African wife, Maria Magdalena Leenders. Their marriage is noted in the Bible between the Old and New Testaments, on the pages provided for family records of marriages, births and deaths. The Bible was printed in Boston in 1831. It may have been taken to the island by one of the many American whaling ships that stopped there at some time before 1836, when the entry relating to the birth of their thirteenth child (of sixteen), on the following page, is written in a different or shakier hand than those of the older children. These entries illustrate the tradition of entering important family events in a Bible, reflecting the Christian belief in Christ's teaching that all who believed in Him would become 'children of God' (John 1:12).

BL Add. MS 43729, ff. 442v-443

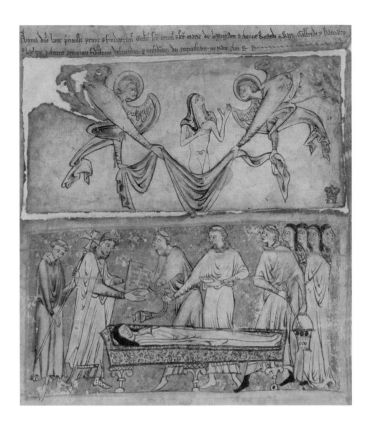

Mortuary Roll of Lucy de Vere

Essex?, England , *c.*1225–30
Death of Lucy de Vere

The death of an abbot or abbess occasioned prayers not only
by their community but also from other monastic institutions.
When Lucy de Vere, the first prioress of the Benedictine
nunnery of Hedingham in Essex, died her successor sent
out this roll asking prayers for Lucy's soul. It is the second
oldest surviving English obituary roll, and is over 19 feet long.
122 monasteries from all over southern England responded
to the request, and added inscriptions asking for reciprocal
prayers. The contribution of the Franciscan house established
in Cambridge in 1226 allows the roll to be dated. At the top
of the roll are images executed in ink with colour washes.
Here, two angels carry the soul of Lucy up to heaven, with
monks and nuns gathered around her coffin below.

BL Egerton MS 2849, Part I

Alabaster Tombstone in the Name of Sultan Baqir al-Ansari

Probably Yazd, Persia, 1014–15

Epitaphs on Islamic tombstones record
the name of the deceased and also bear
witness to their faith. This inscription
is carved in a decorative *kufic* script.
Around the margin is the *basmalah*,
the pious invocation 'In the name of
God, the Merciful, the Compassionate',
which continues with the words,
'Thanks be to God, Lord of the worlds,
and peace be upon Muhammad and
his family'. The name of the deceased,
together with the date of his death, is
inscribed in a prayer-niche design
within the centre of the stone.

British Museum, 1982.0623.1

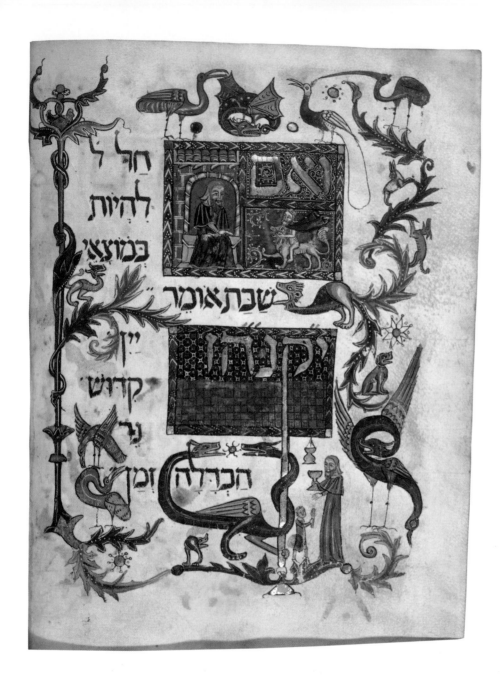

The Barcelona Haggadah

Barcelona, fourteenth century
Mnemonic for Passover

The Haggadah (Telling) is the Hebrew service book used in Jewish homes on Passover eve to commemorate the Israelites' miraculous delivery from Egyptian bondage. Its text is a mosaic of biblical passages, legends, blessings and rituals. It teaches the young about the continuity of the Jewish people and their unflinching faith in God, as in the verse: 'And thou shall tell thy son in that day…. It is because of that which the Lord did for me when I came forth out of Egypt' (Exodus 13:8). The Haggadah has long inspired artists, and remains one of the most frequently illustrated texts in the Jewish liturgy.

Unlike other Spanish Haggadah manuscripts, the Barcelona Haggadah lacks the characteristic cycle of full-page biblical narratives that normally prefaces the main text. By contrast, nearly all its folios are filled with miniatures depicting Passover rituals, biblical and Midrashic episodes, and symbolic foods. Particularly stunning are the tooled Gothic word panels and the lush marginal foliage scrolls inter-woven with human figures, birds, hybrids, grotesques and fabulous animals, as this opening shows. Occasion-ally, animals are portrayed performing human activities, a humorous element probably borrowed from Latin codices. The lower panel on this page contains a mnemonic sign (memory aid) of the rituals that should be performed if Passover falls at the close of the Sabbath.

BL Add. MS 14761, f. 24v

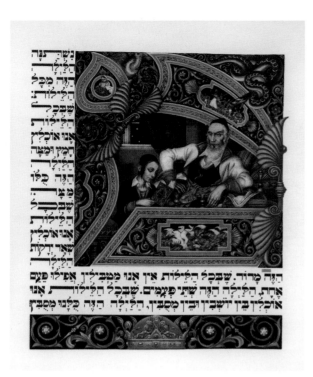

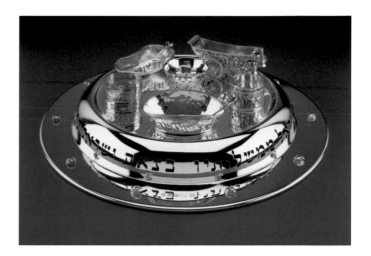

Silver Set for Passover

London, 2000
Daniel Lehrer

The celebratory Passover eve ritual is called the *seder* (meaning 'order') because of its fifteen-step sequence specified in the Haggadah. In the Diaspora the Passover *seder* is celebrated on two consecutive nights. During the ceremony participants must consume four glasses of wine (grape juice for children) and eat symbolic foods, which are usually placed in a special *seder* platter. These include the *maror* (bitter herbs), a reminder of the Israelites' hardship; *haroset* (sweetmeat), recalling the mortar used by the Hebrew slaves in building the Pharaoh's cities; salt water, which symbolizes the tears of oppression and of the joy of freedom; a *zero'a* (usually a shank bone, which is not eaten), symbol of the Paschal lamb; an egg, which recalls the first sacrifice of the Paschal lamb; and the *karpas* (vegetable), a reminder of the Hebrew slaves' meagre diet in Egypt.

This exquisite *seder* plate is made of sterling silver with applied eighteen-carat gold. It comprises a round tray with six containers for the ceremonial foodstuffs, depicting scenes from Exodus. Its creator, Daniel Lehrer, a renowned goldsmith and silversmith, has won commissions from several royal families and heads of state, and for major private collections and synagogues.

Private Collection

Arthur Szyk Haggadah

London, 1940

The opening question of the Passover Haggadah prompts the retelling of the Exodus from Egypt ('What makes this night different from other nights?'). It is introduced here by the beautifully wrought, historiated Hebrew initial *mem*. The letter form itself comprises three small miniatures, showing the baby Moses, the Israelites' flight from Egypt, and the drowning of the Egyptians in the Red Sea, all of which sum up visually the Exodus narrative. The scene inside the letter depicts a religious Jewish man explaining the meaning of the Passover festival to a boy.

The twentieth-century Jewish-Polish illustrator Arthur Szyk drew on medieval illuminations, and Oriental and contemporary sources to create timeless works of art. Due to its immaculately presented calligraphy and elaborate designs executed in luminous, glowing colours, the Szyk Haggadah has deservedly been praised as 'worthy to be placed among the most beautiful of books that the hand of man has produced' (*Times Literary Supplement*, 22 February 1941).

BL Or. 70.c.12

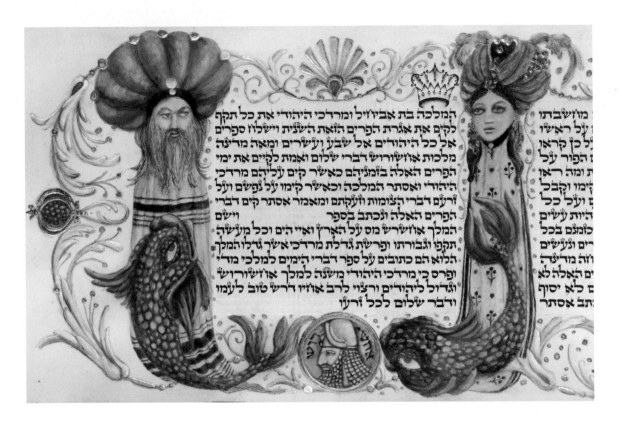

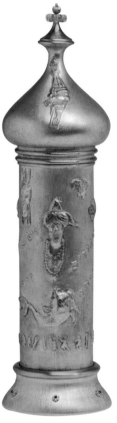

The Ramsgate Esther Scroll with a Silver Jewelled Case

London, 1997–2000
Mark Negin (artist) and Schmuel Meir Anshin (scribe);
case by Daniel Lehrer; *Esther 10*

The Scroll or Book of Esther (*Megilah* in Hebrew) forms part of the *Ketuvim* (Writings) the third section of the Hebrew Bible. It tells how Esther, a Jewish maiden, together with Mordecai, her uncle, helped free the Jews in the Persian Empire during the reign of King Ahasuerus (486–465 BC). These events are commemorated every year in the synagogue during the spring festival of Purim, when the book of Esther is read from an unadorned manuscript scroll. Like the Passover Haggadah, the Purim narrative provides ample scope for the artist. Illustrated Scrolls of Esther on parchment used for home reading during the Purim festival began to appear in Italy from 1567. This tradition of decorating Esther Scrolls continues to this day.

These stunning illuminations were painted by Mark Negin (Aryeh Leib ben Nathan) of Ramsgate, Kent, who is a gifted contemporary artist trained as a stage designer. He uses watercolours and gold leaf for the illustrations, which include characters from the Esther narrative, animals, floral sprigs, the signs of the zodiac, grape clusters and vases. The magnificent sterling silver case, chased with applied eighteen-carat gold, diamonds, rubies and rock crystals, was produced by Daniel Lehrer (see also previous page).

Private Collection

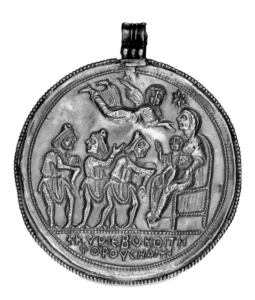

Gold Medallion

Jerusalem?, late sixth to early seventh century
Adoration of the Magi

This impressive gold medallion includes an image of the Adoration of the Magi, where according to Matthew, 'Magi from the east came to Jerusalem and asked, "Where is the one who has been born king of the Jews? We saw his star when it rose and have come to worship him."' (Matthew 2:12). Here an angel hovers near the star, above St Mary's head. Christ's birth, now celebrated as Christmas, is a central festival in the Christian calendar. The medallion was probably made in the Holy Land, and may well have served as an amulet for a wealthy visitor to the holy places there, for the inscription in Greek reads 'Lord protect the wearer, Amen'. On the reverse, an image of Christ's Ascension into heaven is accompanied by a verse based on John 'Our peace we leave with you' (John 14:27).

British Museum MLA 1987, 7-4.1

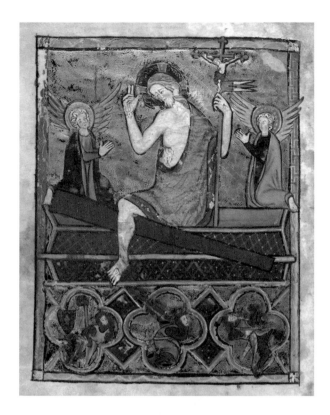

The 'Map' Psalter

London?, last quarter of the thirteenth century
The Resurrection

On what is now celebrated as Easter Sunday, Christians believe that Christ rose or was resurrected by God from the dead, as He had predicted. In this image Christ is shown stepping out of His coffin, a cruciform halo around His head. His wounds are visible, and He is flanked by kneeling angels. His right arm is raised in a gesture of blessing, and in His other hand he holds a cross-shaped staff with a small crucifix and banner. Below, in the pattern of the coffin are depictions of the soldiers who were guarding the tomb. In medieval art they are usually shown sleeping, perhaps to illustrate chapter 27 of St Matthew's Gospel, which states that the soldiers were paid to say that Christ's disciples stole away the body while they slept. This image was added to a Psalter now famous for including another image that shows Christ holding a map of the world with Jerusalem at its centre. It is from the latter image that the Psalter derives its name.

BL Add. MS 28681, f. 5v

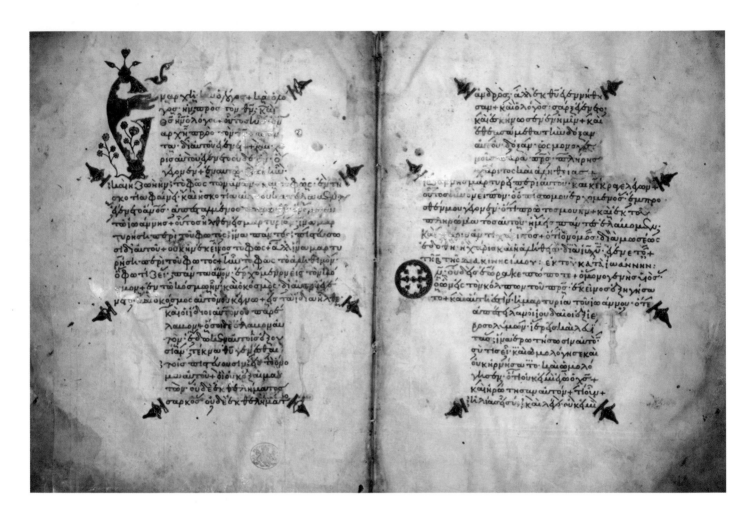

The London Cruciform Lectionary

Constantinople, twelfth century
John 1

The cross is the central symbol of the Christian faith. In this lavish copy of the Gospels the symbol literally shapes the text itself and thus imprints it on the mind of the viewer. The book is one of only four known surviving Greek Gospels of this type. The eagerness of a donor to highlight the special nature of his gift to a religious foundation most probably explains the great expense incurred by this complex and sophisticated layout. As the text of the Gospels is arranged according to the order in which they were read during the Church year, the opening text of the volume is the reading for the beginning of that cycle, namely Easter Day.

BL Add. MS 39603, ff. 1v–2

Metal 'alam for Muharram procession

?Deccan, India, *c.* nineteenth century

Standards known as *'alams* have traditionally been used in
Shi'a communities at ceremonies associated with Muharram.
They commemorate the martyrdom of Imam Husayn and
his followers at Kerbela in Iraq in 680. They were normally
placed on poles and carried in processions, but larger ones like
this may have been carried in a cart. This large tinned copper
'alam is 240 cm high and may come from the Deccan, home
to one of the principal Shi'i communities in India, and also
to many Iranian immigrants. Hyderabad, for example, is
named after Imam 'Ali, who was known also as Haidar 'Ali.
This *'alam* has five flanges rising out of the top, representing
the Prophet Muhammad, his daughter Fatima, his cousin and
son-in law 'Ali, and his grandsons Hasan and Husayn. It is
covered entirely in Arabic inscriptions. On the front, these in-
scriptions consist of verses from the Qur' an, the ninety-nine
'Beautiful names of God' (*al-asma al-husna*), the names of the
Old Testament Prophets and the twelve Shi'i imams. Most of
these inscriptions are in cursive script; on the horizontal
flange the *shahadah* (profession of faith) is in square *kufic* with
further inscriptions within it, a style known as *ghubar*. In the
oval below the *kufic* inscription is an Indian-style canopy
made up of inscriptions, some of which are in mirror writing.
On the back, the inscriptions consist almost entirely of prayers
and references to individuals preceded by the phrase *'salam
'ala…'* ('peace be upon…').

British Museum 1920.7-7.1

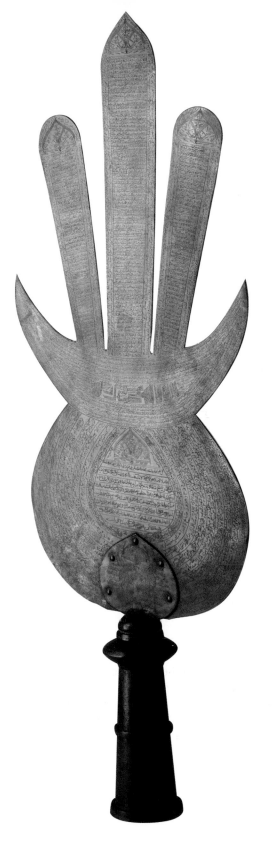

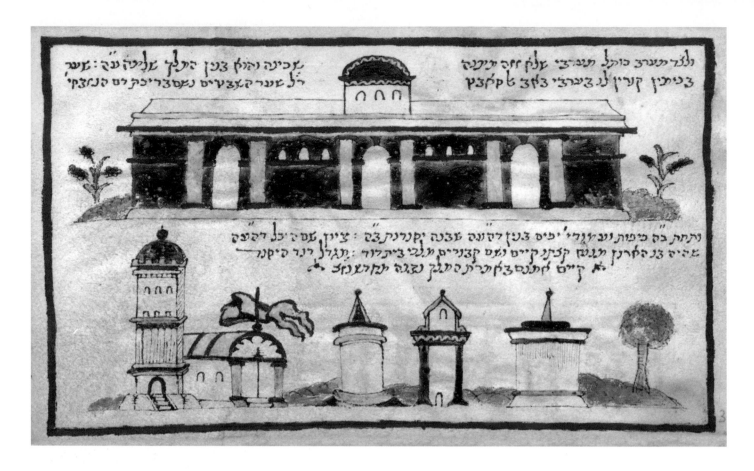

Itinerary of the Holy Land

Casale Monferrato, Piedmont, Italy, 1598

During the Second Temple period (538 BC – 70 AD), Jews (particularly males) were required to go on pilgrimage to Jerusalem and the Temple. They did this three times a year on the Pilgrim Festivals – Passover, Shavu'ot (the Festival of Weeks), and Sukot (the Festival of Tabernacles) – as commanded in the Hebrew Bible. After the destruction of the Temple in 70 AD, these pilgrimages continued throughout the Middle Ages. Later, particularly during the nineteenth century, visits to the Holy Land intensified and included the tombs of Jewish biblical figures, such as King David, as well as those of Moses Maimonides and others. Since the reunification of Jerusalem in 1967, the site of the Temple has once again become a magnet for Jewish pilgrims.

Pilgrimage to the Holy Land has yielded a rich and varied Jewish travel literature: personal accounts, pilgrims' diaries, guides and itineraries to the country's holy sites, which pious pilgrims compiled for others to use. This itinerary of the Holy Land may have been written by a professional author rather than by a genuine pilgrim. It features the remains of the Jerusalem Temple, burial sites of biblical matriarchs, patriarchs and prophets, and also the graves of rabbis of the post-biblical period. It may have been modelled on contemporary scrolls of the genealogy of the righteous, as used in Jewish fundraising missions. It belongs to a tradition of illustrated itineraries equally popular with Christians.

Brotherton Library, University of Leeds, Roth MS 220, f. 3v

Matthew Paris, Chronicle

St Albans, England, between 1250 and 1259

Map of Jerusalem

Matthew Paris (d. 1259) was a chronicler and monk of St Albans Abbey. This is one of several manuscripts in his handwriting and with his drawings. At the beginning of a universal history of the world he included an itinerary of the pilgrimage route from London to Jerusalem, with comments in Latin or French. This page illustrates the end of the journey, with Jerusalem surrounded by a crenellated wall labelled *'civitas Ierusalem'* (Jerusalem city). Paris has included within the city three important sites: on the left, a domed structure for the Dome of the Rock, transformed by the Crusaders into the *Templum Domini* (the temple of the Lord), as it is labelled (although it had already been retaken by the Saracens when this map was made). In the right-hand corner is another mosque that had been turned into a church, the Temple of Solomon, a domed building given to the order of the Knights Templar, who took their name from this structure. The third building is the pilgrimage church of the Holy Sepulchre, represented by a circle in the lower corner.

BL Royal MS 14 C VII, f. 5

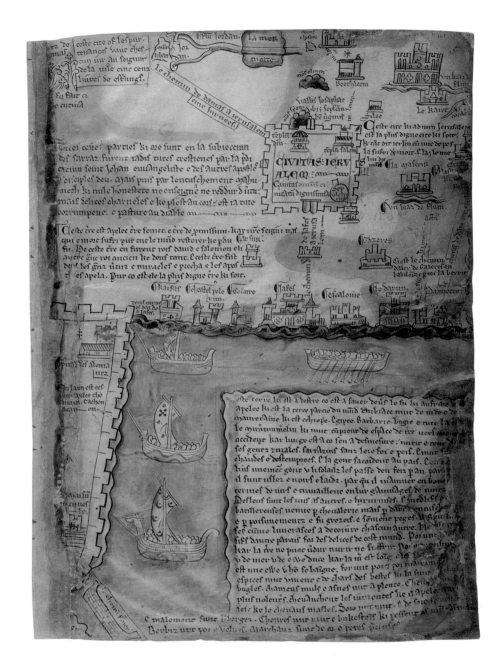

Fragments of Four Gospels

Northern Ethiopia, fourteenth century
The Holy Women visiting the Holy Sepulchre

This image once belonged to a manuscript that also included full-page images of the Crucifixion (now missing), and of Christ in Glory with Mary in her role as the Mother Church, Mary of Zion (Maryam Seyon) before the text of the Four Gospels. The pictures thereby provided a summary of important events in Christ's life: His death, Resurrection and Ascension. They also correspond to the three holy sites in Jerusalem often reproduced on souvenir *ampullae* (clay holy water bottles, see page 212) that were produced for pilgrims in Palestine during the sixth and early seventh centuries. The most popular holy sites were Golgotha, the site of the Crucifixion; the Holy Sepulchre, the site of the Resurrection; and the Mount of Olives, the traditional site of the Ascension. Today the Greek, Catholic and Armenian churches share primary responsibility for the site of the Holy Sepulchre.

Nationalmuseum, Stockholm, B.2034, f. 23

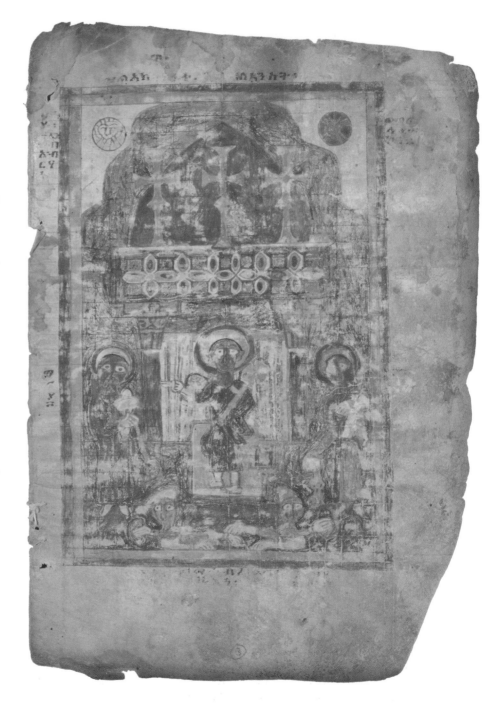

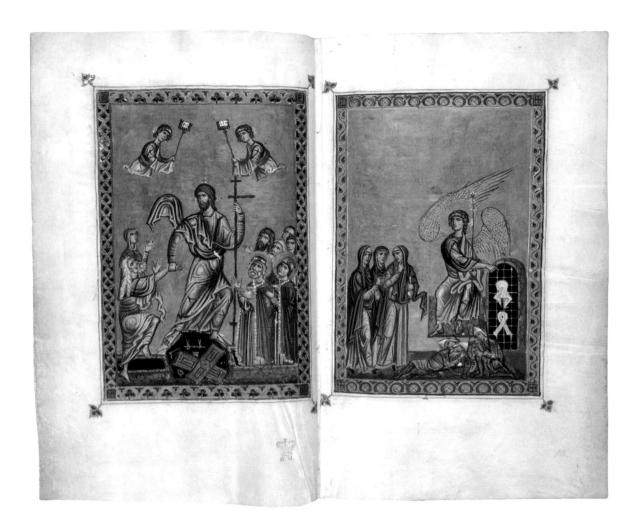

The Melisende Psalter

Crusader kingdom of Jerusalem, between 1131 and 1143
The Resurrection; the Holy Women at the Tomb

The probable first owner of this Psalter, or book of Psalms, was the Frankish princess Melisende, who became Queen of Jerusalem (1131–43) when the Holy Land was ruled by the Crusaders. The manuscript mirrors the hybrid cultural milieu of its owner, with its Latin text preceded by twenty-four images of the life of Christ painted in a style elsewhere employed to illustrate Greek manuscripts. Their content, as well, is derived from Byzantine models. For example, this image of the resurrected Christ victorious over death, trampling the gates of Hell and reaching down to free Adam and

Eve, is known as the *Anastasis* (the Greek word for 'resurrection' or 'to rise or stand again'). On the right, Kings David and Solomon, dressed in imperial Byzantine garb, raise their hands in adoration or prayer. Above Christ, angels hold standards with the letters 'SSS' for *Sanctus, Sanctus, Sanctus* (Holy, Holy, Holy). The shining gold background serves to emphasize the otherworldly and visionary nature of the image, and is the same as would be used for an icon.

BL Egerton MS 1139, ff. 9v–10

Miracles of St Menas

Nubia, 1053
St Menas

St Menas was an Egyptian martyred *c.*295 under the Roman emperor Diocletian (245–313). His place of burial at Bumma (Karm-Abum-Abu Mina), in the Mareotis desert between Alexandria and the valley of Natron, was an important place of pilgrimage for the Eastern church, famous for the miracles wrought there. This manuscript describes his miracles, and is one of the few manuscripts to survive in the Nubian dialect. Although there were probably Christians in Nubia from an early period, the church did not develop there until the sixth century, when the Emperor Justinian and his wife Theodore encouraged missionary activity in the region. In this image, illustrating the last miracle in the collection, St Menas is depicted on horseback, having descended from an icon in his church in Alexandria to cure a woman of her barrenness. The unidentified figure below him touches the foot of the saint's horse, probably as a gesture of submission.

BL Or. MS 6805, f. 10

Ivory Pyx

Probably Alexandria, sixth century
St Menas

Christians adopted the box called a pyx not only for storage of the consecrated host (see page 171) but also for use as reliquaries. This ivory pyx is decorated with scenes from the martyrdom of St Menas, and was probably made as an offering by the four figures also pictured on it with their hands raised in supplication, probably a couple and their two children. St Menas with a halo stands between them, his hands in a gesture of prayer, within two columns covered by an arch, probably representing a sanctuary. To either side, next to the donors, are two small camels, St Menas's symbol. According to tradition an angel appeared to Christians after St Menas's execution and ordered them to put the saint's body on a camel and allow the camel to go into the desert without leading it. The camel would stop at the place that the Lord had designated for St Menas's burial.

British Museum 1879.12-20

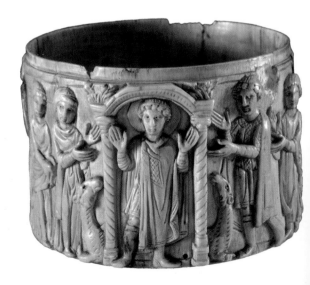

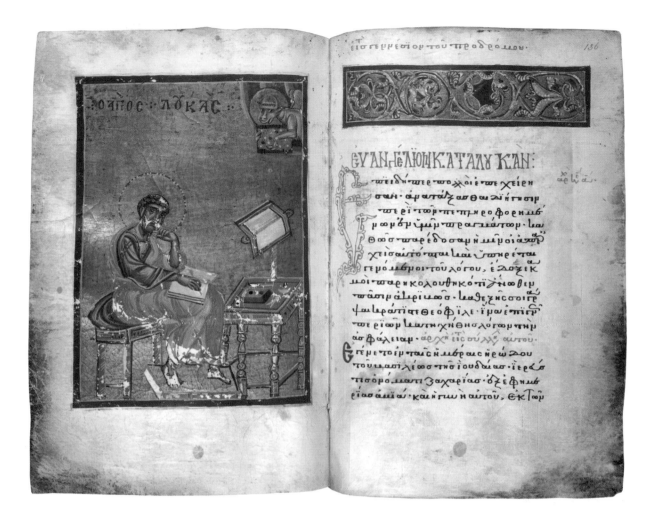

Four Gospels

Eastern Mediterranean, 1325/1326
Luke 1

This elegant copy of the Four Gospels in Greek was probably at the Monastery of St Catherine, Mount Sinai, by the late fifteenth century. It is a good example of the layout typical for a luxury Byzantine Gospel book. In these highly decorated copies a full-page image of the author of each Gospel faces a page with an ornamental band, or headpiece, above the beginning of the Gospel text, with a large decorated first letter at the beginning of the first word. Typically, the Evangelist was shown seated, writing in an open book in front of desk with all of his writing utensils, as in the image of St Luke from a tenth-century copy of the New Testament appearing at the beginning of this catalogue (see page 36). Although common in Evangelist portraits made in Western Europe, the inclusion of Luke's symbol of the lion in the upper right-hand corner of this portrait is a rare Byzantine example.

BL Add. MS 11838, ff. 135v-136

Greek Old Testament Picture Book

Sinai, Egypt, *c*.1500
Legend of the death and burial of Moses

This exceptionally well-preserved manuscript, probably made at the Monastery of St Catherine, Mount Sinai, contains the verse paraphrase of the books of Genesis and Exodus by the Cretan writer Georgios Chumnos. Written in a form of the Greek language close to the spoken language of around 1500, it was intended to allow a wider readership direct access to the biblical text. There were also no fewer than 375 coloured illustrations. Here Moses directs the making of his tomb. The poem records that when Moses tested it to see whether it was the right size, God sent a mist to hide him from the people. This legendary account in verse has its antecedents in the Greek tradition of the death of a classical hero, but also reflects the biblical tradition of the ascension of holy figures, such as Elijah, who was taken up to heaven in a whirlwind, according to 2 Kings, and who was viewed as type or prefiguration of Christ.

BL Add. MS 40724, f. 137

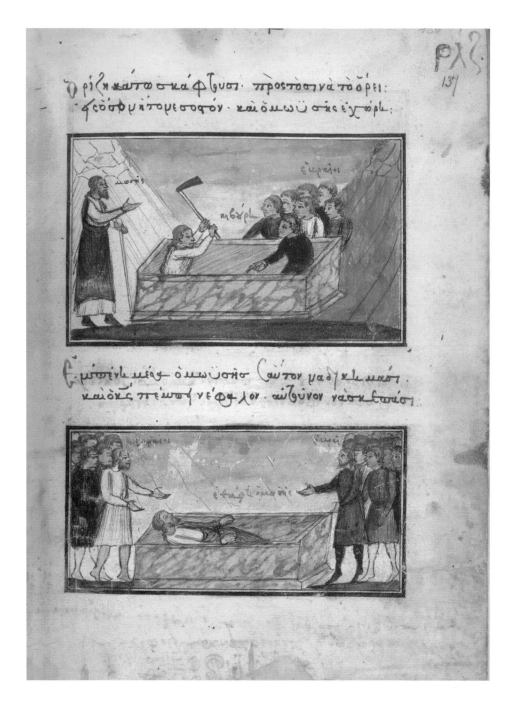

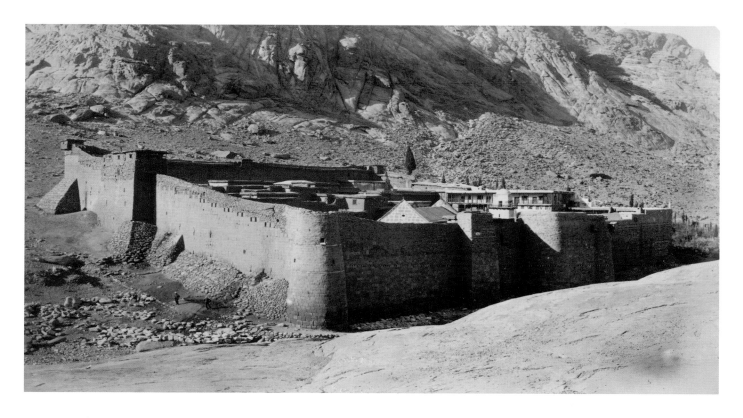

Mount Sinai

The Monastery of St Catherine, Mount Sinai, is the longest continuously active Christian monastic community. That St Catherine's has been a place of Christian pilgrimage from an early period is shown by an account of the Spanish nun Egeria, who visited the church in 383/384. By the middle of the sixth century, the Emperor Justinian had established a fortified monastery there. Later, this monastery was dedicated to St Catherine of Alexandria, a Christian martyr whose remains are believed to have been transported miraculously to the site. In 1328 Pope John XXII granted a one-year indulgence for visits to the church. In addition to the famous Codex Sinaiticus (see pages 66–7) named after Mount Sinai, a number of other important manuscripts from the Monastery are now held by the British Library (see pages 207–8). The Monastery of Saint Catherine continues to have a fine collection of manuscripts, many of which were brought to it by monks settling in the community.

BL 1787.d.13

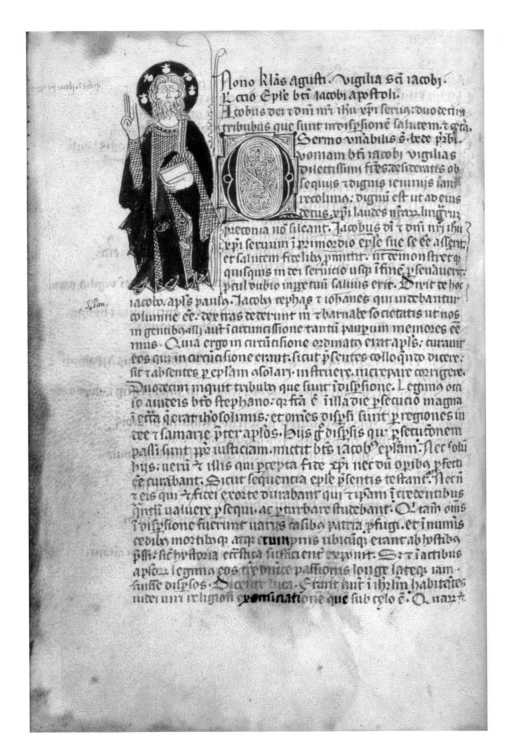

The Pilgrim's Guide to Compostela

Santiago?, Spain, first half of the fourteenth century
Liturgy of St James

One of the medieval pilgrimage routes that remains popular today is the road to Santiago de Compostela in north-western Spain. The great Romanesque cathedral there is dedicated to St James (Santiago), who is identifiable in this manuscript because of the scallop shells outlined on his hat in red. The manuscript includes guidance to pilgrims on such practical problems as which water is safe to drink and how to board ferries, as well as describing sites and the cathedral. This guide was probably written by a Frenchman for French pilgrims, and the author doesn't hesitate to express his opinion of the regional characteristics of people along the way. The Gascons, for example, are 'verbose' and 'drunkards', also 'given to combat but are remarkable for their hospitality to the poor'.

BL Add. MS 12213, f. 3v

The Portuguese Genealogy

Lisbon, Portugal, *c*.1530–4
Image of Queen Isabella on pilgrimage to Compostela

This extraordinarily large leaf is one of several surviving from an ambitious project to complete a genealogy of the royal houses of Spain and Portugal. At the centre of this page is an image of St Isabella (Elizabeth) of Portugal (1271–1336), holding red roses in her lap, who married King Diniz of Portugal when she was twelve. Her pilgrimage to the shrine of St James at Compostela is pictured in the borders. In the lower left she is shown approaching the portal of the church. A contemporary chronicle records that she travelled 'on foot, with great devotion'. In the lower right she kneels before the altar, offering her crown to the bishop. The chronicler reported that she offered to St James the finest crown she possessed, 'with many precious stones' as well as a gold and silver bridle, scalloped pink clothes with the tokens of Portugal and Aragon, and 'very fine, very well-worked goblets'.

BL Add. MS 12531 f. 9*

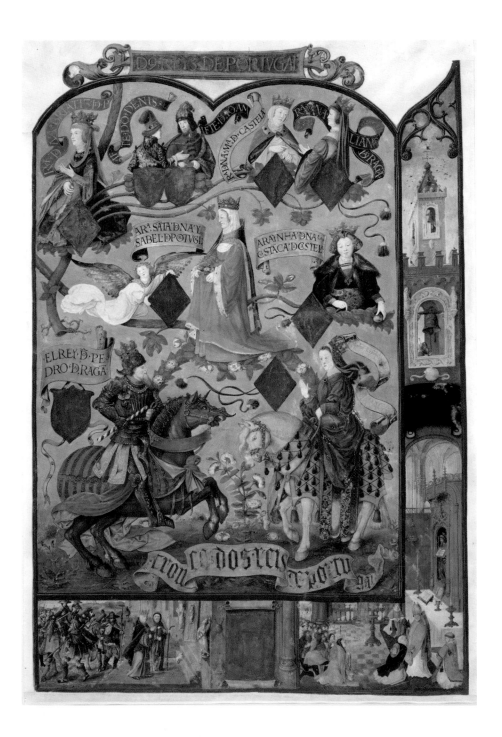

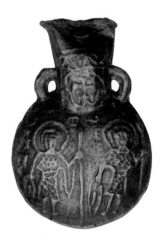

Pilgrim Badges and Ampullae

England, Jerusalem and Spain, twelfth
to fourteenth centuries
*Thomas Becket; the Holy Sepulchre;
Scallop Shell*

The most prominent place of
pilgrimage in England was the shrine
of St Thomas Becket (*c*.1118–70),
murdered in Canterbury Cathedral
while he was celebrating Mass on
29 December, 1170. The ampulla or
flask from Canterbury (upper left)
depicts this event, and identifies one
of his murderers: 'Reginald Fitzurse
caused the martyrdom of Thomas'.
It may have been used to carry water
from the shrine, which was reputed
to have been diluted with drops of the
saint's blood. The standing figure of
Becket demonstrates the high quality
that some badges or tokens achieved,
as well as their lasting popularity and
that of his shrine. Another ampulla
comes from Jerusalem (lower left):
on one side is an image of the Church
of the Holy Sepulchre, and, on the
reverse (shown here), two standing
Byzantine saints, Sts George and
Aetius, with their names inscribed in
Greek beside them. The scallop shell
was originally associated with the
cathedral of St James in Santiago de
Compostela, but came to stand for
Christian pilgrimage generally.

British Museum 1896, 5-1,69; 2001,0702.5;
1856, 7-1,2106; 1876,1214.18

A Fifteenth-century Pilgrimage Certificate

Unknown origin, 1432–3

Every Muslim who is able to do so must, once in a lifetime, journey to Mecca and perform the prescribed rites of *hajj* or pilgrimage. This undertaking is always made in the twelfth month of the Islamic calendar, *Dhu Al-Hijjah*, from which the pilgrimage has taken its name. This scroll attests that Maymunah, daughter of Muhammad ibn 'Abd Allah al-Zarli, made the pilgrimage to Mecca and visited the tomb of the Prophet Muhammad in 1432–3. The certificate depicts the sanctuary of the *Ka'bah* at Mecca; the hill al-Marwah (shown as a series of concentric circles); the shrine of the Prophet Muhammad at Medina; and the sole of the Prophet's sandal, on which is written one of his sayings. The calligraphic bands of Arabic script are quotations from the Qur'an concerning the pilgrimage. While the Prophet's tomb at Medina is not a prescribed part of the pilgrimage, pilgrims do visit other places associated with the Prophet.

BL Add. MS 27566 (detail)

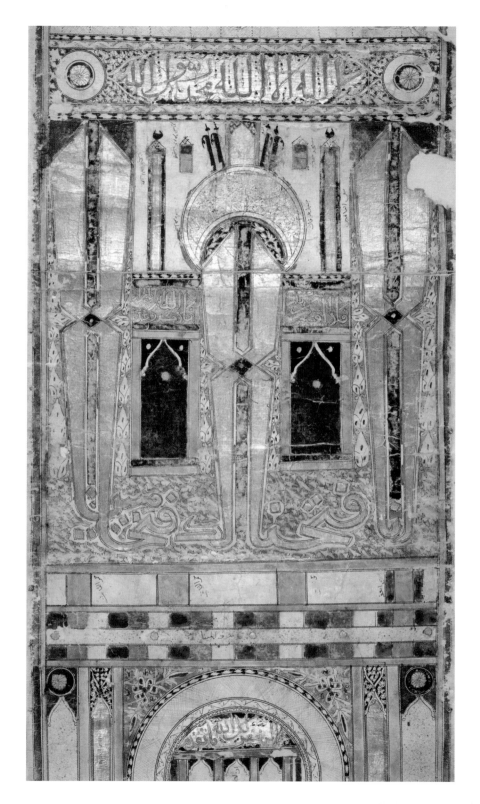

Ka'bah

The name *Ka'bah* comes from the Arabic word meaning 'cube', and refers to the cube-shaped stone structure inside the Grand Mosque in Mecca. As the focal point for worship during the daily prayers, it unifies all Muslims: wherever they are in the world, Muslims pray in the direction of Mecca and the *Ka'bah*. This direction is known as the *qiblah*.

In a tradition that goes back to the time of the Prophet Muhammad, the holy *Ka'bah* is dressed with a new *kiswah* (covering) every year during the month of pilgrimage. During the Mamluk period (1250–1517) Egypt was the centre for making the *Ka'bah* coverings, and the Mamluk ruler had the honour of dressing the structure. However, from the early sixteenth century to the early twentieth century the Ottoman sultan exercised this privilege. The coverings, such as the curtain shown here, were still made in Egypt. Fragments from the previous year's cloth are cut up and kept as relics. The curtain covering the door of the *Ka'bah*, and the strap that wraps around the whole of the structure are considered among the most precious relics.

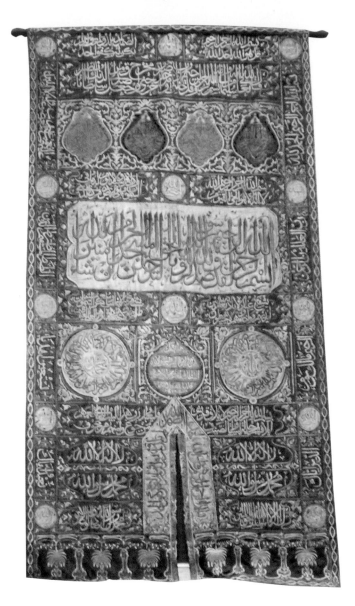

Curtain of the Ka'bah Door

Egypt, 1858

This external curtain once hung over the door of the *Ka'bah* and has a small slit to allow access to the doorway. The hanging consists of a number of segments and cartouches richly ornamented with Qur'anic inscriptions woven in silver and silver-gilt thread over a silk base, and with the *tughra* (calligraphic signature) of the Ottoman sultan Abdulmajid I.

Private collection

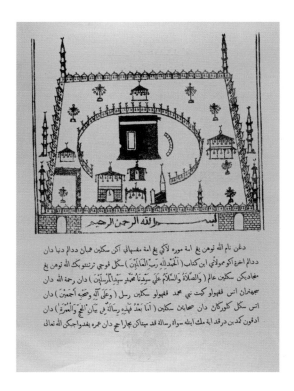

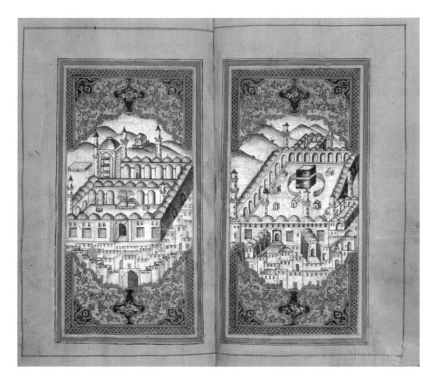

Depiction of the Ka'bah

Singapore, 1900

An illustration of the holy *Ka'bah* in Mecca from a work on Muslim pilgrimage written in the Malay language by Muhammad Azahari bin Abdullah.

BL 14620.g.20, p. 2

Depiction of the Holy Cities of Mecca and Medina

India, nineteenth century

The *Dala'il al-khayrat* (Guide to Goodness) is a popular prayer book for pilgrims. Attributed to Muhammad ibn Sulayman al-Jazuli, this prayer-book contains two miniature paintings of the holy cities of Mecca and Medina.

BL Or. MS 16211, ff. 14v–15

Ark A chest in the synagogue where the Torah scrolls are kept. Its curtain is called the *parokhet*.

Ashkenazim Jews originally from Germany, France and England, and then more widely from Russia and Eastern Europe.

Codex A book in which the writing material (parchment, papyrus or paper) is bound at one edge (left for Greek, Latin and the European vernaculars; right for Hebrew, Arabic and Semitic scripts) and sometimes protected front and back with covers.

Covenant The agreement between God and the Jewish people, whereby He promised to take care of them if they followed His commandments.

Diaspora The Jewish community spread world-wide, except for those living in Israel.

Gemara Part of the Talmud, written in Aramaic and developed in two major centres of Jewish scholarship: Babylonia and Palestine.

Gentiles Jewish term for non-Jews; also known as 'goyim'.

Haggadah, Haggadot Literally 'narration' or 'telling', a collection of holy texts read on Passover eve to commemorate the Exodus of the Jews from Egypt.

Hanukkah The Festival of Lights, a winter celebration that marks the restoration of the temple by the Maccabees in 164 BC.

Havdalah Meaning 'separation', this is the name of a ceremony intended to distinguish between the holiness of the Sabbath and the start of the weekdays.

Humash Pentateuch.

Kabbalah An esoteric form of Jewish mysticism. According to Jewish tradition, Kabbalah dates from the time of Adam, but modern liberal rabbis say it originated in the thirteenth century.

Ketubah Marriage contract.

Ketuvim Writings – the third section of the Hebrew Bible.

Kidush Meaning 'santification'. Blessing recited over wine or bread on the eve of Sabbeth and festivals.

Liberal Judaism A modern subdivision of Judaism that teaches the Torah was written by fallible human beings.

Ma'amadot Daily selections from the Bible, Mishnah and Talmud read after the morning prayer.

Mahzor A Jewish book of festival prayers.

Masorah Tradition, particularly in the way a text is transmitted; the masoretic text of the Hebrew Bible was standardized by the scribal editors of the seventh to tenth centuries AD.

Menorah Seven-branched candelabrum, one of the Temple's sacred objects.

Micrography The practice of using minute script to create abstract shapes or figurative designs.

Midrash Part of Jewish scripture: a collection of teachings of the ancient rabbis, giving their inter-pretation of the Torah and defining Jewish law.

Mikdashyah Literally 'Lord's sanctuary', this was an alternative name for the Hebrew Bible. Used by Jews in Medieval Spain.

Mishnah Literally 'repetition'. The transcription and topical arrangement into six 'orders', of discussions of the law by rabbis.

Mishneh Torah 'Repetition of the Law', some-times known as 'The Second Law', a religious code of law compiled by Moses Maimonides.

Monogrammaton The one-letter divine name.

Orthodox Judaism A conservative subdivision of Judaism that values tradition.

Parashah A portion of the Torah, one of fifty-four, to cover an annual cycle of Sabbath reading in the synagogue.

Passover (Pesah) A spring festival that marks the Jewish people's escape from captivity in Egypt.

Pentateuch Literally 'five pieces' – the first five books of the Bible (i.e. Genesis through to Deuteronomy); the Torah.

Pericope Portion of the Torah.

Purim A festival marking the defeat of an attempt to wipe out the Jews in Persia as recounted in the book of Esther.

Qere The Hebrew text of Scripture as recited; the consonantal text with signs or symbols indicating how it is to be vocalized.

Reform Judaism A subdivision of Judaism that respects the Torah, but does not view it as immutable.

Rimonim (bells) A pair of embellished attach-ments for the Torah scroll made of silver.

Rosh Hashanah Jewish New Year.

Sabbath The Jewish day of rest, from sunset on Friday to sunset on Saturday.

Seder The ceremony conducted in Jewish house-holds on Passover eve.

Sefer Torah The ceremonial prompt-copy of the Torah in a synagogue, written on a parchment scroll.

Sephardim Jews originating from Spain and Portugal.

Septuagint Literally 'seventy'; refers to the Greek translations of the Sacred Books of the Jews undertaken by seventy Jewish scholars. From the third century BC the Septuagint was in broad use among the Greek-speaking Jews and then the Christians.

Shavuot The Festival of Weeks: a harvest festival commemorating the day when Moses received the Torah.

Sidur A Jewish book of daily prayers.

Sukot Literally 'tabernacles'; a festival com-memorating the years the Jews spent in the desert on their way to the Promised Land.

Talmud The body of commentary on the Mishnah, either by the scholars of Palestine *c.* AD 500 (the 'Jerusalem' or 'Palestinian' Talmud), or of Iraq *c.* AD 600 (the 'Babylonian' Talmud).

Tanakh Acronym of the Hebrew words for the three divisions of the Bible: Torah (Law), Nevi'im (Prophets) and Ketuvim (Writings); also a Jewish designation for the Bible.

Tannaim Rabbinic sages of the Mishnah.

Targum A translation, specifically an Aramaic translation-paraphrase of a book of the Hebrew Scripture.

Tetragrammaton The Hebrew name for God, written in four letters, pronounced Yahweh.

Tik An ornate leather or metal case used in Oriental and Sephardic communities to house the sacred Torah scroll.

Torah The central document of Judaism, written in Hebrew and revered by Jews. Also known as the Five Books of Moses or the Pentateuch (i.e. Genesis through to Deuteronomy).

Yad (pointer) A hand-shaped object used when reading the Torah scroll.

Christianity Glossary

Apocalypse The book of Revelation in the New Testament.

Arianism A fourth-century heresy that denied the divinity of Jesus Christ which was rejected at the Council of Nicea in 325.

Byzantium Now modern Istanbul, Byzantium was the site where the Roman emperor Constantine the Great founded a new city, Constantinople, as the eastern capital in 330. It ended with the Ottoman conquest of 1453.

Canon A fixed and closed list of books that are understood to have exclusive authority.

Canon Law From the Greek word *kanon*, meaning 'rule', canon law sets out the rules governing Church organization and Christian practice.

Canon Tables Also known as a concordance, a tabular method of comparing parallel texts in the Four Gospels. Contrived by Bishop Eusebius of Caesarea (*c.* AD 260–340), they preface many Christian manuscripts of the Four Gospels.

Carpet page An ornamental page, sometimes incorporating a cross, similar in design to an eastern carpet.

Codex A book in which the writing material (parchment, papyrus or paper) is bound at one edge (left for Greek, Latin and the European vernaculars; right for Hebrew, Arabic and Semitic scripts).

Coptic The non-Chalcedonian Christian church in Egypt.

Diatessaron 'Through four', a harmonized version of the four canonical Gospels by the Syrian churchman Tatian (*c.* AD 170).

Divine Office A cycle of eight daily devotions or services.

Eucharist The sacrament of Communion. The ritual re-enactment of Jesus's final meal with his Apostles before His arrest and execution.

Evangelist symbols Symbols of the Four Evangelists derived from the Old Testament vision of Ezekiel and the vision of St John in Revelation. St Matthew is represented by a winged man, St Mark by a winged lion, St Luke by a winged bull, and St John by a winged eagle.

Gnosticism From the Greek word *gnosis* (knowledge). Belief in salvation through esoteric knowledge reserved for a few, with an emphasis on spiritual rather than physical reality.

Gospel An account of the life of Jesus of Nazareth and/or His teachings. The four canonical Gospels are Sts Matthew, Mark, Luke and John.

Great Schism The final breach between the Western and Eastern Churches in 1439 over points of doctrine and practice.

Hexateuch The first six books of the Old Testament, which were sometimes contained in a single, separate volume.

Icon From the Greek word for 'image', icons became a standard part of devotion in the Byzantine and Orthodox churches.

Iconoclasm A movement against the veneration of icons, particularly in Byzantium.

Koine The Greek commonly spoken and written around the Mediterranean in Late Antiquity.

Lectionary A volume containing readings for use in the liturgy.

Melkites From *Mălkâya* (imperial), used for those Copts and Syrians who accepted the decisions of the Council of Chalcedon in 451, following the lead of the Byzantine emperor.

New Testament The collection of twenty-seven books that make up the second part of the Christian Bible, including the Four Gospels, the Acts of the Apostles, letters from St Paul and other early Christian leaders, and Revelation.

Non-Chalcedonian Churches that do not recognise the doctrine about the natures of Christ propounded at the Council of Chalcedon in 451.

Octateuch The first eight books of the Old Testament.

Old Testament The Christian name for the Jewish Scriptures that form the first part of the Christian Bible.

Orthodox Church The Eastern Orthodox Church, a major grouping of Christian churches that originated in the Byzantine Empire and that includes the modern-day Greek and Russian Orthodox Churches, among others.

Pentateuch The first five books of the Old Testament, which were sometimes incorporated into a single volume.

Psalter A book containing the Psalms and usually a calendar, canticles, litany, and prayers.

Roman Catholic The Christian church headed by the Pope in Rome.

Vulgate The Latin translation of the Bible made by St Jerome (*c.* 340–420). The word 'vulgate' comes from the Latin *vulgata*, meaning 'common' or 'popular'.

For further detail and other topics see:
www.bl.uk/catalogues/illuminatedmanuscripts/glossary.asp

Michelle P. Brown, *Understanding Illuminated Manuscripts: A Guide to Technical Terms* (J. Paul Getty Museum, Malibu and British Library, 1994)

E. A. Livingstone (ed) *The Oxford Dictionary of the Christian Church* (Oxford University Press, 1977)

Islam Glossary

Abbasids Dynasty that ruled from Baghdad 759–1258.

Ahl al-kitab 'People of the Book'

AH 'After the Hijrah' (see below). The Islamic calendar starts from 622, when the Prophet and his followers migrated from Mecca to Medina.

Allah The Arabic word for 'God'.

Aya A sign, often of a miraculous nature; a verse of the Qur'an.

Basmalah, Bismillah 'In the name of God', an invocation used by Muslims to ask for God's blessing on any action; found at the start of almost every *sura* of the holy Qur'an.

Codex A book in which the writing material (parchment, papyrus or paper) is bound at one edge (left for Greek, Latin and the European vernaculars; right for Hebrew, Arabic and Semitic scripts) and protected front and back with covers.

Diacritics Marks that distinguish between letters of similar shape.

Fatimids Dynasty that ruled Egypt and North Africa 909–1171.

Fatwa A legal opinion on a point of Islamic law.

Five Pillars of Islam The duties carried out by Muslims as part of their faith: to believe that 'There is no God but Allah, and Muhammad is his messenger', to pray five times a day, to fast, to give to charity, and to make the pilgrimage to Mecca.

Ghubar Literally 'dust'; used to describe a minute style of *naskhi* script (see below).

Hadith A saying, action or story of the Prophet Muhammad not recorded in the Qur'an.

Hafiz A person who has learnt the Qur'an by heart.

Hajj The pilgrimage to Mecca that is one of the Five Pillars of Islam.

Haram Taboo or prohibited, referring to people, places and things. The Haram is the sanctuary at the centre of Mecca.

Hegira (Hijrah) The migration of Muhammad and his followers from Mecca to Medina in 622.

Hijaz Region of Arabia that includes the holy places of Mecca and Medina.

Il-Khanids Mongol dynasty that ruled mainly from Tabriz 1256–1353.

Imam A teacher, or leader of the Muslim prayer; for Shiis it means direct descendents of the Prophet.

Jihad A Muslim's personal struggle to live life according to the faith; the struggle to build a good Muslim society and to defend Islam.

Ka'bah The cubic building at the centre of the mosque at Mecca around which pilgrims process. It is the focal point of Muslim prayer.

Kitab Literally 'book'; *Ahl al-kitab* are the People of the Book, referring to Jews and Christians.

Kufic A calligraphy style with very short vertical strokes and elongated horizontal strokes.

Madrassa (Madrasah) Islamic school.

Maghribi A regional style of script in Spain and North Africa.

Ma'il An early style of Arabic script notable for its pronounced slant to the right and for its lack of diacritical marks.

Makkah Alternative spelling of Mecca.

Mamluks Slaves turned rulers, who ruled from Cairo, 1250–1517.

Masjid Arabic word for 'mosque'

Mihrab A niche in a mosque showing the direction of Mecca.

Mughals Dynasty that ruled India from 1526 to 1858.

Muhaqqaq A popular script for larger Qur'ans of the Mamluk and Il-Khanid periods, its angular and cursive features giving the calligrapher an opportunity to combine fluidity with rigidity.

Mushaf A copy of the Qur'an; more specifically, a complete text of the Qur'an in one volume.

Najd Present-day Saudi Arabia.

Naskhi First developed in the tenth century by the Abbasid vizier and calligrapher Ibn Muqlah (886–940), and later perfected by Ibn al-Bawwab (d. 1022), the master calligrapher who continued his tradition. *Naskhi* became one of the most popular styles for transcribing Arabic manuscripts, being favoured for its legibility.

Ottomans Dynasty that ruled from 1281 to 1924, having conquered Byzantium in 1453.

Qari' A Quranic reciter.

Qiblah The direction of Mecca.

Qur'an The holy book of Islam.

Ramadan The month of fasting; the ninth month of the Muslim calendar.

Rawi A reciter and transmitter of poetry and also of Hadith.

Ruq'ah The script used for headlines and titles, the everyday written script of most of the Arab world.

Safavid Dynasty that ruled Persia 1501–1732.

Shari'a Islamic law.

Shi'a, Shi'i The second largest group (10 per cent) within Islam.

Sufism The mystical movement in Islam.

Suhuf A collection of written sheets or leaves placed between two boards.

Sunna Custom, customary behaviour of the Prophet as reported in the Hadith.

Sunni The largest group (90 per cent) within Islam.

Sura(h) A chapter of the holy Qur'an.

Tawrat Torah; the Quranic term for the Jewish Scripture.

Tilawa Recitation, particularly of the Qur'an.

Thuluth A large, ornamental cursive script, primarily for chapter headings and titles, popular in Mamluk Qur'ans.

Timurid Dynasty in Iran (1370–1506).

Ulama' The learned; Muslim lawyers or clerics.

Umayyad Dynasty that ruled from 661 to 750, whose capital was Damascus.

Umma The community of Muslims that constitute Islamic society.

Wahhabism A reform movement founded by Muhammad ibn 'Abd al-Wahhab (1703–92), and now the form of Islam practised in Saudi Arabia.

Further Reading

General

Armstrong, Karen, *A History of God: From Abraham to the Present, the 4000 Year Quest for God* (Heinemann, 1993)

Armstrong, Karen, *Jerusalem: One City, Three Faiths* (Harper Collins, 1996)

Armstrong, Karen, *The Battle for God: Fundamentalism in Judaism, Christianity and Islam* (Alfred Knopf, 2000)

Bowker, John, *God: A Brief History* (Dorling Kindersley, 2002)

Coleman, Simon and Elsner, John, *Pilgrimage* (British Museum Press, 1995)

Fletcher, Richard, *The Cross and the Crescent: Christianity and Islam from Muhammad to the Reformation* (Viking, 2003)

Livres de parole: Tora, Bible, Coran (Bibliothèque Nationale de France, Paris, 2005)

Mazower, Mark, *Salonica, City of Ghosts: Christians, Muslims and Jews 1430–1950* (Harper Collins, 2004)

Menocal, Maria Rosa, *The Ornament of the World: How Muslims, Jews and Christians Created a Culture of Tolerance in Medieval Spain* (Little, Brown, 2002)

Neusner, Jacob, Chilton, Bruce and Graham, William, *Three Faiths, One God: The Formative Faith and Practice of Judaism, Christianity and Islam* (Brill, 2002)

Peters, F.E., *The Voice, the Word, the Books: The Sacred Scripture of the Jews, Christians and Muslims* (British Library, 2007)

Smart, Ninian, *The World's Religions*, 2nd edn (Cambridge University Press, 1998)

Judaism

Aharoni, Yohanan, *Historical Atlas of the Jewish People* (Continuum, 2003)

Beit-Arie, Malachi, *Hebrew Manuscripts of East and West: Towards a Comparative Codicology* (British Library, 1992)

Beit-Arie, Malachi, *Unveiled Faces of Medieval Hebrew Books: The Evolution of Manuscript Production – Progression or Regression?* (Magnes Press, 2003)

Burman, Rickie, et al. (eds.), *Treasures of Jewish Heritage: The Jewish Museum, London* (Scala, 2006)

Cohn-Sherbok, Dan, *Judaism: History, Belief and Practice* (Routledge, 2003)

Coogan, Michael David, *The Old Testament: An Historical and Literary Introduction to the Hebrew Scriptures* (Oxford University Press, 2006)

Folberg, Neil, *And I Shall Dwell among Them: Historic Synagogues of the World* (Aperture, 1995)

Fox, Everett, *The Five Books of Moses: A New English Translation* (Schocken Books, 1995)

Gilbert, Martin, *The Routledge Atlas of Jewish History* (Routledge, 2003)

Hallamish, Mosheh, *An Introduction to the Kabbalah* (State University of New York Press, 1999)

Jacobs, Louis, *The Jewish Religion: A Companion* (Oxford University Press, 1995)

Karp, Abraham J., *From the Ends of the Earth: Judaic Treasures of the Library of Congress* (Rizzoli, 1991)

Lange, Nicholas de, *Judaism*, 2nd edn (Oxford University Press, 2003)

Levin, Christoph, *The Old Testament: A Brief Introduction* (Princeton University Press, 2005)

Levine, Lee, *The Ancient Synagogue – The First Thousand Years*, 2nd edn (Yale University Press, 2000)

Lim, Timothy H., *The Dead Sea Scrolls: A Very Short Introduction* (Oxford University Press, 2005)

Neusner, Jacob, *Judaism: An Introduction* (Penguin, 2002)

Polliack, Meira, *Karaite Judaism: A Guide to Its History and Literary Sources* (Brill, 2003)

Rainey, Anson F., *The Sacred Bridge: Carta's Atlas of the Biblical World* (Carta, 2006)

Reif, Stefan C., *A Jewish Archive from Old Cairo* (Curzon Press, 2000)

Sed-Rajna, Gabrielle, *Jewish Art* (Abrams, 1997)

Sirat, Colette, *Hebrew Manuscripts of the Middle Ages* (Cambridge University Press, 2002)

Tahan, Ilana, *Hebrew Manuscripts: The Power of Script and Image* (British Library, 2007)

Christianity

Brown, Michelle, (ed.), *In the Beginning: Bibles Before the Year 1000* (Freer Gallery of Art and Arthur M. Sackler Gallery, 2006)

The Cambridge History of the Bible, 3 vols (Cambridge University Press, 1963–70)

Campbell, Marian, 'The Medieval Chalices in Iceland', in *Church and Art: The Medieval Church in Norway and Iceland* (Reykjavik, 1997), pp. 102–04.

Cross, F.L. and Livingston, E.A. (eds), *The Oxford Dictionary of the Christian Church*, 3rd edn (Oxford University Press, 1997)

Hamel, Christopher De, *The Book: A History of the Bible* (Phaidon, 2001)

Harries, Richard and Mayr-Harting, Henry (eds), *Christianity: 2,000 Years* (Oxford University Press, 2002)

Kauffmann, C.M., *Biblical Imagery in Medieval England 700–1500* (Harvey Miller, 2003)

McKendrick, Scot, *In a Monastery Library: Preserving Codex Sinaiticus and the Greek Written Heritage* (British Library, 2006)

McKendrick, Scot and Doyle, Kathleen, *Bible Manuscripts: 1400 Years of Scribes and Scripture* (British Library, 2007)

McKendrick, Scot and O'Sullivan, Orlaith (eds), *The Bible as Book: The Transmission of the Greek Text* (British Library, 2003).

Nersessian, Vrej, *The Christian Orient* (British Library, 1978)

Nersessian, Vrej, *The Bible in the Armenian Tradition* (British Library, 2001)

Nersessian, Vrej, *Treasures from the Ark: 1700 years of Armenian Christian Art* (British Library, 2001)

Pattie, T.S., *Manuscripts of the Bible: Greek Bibles in the British Library*, revd edn (British Library, 1995)

Sharpe, John L. and Van Kampen, K. (eds), *The Bible as Book: The Manuscript Tradition* (British Library, 1998)

Williamson, Paul, *Netherlandish Sculpture 1450–1550* (London: V&A, 2002)

Islam

Armstrong, Karen, *Muhammad: A Western Attempt to Understand Islam* (Orion, 1991)

Armstrong, Karen, *Islam: A Short History* (Weidenfeld & Nicolson, 2000)

Baker, Colin F., *Sultan Baybars' Qur'an*, CD Rom (British Library, 2002)

Baker, Colin F., *Qur'an Manuscripts: Calligraphy, Illumination, Design* (British Library, 2007)

Brend, Barbara, *Islamic Art* (British Museum Press, 1991, 2000)

Canby, Sheila, *Islamic Art in Detail* (British Museum Press, 2005)

Esposito, John L., *What Everyone Needs to Know about Islam* (Oxford University Press, 2002)

Folsach, Kjeld von, et al. (eds.), *Sultan, Shah and Great Mughal: The History and Culture of the Islamic World* (The David Collection, Copenhagen, 1996)

Hillenbrand, Carole, *The Crusades: Islamic Perspectives* (Edinburgh University Press, 1999)

Lewis, Bernard (ed.), *The World of Islam* (Thames & Hudson, 1997)

Mackintosh-Smith, Tim (ed.), *The Travels of Ibn Battutah* (Picador, 2003)

Malouf, Amin, *The Crusades through Arab Eyes* (Al Saqi, 1984)

Ruthven, Malise, *Islam: A Very Short Introduction* (Oxford University Press, 1997)

Safadi, Yasin Hamid, *Islamic Calligraphy* (Thames & Hudson, 1978)

Sells, Michael, *Approaching the Qur'an* (White Cloud Press, 1999)

Stanley, Tim, *Palace and Mosque: Islamic Art from the Middle East* (Allen & Unwin/V&A, 2006)

UNITED KINGDOM

Lindisfarne
Northumbria
Durham

IRELAND

Mercia

Hamburg

NETHERLANDS

St Albans
London
Winchester

Amsterdam
Arnhem
Canterbury
Ghent
Antwerp

Hildesheim

GERMANY

BELGIUM

Mainz
Worms
Augsburg

Vienna

Paris

AUSTRIA

FRANCE

Limoges

Venice
Ferrara
Florence

Trieste

Ancona

Santiago de
Compostela

ITALY

Rome

Monte Cassino

The Balkans

GEORGIA

Silos
Monastery

Catalonia

Naples

BULGARIA

Istanbul
(Constantinople)

Tayk

ARMENIA

PORTUGAL

Castile

Barcelona

Palermo

TURKEY

Ta

SPAIN

Amid

Lisbon

Granada

Antioch

SYRIA

Mosul

Faro

Damascus

IRAQ

Bagh

TUNISIA

NORTH AFRICA

ISRAEL

al-Ku

Rabat
Casablanca

Jerusalem

MOROCCO
Marrakesh

Alexandria

Palestine

ALGERIA

Cairo

*Sinai
Peninsula*

St Catherine's
Monastery

EGYPT

Medina

SAUD
ARAB

Nubia

Mecca

SUDAN

ETHIOPIA
Gondar

Malay Peninsula

JAVA

●Herat

AFGHANISTAN

●Kaifeng

...aan

...iraz

●Delhi

CHINA

Bihar

INDIA

Calcutta●

●Bombay

Malay Peninsula

Map 221

Index